EUROPEAN PAINTINGS

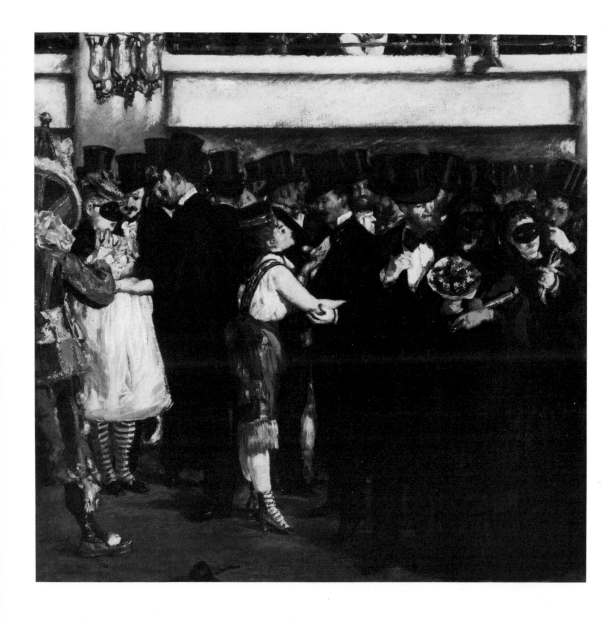

European Paintings

An Illustrated Catalogue

National Gallery of Art Washington 1985

Printed by Comproject b.v., The Netherlands

The type is Sabon, set by Princeton University Press.

Edited by Anne Summerscale. Layout and mechanicals by Lynn Mancini.

Library of Congress Cataloging-in-Publication Data

National Gallery of Art (U.S.)
European paintings.

Include indexes.
1. Painting, European—Catalogs. 2. Painting—Washington (D.C.)—Catalogs. 3. National Gallery of Art (U.S.)—Catalogs. I. Title. ND450.N38 1985
759.94'074'0153 85-28457
ISBN 0-89468-089-7

Cover: Georges de La Tour, *The Repentant Magdalen* (detail), c. 1640

Frontispiece: Edouard Manet, *Ball at the Opera*, (detail), 1873

Contents

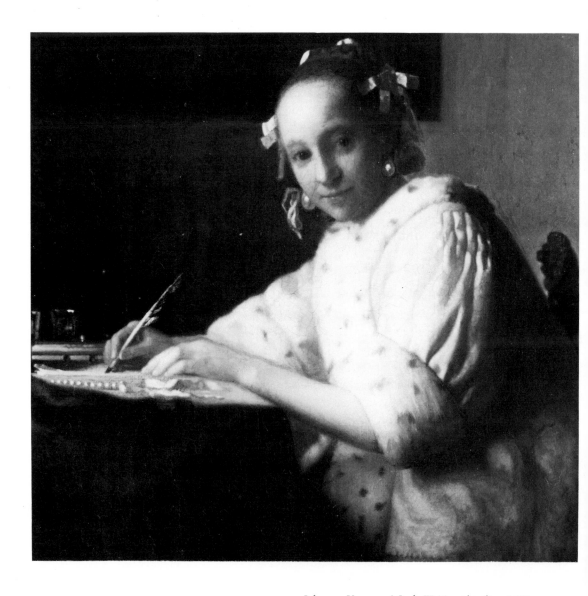

Johannes Vermeer, A Lady Writing (detail), c. 1665

Foreword

In the ten years since the publication of the last *Summary Catalogue of European Paintings*, the holdings of the National Gallery of Art have been significantly enriched, our ability to display them has been enhanced through major expansion of gallery space, and our knowledge about them has been extended through careful research.

This catalogue records our holdings as of the end of 1984. It includes some 102 new acquisitions of European painting since the 1975 edition, among them works by Veronese, van Goyen, Manet, Monet, Gauguin, Miró, Picasso, Kandinsky, and many other masters. The Gallery relies entirely on the generosity of private donors for its collections. The remarkable assembly of paintings which has been gathered since the Gallery opened in 1941, reflected in these pages, is a stirring tribute to the effectiveness of Andrew Mellon's original vision. In discussing the establishment of a National Gallery of Art, he proposed that the federal government would provide operating support and the private sector all of the works of art. That spirit of private generosity has been underscored recently by the successful attainment of the Gallery's goal to raise $50 million to create the Patrons' Permanent Fund, an endowment fund for future acquisitions.

To have these treasures is not enough; it is important to make them accessible to the public. The past decade has seen the size of the National Gallery virtually doubled through the completion, in 1978, of the East Building. Designed by architect I. M. Pei, it provides a dramatic new setting for our twentieth-century holdings as well as space for special loan exhibitions and for our scholarly and administrative activities. The ground floor of John Russell Pope's 1941 building (the West Building) has undergone major renovation to create handsome new galleries for decorative arts, sculpture, prints and drawings, and American naive paint-

ings. Several new galleries have also been created within the original shell of the building on the main floor, enabling us to put more of our Old Master paintings and larger sculptures on view.

Perhaps most important, however, although less readily visible, is the intensified research being conducted on the collections, whose results are already beginning to be reflected in this volume. A Systematic Catalogue, a full scholarly discussion of every painting, sculpture, and decorative arts object in the National Gallery collection, is in active preparation by some thirty scholars, in Washington and worldwide. This endeavor has been greatly facilitated by an expanded curatorial and conservation staff. The naming of Senior Curator John Wilmerding as Deputy Director in 1983 has given the undertaking overall supervision of the best imaginable kind. The appointment later that year of Professor Sydney J. Freedberg of Harvard University as Chief Curator, and his subsequent restructuring of the curatorial staff, have further strengthened our scholarly resources.

Assembling the information for this *Summary Catalogue* has required patience, care, and hard work from the curators and other members of the professional staff, for which we are most grateful. Our particular thanks go to Suzannah Fabing, managing curator of records and loans, and to M. E. Warlick of the department of curatorial records and files, who have seen this essential project to its successful completion.

J. CARTER BROWN
Director

Preface

The 1985 edition of the *Summary Catalogue of European Paintings* varies significantly from its predecessor published ten years ago. Not only has the format of the catalogue changed, but the information accompanying each image often differs from that presented previously. These changes are the result of several years of research by a number of dedicated individuals and they reflect a diversity of projects.

As J. Carter Brown has mentioned, the curatorial staff of the National Gallery has increased dramatically in the past ten years. These scholars have been able to undertake careful research on and examination of the objects assigned to their care, resulting in a number of new attributions and titles since the last catalogue. A combined list of changes in attributions and titles as well as minor changes in nomenclature is found in this volume. Several paintings, formerly housed in the American Department and painted mostly by anonymous artists, are included for the first time in the European catalogue.

One major impetus to the extensive reevaluation of the paintings has been the planned publication of the *Systematic Catalogue*. Under the coordination of Suzannah Fabing, the Gallery's curators and other scholars are preparing a complete scholarly catalogue of the entire collection. The plan calls for approximately twenty-seven volumes to be published over the coming decade. Each volume will contain detailed descriptions of the objects in a particular area of the collection. The authors will bring to their discussions a scholarly synthesis of the current research, laboratory analysis, and connoisseurship. The first of the series, the catalogue of *Early Netherlandish Paintings* by John Hand and Martha Wolff, will be published shortly. Their research is reflected in a number of significant changes of attributions and titles in this *Summary Catalogue* among the Netherlandish works.

While still in its infancy, the *Systematic Catalogue* project has fostered a keen awareness of the importance of presenting accurate data on the collection and has set a standard for the information presented in this volume.

Another factor contributing to the many changes in this edition of the *Summary Catalogue of European Paintings* has been the development of the National Gallery's computer data base. The preparation of this catalogue has progressed hand-in-hand with the Gallery's ongoing efforts to systematize information among the various curatorial departments and to develop a computerized information bank on the collection. As a discipline, art history is not often characterized by dry facts and numbers, and indeed, the metaphorical descriptions of works of art and highly embellished language of scholars often lend a special poetry to our understanding of art. The information on artists and on dates can often be vague or uncertain, much to the dismay of the computer programmers, who would prefer that every piece of information be clear, concise, and uncontested. It has been a special challenge to coordinate the needs of the curators to capture the complexities of information on each individual object with the demands of the computer to establish a systematic language for recording and retrieving information.

The entries in this catalogue represent only a portion of the extensive research accomplished over the past few years. The initial phase of the computer project began in the spring of 1980 with the establishment of a basic inventory system. As the project developed, this data base was expanded into a comprehensive art information system which now serves many of the needs of collection management and a number of more scholarly purposes as well. In the future, it is hoped that the scholarly data can be expanded further, encompassing such information as bibliography, provenance, exhibition history, conservation records, and biographical data on sitters. Several years of research, analysis, and computer programming have been needed to produce this very thorough and systematic body of information.

The first major task of the project was to create an artist file. To date, over 7000 artist records, connected with the Gallery's collections, have been gathered and researched by Robin Dowden and Marc Simpson. They consulted a number of sources for each artist, following the guidelines established in the second edition of the *Anglo-American Cataloguing Rules* (AACR II). Standard art historical references and recent catalogues were consulted for each artist. When discrepancies were found among these sources, other computer indexes, such as Répertoire International de la

Littérature de l'Art (RILA) and the OCLC on-line authority file were consulted. In this catalogue, their exhaustive work is reflected in numerous changes of artists' dates and variant spellings of artists' names.

One of the most obvious differences in this catalogue is the change in the accession number belonging to each painting. The accession number is assigned to an object when it enters the collection. Formerly, these numbers were assigned sequentially beginning with number 1. The 1975 catalogue included the accession numbers of paintings from 1 to 2672. In 1983, in accordance with the standard practice in American museums, the Gallery decided to adopt new accession numbers that would more systematically reflect the year and sequence within the year of each acquisition. The new accession numbers are arranged in several parts and incorporate, in sequential order, the year of acquisition, the lot or transaction by which the object was acquired during that year, and the number of the object within that individual gift. Some paintings that are composed of various parts, such as obverse and reverse sides or multiple panels, have an additional series number at the end. For example, the new accession number for Agnolo Gaddi's *Madonna Enthroned with Saints and Angels* is 1937.1.4.a-c. This indicates that it was acquired during 1937, the gift was the first one of that year, and this object was the fourth object within that gift. The series a-c refer to the left, middle and right panel of the painting.

The task of assigning these numbers fell to Joyce Giuliani, who spent months combing through the minutes of the Board of Trustees' meetings to reconstruct the exact history and acquisition sequence of the entire collection. The transfer from the old to the new accession numbers took place in August 1984. A concordance which relates old accession numbers to new accession numbers is found at the back of this volume.

As coordinator of the project to produce the 1985 edition of the *Summary Catalogue of European Paintings*, I have had the pleasure of working with many talented and dedicated people whose various projects merged into the production of this catalogue. I would like to thank all of the curators and their assistants who made suggestions and corrections and who so patiently and thoroughly reviewed the never-ending computer printouts generated at various stages of the process. These include David Brown, E. A. Carmean, Florence E. Coman, Jack Cowart, Sheldon Grossman, John Hand, Gretchen Hirschauer, Marla Price, Charles Stuckey, Arthur Wheelock, and Martha Wolff.

The researchers for the computerization project, including

Robin Dowden, Joyce Giuliani, Marc Simpson, and Trish Waters, have created through their tireless efforts a superb data base which continues to improve daily. Nancy Iacomini was most helpful in providing answers to questions which arose with the curatorial records. Suzannah Fabing, who is overseeing both the computerization project and the publication of the *Systematic Catalogue*, has generously provided guidance and encouragement along the way. In the Editors Office, Anne Summerscale was very helpful in preparing the final manuscript for publication.

It was through the expertise of several members of the Gallery's computer staff, Ric Snyder, Mike Mauzy, and Rozanne Morley, that the production of this catalogue was made possible. They contributed over a year of planning to design and then modify the computer programs needed to store the information on the collection. Through their efforts, we were able to create and typeset the manuscript for this catalogue directly from the computer. While this proved to be a simple task in the final phase, it required months of preliminary programming and close cooperation among all concerned.

Through the combined efforts of the people mentioned above, this catalogue offers the most accurate and recent information on the National Gallery's European paintings. It is hoped that this *Summary Catalogue* will serve as a useful resource and guide for all those scholars and visitors who admire and enjoy the European collection.

M. E. WARLICK

Donors to the European Collection

George Matthew Adams
Grace Vogel Aldworth
Avalon Foundation
Ursula H. Baird
Charles Ulrick and Josephine
 Bay Foundation, Inc.
James Belden
Ruth B. Benedict
Mrs. Albert J. Beveridge
Mr. and Mrs. William Draper
 Blair
Mr. and Mrs. Robert Woods
 Bliss
John and Louise Booth
Ralph and Mary Booth
Ailsa Mellon Bruce
Syma Busiel
The Morris and Gwendolyn
 Cafritz Foundation
Mrs. Charles S. Carstairs
Mrs. Gilbert W. Chapman
Dr. and Mrs. G. H. Alexander
 Clowes
William Robertson Coe
The Coe Foundation
Collectors Committee
Chester Dale
Mr. and Mrs. Ralph F. Colin
William Nelson Cromwell
Pauline Sabin Davis
Mrs. Watson B. Dickerman
Sally H. Dieke

John Dimick
Eleanor Widener Dixon
The children of William H.
 Donner
Jean McGinley Draper
Mrs. S. W. DuBois
Lewis Einstein
George L. Erion
Dorothea Tanning Ernst
Dr. and Mrs. Henry L. Feffer
David Edward Finley and
 Margaret Eustis Finley
Joanne Freedman
Mr. and Mrs. P. H. B.
 Frelinghuysen
Angelika Wertheim Frink
The Fuller Foundation, Inc.
Samuel L. Fuller
Carol and Edwin Gaines
 Fullinwider
R. Horace Gallatin
Edgar William and Bernice
 Chrysler Garbisch
Emily Floyd Gardiner
Edith Stuyvesant Gerry
Mrs. Robert Giles
Mr. and Mrs. Gordon Gray
Theodore Francis Green
E. J. L. Hallstrom
W. Averell Harriman
 Foundation
Joseph H. Hazen

Joseph H. Hazen Foundation,
 Inc.
Horace Havemeyer
Mrs. Horace Havemeyer
Harry Waldron Havemeyer
Horace Havemeyer, Jr.
Mr. and Mrs. Philip Gibson
 Hodge
Vladimir Horowitz
Mrs. Barbara Hutton
Rupert L. Joseph
Mrs. Otto H. Kahn
Otto and Franziska Kallir
Mr. and Mrs. Stephen M. Kellen
Samuel H. Kress Foundation
Mr. and Mrs. Sidney K. Lafoon
Adele Lewisohn Lehman
Bertha B. Leubsdorf
Adele R. Levy
Mr. and Mrs. Benjamin E. Levy
Margaret Seligman Lewisohn
Sam A. Lewisohn
Charles L. Lindemann
Mr. and Mrs. Earl H. Look
G. Grant Mason, Jr.
John Russell Mason
Mrs. Alexander H. McLanahan
Andrew W. Mellon
Mr. and Mrs. Paul Mellon
Eugene and Agnes E. Meyer
Adolph Caspar Miller
Pepita Milmore Memorial Fund
Jan and Meda Mladek
Mr. and Mrs. John U. Nef
Mr. and Mrs. Morton G.
 Neumann
Clarence Y. Palitz
Count Cecil Pecci-Blunt

Duncan Phillips
Alice Preston
Ethel Gaertner Pyne
Mrs. Henry R. Rea
Curt H. Reisinger
The wife and children of
 Charles Edward Rhetts
Lessing J. Rosenwald
Herbert and Nannette
 Rothschild
Arthur Sachs
Lili-Charlotte Sarnoff
Mrs. Robert W. Schuette
Virginia Steele Scott
Jean W. Simpson
Kate Seney Simpson
Robert H. and Clarice Smith
Mrs. Richard Southgate
Michael Straight
Howard Sturges
Mr. and Mrs. E. W. R.
 Templeton
Lillian S. Timken
Dr. and Mrs. Walter Timme
Josephine Tompkins
Mr. and Mrs. Burton Tremaine
Mr. and Mrs. William D. Vogel
Frieda Schiff Warburg
Cornelius Vanderbilt Whitney
John Hay Whitney
George D. Widener
Joseph E. Widener
Peter A. B. Widener
Emily M. Wilson
Miss Harriet Winslow
Mr. and Mrs. William Wood
 Prince

Attribution Terms

Artist: A named artist.

Attributed to: Indicates varying degrees of doubt or the necessity for emphasizing doubt.

Studio of, Workshop of: Produced in the named artist's workshop or studio, by students or assistants, possibly with some participation by the named artist. Particularly important is that the creative concept is by the named artist and that the work was meant to leave his studio as his.

Follower of: An unknown artist working specifically in the style of the named artist, who may or may not have been trained by the named artist. Some chronological continuity of association or a time limit of about a generation after the named artist's death is implied.

Style of: Indicates a stylistic relationship only, possibly vague, in which there need not be an implied chronological continuity of association or the time limit may be greatly expanded.

After: A copy of any date.

School: Indicates a geographical distinction only, a town, district, or province, etc., used where it is impossible to isolate a specific artist, his studio or following.

Unknown artists: Works by unknown artists are to be found under the designation of anonymous followed by nationality, or under the school with which they are associated.

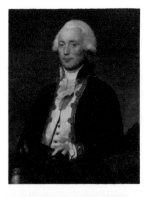

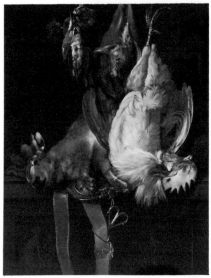

Lemuel Francis Abbott
BRITISH, 1760 – 1803
Captain Robert Calder, c. 1790
Canvas, .921 x .718 (36 1/4 x 28 1/4)
Andrew W. Mellon Collection
1954.1.8

Willem van Aelst
DUTCH, 1625 or 1626 – 1683
Still Life with Dead Game, 1661
Canvas, .847 x .673 (33 3/8 x 26 1/2)
Inscribed at lower right below table top:
Gŭill.ᵐᵒ van. Aelst. 1661.
Pepita Milmore Memorial Fund
1982.36.1

Workshop of Albrecht Altdorfer
GERMAN
The Fall of Man, c. 1535
Transferred from wood to hardboard,
middle panel: .387 x .350 (15 1/4 x 12);
side panels, each: .387 x .159 (15 1/4 x
6 1/4)
Inscribed on left panel across top: [H]VI
[S]ANAS MEN[T]ES FE[BRIS] / QVVM
BACCHIC[A] / TVRBAT (Woe, when Bacchic
fever confuses sound minds); inscribed on
right panel across top: TVNC [D]VRIT[E]R
[PA]CTVM / MISCET MARS IMPIVS / ORBEM
(Then will agreement be difficult when
godless Mars turns the world upside down)
Samuel H. Kress Collection
1952.5.31.a-c

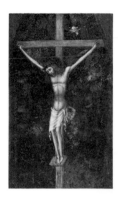
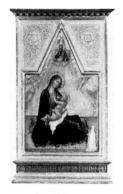

Andrea di Bartolo
SIENESE, active 1389 – 1428
Madonna and Child; reverse: *The Crucifixion,* c. 1415
Wood, each panel: .286 x .178
(11 1/4 x 7)
Samuel H. Kress Collection
1939.1.20.a-b

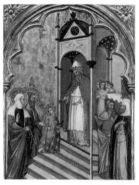

Andrea di Bartolo
SIENESE, active 1389 – 1428
The Presentation of the Virgin, c. 1400
Wood, .442 x .324 (17 3/8 x 12 3/4)
Samuel H. Kress Collection
1939.1.41

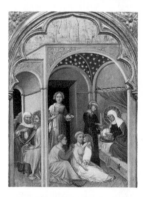

Andrea di Bartolo
SIENESE, active 1389 – 1428
The Nativity of the Virgin, c. 1400
Wood, .442 x .324 (17 3/8 x 12 3/4)
Samuel H. Kress Collection
1939.1.42

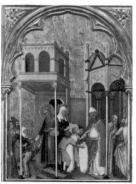

Andrea di Bartolo
SIENESE, active 1389 – 1428
Joachim and the Beggars, c. 1400
Wood, .442 x .324 (17 3/8 x 12 3/4)
Samuel H. Kress Collection
1939.1.43

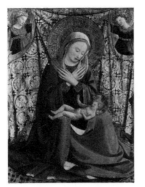

Fra Angelico
FLORENTINE, C. 1400 – 1455
The Madonna of Humility, c. 1430/1435
Wood, .610 x .455 (24 x 17 7/8)
Inscribed at upper center on Virgin's halo:
AVE MARIA GRATIA PLENA DO[MINVS
TECVM] (Hail, Mary, full of grace, the Lord
is with thee) from Luke 1:28
Andrew W. Mellon Collection
1937.1.5

Fra Angelico
FLORENTINE, C. 1400 – 1455
*The Healing of Palladia by Saint Cosmas
and Saint Damian,* probably 1438/1443
Wood, .365 x .467 (14 3/8 x 18 3/8)
Samuel H. Kress Collection
1952.5.3

Fra Angelico and Filippo Lippi
FLORENTINE, C. 1400 – 1455; C. 1406 –
1469
The Adoration of the Magi, c. 1445
Wood, diameter: 1.372 (54)
Samuel H. Kress Collection
1952.2.2

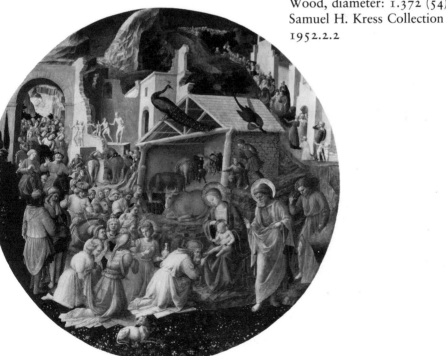

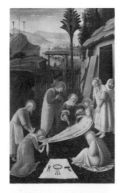

Attributed to Fra Angelico
FLORENTINE, C. 1400 – 1455
The Entombment, c. 1445
Wood, .889 x .549 (35 x 21 5/8)
Samuel H. Kress Collection
1939.1.260

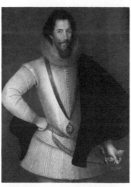

Anonymous British 16th Century
The Earl of Essex, c. 1597
Wood, 1.147 x .877 (45 1/8 x 34 1/2)
Gift of Mrs. Henry R. Rea
1947.18.1

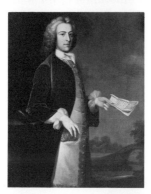

Anonymous British 18th Century
Portrait of a Man, second quarter of the
18th century
Canvas, 1.270 x 1.016 (50 x 40)
Andrew W. Mellon Collection
1947.17.49

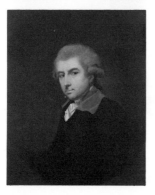

Anonymous British 18th Century
Honorable Sir Francis N. P. Burton (?),
c. 1790
Canvas, .759 x .639 (29 7/8 x 25 1/8)
Andrew W. Mellon Collection
1947.17.102

Anonymous British 18th Century
The Singing Party, c. 1740
Canvas, .731 x .921 (28 3/4 x 36 1/4)
Gift of Duncan Phillips
1952.4.2

Anonymous British 18th Century
James Massy Dawson (?), c. 1790
Wood, .741 x .593 (29 1/8 x 23 3/8)
Andrew W. Mellon Collection
1954.1.11

Anonymous British 18th Century
The Earl of Beverley, third quarter of the
18th century
Canvas, .918 x .715 (36 1/8 x 28 1/8)
Gift of Howard Sturges
1956.9.4

Anonymous British 18th Century
The Countess of Beverley, third quarter of
the 18th century
Canvas, .915 x .715 (36 x 28 1/8)
Gift of Howard Sturges
1956.9.5

Anonymous British 18th Century
Portrait of a Little Girl
Canvas, 1.182 x .842 (46 1/2 x 33 1/8)
Chester Dale Collection
1963.10.144

Anonymous British 19th Century
Portrait of a Man, c. 1830
Canvas, 1.229 x .924 (48 3/8 x 36 3/8)
Andrew W. Mellon Collection
1947.17.76

Anonymous Byzantine 13th Century
Madonna and Child on a Curved Throne
Wood, .815 x .490 (32 1/8 x 19 3/8)
Andrew W. Mellon Collection
1937.1.1

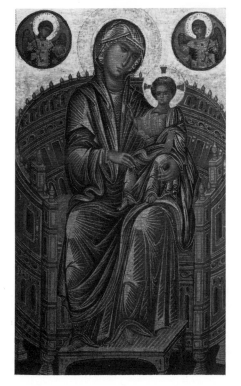

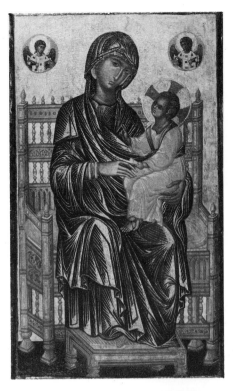

Anonymous Byzantine 13th Century
Enthroned Madonna and Child
Wood, 1.311 x .768 (51 5/8 x 30 1/4)
Gift of Mrs. Otto H. Kahn
1949.7.1

Anonymous French 15th Century
The Expectant Madonna with Saint Joseph
Wood, .702 x .340 (27 5/8 x 13 5/8)
Inscribed at center on edge of the
Madonna's mantle: ALELVI REGINA CELI
LET[ARE ALLE]LVIA QVIA EVAM (Alleluia,
Queen of Heaven, rejoice because He
whom) from the *Regina Coeli,* an Easter
antiphon
Samuel H. Kress Collection
1952.5.32

Anonymous French 15th Century
Portrait of an Ecclesiastic, c. 1480
Wood, .288 x .222 (11 3/8 x 8 3/4)
Samuel H. Kress Collection
1961.9.54

Anonymous French 15th Century
A Knight of the Golden Fleece, c. 1495
Wood, .680 x .535 (26 3/4 x 21 1/8)
Gift of Arthur Sachs
1964.16.1

Anonymous French 16th Century
Portrait of a Nobleman, c. 1570
Wood, .325 x . 235 (12 3/4 x 9 1/4)
Chester Dale Collection
1942.16.1

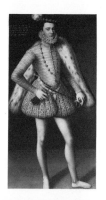

Anonymous French 16th Century
Prince Hercule-François, Duc d'Alençon,
1572
Canvas, 1.886 x 1.022 (74 1/4 x 40 1/4)
Inscribed at upper left:
· FRANCOIS · DVC · DALENCON · /
· EAGE · DE · XVIII · ANS LE XIX E /
· IONR · DE · MARS · AN · 1572 · /
FILS · DE · HENRY IIEDE CE · /
NOM · ROY · DE · FRANCE ·
Samuel H. Kress Collection
1961.9.55

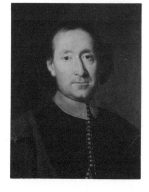

Anonymous French 17th Century
Portrait of a Man, mid-17th century
Canvas, .584 x .470 (23 x 18 1/2)
Andrew W. Mellon Collection
1947.17.99

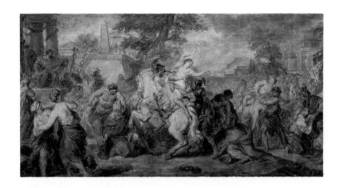

Anonymous French 18th Century
The Rape of the Sabine Women
Paper on canvas, .572 x 1.111 (22 1/2 x
43 3/4)
Widener Collection
1942.9.79

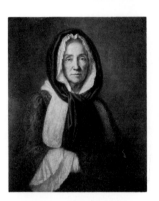

Anonymous French 18th Century
Portrait of an Old Woman
Canvas, .805 x .645 (31 3/4 x 25 3/8)
Samuel H. Kress Collection
1946.7.10

Anonymous French 18th Century
Singerie: The Concert
Canvas, .891 x 1.509 (35 1/8 x 59 3/8)
Gift of George D. Widener and Eleanor
Widener Dixon
1957.7.1

Anonymous French 18th Century
Singerie: The Dance
Canvas, .921 x 1.444 (36 1/4 x 56 7/8)
Gift of George D. Widener and Eleanor
Widener Dixon
1957.7.2

Anonymous French 18th Century
Singerie: The Fishermen
Canvas, .915 x 1.436 (36 x 56 1/2)
Gift of George D. Widener and Eleanor
Widener Dixon
1957.7.3

Anonymous French 18th Century
Singerie: The Picnic
Canvas, .901 x 1.495 (35 1/2 x 58 7/8)
Gift of George D. Widener and Eleanor
Widener Dixon
1957.7.4

Anonymous French 18th Century
Singerie: The Painter
Canvas, .816 x 1.185 (32 1/8 x 46 5/8)
Gift of George D. Widener and Eleanor
Widener Dixon
1957.7.5

Anonymous French 18th Century
Singerie: The Sculptor
Canvas, .830 x 1.195 (32 5/8 x 47)
Gift of George D. Widener and Eleanor
Widener Dixon
1957.7.6

Anonymous French 18th Century
Young Woman and Man
Wood, .118 x .099 (4 5/8 x 3 7/8)
Timken Collection
1960.6.13

Anonymous French 18th Century
Divertissement
Canvas, .322 x .253 (12 5/8 x 10)
Timken Collection
1960.6.15

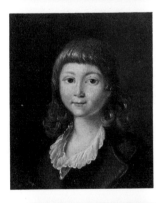

Anonymous French 18th Century
Portrait of a Young Boy, c. 1790/1795
Wood, .145 x .122 (5 3/4 x 4 3/4)
Ailsa Mellon Bruce Collection
1970.17.113

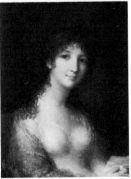

Anonymous French 19th Century
Portrait of a Lady, c. 1810
Canvas, .327 x .244 (12 7/8 x 9 5/8)
Falsely inscribed at upper right: *E. G.
Malbone*
Andrew W. Mellon Collection
1947.17.69

Anonymous French 19th Century
Le Croisic, c. 1900
Wood, .198 x .241 (7 3/4 x 9 1/2)
Falsely inscribed at lower right: CH·
ANGRAND
Ailsa Mellon Bruce Collection
1970.17.1

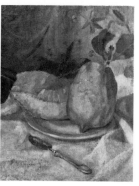

Anonymous French 19th Century
Melon and Lemon, c. 1900
Canvas on wood, .368 x .299
(14 1/2 x 11 3/4)
Falsely inscribed at lower left:
P Gauguin 91
Ailsa Mellon Bruce Collection
1970.17.33

Anonymous French 19th Century
Woman and Two Children in a Field,
1880/1900
Canvas, .206 x .270 (8 1/8 x 10 5/8)
Falsely inscribed at lower left: *renoir.*
Ailsa Mellon Bruce Collection
1970.17.62

Anonymous French 19th Century
Race Course at Longchamps, c. 1870
Canvas, .320 x .492 (12 5/8 x 19 3/8)
Ailsa Mellon Bruce Collection
1970.17.114

Anonymous French 19th Century
Pont Neuf, Paris, 1880/1900
Wood, .324 x .517 (12 3/4 x 20 3/8)
Falsely inscribed at lower left: *E.*
Boudin.84.
Ailsa Mellon Bruce Collection
1970.17.115

Anonymous French 19th Century
Roses in a Vase, 1880/1900
Wood, .087 x .149 (3 3/8 x 5 7/8)
Ailsa Mellon Bruce Collection
1970.17.116

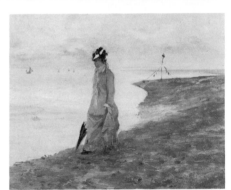

**Attributed to Anonymous French 19th
Century**
Woman by the Seaside
Wood, .216 x .282 (8 1/2 x 11 1/8)
Ailsa Mellon Bruce Collection
1970.17.118

Anonymous German 16th Century
The Crucifixion, c. 1570
Wood, 1.083 x .408 (42 5/8 x 16)
Samuel H. Kress Collection
1952.5.84

Anonymous German 16th Century
Christ in Limbo, c. 1570
Wood, 1.089 x .415 (42 7/8 x 16 1/4)
Samuel H. Kress Collection
1952.5.85

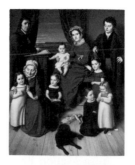

Anonymous German 19th Century
An Artist and His Family, c. 1820
Canvas, .750 x .635 (29 7/8 x 25)
Andrew W. Mellon Collection
1942.8.7

Anonymous Netherlandish 16th Century
The Healing of the Paralytic, c. 1560/1590
Wood, 1.078 x .759 (42 1/2 x 29 7/8)
Chester Dale Collection
1943.7.7

Anonymous Portuguese 17th Century
Four-Panel Screen (not illustrated)
Wood, each panel: 2.219 x .711 (87 3/8 x 28)
Inscribed across center in each panel above saint: ·S· LAURENTIUS.; ·S· DIUNISUS·; ·S· SEBASTIANUS·; ·S· BARBA·
Timken Collection
1960.6.30

Michelangelo Anselmi
PARMESE, 1491 or 1492 – 1554/1556
Apollo and Marsyas, c. 1540
Wood, .559 x 1.170 (22 x 46 1/8)
Samuel H. Kress Collection
1939.1.350

Style of Hendrick van Anthonissen
DUTCH
Ships in the Scheldt Estuary
Canvas, 1.225 x 1.478 (48 1/4 x 58 1/4)
Gift of Mrs. Robert Giles
1947.3.1

Antonello da Messina
SICILIAN, c. 1430 – 1479
Madonna and Child, c. 1475
Wood, .591 x .438 (23 1/4 x 17 1/4)
Andrew W. Mellon Collection
1937.1.30

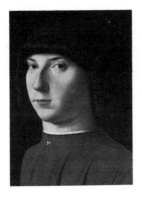

Antonello da Messina
SICILIAN, c. 1430 – 1479
Portrait of a Young Man, probably 1475
Wood, .330 x .248 (13 x 9 3/4)
Andrew W. Mellon Collection
1937.1.31

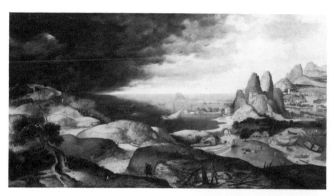

Antwerp 16th Century (Possibly Matthys Cock)
ANTWERP, C. 1509 – 1548
The Martyrdom of Saint Catherine, c. 1540
Transferred from wood to plywood, .622 x
1.182 (24 1/2 x 46 9/16)
Samuel H. Kress Collection
1952.2.18

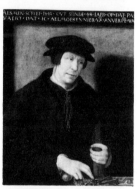

Antwerp 16th Century
Portrait of an Almoner of Antwerp, 1542
Wood, .848 x .632 (33 3/8 x 24 7/8)
Inscribed across top: ALS
MEN · SCHRIEF · 1542 · OVT ·
SIINDE · 48 · IAER · OP · DAT · PAS /
WAERT · DAT · IC · AELMOESENNIER · V\widehat{A} ·
ANVER\widehat{PE} · WAS
(In 1542 when I was 48, I was then
almoner of Antwerp)
Gift of Lewis Einstein
1956.3.2

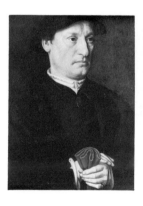

Attributed to Antwerp 16th Century
A Member of the de Hondecoeter Family,
1543
Wood, painted surface: .245 x .188 (9 7/10
x 7 4/10); panel: .256 x .201 (10 1/10 x
7 9/10)
Inscribed across top on banderole on
reverse: TART SVIS VENV; across bottom on
banderole: *Ac(?)* DE HONDECOVTRE 1543
Gift of Adolph Caspar Miller
1953.3.3.a-b

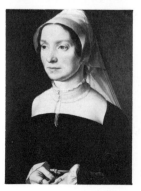

Attributed to Antwerp 16th Century
*Wife of a Member of the de Hondecoeter
Family,* 1543
Wood, painted surface: .245 x .188 (9 7/10
x 7 2/5); panel: .260 x .201 (10 1/5 x 7 9/10)
Gift of Adolph Caspar Miller
1953.3.4

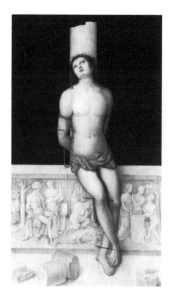

Amico Aspertini
FERRARESE-BOLOGNESE, 1474 or 1475 –
1552
Saint Sebastian, c. 1505
Wood, 1.149 x .660 (45 1/4 x 26)
Samuel H. Kress Collection
1961.9.1

Hendrick Avercamp
DUTCH, 1585 – 1634
A Scene on the Ice, c. 1625
Wood, .393 x .771 (15 1/2 x 30 3/8)
Inscribed at lower left in monogram: HA
Ailsa Mellon Bruce Fund
1967.3.1

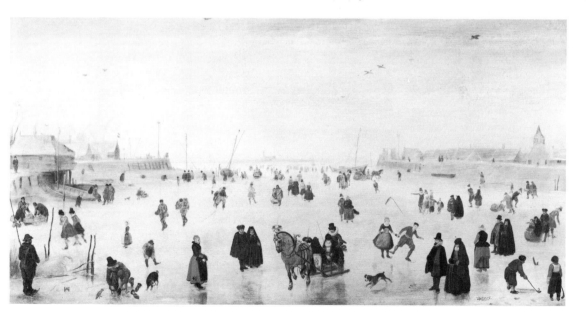

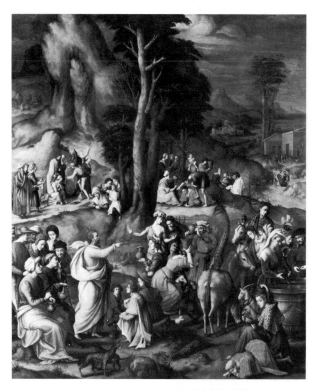

Bacchiacca
FLORENTINE, 1494 – 1557
The Gathering of Manna, c. 1540/1555
Wood, 1.118 x .953 (44 x 37 1/2)
Samuel H. Kress Collection
1952.5.4

Bacchiacca
FLORENTINE, 1494 – 1557
The Flagellation of Christ, c. 1505
Wood, .559 x .481 (22 x 18 7/8)
Samuel H. Kress Collection
1952.5.81

Francis Bacon
BRITISH, b. 1909
Study for a Running Dog, c. 1954
Canvas, 1.527 x 1.167 (60 1/8 x 46)
Given in memory of Charles Edward
Rhetts by his wife and children
1976.7.1

Enrico Baj
ITALIAN, b. 1924
Furniture Style, 1961
Collage on tapestry, .853 x 1.102 (33 5/8 x
43 3/8)
Inscribed at lower left: *baj*; at lower right:
1961; on reverse: *"Meuble de Style" / 61*
Gift of Mr. and Mrs. Burton Tremaine
1969.13.1

Enrico Baj
ITALIAN, b. 1924
When I Was Young, 1951
Collage on tapestry, 1.457 x .971 (57 3/8 x
38 1/4)
Inscribed at lower left: *baj*; on stretcher:
QUANDO ERO GIOVANE
Gift of Mr. and Mrs. Burton Tremaine
1969.13.2

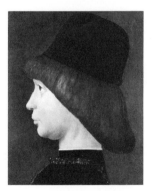

Attributed to Baldassarre d'Este
FERRARESE, c. 1442 – 1504
*Francesco II Gonzaga, Fourth Marquis of
Mantua*, c. 1476/1478
Wood, .265 x .210 (10 1/2 x 8 3/8)
Inscribed across top: FRANC MAR M IIII
(Francesco, Fourth Marquis of Mantua)
Samuel H. Kress Collection
1943.4.41

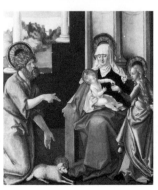

Hans Baldung (called Grien)
GERMAN, 1484 or 1485 – 1545
*Saint Anne with the Christ Child, the
Virgin, and Saint John the Baptist*, c. 1511
Transferred from wood to hardboard, .870
x .759 (34 1/4 x 29 7/8)
Inscribed at center right on middle pillar of
throne with the artist's monogram: HBG (in
ligature); on halos: ·S· IOHANE; ·S·ANNA·;
·MARIA·
Samuel H. Kress Collection
1961.9.62

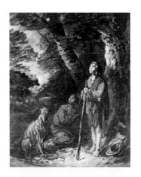

Thomas Barker

BRITISH, 1769 – 1847
Shepherd Boys and Dog Sheltering from Storm, c. 1790
Canvas, .285 x .228 (11 1/4 x 9)
Gift of Howard Sturges
1956.9.1

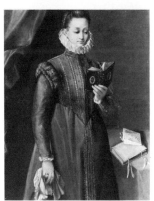

Federico Barocci

ROMAN, probably 1535 – 1612
Quintilia Fischieri, probably c. 1600
Canvas, 1.238 x .953 (48 3/4 x 37 1/2)
Inscribed at center right on folded paper:
All'Ill[ust]re mia s[igno]ra e p[at]rona Oss[ervandissi]ma / la sig[no]ra quintilia fischieri / de Bon[oni]a / Urbino (To my illustrious lady and most respected patroness, Signora Quintilia Fischieri of Bologna / Urbino)
Samuel H. Kress Collection
1939.1.165

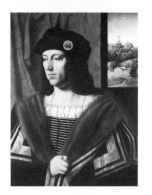

Bartolomeo Veneto

LOMBARD-VENETIAN, active 1502 – 1531
Portrait of a Gentleman, c. 1520
Transferred from wood to canvas, .768 x .584 (30 1/4 x 23)
Samuel H. Kress Collection
1939.1.257

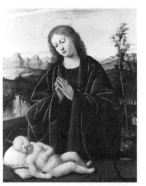

Marco Basaiti

VENETIAN, active 1496 – 1530
Madonna Adoring the Child, c. 1520
Wood, .206 x .165 (8 1/8 x 6 1/2)
Inscribed at lower right: M. BASAITI / P.,
painted over the original signature
MARCHVS / BAXAITI P.
Samuel H. Kress Collection
1939.1.144

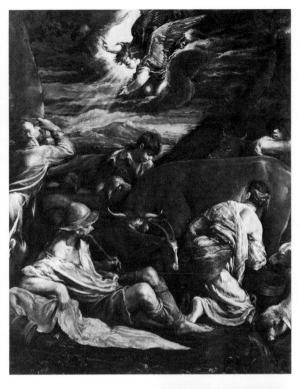

Jacopo Bassano
VENETIAN, C. 1515 – 1592
The Annunciation to the Shepherds,
probably c. 1555/1560
Canvas, 1.061 x .826 (41 3/4 x 32 1/2)
Samuel H. Kress Collection
1939.1.126

Jules Bastien-Lepage
FRENCH, 1848 – 1884
Simon Hayem, 1875
Canvas, .404 x .326 (15 7/8 x 12 7/8)
Inscribed at lower left: *[B?D?]on Souvenir*
à M Nogaro / J. BASTIEN-LEPAGE
Chester Dale Collection
1963.10.1

Frédéric Bazille
FRENCH, 1841 – 1870
Edouard Blau, 1866
Canvas, .597 x .435 (23 1/2 x 17 1/8)
Inscribed at upper left: *F. Bazille. 1866.*
Chester Dale Collection
1963.10.81

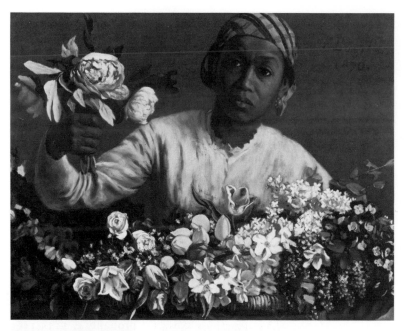

Frédéric Bazille
FRENCH, 1841 – 1870
Negro Girl with Peonies, 1870
Canvas, .603 x .755 (23 3/4 x 29 3/4)
Inscribed at upper right: *F. Bazille. / 1870*
Collection of Mr. and Mrs. Paul Mellon
1983.1.6

Domenico Beccafumi
SIENESE, c. 1485 – 1551
The Holy Family with Angels, c. 1545/
1550
Wood, .813 x .616 (32 x 24 1/4)
Samuel H. Kress Collection
1943.4.28

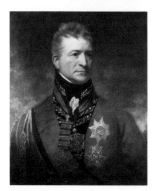

Sir William Beechey
BRITISH, 1753 – 1839
General Sir Thomas Picton, 1815
Canvas, .770 x .637 (30 1/4 x 25)
Gift of The Coe Foundation
1961.5.1

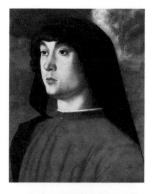

Giovanni Bellini
VENETIAN, C. 1427 – 1516
Portrait of a Young Man in Red, c. 1480
Wood, .320 x .265 (12 1/2 x 10 3/8)
Andrew W. Mellon Collection
1937.1.29

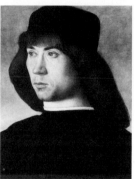

Giovanni Bellini
VENETIAN, C. 1427 – 1516
Portrait of a Young Man, c. 1500
Wood, .308 x .248 (12 1/8 x 9 3/4)
Inscribed at lower center on parapet:
.Joannes.bellinus.
Samuel H. Kress Collection
1939.1.182

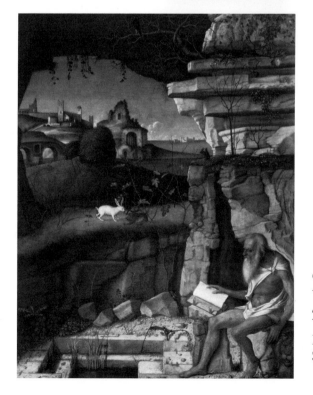

Giovanni Bellini
VENETIAN, C. 1427 – 1516
Saint Jerome Reading, c. 1480/1490
Wood, .489 x .394 (19 1/4 x 15 1/2)
Inscribed at lower left: *...s.Mcccccv[?]*
Samuel H. Kress Collection
1939.1.217

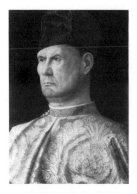

Giovanni Bellini
VENETIAN, C. 1427 – 1516
Giovanni Emo, c. 1475/1480
Wood, .489 x .352 (19 1/4 x 13 7/8)
Samuel H. Kress Collection
1939.1.224

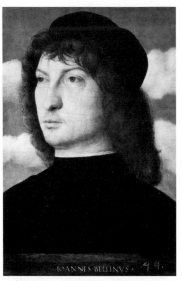

Giovanni Bellini
VENETIAN, C. 1427 – 1516
Portrait of a Venetian Gentleman, c. 1500
Wood, .299 x .203 (11 3/4 x 8)
Inscribed at lower center on parapet:
· IOANNES·BELLINVS · ; at lower left an
inventory number: 98; at lower right an
inventory number: 44
Samuel H. Kress Collection
1939.1.254

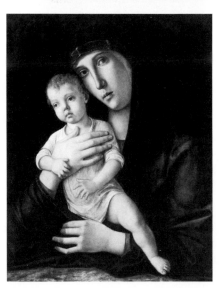

Giovanni Bellini
VENETIAN, C. 1427 – 1516
Madonna and Child, c. 1475
Wood, .533 x .426 (21 x 16 3/4)
Samuel H. Kress Collection
1939.1.352

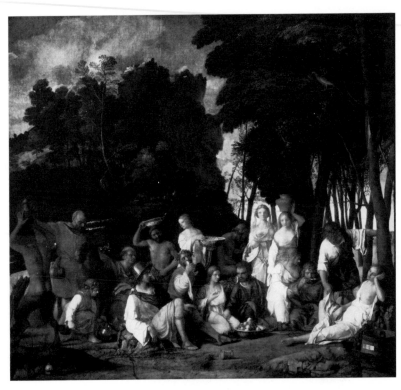

Giovanni Bellini
VENETIAN, C. 1427 – 1516
The Feast of the Gods, 1514
Canvas, 1.702 x 1.880 (67 x 74)
Inscribed at lower right on wooden tub:
joannes bellinus venetus / p MDXIIII
Widener Collection
1942.9.1

Giovanni Bellini
VENETIAN, C. 1427 – 1516
Orpheus, c. 1515
Transferred from wood to canvas, .395 x
.810 (18 5/8 x 32)
Widener Collection
1942.9.2

41 BELLINI

Giovanni Bellini
VENETIAN, C. 1427 – 1516
Madonna and Child with Saints, c. 1490
Wood, .756 x .508 (29 3/4 x 20)
Inscribed at lower center on parapet:
IOANNES BELLINVS P·
Samuel H. Kress Collection
1943.4.37

Giovanni Bellini
VENETIAN, C. 1427 – 1516
Madonna and Child in a Landscape,
c. 1480
Wood, .720 x .532 (28 1/4 x 20 7/8)
Inscribed at lower center on parapet: IDEM
/ Z·B·
Ralph and Mary Booth Collection
1946.19.1

Giovanni Bellini
VENETIAN, C. 1427 – 1516
*An Episode from the Life of Publius
Cornelius Scipio,* after 1506
Canvas, .748 x 3.562 (29 3/8 x 140 1/4)
Inscribed at upper center on plaque:
TVRPIVS / IMPER / VENERE / ·Q· A· / MIS AI
Samuel H. Kress Collection
1952.2.7

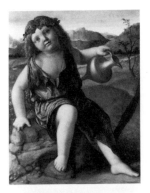

Giovanni Bellini
VENETIAN, C. 1427 – 1516
The Infant Bacchus, probably c. 1505/1510
Transferred from wood to canvas and
wood, .480 x .368 (18 7/8 x 14 1/2)
Samuel H. Kress Collection
1961.9.5

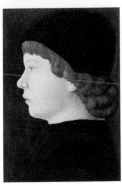

Attributed to Jacopo Bellini
VENETIAN, C. 1400 – 1470 or 1471
Profile Portrait of a Boy, probably c. 1470
Wood, .235 x .180 (9 1/4 x 7)
Samuel H. Kress Collection
1939.1.263

Giovanni Bellini and Workshop
VENETIAN, C. 1427 – 1516
Madonna and Child in a Landscape,
c. 1490/1500
Wood, .750 x .585 (29 1/2 x 23)
Inscribed at lower center on parapet:
JOANNES · BELLINVS ·
Samuel H. Kress Collection
1939.1.262

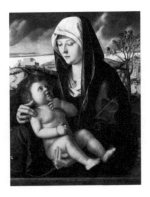

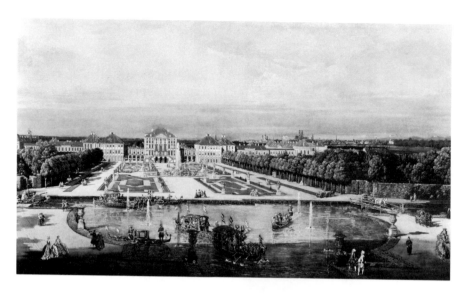

Bernardo Bellotto
VENETIAN, 1721 – 1780
The Castle of Nymphenburg, c. 1761
Canvas, .684 x 1.198 (26 7/8 x 47 1/8)
Samuel H. Kress Collection
1961.9.63

Bernardo Bellotto
VENETIAN, 1721 – 1780
View of Munich, c. 1761
Canvas, .693 x 1.199 (27 1/4 x 47 1/8)
Samuel H. Kress Collection
1961.9.64

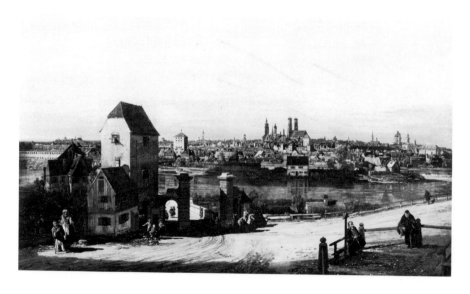

Francesco Benaglio
VERONA, 1432 – C. 1492
Madonna and Child, probably c. 1460/
1470
Transferred from wood to canvas, .807 x
.562 (31 3/4 x 22 1/8)
Widener Collection
1942.9.44

Francesco Benaglio
VERONA, 1432 – C. 1492
Saint Jerome, probably c. 1450/1455
Wood, 1.391 x .673 (54 3/4 x 26 1/2)
Inscribed at lower right on the cartello:
Franciscus benalius Filius petri / Albado;
and below the saint: ·SS· HIERONYMVS·
Samuel H. Kress Collection
1952.5.51

Benvenuto di Giovanni
SIENESE, 1436 – C. 1518
The Adoration of the Magi, c. 1470
Wood, 1.823 x 1.375 (71 3/4 x 54 1/8)
Andrew W. Mellon Collection
1937.1.10

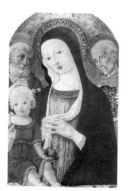

Benvenuto di Giovanni
SIENESE, 1436 – c. 1518
Madonna with Saint Jerome and Saint Bernardine, c. 1475
Wood, .705 x .480 (27 3/4 x 19)
Inscribed at upper center on the Virgin's halo: AVE · GRATIA · PRENA [sic] · DOM[INVS TECVM] (Hail, full of grace the Lord is with thee) from Luke 1:28; at center right on St. Bernardine's plaque: [IH]s
Widener Collection
1942.9.3

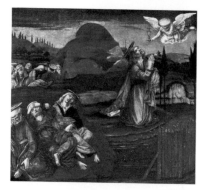

Benvenuto di Giovanni
SIENESE, 1436 – c. 1518
The Agony in the Garden, c. 1490
Wood, .432 x .483 (17 x 19)
Samuel H. Kress Collection
1939.1.318

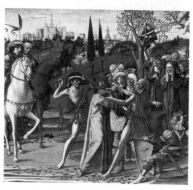

Benvenuto di Giovanni
SIENESE, 1436 – c. 1518
Christ Carrying the Cross, c. 1490
Wood, .432 x .483 (17 x 19)
Samuel H. Kress Collection
1952.5.52

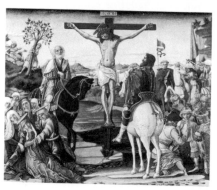

Benvenuto di Giovanni
SIENESE, 1436 – c. 1518
The Crucifixion, c. 1490
Wood, .426 x .546 (16 3/4 x 21 1/2)
Samuel H. Kress Collection
1952.5.53

Benvenuto di Giovanni
SIENESE, 1436 – c. 1518
Christ in Limbo, c. 1490
Wood, .432 x .483 (17 x 19)
Samuel H. Kress Collection
1952.5.54

Benvenuto di Giovanni
SIENESE, 1436 – c. 1518
The Resurrection, c. 1490
Wood, .432 x .489 (17 x 19 1/4)
Samuel H. Kress Collection
1952.5.55

Jean Béraud
FRENCH, 1849 – 1936
Paris, rue du Havre, c. 1882
Canvas, .353 x .273 (13 7/8 x 10 3/4)
Inscribed at lower right: *Jean Beraud.*
Ailsa Mellon Bruce Collection
1970.17.2

Bergognone
LOMBARD, active 1481 – 1522
The Resurrection, c. 1510
Wood, 1.150 x .615 (45 1/4 x 24 1/4)
Samuel H. Kress Collection
1952.5.1

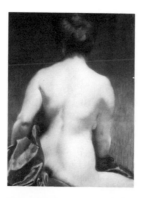

Albert Besnard
FRENCH, 1849 – 1934
Nude, c. 1875
Pastel on paper on cardboard, .907 x .713
(35 3/4 x 28)
Inscribed at upper right: *Besnard*
Gift of Curt H. Reisinger
1957.4.1

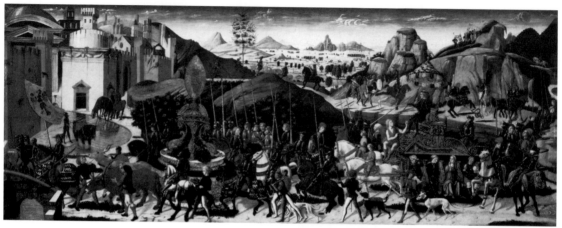

Biagio d'Antonio da Firenze
FLORENTINE, c. 1445 – probably 1510
The Triumph of Camillus, c. 1480
Wood, .600 x 1.543 (23 5/8 x 60 3/4)
Inscribed at center right on the armor of a
soldier: SPQR (Senate and People of Rome)
Samuel H. Kress Collection
1939.1.153

Biagio d'Antonio da Firenze
FLORENTINE, c. 1445 – probably 1510
Portrait of a Boy, probably c. 1475/1480
Wood, .419 x .359 (16 1/2 x 14 1/8)
Samuel H. Kress Collection
1939.1.179

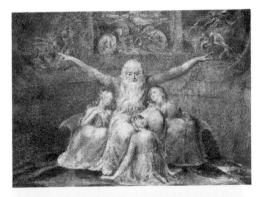

William Blake
BRITISH, 1757 – 1827
Job and His Daughters, c. 1823
Canvas, .273 x .384 (10 3/4 x 15 1/8)
Rosenwald Collection
1943.11.11

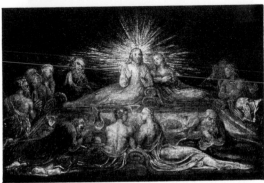

William Blake
BRITISH, 1757 – 1827
The Last Supper, 1799
Canvas, .305 x .482 (12 x 19)
Inscribed at lower left: WB
Rosenwald Collection
1954.13.1

Martin Bloch
GERMAN, 1883 – 1954
The Cocoon Market at Mantua, 1928
Canvas, .660 x 1.016 (26 x 40)
Inscribed at lower left: *Martin Bloch*
Anonymous Gift
1974.88.1

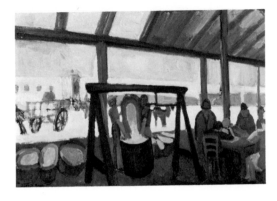

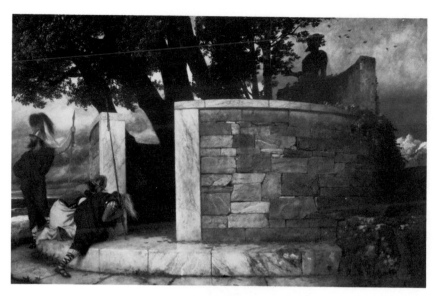

Arnold Böcklin
SWISS, 1827 – 1901
The Sanctuary of Hercules, 1884
Wood, 1.138 x 1.805 (44 7/8 x 71 1/8)
Inscribed at lower right: AB
Andrew W. Mellon Fund
1976.36.1

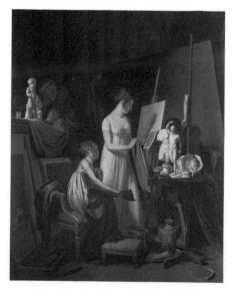

Louis-Léopold Boilly
FRENCH, 1761 – 1845
A Painter's Studio, c. 1800
Canvas, .735 x .595 (29 x 23 3/8)
Inscribed at lower center at right of scroll:
L. Boilly.
Chester Dale Collection
1943.7.1

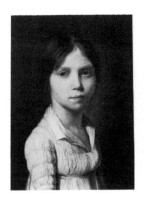 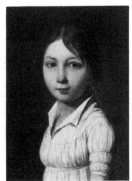

Louis-Léopold Boilly
FRENCH, 1761 – 1845
Mademoiselle Mortier de Trévise (facing right), c. 1800
Canvas, .223 x .165 (8 3/4 x 6 1/2)
Chester Dale Collection
1963.10.2

Louis-Léopold Boilly
FRENCH, 1761 – 1845
Mademoiselle Mortier de Trévise (facing left), c. 1800
Canvas, .222 x .166 (8 3/4 x 6 1/2)
Chester Dale Collection
1963.10.3

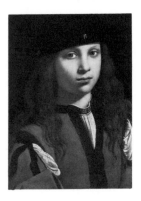

Giovanni Antonio Boltraffio
MILANESE, 1467 – 1516
Portrait of a Youth, before 1500
Wood, .467 x .350 (18 3/8 x 13 3/4)
Ralph and Mary Booth Collection
1946.19.2

Richard Parkes Bonington
BRITISH, 1801 – 1828
Seapiece: Off the French Coast, c. 1826
Canvas, .377 x .520 (14 7/8 x 20 1/2)
Paul Mellon Collection
1982.55.1

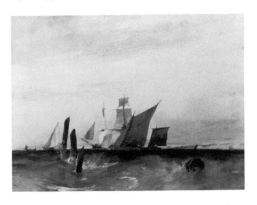

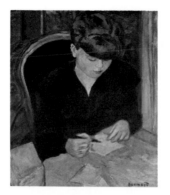

Pierre Bonnard
FRENCH, 1867 – 1947
The Letter, c. 1906
Canvas, .550 x .475 (21 5/8 x 18 3/4)
Inscribed at lower right: *Bonnard*
Chester Dale Collection
1963.10.86

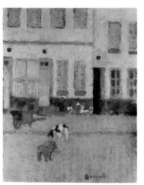

Pierre Bonnard
FRENCH, 1867 – 1947
Two Dogs in a Deserted Street, c. 1894
Wood, .351 x .270 (13 7/8 x 10 5/8)
Inscribed at lower right: *Bonnard*
Ailsa Mellon Bruce Collection
1970.17.3

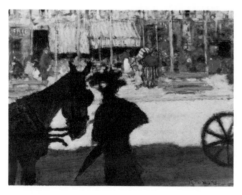

Pierre Bonnard
FRENCH, 1867 – 1947
The Cab Horse, c. 1895
Wood, .297 x .400 (11 3/4 x 15 3/4)
Inscribed at lower right: *Bonnard*
Ailsa Mellon Bruce Collection
1970.17.4

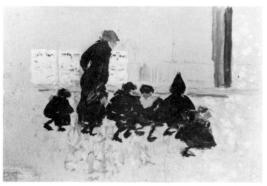

Pierre Bonnard
FRENCH, 1867 – 1947
Children Leaving School, c. 1895
Cardboard on wood, .289 x .440 (11 3/8 x
17 3/8)
Inscribed at lower right: *Bonnard*
Ailsa Mellon Bruce Collection
1970.17.5

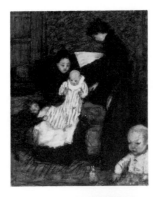

Pierre Bonnard
FRENCH, 1867 – 1947
The Artist's Sister and Her Children, 1898
Cardboard on wood, .305 x .254 (12 x 10)
Inscribed at upper left: *98 Bonnard*
Ailsa Mellon Bruce Collection
1970.17.6

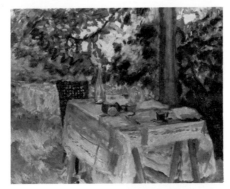

Pierre Bonnard
FRENCH, 1867 – 1947
The Green Table, c. 1910
Canvas, .511 x .651 (20 1/8 x 25 5/8)
Inscribed at lower right with atelier stamp:
Bonnard
Ailsa Mellon Bruce Collection
1970.17.7

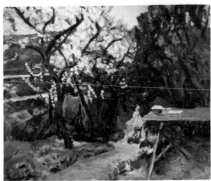

Pierre Bonnard
FRENCH, 1867 – 1947
Table Set in a Garden, c. 1920
Paper on canvas, .495 x .647 (19 1/2 x
25 1/2)
Inscribed at lower right with atelier stamp:
Bonnard
Ailsa Mellon Bruce Collection
1970.17.8

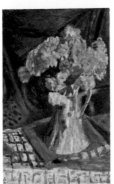

Pierre Bonnard
FRENCH, 1867 – 1947
Bouquet of Flowers, c. 1926
Canvas, .703 x .474 (27 5/8 x 18 5/8)
Inscribed at lower right: *Bonnard*
Ailsa Mellon Bruce Collection
1970.17.9

Pierre Bonnard
FRENCH, 1867 – 1947
A Spring Landscape, c. 1935
Canvas, .676 x 1.030 (26 5/8 x 40 1/2)
Inscribed at lower left with atelier stamp:
Bonnard
Ailsa Mellon Bruce Collection
1970.17.10

Pierre Bonnard
FRENCH, 1867 – 1947
Stairs in the Artist's Garden, 1942/1944
Canvas, .633 x .731 (24 7/8 x 28 3/4)
Inscribed at lower left with atelier stamp:
Bonnard
Ailsa Mellon Bruce Collection
1970.17.11

Francesco Bonsignori
VERONA, C. 1455 – 1519
Francesco Sforza, probably c. 1490
Wood, .725 x .620 (28 1/2 x 24 1/2)
Inscribed at lower center on breastplate:
AN · MANTINIA / PINX·ANNO / M.CCCC / LV·
Widener Collection
1942.9.4

Paris Bordone
VENETIAN, 1500 – 1571
The Baptism of Christ, c. 1535/1540
Canvas, 1.295 x 1.320 (51 x 52)
Widener Collection
1942.9.5

Hieronymus Bosch
NORTH NETHERLANDISH, C. 1450 – 1516
Death and the Miser, c. 1485/1490
Wood, .930 x .308 (36 5/8 x 12 1/8)
Samuel H. Kress Collection
1952.5.33

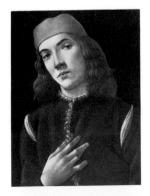

Botticelli
FLORENTINE, 1444 or 1445 – 1510
Portrait of a Youth, early 1480s
Wood, .412 x .318 (16 1/4 x 12 1/2)
Andrew W. Mellon Collection
1937.1.19

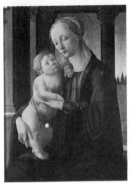

Botticelli
FLORENTINE, 1444 or 1445 – 1510
Madonna and Child, c. 1470
Wood, .760 x .555 (29 7/8 x 21 7/8)
Andrew W. Mellon Collection
1937.1.21

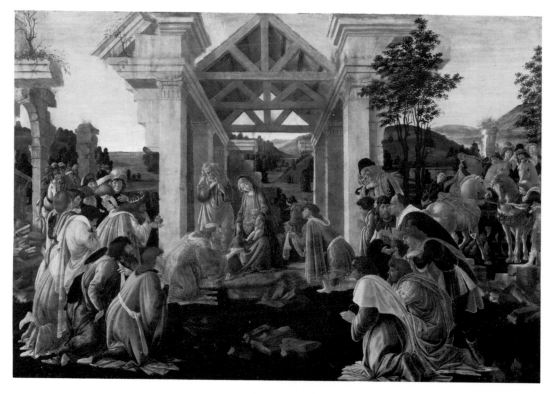

Botticelli
FLORENTINE, 1444 or 1445 – 1510
The Adoration of the Magi, early 1480s
Wood, .702 x 1.042 (27 5/8 x 41)
Andrew W. Mellon Collection
1937.1.22

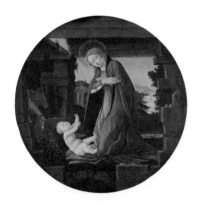

Botticelli
FLORENTINE, 1444 or 1445 – 1510
The Virgin Adoring the Child, c. 1480/
1490
Wood, diameter: .596 (23 3/8)
Samuel H. Kress Collection
1952.2.4

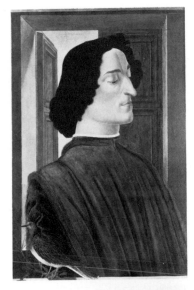

Botticelli
FLORENTINE, 1444 or 1445 – 1510
Giuliano de' Medici, c. 1478
Wood, .756 x .526 (29 3/4 x 20 5/8)
Samuel H. Kress Collection
1952.5.56

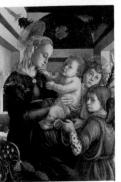

Attributed to Botticelli
FLORENTINE, 1444 or 1445 – 1510
Madonna and Child with Angels, c. 1465/
1470
Wood, .889 x .600 (35 x 23 5/8)
Samuel H. Kress Collection
1943.4.47

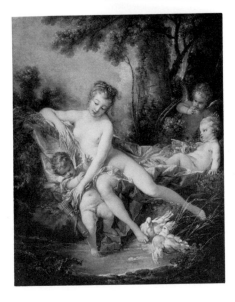

François Boucher
FRENCH, 1703 – 1770
Venus Consoling Love, 1751
Canvas, 1.070 x .848 (42 1/8 x 33 3/8)
Inscribed at lower left: *F Boucher / 1751*
Chester Dale Collection
1943.7.2

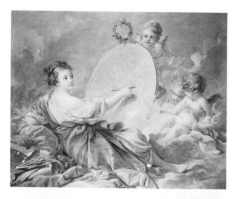

François Boucher
FRENCH, 1703 – 1770
Allegory of Painting, 1765
Canvas, 1.015 x 1.300 (40 x 51 1/8)
Inscribed at lower right: *F.Boucher 1765*
Samuel H. Kress Collection
1946.7.1

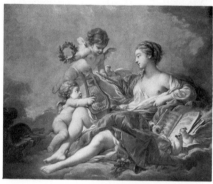

François Boucher
FRENCH, 1703 – 1770
Allegory of Music, 1764
Canvas, 1.035 x 1.300 (40 3/4 x 51 1/8)
Inscribed at lower right: *F.Boucher 1764*
Samuel H. Kress Collection
1946.7.2

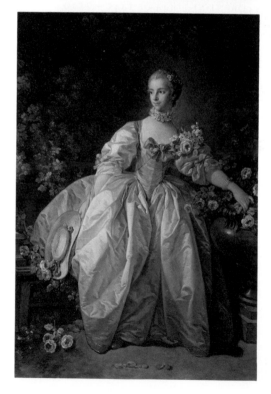

François Boucher
FRENCH, 1703 – 1770
Madame Bergeret, 1746
Canvas, 1.429 x 1.051 (56 1/4 x 41 3/8)
Inscribed at center left: *F. Boucher / 1746*
Samuel H. Kress Collection
1946.7.3

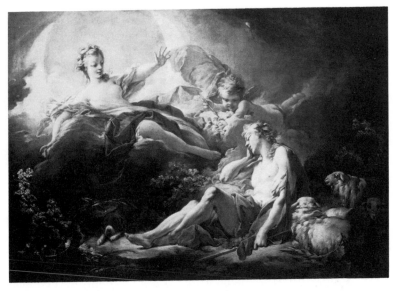

François Boucher
FRENCH, 1703 − 1770
Diana and Endymion, c. 1765
Canvas, .950 x 1.370 (37 3/8 x 53 7/8)
Timken Collection
1960.6.2

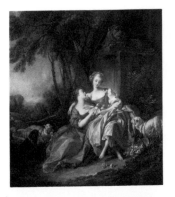

François Boucher
FRENCH, 1703 − 1770
The Love Letter, 1750
Canvas on wood, fabric: .812 x .742
(31 15/16 x 29 3/16); panel: .820 x .752
(32 1/4 x 29 5/8)
Inscribed at upper right on lintel:
f. Boucher / 1750
Timken Collection
1960.6.3

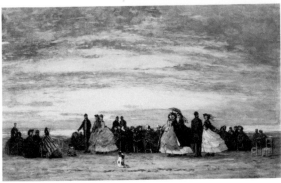

Eugène Boudin
FRENCH, 1824 − 1898
The Beach at Villerville, 1864
Canvas, .457 x .763 (18 x 30)
Inscribed at lower right: *E. Boudin-64.*
Chester Dale Collection
1963.10.4

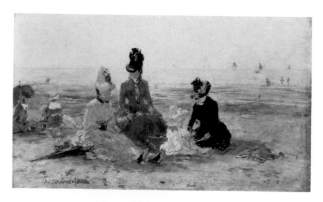

Eugène Boudin
FRENCH, 1824 – 1898
On the Beach, Trouville, 1887
Wood, .184 x .327 (7 1/2 x 12 7/8)
Inscribed at lower left: *E. Boudin;* at lower
right: *T^{ll.}* [Trouville] 87
Chester Dale Collection
1963.10.5

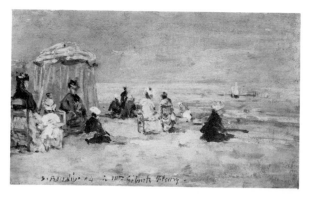

Eugène Boudin
FRENCH, 1824 – 1898
On the Beach, 1894
Wood, .139 x .239 (5 3/8 x 9 3/8)
Inscribed across bottom: *E. Boudin. 94 à
M^m Gilberte Fleury.*
Chester Dale Collection
1963.10.6

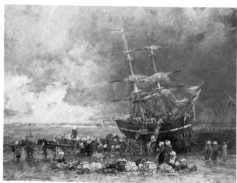

Eugène Boudin
FRENCH, 1824 – 1898
Return of the Terre-Neuvier, 1875
Canvas, .735 x 1.007 (29 x 39 5/8)
Inscribed at lower left: *Portrieux..;* at
lower right: *E Boudin / 1875.*
Chester Dale Collection
1963.10.87

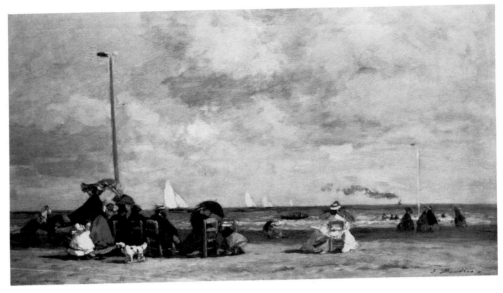

Eugène Boudin
FRENCH, 1824 – 1898
Beach at Trouville, 1864/1865
Wood, .259 x .479 (10 1/4 x 18 7/8)
Inscribed at lower right: *E. Boudin.*
Ailsa Mellon Bruce Collection
1970.17.12

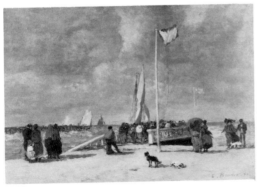

Eugène Boudin
FRENCH, 1824 – 1898
On the Jetty, c. 1869/1870
Wood, .184 x .273 (7 1/4 x 10 3/4)
Inscribed at lower right by later hand: *E.
Boudin 1870 [?]*
Ailsa Mellon Bruce Collection
1970.17.13

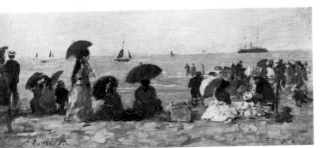

Eugène Boudin
FRENCH, 1824 – 1898
The Beach, 1877
Wood, .109 x .254 (4 1/4 x 10)
Inscribed at lower left: *E. Boudin;* at lower
right: *T$^{ll.}$ [Trouville] 77.*
Ailsa Mellon Bruce Collection
1970.17.14

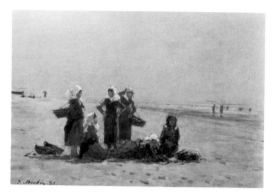

Eugène Boudin
FRENCH, 1824 – 1898
Women on the Beach at Berck, 1881
Wood, .248 x .362 (9 3/4 x 14 1/4)
Inscribed at lower left: *E. Boudin.81 /
Berck*
Ailsa Mellon Bruce Collection
1970.17.15

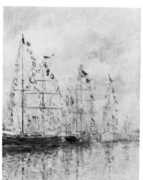

Eugène Boudin
FRENCH, 1824 – 1898
Yacht Basin at Trouville-Deauville,
probably 1895/1896
Wood, .458 x .371 (18 x 14 5/8)
Inscribed at lower right with atelier stamp:
E. Boudin
Ailsa Mellon Bruce Collection
1970.17.16

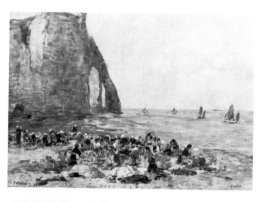

Eugène Boudin
FRENCH, 1824 – 1898
Washerwomen on the Beach of Etretat,
1894
Wood, .372 x .549 (14 5/8 x 21 5/8)
Inscribed at lower left: *E. Boudin 94;* at
lower right: *Etretat.*
Ailsa Mellon Bruce Collection
1970.17.17

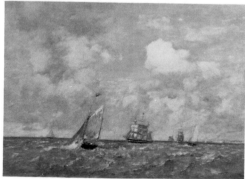

Eugène Boudin
FRENCH, 1824 – 1898
Ships and Sailing Boats Leaving Le Havre,
1887
Canvas, .902 x 1.305 (35 1/2 x 51 3/8)
Inscribed at lower right: *E. Boudin 1887*
Collection of Mr. and Mrs. Paul Mellon
1983.1.7

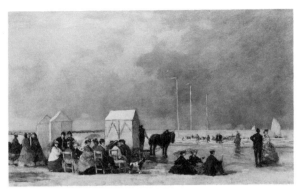

Eugène Boudin
FRENCH, 1824 – 1898
Bathing Time at Deauville, 1865
Wood, .345 x .579 (13 5/8 x 22 3/4)
Inscribed at lower right: *E. Boudin – 65*
Collection of Mr. and Mrs. Paul Mellon
1983.1.8

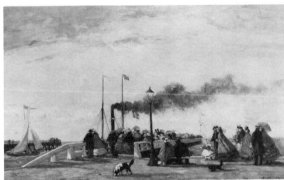

Eugène Boudin
FRENCH, 1824 – 1898
Jetty and Wharf at Trouville, 1863
Wood, .346 x .578 (13 5/8 x 22 3/4)
Inscribed at lower right: *E. Boudin. 63*
Collection of Mr. and Mrs. Paul Mellon
1983.1.9

Eugène Boudin
FRENCH, 1824 – 1898
Festival in the Harbor of Honfleur, 1858
Wood, .410 x .593 (16 1/8 x 23 3/8)
Inscribed at lower left: *Boudin 5[8?];* at
lower right: *Hon[fl]eur*
Collection of Mr. and Mrs. Paul Mellon
1983.1.10

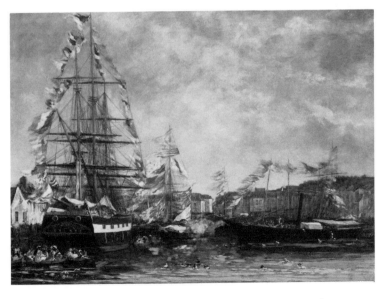

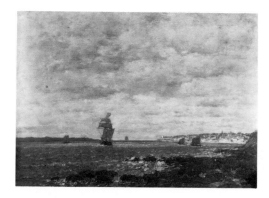

Eugène Boudin
FRENCH, 1824 – 1898
Coast of Brittany, 1870
Canvas, .473 x .660 (18 5/8 x 26)
Inscribed at lower right: *E. Boudin 70*
Collection of Mr. and Mrs. Paul Mellon
1983.1.11

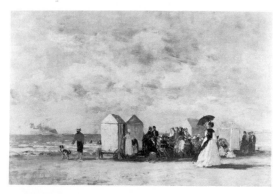

Eugène Boudin
FRENCH, 1824 – 1898
Figures on the Beach, c. 1867/1870
Canvas, .384 x .613 (15 1/8 x 24 1/8)
Inscribed at lower left: *E. Boudin*
Collection of Mr. and Mrs. Paul Mellon
1983.1.12

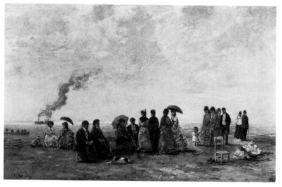

Eugène Boudin
FRENCH, 1824 – 1898
Beach Scene, 1862
Wood, .317 x .482 (12 1/2 x 19)
Inscribed at lower left: *E. Boudin 1862*
Collection of Mr. and Mrs. Paul Mellon
1983.1.13

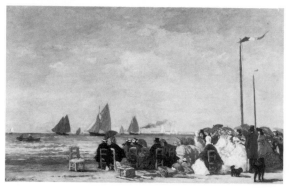

Eugène Boudin
FRENCH, 1824 – 1898
Beach Scene at Trouville, 1863
Wood, .349 x .578 (13 3/4 x 22 3/4)
Inscribed at lower left: *E. Boudin 63*
Collection of Mr. and Mrs. Paul Mellon
1983.1.14

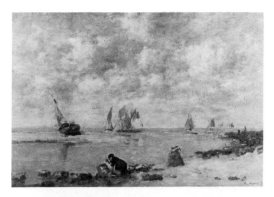

Eugène Boudin
FRENCH, 1824 – 1898
Washerwoman near Trouville, c. 1872/
1876
Wood, .276 x .413 (10 7/8 x 16 1/4)
Inscribed at lower right: *E. Boudin*
Collection of Mr. and Mrs. Paul Mellon
1983.1.15

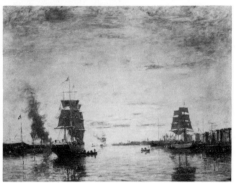

Eugène Boudin
FRENCH, 1824 – 1898
Entrance to the Harbor, Le Havre, 1883
Canvas, 1.191 x 1.604 (46 7/8 x 63 1/8)
Inscribed at lower left: *E. Boudin / Le
Havre 83*
Collection of Mr. and Mrs. Paul Mellon
1983.1.16

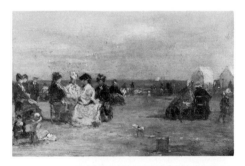

Style of Eugène Boudin
FRENCH
Beach at Deauville
Wood, .153 x .243 (6 x 9 5/8)
Falsely inscribed at lower right: *E. Boudin.*
Ailsa Mellon Bruce Collection
1970.17.18

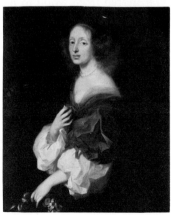

Sébastien Bourdon
FRENCH, 1616 – 1671
Countess Ebba Sparre, probably 1653
Canvas, 1.061 x .902 (41 3/4 x 35 1/2)
Samuel H. Kress Collection
1952.5.34

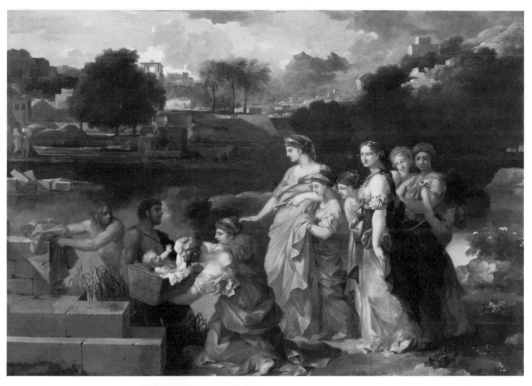

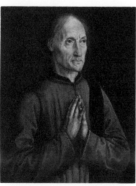

Sébastien Bourdon
FRENCH, 1616 – 1671
The Finding of Moses, probably c. 1650
Canvas, 1.196 x 1.728 (47 x 68)
Samuel H. Kress Collection
1961.9.65

Follower of Dirck Bouts
NETHERLANDISH
Portrait of a Donor, c. 1470/1475
Transferred from wood to hardboard,
painted surface: .257 x.206 (10 1/8 x
8 1/8); panel: .272 x .222 (10 11/16 x
8 3/4)
Samuel H. Kress Collection
1961.9.66

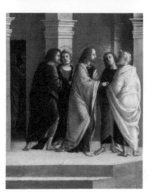

Bramantino
MILANESE, c. 1465 – 1530
*The Apparition of Christ among the
Apostles,* c. 1500
Wood, .238 x .195 (9 3/8 x 7 5/8)
Samuel H. Kress Collection
1961.9.67

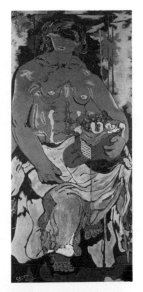

Georges Braque
FRENCH, 1882 – 1963
Nude Woman with Basket of Fruit, 1926
Canvas, 1.620 x .743 (63 3/4 x 29 1/4)
Inscribed at lower left: *G Braque / 26*
Chester Dale Collection
1963.10.88

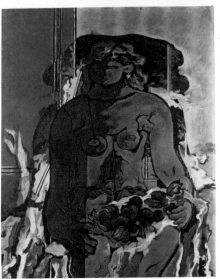

Georges Braque
FRENCH, 1882 – 1963
Nude Woman with Fruit, 1925
Canvas, 1.003 x .813 (39 1/2 x 32)
Inscribed at lower left: *G Braque / 25*
Chester Dale Collection
1963.10.89

Georges Braque
FRENCH, 1882 – 1963
Peonies, 1926
Wood, .562 x .693 (22 1/8 x 27 1/4)
Inscribed at lower left: *G. Braque / 26*
Chester Dale Collection
1963.10.90

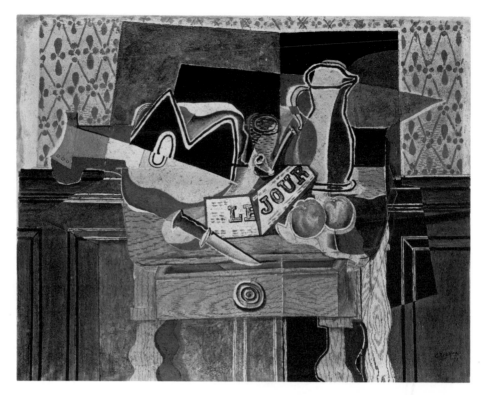

Georges Braque
FRENCH, 1882 – 1963
Still Life: Le Jour, 1929
Canvas, 1.150 x 1.467 (45 1/4 x 57 3/4)
Inscribed at lower right: *G Braque / 29*
Chester Dale Collection
1963.10.91

Georges Braque
FRENCH, 1882 – 1963
Still Life: The Table, 1928
Canvas, .813 x 1.308 (32 x 51 1/2)
Inscribed at lower left: *G Braque / 28*
Chester Dale Collection
1963.10.92

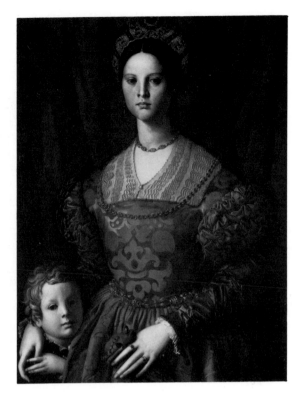

Agnolo Bronzino
FLORENTINE, 1503 – 1572
A Young Woman and Her Little Boy,
c. 1540
Wood, .995 x .760 (39 1/8 x 29 7/8)
Widener Collection
1942.9.6

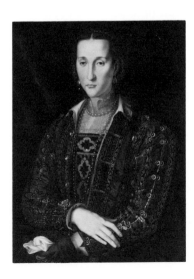

Agnolo Bronzino
FLORENTINE, 1503 – 1572
Eleonora di Toledo, c. 1560
Wood, .864 x .651 (34 x 25 5/8)
Samuel H. Kress Collection
1961.9.7

Follower of Pieter Bruegel, the Elder
NETHERLANDISH
The Temptation of Saint Anthony, c. 1550/
1575
Wood, .585 x .857 (23 x 33 3/4)
Samuel H. Kress Collection
1952.2.19

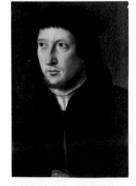

Bartholomaeus Bruyn, the Elder
GERMAN, 1493 – 1555
Portrait of a Man, c. 1535
Wood, .346 x .234 (13 5/8 x 9 1/4)
Gift of Adolph Caspar Miller
1953.3.5

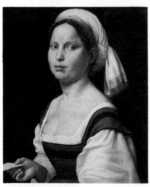

Giuliano Bugiardini
FLORENTINE, 1475 – 1554
Portrait of a Young Woman, c. 1525
Canvas, .578 x .496 (22 3/4 x 19 1/2)
Samuel H. Kress Collection
1939.1.31

Giuliano Bugiardini
FLORENTINE, 1475 – 1554
Portrait of a Man, c. 1530
Wood, .629 x .470 (24 3/4 x 18 1/2)
Widener Collection
1942.9.36

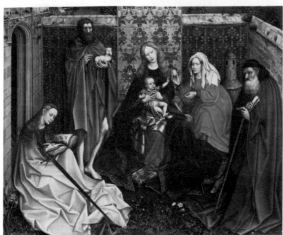

Follower of Robert Campin
NETHERLANDISH
*Madonna and Child with Saints in the
Enclosed Garden*, c. 1440/1460
Wood, painted surface: 1.198 x 1.485
(47 1/4 x 58 1/2); panel: 1.222 x 1.512
(48 1/4 x 59 9/16)
Samuel H. Kress Collection
1959.9.3

Canaletto
VENETIAN, 1697 – 1768
View in Venice, c. 1740
Canvas, .711 x 1.118 (28 x 44)
Widener Collection
1942.9.7

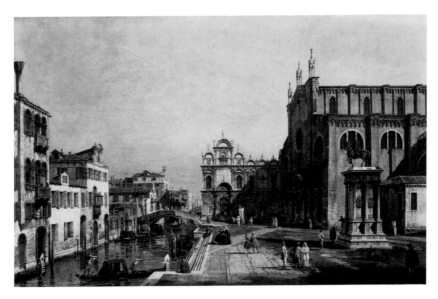

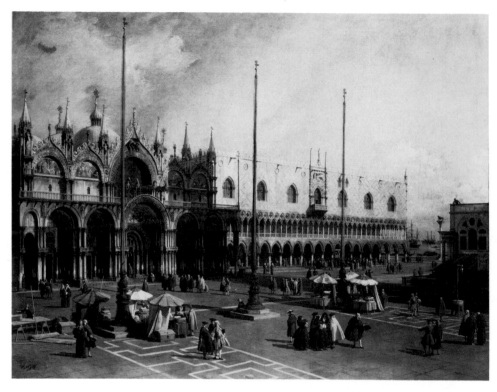

Canaletto
VENETIAN, 1697 – 1768
The Square of Saint Mark's, early 1730s
Canvas, 1.145 x 1.540 (45 x 60 1/2)
Inscribed at lower left: A·C·F (Antonio
Canal Fecit)
Gift of Mrs. Barbara Hutton
1945.15.3

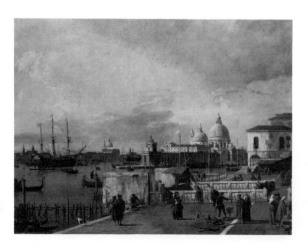

Canaletto
VENETIAN, 1697 – 1768
Venice, the Quay of the Piazzetta, early
1730s
Canvas, 1.152 x 1.536 (45 1/8 x 60 3/8)
Inscribed at lower center on harbor wall:
A·C·F (Antonio Canal Fecit)
Gift of Mrs. Barbara Hutton
1945.15.4

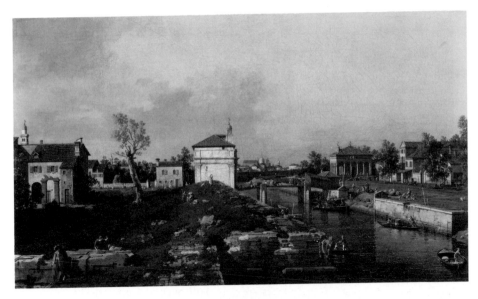

Canaletto
VENETIAN, 1697 – 1768
*The Portello and the Brenta Canal at
Padua,* c. 1740
Canvas, .625 x 1.090 (24 5/8 x 43)
Samuel H. Kress Collection
1961.9.53

Canaletto
VENETIAN, 1697 – 1768
Landscape Capriccio with Column, c. 1754
Canvas, 1.320 x 1.042 (52 x 41)
Paul Mellon Collection
1964.2.1

Canaletto
VENETIAN, 1697 – 1768
Landscape Capriccio with Palace, c. 1754
Canvas, 1.320 x 1.067 (52 x 42)
Paul Mellon Collection
1964.2.2

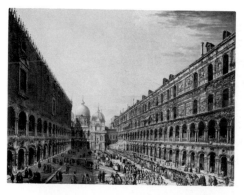

Follower of Canaletto
VENETIAN
*The Courtyard, Doge's Palace, with the
Procession of the Papal Legate,* c. 1750
Canvas, 1.607 x 2.216 (63 1/4 x 87 1/4)
Gift of Mrs. Barbara Hutton
1945.15.1

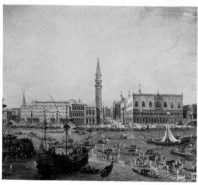

Follower of Canaletto
VENETIAN
A Fete Day, Venice, c. 1750
Canvas, 1.607 x 2.216 (63 1/4 x 87 1/4)
Gift of Mrs. Barbara Hutton
1945.15.2

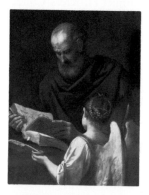

Simone Cantarini
BOLOGNESE, 1612 – 1648
Saint Matthew and the Angel,
c. 1640/1645
Canvas, 1.168 x .908 (46 x 35 3/4)
Gift of James Belden in memory of Evelyn
Berry Belden
1972.44.1

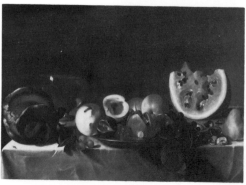

**Follower of Michelangelo Merisi da
Caravaggio**
ROMAN
Still Life, 1615/1620
Canvas, .505 x .718 (19 7/8 x 28 1/4)
Samuel H. Kress Collection
1939.1.159

Cariani
VENETIAN, 1485/1490 – after 1547
Portrait of a Man with a Dog, c. 1520
Canvas, .667 x .532 (26 1/4 x 20 7/8)
Inscribed at lower left on parapet: ...
VICO / ...LO / OPVS / ...AETA...
Gift of Samuel L. Fuller
1950.11.2

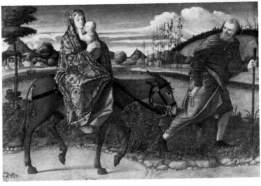

Vittore Carpaccio
VENETIAN, 1455/1465 – 1525 or 1526
The Flight into Egypt, c. 1500
Wood, .720 x 1.115 (28 1/4 x 43 7/8)
Andrew W. Mellon Collection
1937.1.28

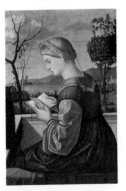

Vittore Carpaccio
VENETIAN, 1455/1465 – 1525 or 1526
The Virgin Reading, c. 1505
Transferred from wood to canvas, .781 x
.506 (30 3/4 x 20)
Samuel H. Kress Collection
1939.1.354

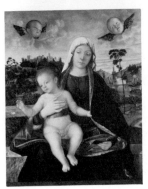

Vittore Carpaccio
VENETIAN, 1455/1465 – 1525 or 1526
Madonna and Child, c. 1505
Wood, .848 x .683 (33 3/8 x 26 7/8)
Samuel H. Kress Collection
1961.9.8

Annibale Carracci
BOLOGNESE, 1560 – 1609
Landscape, probably c. 1590
Canvas, .885 x 1.482 (34 3/4 x 58 1/4)
Samuel H. Kress Collection
1952.5.58

Annibale Carracci
BOLOGNESE, 1560 – 1609
Venus Adorned by the Graces, c. 1595
Transferred from wood to canvas, 1.330 x
1.706 (52 3/8 x 67 1/8)
Samuel H. Kress Collection
1961.9.9

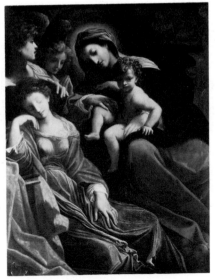

Lodovico Carracci
BOLOGNESE, 1555 – 1619
*The Dream of Saint Catherine of
Alexandria*, c. 1590
Canvas, 1.388 x 1.105 (54 5/8 x 43 1/2)
Inscribed at center left on the book in
Greek letters: Gospel of Christ
Samuel H. Kress Collection
1952.5.59

Andrea del Castagno
FLORENTINE, 1417/1419 – 1457
Portrait of a Man, c. 1450
Wood, .540 x .405 (21 1/4 x 15 7/8)
Andrew W. Mellon Collection
1937.1.17

Andrea del Castagno
FLORENTINE, 1417/1419 – 1457
The Youthful David, c. 1450
Leather on wood, 1.156 x .769 to .410
(45 1/2 x 30 1/4 to 16 1/8)
Widener Collection
1942.9.8

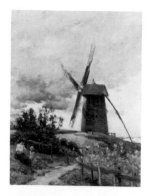

Jean-Charles Cazin
FRENCH, 1841 – 1901
The Windmill, probably after 1884
Wood, .405 x .320 (15 7/8 x 12 1/2)
Inscribed at lower left: J.C.CAZIN
Gift of R. Horace Gallatin
1949.1.1

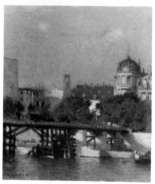

Jean-Charles Cazin
FRENCH, 1841 – 1901
Paris Scene with Bridge
Wood, .244 x .212 (9 5/8 x 8 3/8)
Inscribed at lower left: J C CAZIN
Ailsa Mellon Bruce Collection
1970.17.20

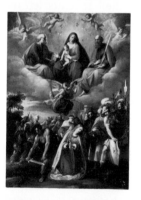

Giuseppe Cesari (called Cavaliere d'Arpino)
ITALIAN, 1568 – 1640
Martyrdom of Saint Margaret, c. 1615
Wood, .845 x .622 (33 5/8 x 24 3/4)
Inscribed at lower left: IOSEPIIVS CAESAR /
ARPINAS
Gift of David Edward Finley and Margaret
Eustis Finley
1984.4.1

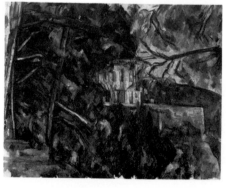

Paul Cézanne
FRENCH, 1839 – 1906
Le Château Noir, 1900/1904
Canvas, .737 x .966 (29 x 38)
Gift of Eugene and Agnes E. Meyer
1958.10.1

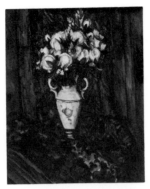

Paul Cézanne
FRENCH, 1839 — 1906
Vase of Flowers, 1900/1903
Canvas, 1.012 x .822 (39 7/8 x 32 3/8)
Gift of Eugene and Agnes E. Meyer
1958.10.2

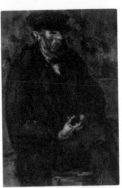

Paul Cézanne
FRENCH, 1839 — 1906
The Gardener Vallier, c. 1905
Canvas, 1.074 x .745 (42 1/4 x 29 3/8)
Gift of Eugene and Agnes E. Meyer
1959.2.1

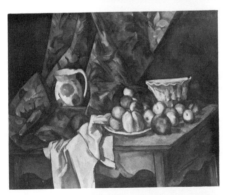

Paul Cézanne
FRENCH, 1839 — 1906
Still Life with Apples and Peaches, c. 1905
Canvas, .812 x 1.006 (32 x 39 5/8)
Gift of Eugene and Agnes E. Meyer
1959.15.1

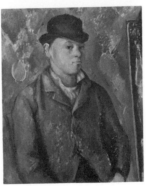

Paul Cézanne
FRENCH, 1839 — 1906
The Artist's Son, Paul, 1885/1890
Canvas, .653 x .540 (25 3/4 x 21 1/4)
Chester Dale Collection
1963.10.100

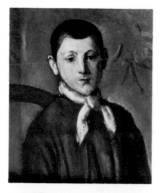

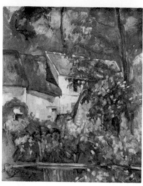

Paul Cézanne
FRENCH, 1839 – 1906
Louis Guillaume, c. 1882
Canvas, .559 x .467 (22 x 18 3/8)
Chester Dale Collection
1963.10.101

Paul Cézanne
FRENCH, 1839 – 1906
House of Père Lacroix, 1873
Canvas, .613 x .506 (24 1/8 x 20)
Inscribed at lower left: *P. Cezanne 73.*
Chester Dale Collection
1963.10.102

Paul Cézanne
FRENCH, 1839 – 1906
Landscape near Paris, c. 1876
Canvas, .502 x .600 (19 3/4 x 23 7/8)
Chester Dale Collection
1963.10.103

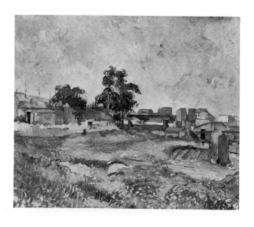

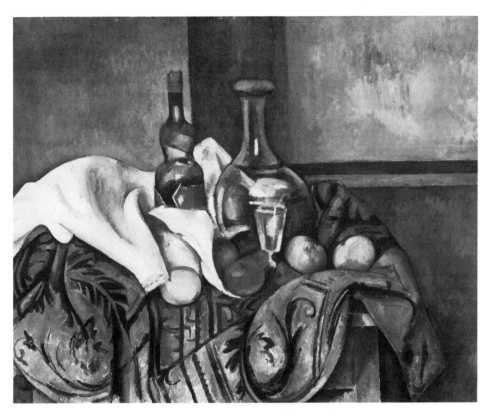

Paul Cézanne
FRENCH, 1839 – 1906
Still Life with Peppermint Bottle, c. 1894
Canvas, .659 x .821 (26 x 32 3/8)
Chester Dale Collection
1963.10.104

Paul Cézanne
FRENCH, 1839 – 1906
Flowers in a Rococo Vase, c. 1876
Canvas, .730 x .598 (28 3/4 x 23 1/2)
Inscribed at lower left: *Cezanne*
Chester Dale Collection
1963.10.105

Paul Cézanne
FRENCH, 1839 – 1906
The Artist's Father, 1866
Canvas, 1.985 x 1.193 (78 1/8 x 47)
Collection of Mr. and Mrs. Paul Mellon
1970.5.1

Paul Cézanne
FRENCH, 1839 – 1906
Riverbank, c. 1895
Canvas, .730 x .923 (28 3/4 x 36 3/8)
Ailsa Mellon Bruce Collection
1970.17.21

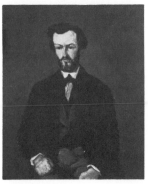

Paul Cézanne
FRENCH, 1839 – 1906
Antony Valabrègue, 1866
Canvas, 1.163 x .984 (45 3/4 x 38 3/4)
Inscribed at lower right: *P.Cezanne*
Collection of Mr. and Mrs. Paul Mellon
1970.35.1

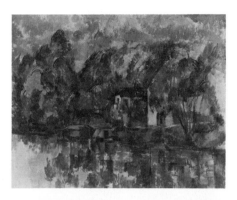

Paul Cézanne
FRENCH, 1839 – 1906
At the Water's Edge, c. 1890
Canvas, .733 x .928 (28 7/8 x 36 1/2)
Gift of the W. Averell Harriman
Foundation in memory of Marie N.
Harriman
1972.9.1

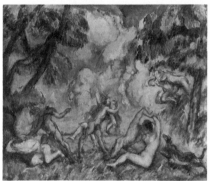

Paul Cézanne
FRENCH, 1839 – 1906
The Battle of Love, c. 1880
Canvas, .378 x .462 (14 7/8 x 18 1/4)
Gift of the W. Averell Harriman
Foundation in memory of Marie
N. Harriman
1972.9.2

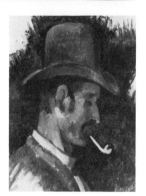

Paul Cézanne
FRENCH, 1839 – 1906
Man with Pipe, 1892/1896
Canvas, .261 x .202 (10 1/4 x 8)
Gift of the W. Averell Harriman
Foundation in memory of Marie
N. Harriman
1972.9.3

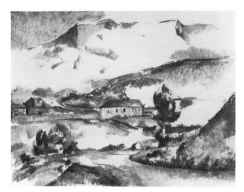

Paul Cézanne
FRENCH, 1839 – 1906
Mont Sainte-Victoire, c. 1887
Canvas, .672 x .913 (26 1/2 x 36)
Gift of the W. Averell Harriman
Foundation in memory of Marie
N. Harriman
1972.9.4

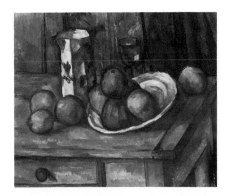

Paul Cézanne
FRENCH, 1839 – 1906
Still Life, c. 1900
Canvas, .458 x .549 (18 x 21 5/8)
Gift of the W. Averell Harriman
Foundation in memory of Marie
N. Harriman
1972.9.5

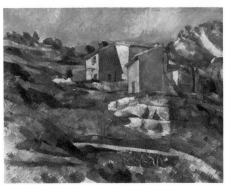

Paul Cézanne
FRENCH, 1839 – 1906
Houses in Provence, c. 1880
Canvas, .650 x .813 (25 5/8 x 32)
Collection of Mr. and Mrs. Paul Mellon
1973.68.1

Marc Chagall
RUSSIAN, 1887-1985
Houses at Vitebsk, 1917
Paper on canvas, .473 x .613 (18 5/8 x 24)
Inscribed at lower right: *Marc Chagall*
Gift of Mr. and Mrs. John U. Nef and
Mr. and Mrs. William Wood Prince
1973.7.1

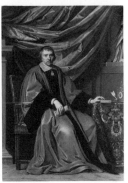

Philippe de Champagne
FRENCH, 1602 – 1674
Omer Talon, 1649
Canvas, 2.250 x 1.616 (88 1/2 x 63 5/8)
Inscribed at lower left: *P·Champagne.F A̤*
1649.Aetaˢ·54·
Samuel H. Kress Collection
1952.5.35

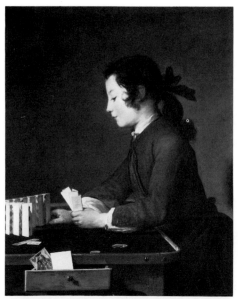

Jean Siméon Chardin
FRENCH, 1699 – 1779
The House of Cards, c. 1735
Canvas, .822 x 660 (32 3/8 x 26)
Inscribed at lower center on table frame: *J. Chardin*
Andrew W. Mellon Collection
1937.1.90

Jean Siméon Chardin
FRENCH, 1699 – 1779
The Young Governess, c. 1739
Canvas, .583 x .740 (22 7/8 x 29 1/8)
Inscribed at lower center: *Chardin*
Andrew W. Mellon Collection
1937.1.91

Jean Siméon Chardin
FRENCH, 1699 – 1779
Soap Bubbles, probably 1733/1734
Canvas, .930 x .746 (36 5/8 x 29 3/8)
Inscribed at lower left on sill: *J. S. Chardin*
Gift of Mrs. John W. Simpson
1942.5.1

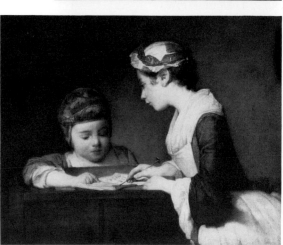

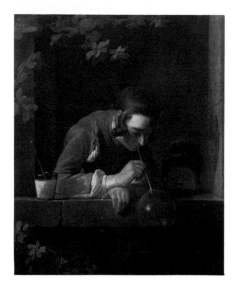

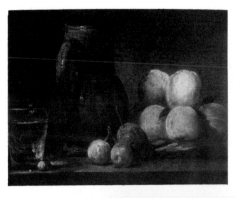

Jean Siméon Chardin
FRENCH, 1699 – 1779
Fruit, Jug and a Glass, c. 1755
Canvas, .335 x .430 (13 1/4 x 17)
Chester Dale Collection
1943.7.4

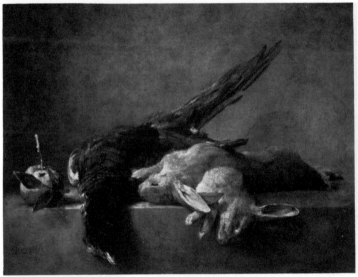

Jean Siméon Chardin
FRENCH, 1699 – 1779
Still Life with Game, c. 1760/1765
Canvas, .496 x .594 (19 1/2 x 23 3/8)
Inscribed at lower left: *Chardin*
Samuel H. Kress Collection
1952.5.36

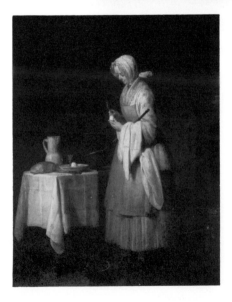

Jean Siméon Chardin
FRENCH, 1699 – 1779
The Attentive Nurse, probably 1738
Canvas, .462 x .370 (18 1/8 x 14 1/2)
Samuel H. Kress Collection
1952.5.37

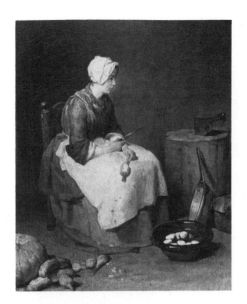

Jean Siméon Chardin
FRENCH, 1699 – 1779
The Kitchen Maid, 1738
Canvas, .462 x .375 (18 1/8 x 14 3/4)
Inscribed at center right: *Chardin / 1738*
Samuel H. Kress Collection
1952.5.38

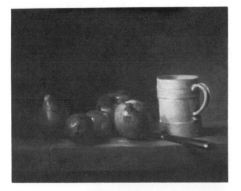

Jean Siméon Chardin
FRENCH, 1699 – 1779
Still Life with a White Mug, c. 1756
Canvas, .331 x .412 (13 x 16 1/4)
Gift of the W. Averell Harriman
Foundation in memory of Marie
N. Harriman
1972.9.6

Follower of Jean Siméon Chardin
FRENCH
Portrait of a Man
Canvas, .510 x .413 (20 1/8 x 16 1/4)
Falsely inscribed at upper right: *Chardin*
Chester Dale Collection
1943.7.3

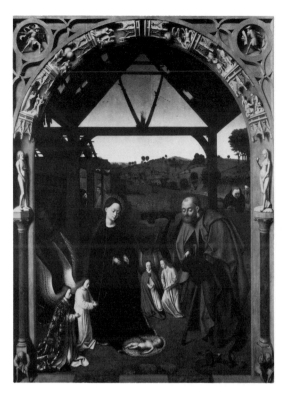

Petrus Christus
BRUGES, active 1444 – 1472 or 1473
The Nativity, c. 1450
Wood, painted surface: 1.276 x .949
(50 1/4 x 37 3/8); panel: 1.302 x .972
(51 1/4 x 38 1/4)
Andrew W. Mellon Collection
1937.1.40

Petrus Christus
BRUGES, active 1444 – 1472 or 1473
Portrait of a Male Donor, c. 1455
Wood, .420 x .212 (16 1/2 x 8 3/8)
Samuel H. Kress Collection
1961.9.10

Petrus Christus
BRUGES, active 1444 – 1472 or 1473
Portrait of a Female Donor, c. 1455
Wood, .418 x .216 (16 7/16 x 8 1/2)
Inscribed at center left on woodcut: O s
...a elisab . / O ... /...
Samuel H. Kress Collection
1961.9.11

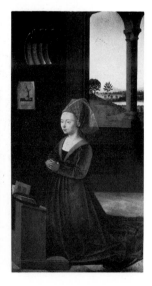

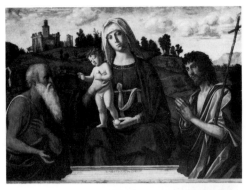

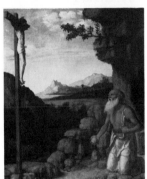

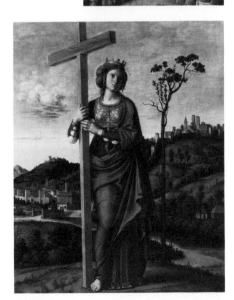

Cima da Conegliano

VENETIAN, 1459 or 1460 – 1517 or 1518
Madonna and Child with Saint Jerome and Saint John the Baptist, c. 1500
Wood, 1.051 x 1.464 (41 3/8 x 57 5/8)
Inscribed at lower center: IOANNES
BAPTISTA PINXIT
Andrew W. Mellon Collection
1937.1.33

Cima da Conegliano

VENETIAN, 1459 or 1460 – 1517 or 1518
Saint Jerome in the Wilderness, c. 1495
Transferred from wood to canvas, .483 x
.400 (19 x 15 3/4)
Inscribed at lower right on scroll: *Joannis
b[a]pt[ista] C[o]n[eglianensis]*
Samuel H. Kress Collection
1939.1.168

Cima da Conegliano

VENETIAN, 1459 or 1460 – 1517 or 1518
Saint Helena, c. 1495
Wood, .404 x .324 (16 x 12 3/4)
Samuel H. Kress Collection
1961.9.12

Attributed to Cimabue

FLORENTINE, mentioned 1272 – active
1302
*Madonna and Child with Saint John the
Baptist and Saint Peter*, probably c. 1290
Wood, .343 x .248 (13 1/2 x 9 3/4)
Samuel H. Kress Collection
1952.5.60

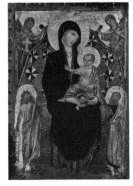

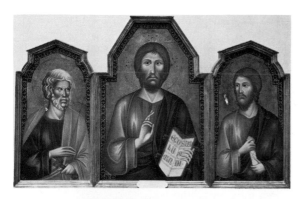

Follower of Cimabue
FLORENTINE
*Christ between Saint Peter and Saint James
Major,* late 13th century
Wood, left panel: .680 x .362 (26 3/4 x
14 1/4); middle panel: .787 x .553 (31 x
21 3/4); right panel: .660 x .362 (26 x
14 1/4)
Inscribed at lower right on book: EGO SUM
LUX MUNDI (I am the light of the world)
Andrew W. Mellon Collection
1937.1.2.a-c

Claude Lorrain
FRENCH, 1600 – 1682
The Herdsman, c. 1635
Canvas, 1.215 x 1.605 (47 3/4 x 63 1/8)
Inscribed at lower right: CLAVDIO RO...
Samuel H. Kress Collection
1946.7.12

Claude Lorrain
FRENCH, 1600 – 1682
Landscape with Merchants, c. 1630
Canvas, .972 x 1.436 (38 1/4 x 56 1/2)
Inscribed at lower left on boat: CLAVDIO·...
Samuel H. Kress Collection
1952.5.44

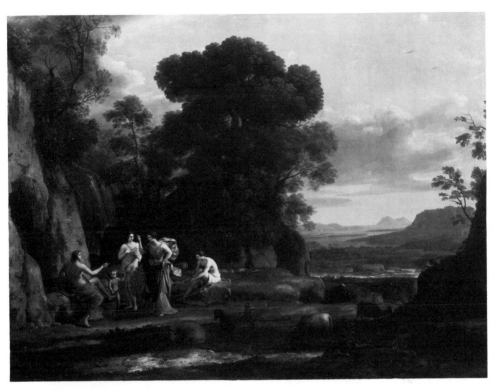

Claude Lorrain
FRENCH, 1600 – 1682
The Judgment of Paris, 1645/1646
Canvas, 1.123 x 1.495 (44 1/4 x 58 7/8)
Ailsa Mellon Bruce Fund
1969.1.1

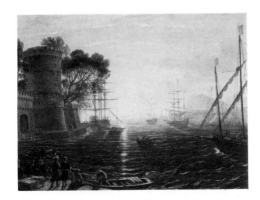

Follower of Claude Lorrain
FRENCH
Harbor at Sunset, late 17th century
Canvas, .489 x .667 (19 1/4 x 26 1/4)
Gift of R. Horace Gallatin
1949.1.8

Joos van Cleve
ANTWERP, active 1505/1508 — 1540 or
1541
Joris Vezeleer, probably 1518
Wood, painted surface: .563 x .382
(22 3/16 x 15 1/16); panel: .581 x .400
(22 7/8 x 15 3/4)
Ailsa Mellon Bruce Fund
1962.9.1

Joos van Cleve
ANTWERP, active 1505/1508 — 1540 or
1541
Margaretha Boghe, Wife of Joris Vezeleer,
probably 1518
Wood, painted surface: .551 x .372
(21 11/16 x 14 5/8); panel: .571 x .396
(22 7/16 x 15 5/8)
Ailsa Mellon Bruce Fund
1962.9.2

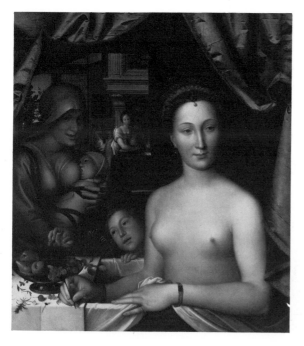

François Clouet
FRENCH, before 1522 — 1572
"Diane de Poitiers," probably c. 1571
Wood, .921 x .813 (36 1/4 x 32)
Inscribed at lower center: FR. IANETII OPVS
Samuel H. Kress Collection
1961.9.13

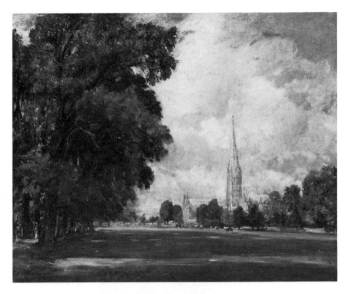

John Constable
BRITISH, 1776 – 1837
A View of Salisbury Cathedral,
probably c. 1825
Canvas, .730 x .914 (28 3/4 x 36)
Andrew W. Mellon Collection
1937.1.108

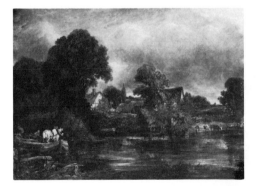

John Constable
BRITISH, 1776 – 1837
The White Horse, probably 1819
Canvas, 1.270 x 1.829 (50 x 72)
Widener Collection
1942.9.9

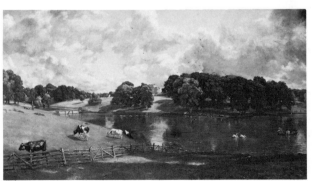

John Constable
BRITISH, 1776 – 1837
Wivenhoe Park, Essex, 1816
Canvas, .561 x 1.012 (22 1/8 x 39 7/8)
Widener Collection
1942.9.10

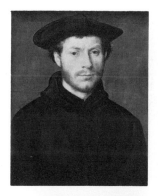

Corneille de Lyon
FRENCH, active 1534 – 1574
Portrait of a Man, c. 1540
Wood, .165 x .143 (6 1/2 x 5 5/8)
Ailsa Mellon Bruce Fund
1965.8.1

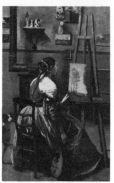

Jean-Baptiste-Camille Corot
FRENCH, 1796 – 1875
The Artist's Studio, c. 1855/1860
Wood, .619 x .400 (24 3/8 x 15 3/4)
Inscribed at lower right: COROT
Widener Collection
1942.9.11

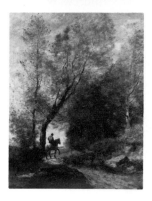

Jean-Baptiste-Camille Corot
FRENCH, 1796 – 1875
The Forest of Coubron, 1872
Canvas, .959 x .762 (37 3/4 x 30)
Inscribed at lower center: COROT 1872
Widener Collection
1942.9.12

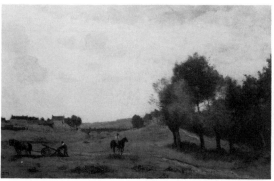

Jean-Baptiste-Camille Corot
FRENCH, 1796 – 1875
View near Epernon, 1850/1860
Canvas, .325 x .535 (12 3/4 x 21)
Inscribed at lower left: COROT
Widener Collection
1942.9.13

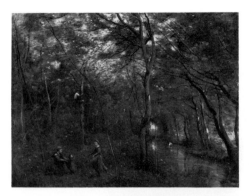

Jean-Baptiste-Camille Corot
FRENCH, 1796 – 1875
The Eel Gatherers, c. 1860/1865
Canvas, .605 x .815 (23 3/4 x 32)
Inscribed at lower right: COROT
Gift of Mr. and Mrs. P. H. B.
Frelinghuysen in memory of her father and
mother, Mr. and Mrs. H. O. Havemeyer
1943.15.1

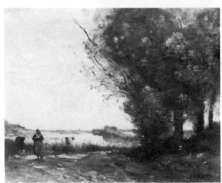

Jean-Baptiste-Camille Corot
FRENCH, 1796 – 1875
River View, probably c. 1870
Wood, .323 x .418 (12 5/8 x 16 3/8)
Inscribed at lower right: COROT
Gift of R. Horace Gallatin
1949.1.2

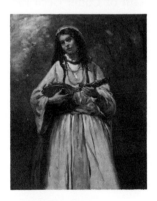

Jean-Baptiste-Camille Corot
FRENCH, 1796 – 1875
Gypsy Girl with Mandolin,
probably c. 1870/1875
Canvas, .639 x .510 (25 x 20)
Inscribed at lower left: COROT
Gift of Count Cecil Pecci-Blunt
1951.21.1

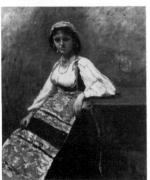

Jean-Baptiste-Camille Corot
FRENCH, 1796 – 1875
Italian Girl, c. 1871/1872
Canvas, .651 x .524 (25 5/8 x 21 5/8)
Inscribed at lower right: COROT
Gift of the Avalon Foundation
1954.6.1

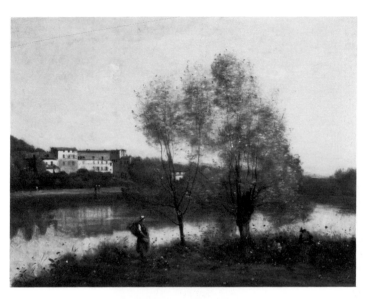

Jean-Baptiste-Camille Corot
FRENCH, 1796 – 1875
Ville d'Avray, c. 1867/1870
Canvas, .492 x .653 (19 3/8 x 25 5/8)
Inscribed at lower left: COROT
Gift of Count Cecil Pecci-Blunt
1955.9.1

Jean-Baptiste-Camille Corot
FRENCH, 1796 – 1875
*Saint Sebastian Succored by the Holy
Women*, c. 1874
Canvas, 1.301 x .860 (51 1/4 x 33 5/8)
Inscribed at lower right: COROT
Timken Collection
1960.6.4

Jean-Baptiste-Camille Corot
FRENCH, 1796 – 1875
Italian Peasant Boy, 1825/1826
Paper on canvas, .254 x .326 (10 x 12 7/8)
Inscribed at lower left: COROT
Chester Dale Collection
1963.10.8

Jean-Baptiste-Camille Corot
FRENCH, 1796 – 1875
Portrait of a Young Girl, 1859
Canvas, .274 x .232 (10 3/4 x 9 1/8)
Inscribed at lower left: COROT / 1859
Chester Dale Collection
1963.10.9

Jean-Baptiste-Camille Corot
FRENCH, 1796 – 1875
Agostina, probably 1866
Canvas, 1.324 x .976 (52 1/8 x 38 3/8)
Inscribed at lower left: COROT.
Chester Dale Collection
1963.10.108

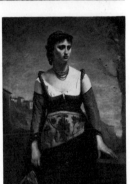

Jean-Baptiste-Camille Corot
FRENCH, 1796 – 1875
Forest of Fontainebleau, c. 1830
Canvas, 1.756 x 2.426 (69 1/8 x 95 1/2)
Inscribed at lower left: COROT
Chester Dale Collection
1963.10.109

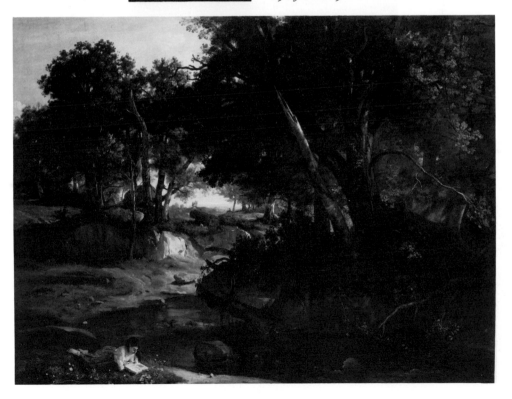

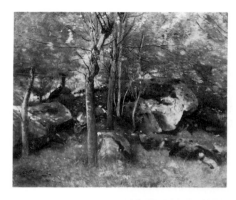

Jean-Baptiste-Camille Corot
FRENCH, 1796 – 1875
Rocks in the Forest of Fontainebleau,
1860/1865
Canvas, .459 x .585 (18 x 23)
Inscribed at lower left: COROT
Chester Dale Collection
1963.10.110

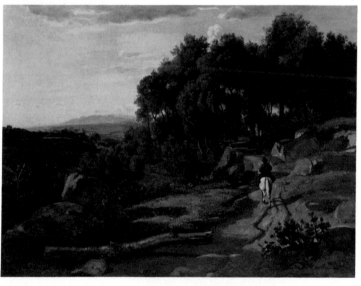

Jean-Baptiste-Camille Corot
FRENCH, 1796 – 1875
A View near Volterra, 1838
Canvas, .695 x .951 (27 3/8 x 37 1/2)
Inscribed at lower left: COROT. / 1838
Chester Dale Collection
1963.10.111

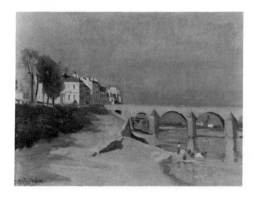

Jean-Baptiste-Camille Corot
FRENCH, 1796 – 1875
River Scene with Bridge, 1834
Canvas, .250 x .338 (9 7/8 x 13 3/8)
Inscribed at lower left: *corot 1834* [later
addition] / *Corot Pingebat 1834*
Ailsa Mellon Bruce Collection
1970.17.22

Jean-Baptiste-Camille Corot
FRENCH, 1796 – 1875
Madame Stumpf and Her Daughter, 1872
Canvas, 1.060 x .742 (41 3/4 x 29 1/4)
Inscribed at lower right: COROT
Ailsa Mellon Bruce Collection
1970.17.23

Jean-Baptiste-Camille Corot
FRENCH, 1796 – 1875
Beach near Etretat, 1872
Canvas, .125 x .255 (4 7/8 x 10)
Inscribed at lower left: COROT
Ailsa Mellon Bruce Collection
1970.17.117

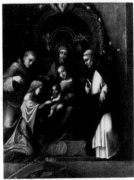

Correggio
PARMESE, c. 1489/1494 – 1534
The Mystic Marriage of Saint Catherine,
c. 1510/1515
Wood, .278 x .213 (11 x 8 3/8)
Samuel H. Kress Collection
1939.1.83

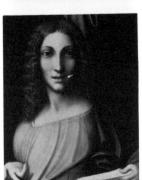

Correggio
PARMESE, c. 1489/1494 – 1534
Salvator Mundi, c. 1515
Wood, .426 x .333 (16 3/4 x 13 1/8)
Samuel H. Kress Collection
1961.9.68

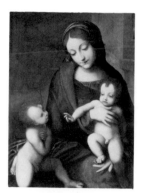

After Correggio
PARMESE
Madonna and Child with the Infant Saint John, c. 1510
Wood, .692 x .511 (27 1/4 x 20 1/8)
Timken Collection
1960.6.5

Francesco del Cossa
FERRARESE, C. 1435 – 1477
Saint Florian, after 1470
Wood, .794 x .549 (31 1/4 x 21 5/8)
Samuel H. Kress Collection
1939.1.227

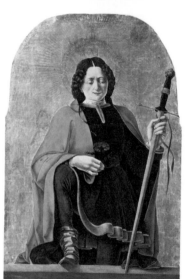

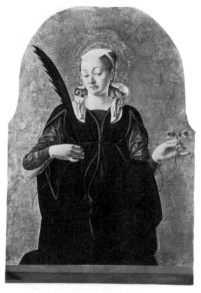

Francesco del Cossa
FERRARESE, C. 1435 – 1477
Saint Lucy, after 1470
Wood, .794 x .559 (31 1/4 x 22)
Samuel H. Kress Collection
1939.1.228

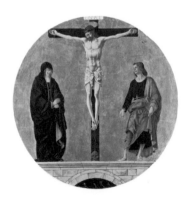

Francesco del Cossa
FERRARESE, C. 1435 – 1477
The Crucifixion, after 1470
Wood, diameter: .641 (25 1/8)
Samuel H. Kress Collection
1952.5.5

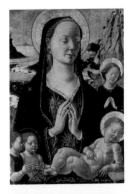

Attributed to Francesco del Cossa
FERRARESE, c. 1435 – 1477
Madonna and Child with Angels, c. 1465
Wood, .535 x .362 (21 1/8 x 14 1/4)
Samuel H. Kress Collection
1939.1.115

Francis Cotes
BRITISH, 1726 – 1770
Miss Elizabeth Crewe, c. 1765/1770
Canvas, .780 x .631 (30 5/8 x 24 3/4)
Inscribed at lower right: *F. Cotes, f.* (FC in
ligature)
Gift of The Coe Foundation
1961.5.2

Style of Francis Cotes
BRITISH
Portrait of a Lady, c. 1765/1770
Canvas, oval, .200 x .158 (7 7/8 x 6 1/4)
Timken Collection
1960.6.6

Style of Francis Cotes
BRITISH
Portrait of a Lady, c. 1765/1770
Canvas, oval, .200 x .158 (7 7/8 x 6 1/4)
Timken Collection
1960.6.7

Gustave Courbet
FRENCH, 1819 – 1877
The Stream, 1855
Canvas, 1.041 X 1.371 (41 X 54)
Inscribed at lower left: *G. Courbet '55*
Gift of Mr. and Mrs. P. H. B.
Frelinghuysen in memory of her father and
mother, Mr. and Mrs. H. O. Havemeyer
1943.15.2

Gustave Courbet
FRENCH, 1819 – 1877
La Grotte de la Loue, c. 1865
Canvas, .984 X 1.304 (38 3/4 X 51 3/8)
Inscribed at lower left: *Gustave Courbet*
Gift of Charles L. Lindemann
1957.6.1

Gustave Courbet
FRENCH, 1819 – 1877
Beach in Normandy, c. 1869
Canvas, .613 X .902 (24 1/8 X 35 1/2)
Inscribed at lower left: *G. Courbet.*
Chester Dale Collection
1963.10.10

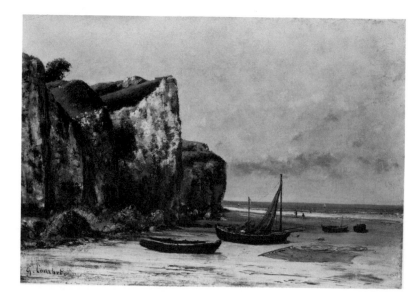

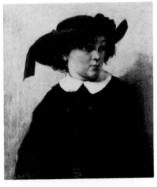

Gustave Courbet
FRENCH, 1819 – 1877
Portrait of a Young Girl, 1857
Canvas, .604 x .524 (23 3/4 x 20 5/8)
Inscribed at lower left: *..57 / G. Courbet.*
Chester Dale Collection
1963.10.112

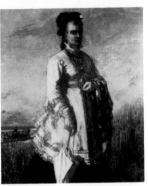

Gustave Courbet
FRENCH, 1819 – 1877
The Promenade, 1866
Canvas, .855 x .725 (33 5/8 x 28 1/2)
Inscribed at lower left: *'66 / G.Courbet.*
Chester Dale Collection
1963.10.113

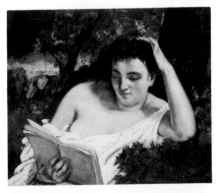

Gustave Courbet
FRENCH, 1819 – 1877
A Young Woman Reading, 1868/1872
Canvas, .600 x .729 (23 5/8 x 29 3/4)
Inscribed at lower right: *G.Courbet.*
Chester Dale Collection
1963.10.114

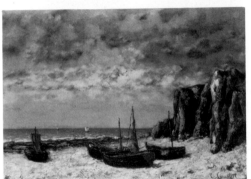

Gustave Courbet
FRENCH, 1819 – 1877
Boats on a Beach, Etretat, 1869
Canvas, .649 x .920 (25 1/2 x 36 1/4)
Inscribed at lower right: *G. Courbet*
Gift of the W. Averell Harriman
Foundation in memory of Marie
N. Harriman
1972.9.7

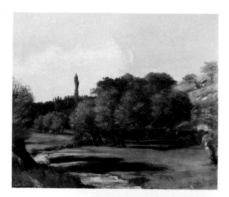

Gustave Courbet
FRENCH, 1819 – 1877
Landscape near the Banks of the Indre,
1856
Canvas, .608 x .733 (24 x 28 7/8)
Inscribed at lower left: *G.Courbet / 56*
Gift of the W. Averell Harriman
Foundation in memory of Marie
N. Harriman
1972.9.8

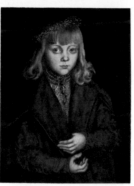

Lucas Cranach, the Elder
GERMAN, 1472 – 1553
A Prince of Saxony, c. 1517
Wood, .437 x .344 (17 1/4 x 13 1/2)
Ralph and Mary Booth Collection
1947.6.1

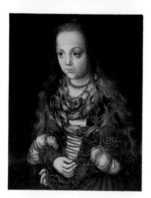

Lucas Cranach, the Elder
GERMAN, 1472 – 1553
A Princess of Saxony, c. 1517
Wood, .436 x .343 (17 1/8 x 13 1/2)
Ralph and Mary Booth Collection
1947.6.2

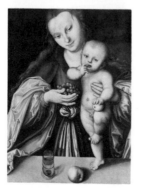

Lucas Cranach, the Elder
GERMAN, 1472 – 1553
Madonna and Child, probably c. 1535
Wood, .711 x .521 (28 x 20 1/2)
Gift of Adolph Caspar Miller
1953.3.1

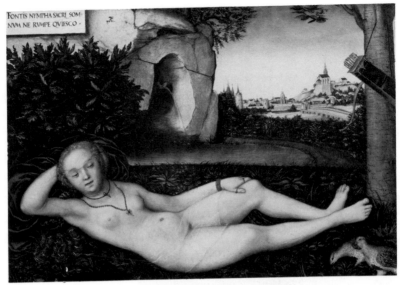

Lucas Cranach, the Elder

GERMAN, 1472 – 1553
The Nymph of the Spring, after 1537
Wood, .485 x .729 (19 x 28 5/8)
Inscribed at upper left: FONTIS NYMPHA
SACRI SOM / NVM NE RVMPE QVIESCO (I am
the Nymph of the Sacred Spring. Do not
disturb my sleep. I am resting); at center
left on the rock: the artist's device, a
serpent with raised wings carrying a ring in
its mouth
Gift of Clarence Y. Palitz
1957.12.1

Lucas Cranach, the Elder

GERMAN, 1472 – 1553
Portrait of a Man, 1522
Wood, .568 x .384 (22 3/8 x 15 1/8)
Inscribed at upper left on tablet: 1522; and
below this, the artist's device, a serpent
with raised wings carrying a ring in its
mouth
Samuel H. Kress Collection
1959.9.1

Lucas Cranach, the Elder

GERMAN, 1472 – 1553
Portrait of a Woman, 1522
Wood, .568 x .381 (22 3/8 x 15)
Samuel H. Kress Collection
1959.9.2

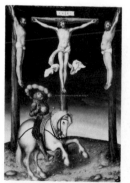

Lucas Cranach, the Elder

GERMAN, 1472 – 1553
The Crucifixion with the Converted Centurion, 1536
Wood, .508 x .349 (20 x 13 3/4)
Inscribed at lower right: 1536, and below, the artist's device, a serpent with raised wings carrying a ring in its mouth; across top: VATER IN DEIN HET BEFIL ICH MEIN GAIST (Father, into thy hand I commend my spirit) from Luke 23:46; beside the centurion: WARLICH DISER MENSCH IS GOTES SVN GEWEST (Truly, this man was the Son of God) from Matthew 25:54
Samuel H. Kress Collection
1961.9.69

Giuseppe Maria Crespi

BOLOGNESE, 1665 – 1747
Cupids with Sleeping Nymphs, c. 1700
Copper, .530 x .759 (20 7/8 x 29 7/8)
Samuel H. Kress Collection
1939.1.62

Giuseppe Maria Crespi

BOLOGNESE, 1665 – 1747
Lucretia Threatened by Tarquin, c. 1700
Canvas, 1.950 x 1.718 (76 3/4 x 67 5/8)
Samuel H. Kress Collection
1952.5.30

Donato Creti
BOLOGNESE, 1671 – 1749
The Quarrel, c. 1705
Canvas, 1.299 x .965 (51 1/8 x 38)
Samuel H. Kress Collection
1961.9.6

Carlo Crivelli
VENETIAN, C. 1430 – C. 1495
Madonna and Child, before 1490
Wood, .394 x .305 (15 1/2 x 12)
Samuel H. Kress Collection
1939.1.264

Carlo Crivelli
VENETIAN, C. 1430 – C. 1495
Madonna and Child Enthroned with Donor, c. 1470
Wood, 1.295 x .545 (51 x 21 3/8)
Inscribed at upper center on arch:
MEMENTO·MEI·MATER·DEI·REGINA·CELI·
LETARE (Remember me, O Mother of God,
O Queen of Heaven, rejoice!) from an
Easter antiphon
Samuel H. Kress Collection
1952.5.6

John Crome
BRITISH, 1768 – 1821
Moonlight on the Yare, c. 1808/1815
Canvas, .984 x 1.257 (38 3/4 x 49 1/2)
Paul Mellon Collection
1983.1.39

Follower of John Crome
BRITISH
Harling Gate, near Norwich
Canvas, 1.232 x .991 (48 1/2 x 39)
Widener Collection
1942.9.14

Henri Edmond Cross
FRENCH, 1856 – 1910
Coast near Antibes, 1891/1892
Canvas, .651 x .923 (25 5/8 x 36 3/8)
Inscribed at lower right: *henriEdmond
Cross*
John Hay Whitney Collection
1982.76.2

George Cuitt, the Younger
BRITISH, 1779 – 1854
Easby Abbey, near Richmond, c. 1829
Canvas, .659 x .916 (26 x 36)
Gift of Miss Harriet Winslow
1959.1.1

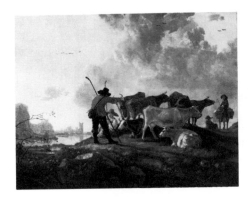

Aelbert Cuyp
DUTCH, 1620 – 1691
Herdsmen Tending Cattle, c. 1650
Canvas, .660 x .876 (26 x 34 1/2)
Inscribed at lower left: *A.cuyp*
Andrew W. Mellon Collection
1937.1.59

Aelbert Cuyp
DUTCH, 1620 – 1691
The Maas at Dordrecht, c. 1660
Canvas, 1.149 x 1.702 (45 1/4 x 67)
Inscribed at lower center on side of ship:
A.cuÿp
Andrew W. Mellon Collection
1940.2.1

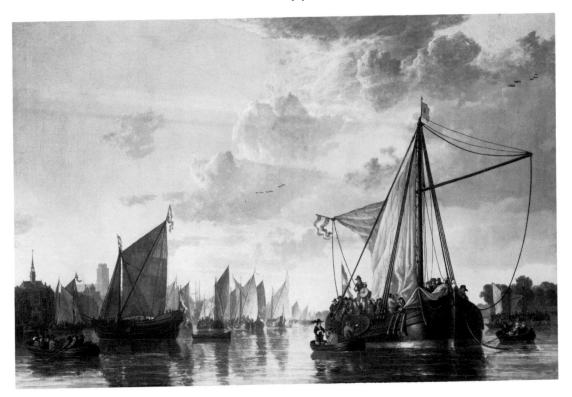

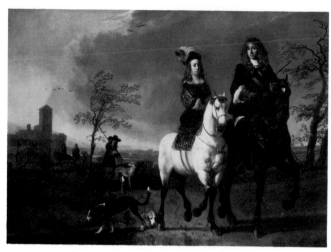

Aelbert Cuyp
DUTCH, 1620 – 1691
Lady and Gentleman on Horseback,
c. 1660
Canvas, 1.232 x 1.721 (48 1/2 x 67 3/4)
Inscribed at lower left: *A:Cuÿp,*
Widener Collection
1942.9.15

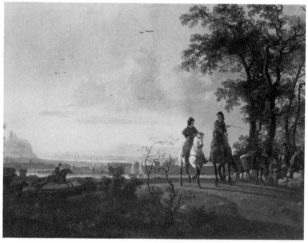

Aelbert Cuyp
DUTCH, 1620 – 1691
Horsemen and Herdsmen with Cattle,
c. 1660/1670
Canvas, 1.200 x 1.715 (47 3/8 x 67 1/2)
Inscribed at lower right: *A.cuÿp.*
Widener Collection
1942.9.16

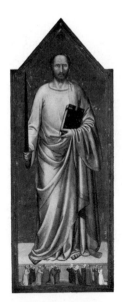

Bernardo Daddi

FLORENTINE, active 1312 – probably 1348
Saint Paul, 1333
Wood, 2.337 x .892 (92 x 35 1/8)
Inscribed across top: $\widehat{\text{S}}$ PAULUS; across
bottom on original frame: MCCCXXXIII
...ESPLETUM FUIT H. OPUS. (1333... this
work was finished)
Andrew W. Mellon Collection
1937.1.3

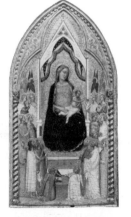

Bernardo Daddi

FLORENTINE, active 1312 – probably 1348
*Madonna and Child with Saints and
Angels,* 1330s
Wood, .502 x .242 (19 3/4 x 9 1/2)
Samuel H. Kress Collection
1952.5.61

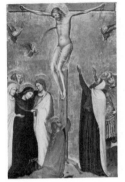

Attributed to Bernardo Daddi

FLORENTINE, active 1312 – probably 1348
The Crucifixion, c. 1335
Wood, .360 x .235 (14 1/8 x 9 1/4)
Inscribed at upper center on cross: IC · XC
(Jesus Christ)
Samuel H. Kress Collection
1961.9.2

Salvador Dali
SPANISH, b. 1904
Chester Dale, 1958
Canvas, .888 x .589 (34 15/16 x 23 3/16)
Inscribed at lower left: *Pour Chester Dale et Coco / Mon Pape Innocent X de Velasquez / Salvador Dali 1958*
Chester Dale Collection
1963.10.11

Salvador Dali
SPANISH, b. 1904
The Sacrament of the Last Supper, 1955
Canvas, 1.667 x 2.670 (65 5/8 x 105 1/8)
Inscribed at lower right on tablecloth: *Gala Salvador Dali / 1955*
Chester Dale Collection
1963.10.115

Michel-François Dandré-Bardon
FRENCH, 1700 – 1783
The Adoration of the Skulls, mid-18th century
Canvas, .528 x .636 (20 3/4 x 25 1/8)
Gift of Lewis Einstein
1956.3.1

Charles-François Daubigny
FRENCH, 1817 – 1878
Landscape with Figures, 1865
Wood, .245 x .462 (9 1/2 x 18 1/8)
Inscribed at lower left: *Daubigny 1865*
Gift of R. Horace Gallatin
1949.1.3

Charles-François Daubigny
FRENCH, 1817 – 1878
The Farm, 1855
Canvas, .514 x .812 (20 1/4 x 32)
Inscribed at lower left: *Daubigny. 1855*
Chester Dale Collection
1963.10.116

Honoré Daumier
FRENCH, 1808 – 1879
Advice to a Young Artist,
probably after 1860
Canvas, .410 x .327 (16 1/8 x 12 7/8)
Inscribed at lower left: *h. Daumier*
Gift of Duncan Phillips
1941.6.1

Honoré Daumier
FRENCH, 1808 – 1879
In Church, probably c. 1860
Wood, .152 x .220 (6 x 8 5/8)
Rosenwald Collection
1943.11.1

Honoré Daumier
FRENCH, 1808 – 1879
The Beggars, c. 1845
Canvas, .597 x .740 (23 1/2 x 29 1/8)
Inscribed at lower left: *h.Daumier*
Chester Dale Collection
1963.10.12

Honoré Daumier
FRENCH, 1808 – 1879
French Theater, c. 1857/1860
Wood, .259 x .350 (10 1/4 x 13 3/4)
Inscribed at center right: *h.Daumier*
Chester Dale Collection
1963.10.13

Honoré Daumier
FRENCH, 1808 – 1879
Wandering Saltimbanques, c. 1847/1850
Wood, .326 x .248 (12 7/8 x 9 3/4)
Chester Dale Collection
1963.10.14

Follower of Honoré Daumier
FRENCH
Feast of the Gods
Wood, .289 x .387 (11 3/8 x 15 1/4)
Rosenwald Collection
1943.11.2

Follower of Honoré Daumier
FRENCH
Hippolyte Lavoignat
Canvas, .465 x .383 (18 1/4 x 15 1/8)
Chester Dale Collection
1963.10.117

Style of Honoré Daumier
FRENCH
Study of Clowns
Wood, .085 x .111 (3 3/8 x 4 3/8)
Falsely inscribed at upper right: *h.D.*
Ailsa Mellon Bruce Collection
1970.17.24

Charles David
FRENCH, 1797 – 1869
Portrait of a Young Horsewoman, 1839
Canvas, .745 x .606 (29 3/8 x 23 7/8)
Inscribed at lower right on parapet: 1839
CHARLES DAVID
Chester Dale Collection
1963.10.15

Gerard David
BRUGES, C. 1460 – 1523
The Rest on the Flight into Egypt, c. 1510
Wood, painted surface: .419 x .422 (16 1/2
x 16 5/8); panel: .443 x .449 (17 7/16 x
17 1/16)
Andrew W. Mellon Collection
1937.1.43

Gerard David and Workshop
BRUGES, C. 1460 – 1523
The Saint Anne Altarpiece, c. 1500/1520
Wood, left panel: 2.361 x .759 (92 5/8 x
29 13/16); painted surface: 2.340 x .749
(92 1/8 x 29 7/16); middle panel: 2.361 x
.975 (92 5/8 x 38 3/8); painted surface:
2.325 x .960 (91 3/4 x 37 13/16); right
panel: 2.354 x .759 (92 11/16 x 29 13/16);
painted surface: 2.340 x .738 (92 1/8 x
29 1/16)
Inscribed at upper center on band on the
Virgin's forehead: SVSSIPE MARIA MATER
GRACIE
Widener Collection
1942.9.17.a-c

Jacques-Louis David
FRENCH, 1748 – 1825
Madame David, 1813
Canvas, .729 x .594 (28 3/4 x 23 3/8)
Inscribed at lower left: *L. David. 1813.*
Samuel H. Kress Collection
1961.9.14

Jacques-Louis David
FRENCH, 1748 – 1825
Napoleon in His Study, 1812
Canvas, 2.039 x 1.251 (80 1/4 x 49 1/4)
Inscribed at lower left: LVD.^{CI.}DAVID OPVS /
1812; at center right on scroll: CODE
Samuel H. Kress Collection
1961.9.15

Follower of Jacques-Louis David
FRENCH
Portrait of a Young Woman in White,
probably 1800/1850
Canvas, 1.254 x .952 (49 3/8 x 37 1/2)
Chester Dale Collection
1963.10.118

Giorgio De Chirico
ITALIAN, 1888 – 1978
Conversation Among the Ruins, 1927
Canvas, 1.305 x .972 (51 3/8 x 38 1/4)
Inscribed at lower right: *G. de Chirico*
Chester Dale Collection
1963.10.107

Giorgio De Chirico
ITALIAN, 1888 – 1978
Via Appia Antica, c. 1945/1950
Canvas, .445 x .543 (17 1/2 x 21 3/8)
Inscribed at lower right: *G. de Chirico*
Gift of Mr. and Mrs. Philip Gibson Hodge
1984.52.1

Thérèse Debains
FRENCH, b. 1907
Head of a Woman
Canvas, .461 x .382 (18 1/8 x 15)
Inscribed at lower left: *Thérèse Debains*
Chester Dale Collection
1964.19.2

Edgar Degas
FRENCH, 1834 – 1917
The Races, before 1873
Wood, .265 x .350 (10 1/2 x 13 3/4)
Inscribed at lower right: *Degas*
Widener Collection
1942.9.18

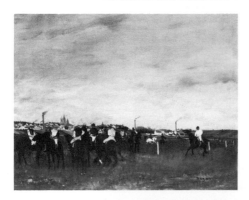

Edgar Degas
FRENCH, 1834 – 1917
Before the Ballet, 1888
Canvas, .400 x .889 (15 3/4 x 35)
Inscribed at lower left: *Degas*
Widener Collection
1942.9.19

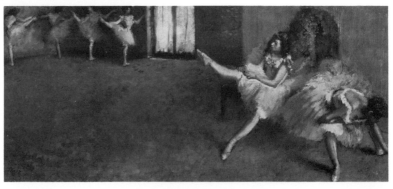

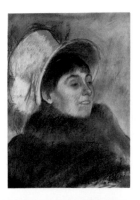

Edgar Degas
FRENCH, 1834 – 1917
Madame Dietz-Monnin, 1879
Pastel on paper, .600 x .451 (23 5/8 x
17 3/4)
Gift of Mrs. Albert J. Beveridge in memory
of her aunt Delia Spencer Field
1951.2.1

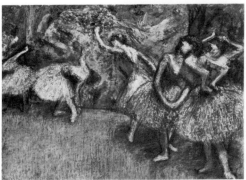

Edgar Degas
FRENCH, 1834 – 1917
Ballet Scene, c. 1900
Pastel on cardboard, .768 x 1.112 (30 1/4
x 43 3/4)
Inscribed at lower left with atelier stamp:
Degas
Chester Dale Collection
1963.10.16

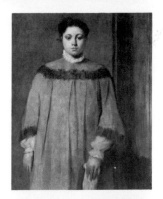

Edgar Degas
FRENCH, 1834 – 1917
Girl in Red, c. 1866
Canvas, .989 x .808 (38 7/8 x 31 7/8)
Chester Dale Collection
1963.10.17

Edgar Degas
FRENCH, 1834 – 1917
Mademoiselle Malo, c. 1877
Canvas, .811 x .651 (31 7/8 x 25 5/8)
Inscribed at lower right with atelier stamp:
Degas
Chester Dale Collection
1963.10.18

Edgar Degas
FRENCH, 1834 – 1917
Madame Camus, 1869/1870
Canvas, .727 x .921 (28 5/8 x 36 1/4)
Inscribed at lower right with atelier stamp:
Degas
Chester Dale Collection
1963.10.121

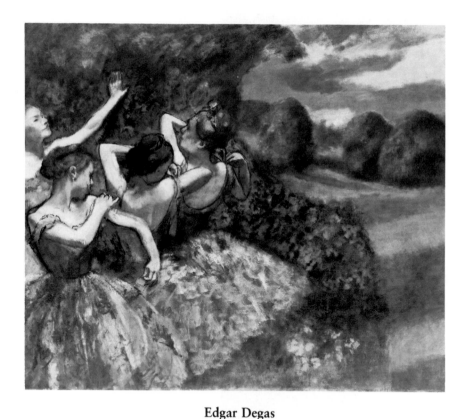

Edgar Degas
FRENCH, 1834 – 1917
Four Dancers, c. 1899
Canvas, 1.511 x 1.802 (59 1/2 x 71)
Inscribed at lower right with atelier stamp:
Degas
Chester Dale Collection
1963.10.122

Edgar Degas
FRENCH, 1834 – 1917
Achille de Gas in the Uniform of a Cadet,
1856/1857
Canvas, .645 x .462 (25 3/8 x 20 1/8)
Chester Dale Collection
1963.10.123

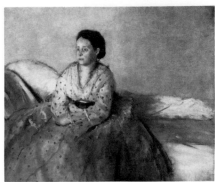

Edgar Degas
FRENCH, 1834 – 1917
Madame René de Gas, 1872/1873
Canvas, .729 x .920 (28 3/4 x 36 1/4)
Inscribed at lower right with atelier stamp:
Degas
Chester Dale Collection
1963.10.124

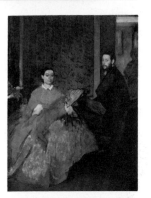

Edgar Degas
FRENCH, 1834 – 1917
Edmondo and Thérèse Morbilli, c. 1865
Canvas, 1.171 x .899 (46 1/8 x 35 3/8)
Chester Dale Collection
1963.10.125

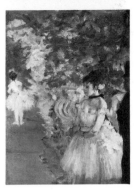

Edgar Degas
FRENCH, 1834 – 1917
Dancers Backstage, c. 1890
Canvas, .242 x .188 (9 1/2 x 7 3/8)
Inscribed at upper right: *Degas*
Ailsa Mellon Bruce Collection
1970.17.25

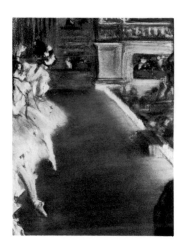

Edgar Degas
FRENCH, 1834 – 1917
Dancers at the Old Opera House, c. 1877
Pastel over monotype on laid paper, .218 x
.171 (8 5/8 x 6 3/4)
Inscribed at lower right: *Degas*
Ailsa Mellon Bruce Collection
1970.17.26

Edgar Degas
FRENCH, 1834 – 1917
Ballet Dancers, c. 1877
Pastel and gouache over monotype,
.297 x .269 (11 3/4 x 10 5/8)
Inscribed at lower left: *Degas;* at lower
right in graphite: *Degas*
Ailsa Mellon Bruce Collection
1970.17.27

Edgar Degas
FRENCH, 1834 – 1917
Girl Drying Herself, 1885
Pastel on paper, .801 x .512 (31 1/2 x
20 1/8)
Inscribed at lower right: *Degas / 85*
Gift of the W. Averell Harriman
Foundation in memory of Marie
N. Harriman
1972.9.9

Edgar Degas
FRENCH, 1834 – 1917
Woman Ironing, 1882
Canvas, .813 x .660 (32 x 26)
Inscribed at lower left: *Degas*
Collection of Mr. and Mrs. Paul Mellon
1972.74.1

Edgar Degas
FRENCH, 1834 – 1917
The Loge, c. 1883
Wood, .127 x .219 (5 x 8 5/8)
Inscribed at upper center: *Degas*
Gift of Emily M. Wilson in memory of
Anthony T. Wilson
1980.5.1

Eugène Delacroix
FRENCH, 1798 – 1863
Columbus and His Son at La Rábida, 1838
Canvas, .904 x 1.183 (35 5/8 x 46 5/8)
Inscribed at lower left: *Eug. Delacroix.*
1838.
Chester Dale Collection
1963.10.127

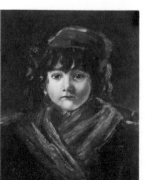

Eugène Delacroix
FRENCH, 1798 – 1863
Arabs Skirmishing in the Mountains, 1863
Canvas, .925 x .746 (36 3/8 x 29 3/8)
Inscribed at lower center: *Eug. Delacroix
1863.*
Chester Dale Fund
1966.12.1

Follower of Eugène Delacroix
FRENCH
Michelangelo in His Studio
Wood, .243 x .185 (9 5/8 x 7 1/4)
Chester Dale Collection
1963.10.19

Follower of Eugène Delacroix
FRENCH
Algerian Child
Canvas, .465 x .381 (18 3/8 x 15)
Falsely inscribed at lower left: *Eug
Delacroix*
Chester Dale Collection
1963.10.126

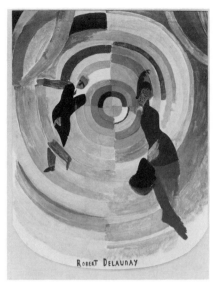

Robert Delaunay
FRENCH, 1885 – 1941
Political Drama, 1914
Collage on cardboard, .887 x .673 (35 x 26)
Inscribed at lower center: ROBERT DELAUNAY
Gift of the Joseph H. Hazen Foundation, Inc.
1971.2.1

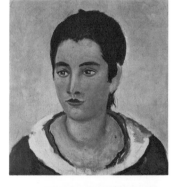

André Derain
FRENCH, 1880 – 1954
Head of a Woman, 1926
Canvas, .362 x 330 (14 1/2 x 13)
Inscribed at lower right: *a derain*
Chester Dale Collection
1963.10.20

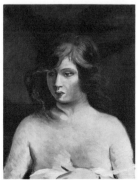

André Derain
FRENCH, 1880 – 1954
Portrait of a Girl, 1923/1924
Canvas, .610 x .464 (24 x 18 1/4)
Inscribed at lower right: *a derain*
Chester Dale Collection
1963.10.21

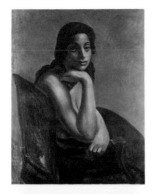

André Derain
FRENCH, 1880 – 1954
Woman in an Armchair, 1920/1925
Canvas, .924 x .737 (36 3/8 x 29)
Inscribed at lower right: *a derain*
Chester Dale Collection
1963.10.72

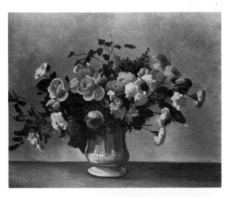

André Derain
FRENCH, 1880 – 1954
Woman in a Chemise, c. 1928
Canvas, .779 x .606 (30 5/8 x 23 7/8)
Inscribed at lower right: *a derain*
Chester Dale Collection
1963.10.73

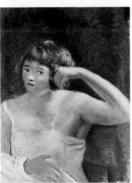

André Derain
FRENCH, 1880 – 1954
Flowers in a Vase, 1932
Canvas, .750 x .940 (29 1/2 x 37)
Inscribed at lower right: *a derain*
Chester Dale Collection
1963.10.128

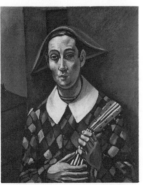

André Derain
FRENCH, 1880 – 1954
Harlequin, 1919
Canvas, .740 x .610 (29 1/8 x 24)
Inscribed at lower left and, again, at lower
right: *a derain*
Chester Dale Collection
1963.10.129

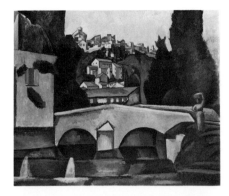

André Derain
FRENCH, 1880 – 1954
The Old Bridge, 1910
Canvas, .810 x 1.003 (31 7/8 x 39 1/2)
Inscribed at lower right: *a derain*
Chester Dale Collection
1963.10.130

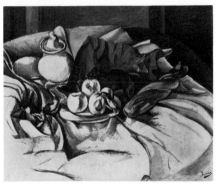

André Derain
FRENCH, 1880 – 1954
Still Life, 1913
Canvas, .734 x .924 (28 7/8 x 36 3/8)
Inscribed at lower right: *a derain*
Chester Dale Collection
1963.10.131

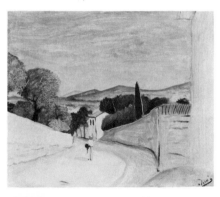

André Derain
FRENCH, 1880 – 1954
Road in Provence, probably 1920/1935
Canvas, .333 x .414 (13 1/8 x 16 1/4)
Inscribed at lower right: *a derain*
Ailsa Mellon Bruce Collection
1970.17.28

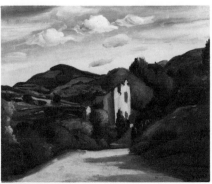

André Derain
FRENCH, 1880 – 1954
Abandoned House in Provence,
probably 1920/1935
Canvas, .347 x .429 (13 5/8 x 16 7/8)
Inscribed at lower right: *a derain*
Ailsa Mellon Bruce Collection
1970.17.29

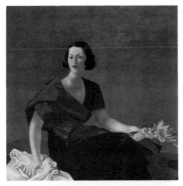

André Derain
FRENCH, 1880 – 1954
Marie Harriman, 1935
Canvas, 1.143 x 1.184 (45 x 46 5/8)
Inscribed at lower right: *A.Derain*
Gift of W. Averell Harriman
1972.8.1

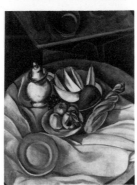

André Derain
FRENCH, 1880 – 1954
Still Life, 1913
Canvas, .914 x .727 (36 x 28 5/8)
Gift of the W. Averell Harriman
Foundation in memory of Marie
N. Harriman
1972.9.10

André Derain
FRENCH, 1880 – 1954
Charing Cross Bridge, London, 1906
Canvas, .803 x 1.003 (31 5/8 x 39 1/2)
Inscribed at lower left: *a derain*
John Hay Whitney Collection
1982.76.3

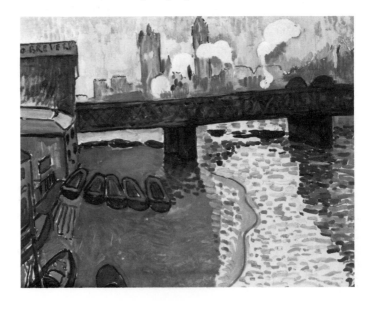

André Derain
FRENCH, 1880 – 1954
Mountains at Collioure, 1905
Canvas, .813 x 1.003 (32 x 39 1/2)
Inscribed at lower left: *a derain*
John Hay Whitney Collection
1982.76.4

Arthur Devis
BRITISH, 1712 – 1787
*Portrait of a Gentleman Netting Game
Birds,* 1756
Canvas, .699 x .978 (27 1/2 x 38 1/2)
Inscribed at lower center: *Art. Devis / 1756*
Paul Mellon Collection
1964.2.3

Arthur Devis
BRITISH, 1712 – 1787
Conversation Piece, Ashdon House,
c. 1760
Canvas, 1.385 x 1.956 (54 1/2 x 77)
Paul Mellon Collection
1964.2.4

Arthur Devis
BRITISH, 1712 – 1787
Arthur Holdsworth, Thomas Taylor and Captain Stancombe Conversing by the River Dart, c. 1757
Canvas, 1.276 x 1.021 (50 1/4 x 40 1/4)
Inscribed at lower center: *Arth^r: Devis fe 175[7?]*
Paul Mellon Collection
1983.1.40

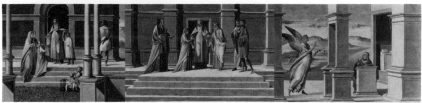

Benedetto Diana
VENETIAN, C. 1460 – 1525
The Presentation and Marriage of the Virgin, and the Annunciation,
c. 1520/1525
Wood, .371 x 1.638 (14 5/8 x 64 1/2)
Samuel H. Kress Collection
1961.9.70

Narcisse Virgilio Diaz de la Peña
FRENCH, 1807 or 1808 – 1876
Forest Scene, 1874
Wood, .318 x .439 (12 1/2 x 17 1/4)
Inscribed at lower left: *N. Diaz '74*
Gift of R. Horace Gallatin
1949.1.4

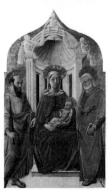

Domenico di Bartolo
SIENESE, C. 1400 – 1447
Madonna and Child Enthroned with Saint Peter and Saint Paul, c. 1430
Wood, .527 x .311 (20 3/4 x 12 1/4)
Samuel H. Kress Collection
1961.9.3

Domenico Veneziano
FLORENTINE, C. 1410 – 1461
Saint Francis Receiving the Stigmata,
c. 1445
Wood, .267 x .305 (10 7/8 x 12)
Samuel H. Kress Collection
1939.1.140

Domenico Veneziano
FLORENTINE, C. 1410 – 1461
Madonna and Child, c. 1445
Wood, .826 x .565 (32 1/2 x 22 1/4)
Samuel H. Kress Collection
1939.1.221

Domenico Veneziano
FLORENTINE, C. 1410 – 1461
Saint John in the Desert, c. 1445
Wood, .284 x .324 (11 1/8 x 12 3/4)
Samuel H. Kress Collection
1943.4.48

Jean-Gabriel Domergue
FRENCH, 1889 – 1962
Maud Dale, 1923
Canvas, 1.537 x 1.121 (60 1/2 x 44 1/8)
Inscribed at lower right: *jean / gabriel / Domergue / 23*
Chester Dale Collection
1963.10.132

Jean-Gabriel Domergue
FRENCH, 1889 – 1962
A Picador, 1914
Canvas, .811 x .648 (32 x 25 1/2)
Inscribed at lower left: *jean / gabriel / Domergue / 1914*
Chester Dale Collection
1963.10.133

Giovanni Andrea Donducci (called Mastelletta)
PARMESE, 1575 – 1655
Allegorical Landscape, early 17th century
Canvas, .635 x .839 (25 x 33)
Gift of Duncan Phillips
1952.4.1

Frans van Doornik
FLEMISH, active 1714/1715 – 1731
Anna de Peyster (?), 1731
Canvas, oval, .765 x .607 (30 1/8 x 23 7/8)
Inscribed at center left: *F.V. Doornik. f 1731*
Chester Dale Collection
1963.10.134

Frans van Doornik
FLEMISH, active 1714/1715 – 1731
Isaac de Peyster (?), 1731
Canvas, oval, .766 x .606 (30 1/8 x 23 7/8)
Inscribed at center left: illegible signature; 1731
Chester Dale Collection
1963.10.135

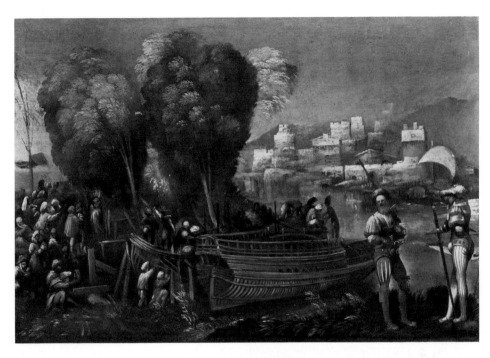

Dosso Dossi
FERRARESE, active 1512 – 1542
Aeneas and Achates on the Libyan Coast,
c. 1520
Canvas, .587 x .876 (23 1/8 x 34 1/2)
Samuel H. Kress Collection
1939.1.250

Dosso Dossi
FERRARESE, active 1512 – 1542
Saint Lucretia, c. 1520
Wood, .530 x .419 (20 7/8 x 16 1/2)
Inscribed at center right on parapet: S ·
LVCRETIA
Samuel H. Kress Collection
1939.1.388

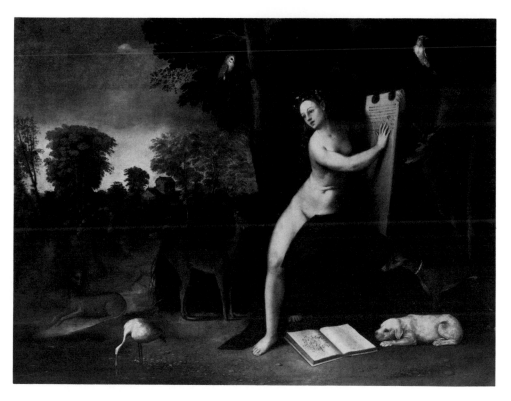

Dosso Dossi
FERRARESE, active 1512 – 1542
Circe and Her Lovers in a Landscape,
c. 1525
Canvas, 1.008 x 1.361 (39 5/8 x 53 1/2)
Samuel H. Kress Collection
1943.4.49

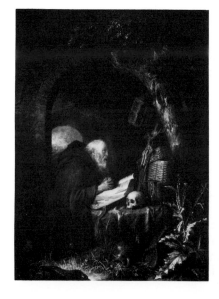

Gerard Dou
DUTCH, 1613 – 1675
The Hermit, 1670
Wood, .460 x .345 (18 1/8 x 13 5/8)
Inscribed at lower center on book strap:
GDou 1670 (GD in ligature)
Timken Collection
1960.6.8

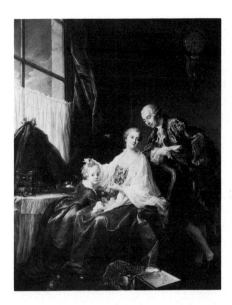

François-Hubert Drouais
FRENCH, 1727 – 1775
Group Portrait, 1756
Canvas, 2.438 x 1.946 (96 x 76 5/8)
Inscribed at lower right on box lid: *F.*
Drouais.ce 1 avril. 1756
Samuel H. Kress Collection
1946.7.4

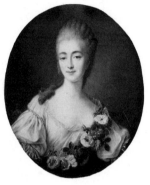

François-Hubert Drouais
FRENCH, 1727 – 1775
Madame du Barry, probably c. 1770
Canvas, oval, .711 x .593 (28 x 23 3/8)
Timken Collection
1960.6.9

Attributed to François-Hubert Drouais
FRENCH, 1727 – 1775
Marquis d'Ossun, after 1762
Canvas, 2.180 x 1.641 (85 7/8 x 64 5/8)
Inscribed at center left on treaty: *Pacte / De*
Famille / en L'année / 1762
Gift of Mrs. Albert J. Beveridge in memory
of her grandfather Franklin Spencer
1955.7.1

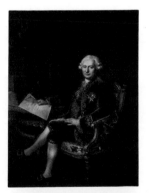

Hubert Drouais
FRENCH, 1699 – 1767
Portrait of a Lady, c. 1750
Canvas, 1.181 x .953 (46 1/2 x 37 1/2)
Chester Dale Collection
1943.7.5

Duccio di Buoninsegna
SIENESE, C. 1255 – 1318
Nativity with the Prophets Isaiah and Ezekiel, 1308/1311
Wood, middle panel: .438 x .444 (17 1/4 x 17 1/2); side panels, each: .438 x .165 (17 1/4 x 6 1/2)
Inscribed on left panel at center left on scroll: ECCE VIRGO CONCIPIET & PARIET FILIŪ & VOCABITUR NOMEN EIUS EMANUEL (Behold a Virgin shall conceive and bear a son, and his name shall be called Immanuel) from Isaiah 7:14; on middle panel at center right on scroll: *Anūncio uobis gaudīu magnum...* (Behold, I bring you tidings of great joy) from Luke 2:10; on right panel at center right on scroll: VIDI PORTĀ Ī DOMO DOM CLAUSĀ VIR NŌ TR̄SIBIT P[ER] ĒA DOMĪN SOLUS ĪTRAT ET IT P[ER] EA[M] (I saw a door in the house of the Lord which was closed and no man went through it. The Lord only enters and goes through it), a variant of Ezekiel 44:2.
Andrew W. Mellon Collection
1937.1.8.a-c

Duccio di Buoninsegna
SIENESE, C. 1255 – 1318
The Calling of the Apostles Peter and Andrew, 1308/1311
Wood, .435 X .460 (17 1/8 X 18 1/8)
Samuel H. Kress Collection
1939.1.141

Follower of Duccio di Buoninsegna
SIENESE
Madonna and Child Enthroned with Angels, early 14th century
Wood, 2.304 X 1.418 (90 3/4 X 55 7/8)
Samuel H. Kress Collection
1961.9.77

Edouard-Jacques Dufeu
FRENCH, 1840 – 1900
Moroccan Landscape
Canvas, .382 X .527 (15 X 20 3/4)
Chester Dale Collection
1964.19.3

Charles Georges Dufresne
FRENCH, 1876 – 1938
Judgment of Paris, 1925
Canvas, 1.312 X 1.626 (51 5/8 X 64)
Inscribed at lower right: *dufresne*
Chester Dale Collection
1963.10.140

Charles Georges Dufresne
FRENCH, 1876 – 1938
Still Life, 1927/1928
Canvas, .816 x 1.003 (32 1/8 x 39 1/2)
Inscribed at lower right: *dufresne*
Chester Dale Collection
1963.10.141

Raoul Dufy
FRENCH, 1877 – 1953
The Basket, 1926
Canvas, .540 x .651 (21 1/4 x 25 5/8)
Inscribed at lower center: *Raoul Dufy*
Chester Dale Collection
1963.10.22

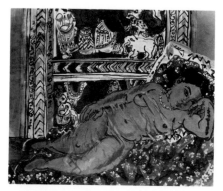

Raoul Dufy
FRENCH, 1877 – 1953
Reclining Nude, 1930
Canvas, .654 x .813 (25 3/4 x 32)
Inscribed at lower left: *Raoul Dufy / 1930*
Chester Dale Collection
1963.10.142

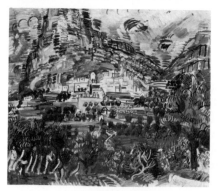

Raoul Dufy
FRENCH, 1877 – 1953
Saint-Jeannet, 1910
Canvas, .807 x 1.000 (31 3/4 x 39 3/8)
Inscribed at lower left: *Raoul Dufy*
Chester Dale Collection
1963.10.143

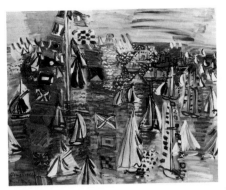

Raoul Dufy
FRENCH, 1877 – 1953
Regatta at Cowes, 1934
Canvas, .816 x 1.003 (32 1/8 x 39 1/2)
Inscribed at lower left: *Cowes 1934 /*
Raoul Dufy
Ailsa Mellon Bruce Collection
1970.17.30

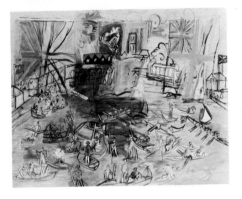

Raoul Dufy
FRENCH, 1877 – 1953
Regatta at Henley, 1937
Canvas, .892 x 1.162 (35 1/8 x 45 3/4)
Ailsa Mellon Bruce Collection
1970.17.31

Raoul Dufy
FRENCH, 1877 – 1953
The Basin at Deauville, 1937
Canvas, .815 x 1.003 (32 1/8 x 39 1/2)
Inscribed at lower left: *Raoul Dufy*
Ailsa Mellon Bruce Collection
1970.17.32

Gainsborough Dupont
BRITISH, C. 1754 – 1797
Georgiana, Duchess of Devonshire,
c. 1790/1797
Canvas, .591 x .399 (23 1/4 x 15 3/4)
Ailsa Mellon Bruce Collection
1970.17.119

Gainsborough Dupont
BRITISH, C. 1754 – 1797
William Pitt, c. 1790/1797
Wood, .155 x .124 (6 1/8 x 4 7/8)
Ailsa Mellon Bruce Collection
1970.17.120

Gainsborough Dupont
BRITISH, C. 1754 – 1797
Mrs. Richard Brinsley Sheridan, c. 1790/
1797
Canvas, .594 x .397 (23 3/8 x 15 5/8)
Ailsa Mellon Bruce Collection
1970.17.122

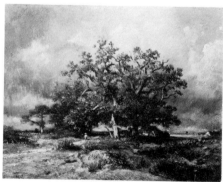

Jules Dupré
FRENCH, 1811 – 1889
The Old Oak, c. 1870
Canvas, .323 x .421 (12 5/8 x 16 1/2)
Inscribed at lower left: *Jules Dupré*
Gift of R. Horace Gallatin
1949.1.5

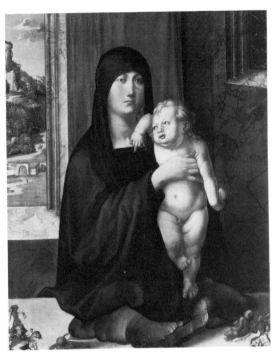

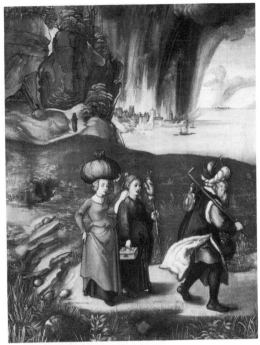

Albrecht Dürer
GERMAN, 1471 – 1528
Madonna and Child; reverse: *Lot and His Daughters,* c. 1505
Wood, each panel: .502 x .397 (19 3/4 x 15 5/8)
Inscribed on reverse at center left on rock: AD (in ligature)
Samuel H. Kress Collection
1952.2.16.a-b

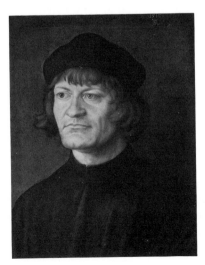

Albrecht Dürer
GERMAN, 1471 – 1528
Portrait of a Clergyman, 1516
Parchment on canvas, .429 x .332 (16 7/8 x 13)
Inscribed at upper right: 1516 / AD (in ligature)
Samuel H. Kress Collection
1952.2.17

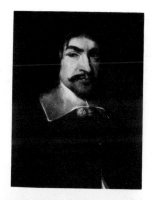

Dutch 17th Century
Portrait of a Man, c. 1655
Canvas, .546 x .419 (21 1/2 x 16 1/2)
Falsely inscribed at upper right:
AETATIS ·38 / ·1655
Andrew W. Mellon Collection
1947.17.98

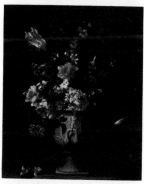

Dutch 17th Century
Flowers in a Classical Vase, late
17th century
Canvas, .749 x .615 (29 1/2 x 24 1/4)
Gift of Mr. and Mrs. William Draper Blair
1976.26.1

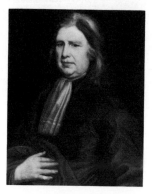

Dutch 18th Century
Portrait of a Man, first quarter of the
18th century
Canvas, .762 x .635 (30 x 25)
Falsely inscribed at center right: *J. Smibert
fecit 1734*
Andrew W. Mellon Collection
1947.17.92

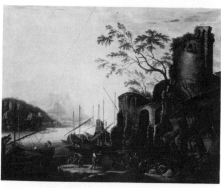

Dutch 18th Century
The Harbor, 18th century
Canvas, .979 x 1.274 (38 1/2 x 50 1/8)
Chester Dale Collection
1964.19.4

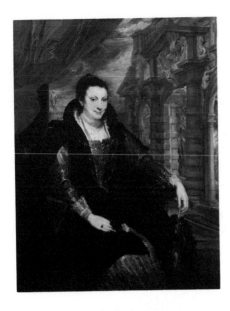

Sir Anthony van Dyck
FLEMISH, 1599 – 1641
Isabella Brant, c. 1621
Canvas, 1.530 x 1.200 (60 1/4 x 47 1/4)
Andrew W. Mellon Collection
1937.1.47

Sir Anthony van Dyck
FLEMISH, 1599 – 1641
Susanna Fourment and Her Daughter,
c. 1620
Canvas, 1.727 x 1.175 (68 x 46 1/4)
Andrew W. Mellon Collection
1937.1.48

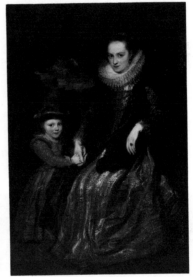

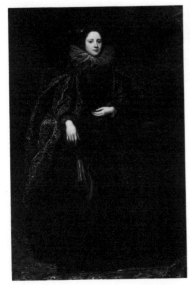

Sir Anthony van Dyck
FLEMISH, 1599 – 1641
Marchesa Balbi, 1622/1627
Canvas, 1.829 x 1.219 (72 x 48)
Andrew W. Mellon Collection
1937.1.49

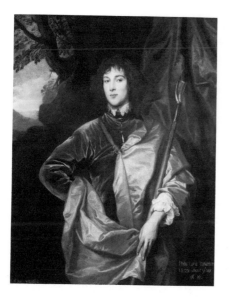

Sir Anthony van Dyck
FLEMISH, 1599 – 1641
Philip, Lord Wharton, 1632
Canvas, 1.334 x 1.064 (52 1/2 x 41 7/8)
Inscribed at lower left: *P.Sʳ Ant: vandike;*
at lower right: *Philip Lord Wharton / 1632*
about yᵉ age / of 19.
Andrew W. Mellon Collection
1937.1.50

Sir Anthony van Dyck
FLEMISH, 1599 – 1641
Portrait of a Flemish Lady, probably 1618
Canvas, 1.229 x .902 (48 3/8 x 35 1/2)
Andrew W. Mellon Collection
1940.1.14

Sir Anthony van Dyck
FLEMISH, 1599 – 1641
The Assumption of the Virgin, 1628/1632
Canvas, 1.181 x 1.022 (46 1/2 x 40 1/4)
Widener Collection
1942.9.88

Sir Anthony van Dyck
FLEMISH, 1599 – 1641
Giovanni Vincenzo Imperiale, 1626
Canvas, 1.270 x 1.055 (50 x 41 1/2)
Inscribed at upper right under coat of
arms: IO:VINC^S:IMP^S: / ANN:SAL:1625[6?] /
AET:SVAE:44.
Widener Collection
1942.9.89

Sir Anthony van Dyck
FLEMISH, 1599 – 1641
The Prefect Raphael Racius, c. 1625
Canvas, 1.310 x 1.055 (51 5/8 x 41 5/8)
Inscribed at upper right above coat of
arms: M D V / RAPHAEL RACIVS.I. / REIP.
TRIREMIVM / PRAEFECTVS.
Widener Collection
1942.9.90

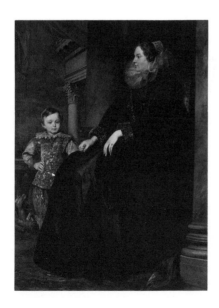

Sir Anthony van Dyck
FLEMISH, 1599 – 1641
*Portrait of an Italian Noblewoman and
Her Son, c. 1625*
Canvas, 1.892 x 1.397 (74 1/2 x 55)
Widener Collection
1942.9.91

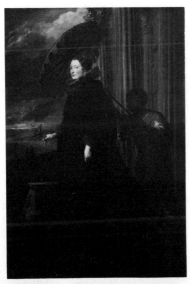

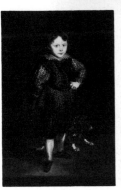

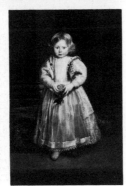

Sir Anthony van Dyck
FLEMISH, 1599 – 1641
*Marchesa Elena Grimaldi, Wife of
Marchese Nicola Cattaneo,* probably 1623
Canvas, 2.464 x 1.727 (97 x 68)
Widener Collection
1942.9.92

Sir Anthony van Dyck
FLEMISH, 1599 – 1641
*Filippo Cattaneo, Son of Marchesa Elena
Grimaldi,* 1623
Canvas, 1.223 x .842 (48 1/8 x 33 1/8)
Inscribed at upper left: A° 1623 AET. 4 : 7
Widener Collection
1942.9.93

Sir Anthony van Dyck
FLEMISH, 1599 – 1641
*Clelia Cattaneo, Daughter of Marchesa
Elena Grimaldi,* 1623
Canvas, 1.222 x .841 (48 1/8 x 33 1/8)
Inscribed at center left: A° 1623 AET. 2 : 8
Widener Collection
1942.9.94

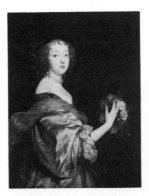

Sir Anthony van Dyck
FLEMISH, 1599 – 1641
Lady d'Aubigny, c. 1638
Canvas, 1.065 x .850 (42 x 33 1/2)
Inscribed at lower right: LADY AVBIGNY
Widener Collection
1942.9.95

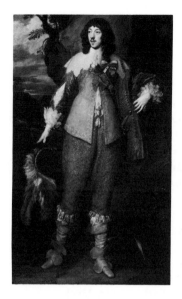

Sir Anthony van Dyck
FLEMISH, 1599 – 1641
Henri II de Lorraine, Duc de Guise,
c. 1634
Canvas, 2.046 x 1.238 (80 5/8 x 48 5/8)
Gift of Cornelius Vanderbilt Whitney
1947.14.1

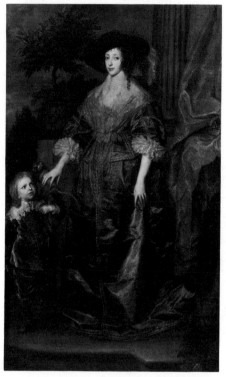

Sir Anthony van Dyck
FLEMISH, 1599 – 1641
Queen Henrietta Maria with Her Dwarf,
probably 1633
Canvas, 2.191 x 1.348 (86 1/4 x 53 1/8)
Samuel H. Kress Collection
1952.5.39

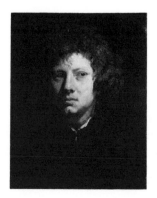

Sir Anthony van Dyck
FLEMISH, 1599 – 1641
Portrait of a Man
Paper on wood, .512 x .413 (20 1/8 x
16 1/4)
Gift of Adolph Caspar Miller
1953.3.2

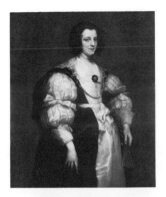

Sir Anthony van Dyck
FLEMISH, 1599 – 1641
*Doña Polyxena Spinola Guzman de
Leganés*, early 1630s
Canvas, 1.097 x .970 (43 1/8 x 38 1/8)
Samuel H. Kress Collection
1957.14.1

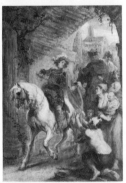

Sir Anthony van Dyck
FLEMISH, 1599 – 1641
Saint Martin Dividing His Cloak, c. 1630
Wood, .346 x .244 (13 5/8 x 9 5/8)
Ailsa Mellon Bruce Collection
1970.17.107

After Sir Anthony van Dyck
FLEMISH
Twelve Apostles, after 1660
Wood, each panel: .121 x .102 (4 3/4 x 4)
Timken Collection
1960.6.11

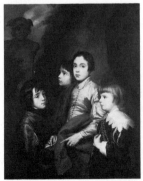

After Sir Anthony van Dyck
FLEMISH
Group of Four Boys
Canvas, 1.272 x 1.013 (50 1/8 x 39 7/8)
Timken Collection
1960.6.21

Dietz Edzard
GERMAN, 1893 – 1963
Flowers in a Vase
Canvas, .180 x .142 (7 1/8 x 5 5/8)
Inscribed at lower left: *D Edzard*
Ailsa Mellon Bruce Collection
1970.17.108

Dietz Edzard
GERMAN, 1893 – 1963
Three Flowers in a Vase
Canvas, .180 x .142 (7 1/8 x 5 5/8)
Inscribed at lower left: *D Edzard*
Ailsa Mellon Bruce Collection
1970.17.109

Max Ernst
GERMAN, 1891 – 1976
A Moment of Calm, 1939
Canvas, 1.698 x 3.250 (66 7/8 x 128)
Inscribed at lower right: *max ernst / 1939*
(added c. 1953)
Gift of Dorothea Tanning Ernst
1982.34.1

Agnolo degli Erri

EMILIAN, active 1448 – 1482
A Dominican Preaching, probably c. 1470
Wood, .438 x .343 (17 1/4 x 13 1/2)
Gift of Frieda Schiff Warburg in memory
of her husband Felix M. Warburg
1941.5.2

Adrianus Eversen

DUTCH, 1818 – 1897
Amsterdam Street Scene
Wood, .248 x .187 (9 3/4 x 7 3/8)
Inscribed at lower right: *A. Everson*
Ailsa Mellon Bruce Collection
1970.26.1

Jan van Eyck

NETHERLANDISH, C. 1390 – 1441
The Annunciation, c. 1434/1436
Transferred from wood to canvas, painted
surface: .902 x .341 (35 3/8 x 13 7/8);
panel: .927 x .367 (36 1/2 x 14 7/16)
Inscribed on top of back wall to the right
of furthest left figure: MOYSES F[I]SCELLA;
above second figure from left: FI . . .
PHARAONIS; on banderole: O IN VS
HEBREORVM HIC EST; on globe in window:
ASIA; above third figure from left: MOYSES;
on banderole: N͠O ASSVMES N͠OM D͠I TVI I͡
VAN[VM]; above fourth figure from left:
D͞N͞S; middle of back wall on left roundel:
ISAAC; on right roundel: JACOB; to the
right of Gabriel: AVE G͞R͞A PLENA; to the left
of Mary: INꝺ ∀⅂⅂IƆN∀ ƎƆƆƎ; lower left on
floor: A DALIDA VXORE S; lower center:
SAVL REX; DAVID; GOLIAS; second row
center: SAMSSON MVLTAS GENTES
INTERFECIT T 9VIVIO
Andrew W. Mellon Collection
1937.1.39

Henri Fantin-Latour
FRENCH, 1836 – 1904
Duchess de Fitz-James, 1867
Canvas, .503 x .422 (19 3/4 x 16 5/8)
Inscribed at lower left: *Fantin*
Chester Dale Collection
1963.10.23

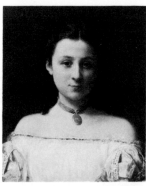

Henri Fantin-Latour
FRENCH, 1836 – 1904
Mademoiselle de Fitz-James, 1867
Canvas, .511 x .428 (20 1/8 x 16 7/8)
Inscribed at upper left: *Fantin. 67.*
Chester Dale Collection
1963.10.24

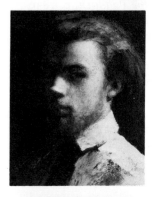

Henri Fantin-Latour
FRENCH, 1836 – 1904
Self-Portrait, 1858
Canvas, .407 x .327 (16 x 12 7/8)
Inscribed at lower left: *1858—*
Chester Dale Collection
1963.10.25

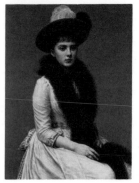

Henri Fantin-Latour
FRENCH, 1836 – 1904
Portrait of Sonia, 1890
Canvas, 1.092 x .810 (43 x 31 7/8)
Inscribed at upper right: *A ma chére* [sic]
nièce Sonia / Fantin. 90
Chester Dale Collection
1963.10.145

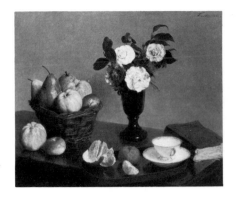

Henri Fantin-Latour
FRENCH, 1836 – 1904
Still Life, 1866
Canvas, .620 x .748 (24 3/8 x 29 1/2)
Inscribed at upper right: *Fantin. 1866.*
Chester Dale Collection
1963.10.146

John Ferneley
BRITISH, 1782 – 1860
In the Paddock, c. 1830
Canvas, .920 x 1.526 (36 1/4 x 60 1/8)
Ailsa Mellon Bruce Collection
1970.17.110

Domenico Fetti
ROMAN, c. 1589 – 1623 or 1624
The Parable of Dives and Lazarus, c. 1620
Wood, .597 x .435 (23 1/2 x 17 1/8)
Samuel H. Kress Collection
1939.1.88

Domenico Fetti
ROMAN, c. 1589 – 1623 or 1624
The Veil of Veronica, c. 1615
Wood, .815 x .675 (32 1/8 x 26 1/2)
Samuel H. Kress Collection
1952.5.7

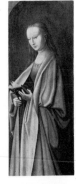

Imitator of Flemish 15th Century
Saint Bernard with Donor; reverse: *Saint Margaret,* probably after 1900
Wood, painted surface obverse: .575 x .221 (22 5/8 x 8 11/16); panel: .588 x .233 (23 1/8 x 9 3/16); painted surface reverse: .578 x .223 (22 3/4 x 8 3/4)
Chester Dale Collection
1942.16.2.a-b

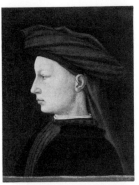

Florentine 15th Century
Profile Portrait of a Young Man, c. 1430/1450
Wood, .422 x .324 (16 5/8 x 12 3/4)
Andrew W. Mellon Collection
1937.1.14

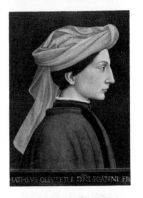

Florentine 15th Century
Matteo Olivieri, c. 1440/1450
Transferred from wood to canvas, .476 x .337 (18 7/8 x 13 1/4)
Inscribed across bottom: MATHEVS OLIVIERI DÑI IOANNI FILI[VS] (Matteo Olivieri, son of Don Giovanni)
Andrew W. Mellon Collection
1937.1.15

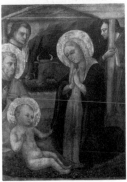

Florentine 15th Century
The Adoration of the Shepherds, 15th century
Wood, .481 x .361 (19 x 14 1/4)
Timken Collection
1960.6.25

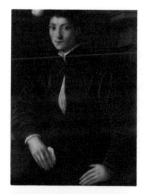

Florentine 16th Century
Ugolino Martelli, mid-16th century
Wood, .914 x .680 (36 x 26 3/4)
Samuel H. Kress Collection
1939.1.79

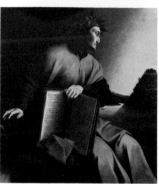

Florentine 16th Century
Allegorical Portrait of Dante, late 16th
century
Wood, 1.269 x 1.200 (50 x 47 1/4)
Inscribed at center on open book: the first
forty-eight lines of canto 25 of *Paradiso,*
beginning *"Se mai continga..."*
Samuel H. Kress Collection
1961.9.57

Vincenzo Foppa
LOMBARD, 1427/1430 – 1515 or 1516
Saint Anthony of Padua, before 1500
Wood, 1.490 x .565 (58 5/8 x 22 1/4)
Samuel H. Kress Collection
1952.5.63

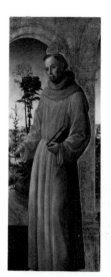
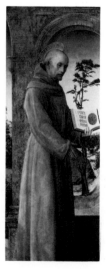

Vincenzo Foppa
LOMBARD, 1427/1430 – 1515 or 1516
Saint Bernardine, before 1500
Wood, 1.489 x .570 (58 5/8 x 22 1/2)
Inscribed at center right on open book:
Pater manefestavi nomen (Father, I have
manifested [Thy] name) from John 17:5,6;
and also from the antiphon of the first
Vespers of the Ascension; on the opposite
page is the emblematic monogram of
Christ
Samuel H. Kress Collection
1961.9.72

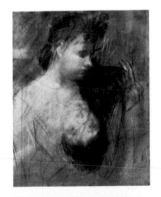

Jean-Louis Forain
FRENCH, 1852 – 1931
Sketch of a Woman, 1885/1890
Pastel on linen, .611 x .498 (24 1/16 x
19 5/8)
Rosenwald Collection
1943.3.26

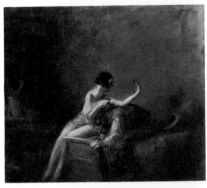

Jean-Louis Forain
FRENCH, 1852 – 1931
Artist and Model, 1925
Canvas, .546 x .654 (21 1/2 x 25 3/4)
Inscribed at upper right: *forain 1925*
Rosenwald Collection
1943.11.3

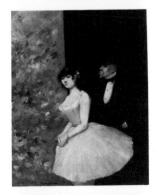

Jean-Louis Forain
FRENCH, 1852 – 1931
Behind the Scenes, c. 1880
Canvas, .464 x .384 (18 1/4 x 15 1/8)
Inscribed at lower left: *forain*
Rosenwald Collection
1943.11.4

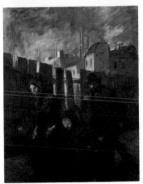

Jean-Louis Forain
FRENCH, 1852 – 1931
The Stockade, probably c. 1908
Canvas, .762 x .660 (30 x 26)
Inscribed at lower right: *forain*
Rosenwald Collection
1943.11.5

Jean-Louis Forain
FRENCH, 1852 – 1931
The Petitioner, c. 1910
Canvas, .615 x .510 (24 1/4 x 20)
Inscribed at lower right: *forain*
Rosenwald Collection
1943.11.6

Jean-Louis Forain
FRENCH, 1852 – 1931
The Charleston, 1926
Canvas, .601 x .736 (23 5/8 x 29)
Inscribed at lower right: *forain / 1926*
Chester Dale Collection
1963.10.26

Jean-Louis Forain
FRENCH, 1852 – 1931
Backstage at the Opera, c. 1910
Canvas, .730 x .605 (28 3/4 x 23 7/8)
Rosenwald Collection
1980.45.1

Jean-Louis Forain
FRENCH, 1852 – 1931
The Petition, 1906
Canvas, 1.016 x .820 (40 x 32 1/4)
Inscribed at lower right: *forain / 1906*
Rosenwald Collection
1980.45.2

Jean-Louis Forain
FRENCH, 1852 – 1931
The Requisition, c. 1919
Canvas, .505 x .613 (19 7/8 x 24 1/8)
Inscribed at lower right: *forain*
Rosenwald Collection
1980.45.3

Jean-Honoré Fragonard
FRENCH, 1732 – 1806
A Game of Horse and Rider, 1767/1773
Canvas, 1.150 x .875 (45 3/8 x 34 1/2)
Samuel H. Kress Collection
1946.7.5

Jean-Honoré Fragonard
FRENCH, 1732 – 1806
A Game of Hot Cockles, 1767/1773
Canvas, 1.155 x .915 (45 1/2 x 36)
Samuel H. Kress Collection
1946.7.6

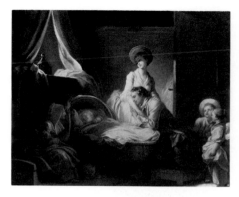

Jean-Honoré Fragonard
FRENCH, 1732 – 1806
The Visit to the Nursery, before 1784
Canvas, .730 x .921 (28 3/4 x 36 1/4)
Samuel H. Kress Collection
1946.7.7

Jean-Honoré Fragonard
FRENCH, 1732 – 1806
Love as Folly, c. 1775
Canvas, oval, .559 x .464 (22 x 18 1/4)
In memory of Kate Seney Simpson
1947.2.1

Jean-Honoré Fragonard
FRENCH, 1732 – 1806
Love as Conqueror, c. 1775
Canvas, oval, .559 x .467 (22 x 18 3/8)
Inscribed at lower center: *Fragonard*
In memory of Kate Seney Simpson
1947.2.2

Jean-Honoré Fragonard
FRENCH, 1732 – 1806
The Happy Family, after 1769
Canvas, oval, .539 x .651 (21 1/4 x
25 5/8)
Timken Collection
1960.6.12

Jean-Honoré Fragonard
FRENCH, 1732 – 1806
Blindman's Buff, probably c. 1765
Canvas, 2.162 x 1.978 (85 1/8 x 77 7/8)
Samuel H. Kress Collection
1961.9.16

Jean-Honoré Fragonard
FRENCH, 1732 – 1806
The Swing, probably c. 1765
Canvas, 2.159 x 1.855 (85 x 73)
Samuel H. Kress Collection
1961.9.17

Jean-Honoré Fragonard
FRENCH, 1732 – 1806
Hubert Robert, probably c. 1760
Canvas, .653 x .544 (25 3/4 x 21 1/2)
Samuel H. Kress Collection
1961.9.18

Jean-Honoré Fragonard
FRENCH, 1732 – 1806
A Young Girl Reading, c. 1776
Canvas, .811 x .648 (32 x 25 1/2)
Gift of Mrs. Mellon Bruce in memory of
her father, Andrew W. Mellon
1961.16.1

Jean-Honoré Fragonard
FRENCH, 1732 – 1806
Love as Folly, c. 1775
Canvas, oval, .562 x .473 (22 1/8 x
18 5/8)
Inscribed at lower center: *frago*
Ailsa Mellon Bruce Collection
1970.17.111

Jean-Honoré Fragonard
FRENCH, 1732 – 1806
Love as Conqueror, c. 1775
Canvas, oval, .562 x .473 (22 1/8 x
18 5/8)
Inscribed at lower center: *frago*
Ailsa Mellon Bruce Collection
1970.17.112

Francesco di Giorgio Martini
SIENESE, 1439 – 1501 or 1502
*God the Father Surrounded by Angels and
Cherubim*, c. 1470
Wood, oval, .365 x .518 (14 3/8 x 20 3/8)
Samuel H. Kress Collection
1952.5.8

Francesco Francia
BOLOGNESE, C. 1450 – 1517
Bishop Altobello Averoldo, probably 1505
Wood, .527 x .397 (20 3/4 x 15 5/8)
Inscribed across bottom: ALTOBELLVS
AVEROLDVS B̂RIX EP̂VS· (Altobello
Averoldo, a Brescian and a Bishop)
Samuel H. Kress Collection
1952.5.64

Franco-Flemish 15th Century
FRANCO-FLEMISH
Profile Portrait of a Lady, c. 1410
Wood, painted surface: .520 x .366 (20 1/2
x 14 3/8); panel: .530 x .376 (20 7/8 x
14 13/16)
Andrew W. Mellon Collection
1937.1.23

Henry Fuseli
SWISS, 1741 – 1825
Oedipus Cursing His Son, Polynices,
c. 1776/1778
Canvas, 1.498 x 1.654 (59 x 65 1/8)
Paul Mellon Collection
1983.1.41

Agnolo Gaddi

FLORENTINE, active 1369 – 1396
Madonna Enthroned with Saints and Angels, c. 1380/1390
Wood, left panel: 1.972 x .800 (77 5/8 x 31 1/2); middle panel: 2.038 x .800 (80 1/4 x 31 1/2); right panel: 1.946 x .806 (76 5/8 x 31 3/4)
Inscribed on left panel across bottom below saints: S ANDREAS APPUS; S BENEDICTUS; at center right on book:

AUSCU / LTA O / FILI PR/ECEPTA / MAGIS/ [T]RI ET IN/CLINA AUREM / CORDIS T/UI ET AMONITIONE/M PII PA/TRIS LI/BENTE/R EXCIP/E ET EF[FICACITER] (Harken, O son, to the precepts of the master and incline the ear of your heart and willingly receive the admonition of the pious father and efficiently) from a part of the Benedictine Rule; inscribed on middle panel at upper center on Christ's book: EGO SUM A & O PRINCIPĪU & FINIS EGO SUM VIA VERITAS VITA (I am Alpha & Omega, the beginning & the end, I am the way, the truth, and the life) from Rev. 22:13; John 14:6; across bottom: AVE MARIA GRATIA PLENA DOMINUS S [*sic*] (Hail, Mary, full of grace, the Lord is with thee) from Luke 1:28; inscribed on right panel across bottom under saints: S BERNARDUS DOCTOR; S KTHERINA VIRGO
Andrew W. Mellon Collection
1937.1.4.a-c

Agnolo Gaddi
FLORENTINE, active 1369 – 1396
The Coronation of the Virgin,
probably c. 1370
Wood, 1.626 x .794 (64 x 31 1/4)
Samuel H. Kress Collection
1939.1.203

Eduard Gaertner
GERMAN, 1801 – 1877
City Hall at Torun, 1848
Canvas, .509 x .801 (20 x 31 1/2)
Inscribed at lower right: *E. Gaertner fec.*
1848
Gift of Ethel Gaertner Pyne
1973.13.1

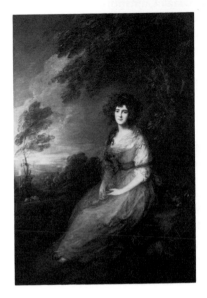

Thomas Gainsborough
BRITISH, 1727 – 1788
Mrs. Richard Brinsley Sheridan, probably
1785/1786
Canvas, 2.197 x 1.537 (86 1/2 x 60 1/2)
Andrew W. Mellon Collection
1937.1.92

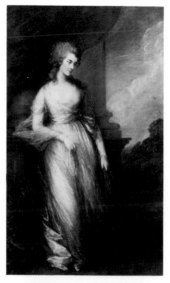

Thomas Gainsborough
BRITISH, 1727 – 1788
Georgiana, Duchess of Devonshire,
probably 1783
Canvas, 2.356 x 1.465 (92 3/4 x 57 5/8)
Andrew W. Mellon Collection
1937.1.93

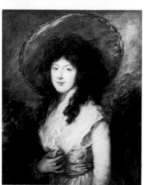

Thomas Gainsborough
BRITISH, 1727 – 1788
Miss Catherine Tatton, probably 1785
Canvas, .762 x .635 (30 x 25)
Andrew W. Mellon Collection
1937.1.99

Thomas Gainsborough
BRITISH, 1727 – 1788
Mrs. John Taylor, probably c. 1778
Canvas, oval, .762 x .635 (30 x 25)
Andrew W. Mellon Collection
1937.1.100

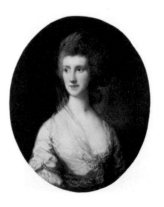

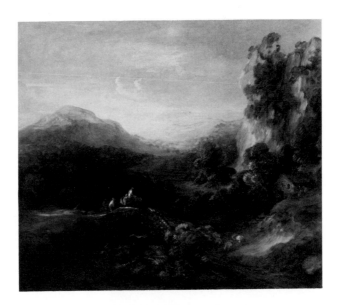

Thomas Gainsborough
BRITISH, 1727 – 1788
Landscape with a Bridge, c. 1785
Canvas, 1.130 x 1.334 (44 1/2 x 52 1/2)
Andrew W. Mellon Collection
1937.1.107

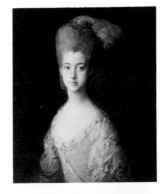

Thomas Gainsborough
BRITISH, 1727 – 1788
Mrs. Methuen, probably 1776
Canvas, .838 x .711 (33 x 28)
Widener Collection
1942.9.20

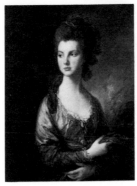

Thomas Gainsborough
BRITISH, 1727 – 1788
The Honorable Mrs. Graham, probably
1775
Canvas, .895 x .692 (36 x 27 1/4)
Widener Collection
1942.9.21

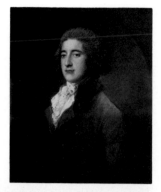

Thomas Gainsborough
BRITISH, 1727 – 1788
The Earl of Darnley, probably 1785
Canvas, .760 x .635 (30 x 25)
Widener Collection
1942.9.22

Thomas Gainsborough
BRITISH, 1727 – 1788
Master John Heathcote, c. 1770/1774
Canvas, 1.270 x 1.012 (50 x 39 7/8)
Given in memory of Governor Alvan
T. Fuller by The Fuller Foundation, Inc.
1961.2.1

Thomas Gainsborough
BRITISH, 1727 – 1788
William Yelverton Davenport, 1780s
Canvas, 1.275 x 1.021 (50 1/8 x 40 1/8)
Gift of The Coe Foundation
1961.5.3

Thomas Gainsborough
BRITISH, 1727 — 1788
Seashore with Fishermen, probably 1781
Canvas, 1.022 x 1.279 (40 1/4 x 50 3/8)
Ailsa Mellon Bruce Collection
1970.17.121

Studio of Thomas Gainsborough
BRITISH
George IV as Prince of Wales, 1780/1788
Canvas, oval, .765 x .632 (30 1/8 x 24 7/8)
Andrew W. Mellon Collection
1937.1.98

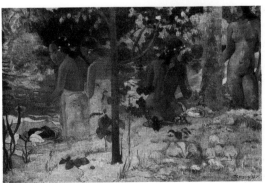

Paul Gauguin
FRENCH, 1848 — 1903
The Bathers, 1898
Canvas, .604 x .934 (23 3/4 x 36 3/4)
Inscribed at lower right: *P Gauguin 98*
Gift of Sam A. Lewisohn
1951.5.1

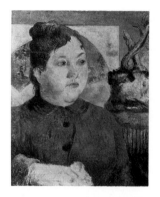

Paul Gauguin
FRENCH, 1848 – 1903
Madame Alexandre Kohler, 1887/1888
Canvas, .463 x .380 (18 1/4 x 15)
Inscribed at lower right: *P Gauguin*
Chester Dale Collection
1963.10.27

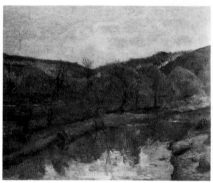

Paul Gauguin
FRENCH, 1848 – 1903
Brittany Landscape, 1888
Canvas, .711 x .895 (28 x 35 1/4)
Inscribed at lower left: *P. Gauguin 88*
Chester Dale Collection
1963.10.148

Paul Gauguin
FRENCH, 1848 – 1903
Fatata te Miti (By the Sea), 1892
Canvas, .679 x .915 (26 3/4 x 36)
Inscribed at lower left: *Fatata te Miti* (By
the Sea); at lower right: *P Gauguin 92*
Chester Dale Collection
1963.10.149

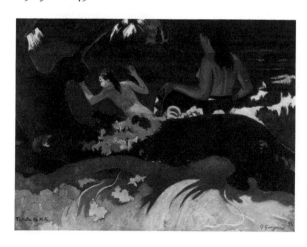

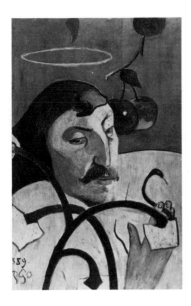

Paul Gauguin
FRENCH, 1848 – 1903
Self-Portrait, 1889
Wood, .792 x .513 (31 1/4 x 20 1/4)
Inscribed at lower left: *1889. / P Go*
Chester Dale Collection
1963.10.150

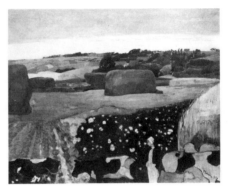

Paul Gauguin
FRENCH, 1848 – 1903
Haystacks in Brittany, 1890
Canvas, .743 x .936 (29 1/4 x 36 7/8)
Inscribed at lower right: *P Gauguin 90*
Gift of the W. Averell Harriman
Foundation in memory of Marie
N. Harriman
1972.9.11

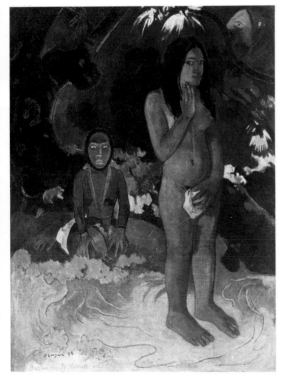

Paul Gauguin
FRENCH, 1848 – 1903
Parau na te Varua ino (Words of the Devil), 1892
Canvas, .917 x .685 (36 1/8 x 27)
Inscribed at lower left: *P Gauguin 92 / Parau na te Varua ino*
Gift of the W. Averell Harriman
Foundation in memory of Marie
N. Harriman
1972.9.12

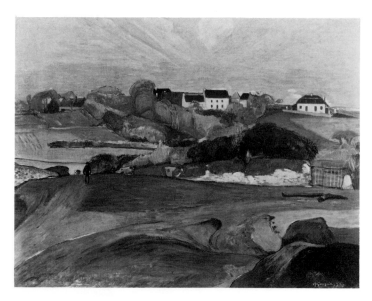

Paul Gauguin
FRENCH, 1848 – 1903
Landscape at Le Pouldu, 1890
Canvas, .733 x .924 (28 7/8 x 36 3/8)
Inscribed at lower right: *P. Gauguin. 90—*
Collection of Mr. and Mrs. Paul Mellon
1983.1.20

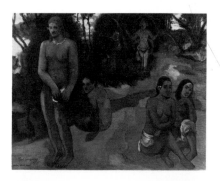

Paul Gauguin
FRENCH, 1848 – 1903
Te Pape Nave Nave (Delectable Waters),
1898
Canvas, .740 x .953 (29 1/8 x 37 1/2)
Inscribed at lower left: *Paul Gauguin / 98 /*
TE PAPE NAVE NAVE
Collection of Mr. and Mrs. Paul Mellon
1973.68.2

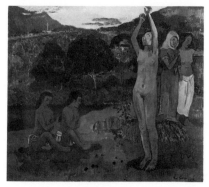

Paul Gauguin
FRENCH, 1848 – 1903
The Invocation, 1903
Canvas, .655 x .756 (25 3/4 x 29 3/4)
Inscribed at lower right: *Paul Gauguin /*
1903
Gift from the Collection of John and
Louise Booth in memory of their daughter
Winkie
1976.63.1

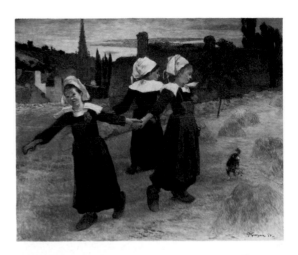

Paul Gauguin

FRENCH, 1848 – 1903
Breton Girls Dancing, Pont-Aven, 1888
Canvas, .730 x .927 (28 3/4 x 36 1/2)
Inscribed at lower right: *P. Gauguin 88—*
Collection of Mr. and Mrs. Paul Mellon
1983.1.19

Gentile da Fabriano

UMBRIAN, C. 1370 – 1427
Madonna and Child, c. 1422
Wood, .959 x .565 (37 3/4 x 22 1/4)
Inscribed at upper center on the Virgin's
collar: MATER (Mother); across bottom on
the lower border of her dress: AVE MARIA
GRATIA PLENA DOM[INVS] TECVM
BEN[EDICTA] (Hail, Mary, full of grace, the
Lord is with thee, blessed) from Luke 1:28.
Samuel H. Kress Collection
1939.1.255

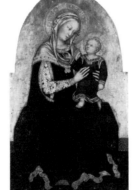

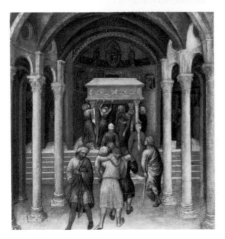

Gentile da Fabriano

UMBRIAN, C. 1370 – 1427
A Miracle of Saint Nicholas, 1425
Wood, .362 x .356 (14 1/4 x 14)
Samuel H. Kress Collection
1939.1.268

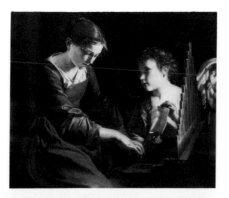

Orazio Gentileschi
FLORENTINE, 1563 – 1639
Saint Cecilia and an Angel, c. 1610
Canvas, .878 x 1.081 (34 5/8 x 42 1/2)
Samuel H. Kress Collection
1961.9.73

Orazio Gentileschi
FLORENTINE, 1563 – 1639
The Lute Player, probably c. 1610
Canvas, 1.435 x 1.288 (56 1/2 x 50 5/8)
Ailsa Mellon Bruce Fund
1962.8.1

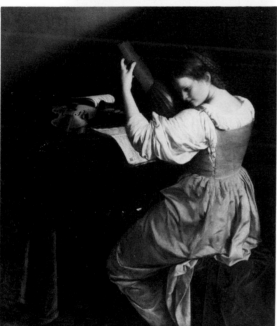

Baron François Gérard
FRENCH, 1770 – 1837
The Model, c. 1790
Canvas, .612 x .502 (24 1/8 x 19 3/4)
Chester Dale Collection
1963.10.28

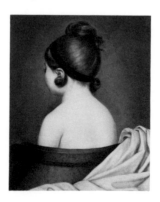

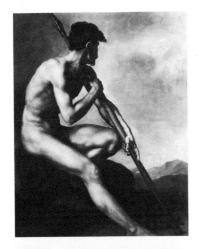

Théodore Géricault
FRENCH, 1791 – 1824
Nude Warrior with a Spear, 1810/1812
Canvas, .936 x .755 (36 7/8 x 29 3/4)
Chester Dale Collection
1963.10.29

Théodore Géricault
FRENCH, 1791 – 1824
Trumpeters of Napoleon's Imperial Guard,
1812/1814
Canvas, .604 x .496 (23 3/4 x 19 1/2)
Chester Dale Fund
1972.25.1

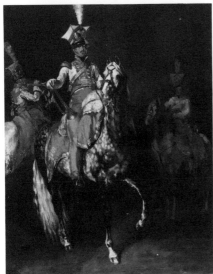

Attributed to Théodore Géricault
FRENCH, 1791 – 1824
Grey Stallion
Canvas, .597 x .736 x 29 (23 1/2 x 29)
Inscribed at lower left: *Gericault*
Collection of Mr. and Mrs. Paul Mellon
1984.29.2

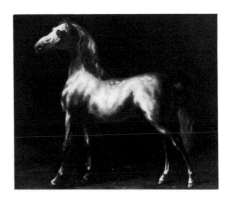

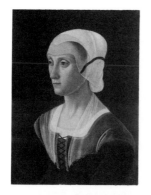

Domenico Ghirlandaio
FLORENTINE, 1449 – 1494
Lucrezia Tornabuoni, before 1475
Wood, .533 x .399 (21 x 15 3/4)
Inscribed on reverse: *...Tornabuoni...*
Samuel H. Kress Collection
1952.5.62

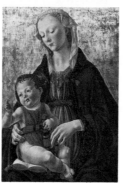

Domenico Ghirlandaio
FLORENTINE, 1449 – 1494
Madonna and Child, c. 1470
Transferred from wood to hardboard, .734
x .508 (28 7/8 x 20)
Samuel H. Kress Collection
1961.9.49

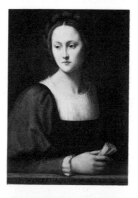

Ridolfo Ghirlandaio
FLORENTINE, 1483 – 1561
Lucrezia Sommaria, c. 1510
Wood, .629 x .457 (24 3/4 x 18)
Inscribed at lower center on parapet:
·LVCRETIAE·SVMARIAE·EFFIGIES·
Widener Collection
1942.9.23

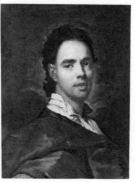

Giuseppe Ghislandi
BERGAMO, 1655 – 1743
Portrait of a Young Man, c. 1710/1720
Canvas, .730 x .565 (28 3/4 x 22 1/4)
Samuel H. Kress Collection
1939.1.102

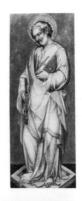

Michele Giambono
VENETIAN, active 1420 – 1462
Saint Peter, probably c. 1440
Wood, .857 x .349 (33 3/4 x 13 3/4)
Samuel H. Kress Collection
1939.1.80

Giannicola di Paolo
UMBRIAN, C. 1460 – 1544
The Annunciation, c. 1510/1515
Wood, .403 x .359 (15 7/8 x 14 1/8)
Samuel H. Kress Collection
1939.1.155

Giorgione
VENETIAN, 1477 or 1478 – 1510
The Adoration of the Shepherds, c. 1505/
1510
Wood, .908 x .1.105 (35 3/4 x 43 1/2)
Samuel H. Kress Collection
1939.1.289

Giorgione
VENETIAN, 1477 or 1478 – 1510
The Holy Family, probably c. 1500
Transferred from wood to hardboard,
.373 x .456 (14 5/8 x 17 7/8)
Samuel H. Kress Collection
1952.2.8

Giorgione and Titian
VENETIAN, 1477 or 1478 – 1510; c. 1488 –
1576
Portrait of a Venetian Gentleman, c. 1510
Canvas, .762 x .635 (30 x 25)
Inscribed at lower center on parapet: VVO
Samuel H. Kress Collection
1939.1.258

Attributed to Giorgione
VENETIAN, 1477 or 1478 – 1510
Giovanni Borgherini and His Tutor
Canvas, .470 x .607 (18 1/2 x 23 7/8)
Inscribed at lower center on scroll: NON
VALET· / INGENIVM.NISI / FACTA/ VAL^EBVNT
(Talent has no worth unless
accomplishment follows)
Gift of Michael Straight
1974.87.1

Circle of Giorgione
VENETIAN
Venus and Cupid in a Landscape, c. 1505/
1515
Wood, .110 x .200 (4 3/8 x 8)
Samuel H. Kress Collection
1939.1.142

Giotto
FLORENTINE, probably 1266 – 1337
Madonna and Child,
probably c. 1320/1330
Wood, .855 x .620 (33 5/8 x 24 3/8)
Samuel H. Kress Collection
1939.1.256

Giovanni di Paolo di Grazia
SIENESE, c. 1403 – 1482
The Adoration of the Magi, c. 1450
Wood, .260 x .451 (10 1/4 x 17 3/4)
Andrew W. Mellon Collection
1937.1.13

Giovanni di Paolo di Grazia
SIENESE, C. 1403 – 1482
The Annunciation, c. 1445
Wood, .400 x .464 (15 3/4 x 18 1/4)
Samuel H. Kress Collection
1939.1.223

Girolamo da Carpi
FERRARESE, 1501 – 1556
The Apparition of the Virgin, c. 1530/1540
Wood, 1.994 x 1.311 (78 1/2 x 51 5/8)
Samuel H. Kress Collection
1939.1.382

Girolamo di Benvenuto
SIENESE, 1470 – 1524
Portrait of a Young Woman, c. 1505
Wood, .600 x .454 (23 5/8 x 17 7/8)
Samuel H. Kress Collection
1939.1.353

Albert Gleizes
FRENCH, 1881 – 1953
Football Players, 1912/1913
Canvas, 2.261 x 1.829 (89 x 72)
Inscribed at lower left: *Albert Gleizes /
1912-13*
Ailsa Mellon Bruce Fund
1970.11.1

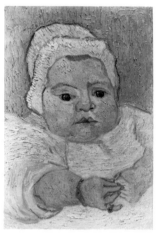

Vincent van Gogh
DUTCH, 1853 – 1890
Roulin's Baby, 1888
Canvas, .350 x .239 (13 3/4 x 9 3/8)
Chester Dale Collection
1963.10.31

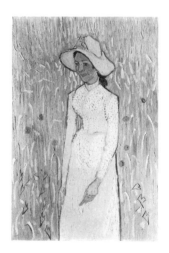

Vincent van Gogh
DUTCH, 1853 – 1890
Girl in White, 1890
Canvas, .663 x .453 (26 1/8 x 17 7/8)
Chester Dale Collection
1963.10.30

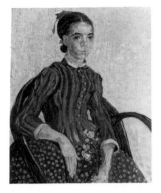

Vincent van Gogh
DUTCH, 1853 – 1890
La Mousmé, 1888
Canvas, .733 x .603 (28 7/8 x 23 3/4)
Chester Dale Collection
1963.10.151

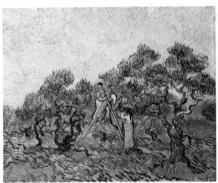

Vincent van Gogh
DUTCH, 1853 – 1890
The Olive Orchard, 1889
Canvas, .730 x .921 (28 3/4 x 36 1/4)
Chester Dale Collection
1963.10.152

Vincent van Gogh
DUTCH, 1853 – 1890
Farmhouse in Provence, Arles, 1888
Canvas, .461 x .609 (18 1/8 x 24)
Ailsa Mellon Bruce Collection
1970.17.34

Vincent van Gogh
DUTCH, 1853 – 1890
Flower Beds in Holland, c. 1883
Canvas on wood, .489 x .660 (19 1/4
x 26)
Collection of Mr. and Mrs. Paul Mellon
1983.1.21

Imitator of Vincent van Gogh
DUTCH
Portrait of van Gogh, 1925/1928
Canvas, .589 x .486 (23 1/4 x 19 1/8)
Chester Dale Collection
1963.10.153

Jan Gossaert
NETHERLANDISH, C. 1478 – 1532
Saint Jerome Penitent, c. 1509/1512
Wood, two panels, each painted surface:
.867 x .245 (34 1/8 x 9 5/8); each panel:
.867 x .253 (34 1/8 x 10)
Falsely inscribed on reverse panel at center
right on small stone: AD (in ligature)
Samuel H. Kress Collection
1952.5.40.a-b

Jan Gossaert
NETHERLANDISH, C. 1478 – 1532
Portrait of a Merchant, c. 1530
Wood, .636 x .475 (25 x 18 3/4)
Inscribed at upper left on paper: *Alrehande
Missiven* (miscellaneous letters); at upper
right on paper: *Alrehande Minuten*
(miscellaneous drafts)
Ailsa Mellon Bruce Fund
1967.4.1

Jan Gossaert
NETHERLANDISH, C. 1478 – 1532
Madonna and Child, c. 1532
Wood, .344 x .248 (13 1/2 x 9 3/4)
Falsely inscribed at lower right: AD (in ligature)
Gift of Grace Vogel Aldworth in memory of her grandparents Ralph and Mary Booth
1981.87.1

Francisco de Goya
SPANISH, 1746 – 1828
The Marquesa de Pontejos, probably 1786
Canvas, 2.108 x 1.264 (83 x 49 3/4)
Andrew W. Mellon Collection
1937.1.85

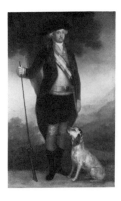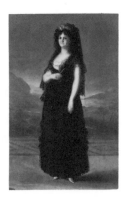

Francisco de Goya
SPANISH, 1746 – 1828
Carlos IV of Spain as Huntsman,
probably 1799 or after
Canvas, .464 x .299 (18 1/4 x 11 3/4)
Andrew W. Mellon Collection
1937.1.86

Francisco de Goya
SPANISH, 1746 – 1828
Maria Luisa, Queen of Spain,
probably 1799 or after
Canvas, .464 x .299 (18 1/4 x 11 3/4)
Andrew W. Mellon Collection
1937.1.87

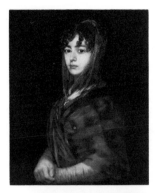

Francisco de Goya
SPANISH, 1746 – 1828
Señora Sabasa García, c. 1806/1807
Canvas, .711 x .584 (28 x 23)
Andrew W. Mellon Collection
1937.1.88

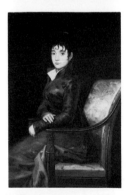

Francisco de Goya
SPANISH, 1746 – 1828
Don Bartolomé Sureda, c. 1805
Canvas, 1.197 x .794 (47 1/8 x 31 1/4)
Gift of Mr. and Mrs. P. H. B.
Frelinghuysen in memory of her father and
mother, Mr. and Mrs. H. O. Havemeyer
1941.10.1

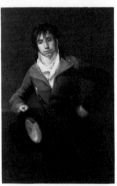

Francisco de Goya
SPANISH, 1746 – 1828
Doña Teresa Sureda, c. 1805
Canvas, 1.197 x .794 (47 1/8 x 31 1/4)
Gift of Mr. and Mrs. P. H. B.
Frelinghuysen in memory of her father and
mother, Mr. and Mrs. H. O. Havemeyer
1942.3.1

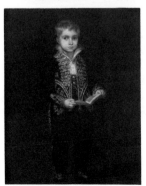

Francisco de Goya
SPANISH, 1746 – 1828
Victor Guye, 1810
Canvas, 1.067 x .851 (42 x 33 1/2)
Originally inscribed on the back of the
canvas: *Ce portrait de mon Fils a été peint
par Goya pour faire le pendant de celui de
mon Frère le Général,* and signed, *Vt*
(Vincent) *Guye*
Gift of William Nelson Cromwell
1956.11.1

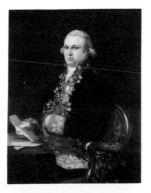

Francisco de Goya
SPANISH, 1746 – 1828
Don Antonio Noriega, 1801
Canvas, 1.026 x .809 (40 3/8 x 31 7/8)
Inscribed at center left on paper in sitter's
hand: *el S.º.r D.º / Antonio / Noriega /
Tesorero / General / F. Goya / 1801*
Samuel H. Kress Collection
1961.9.74

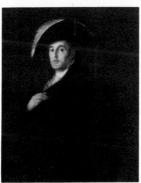

Francisco de Goya
SPANISH, 1746 – 1828
The Duke of Wellington, probably 1812
Canvas, 1.055 x .837 (41 1/2 x 33)
Inscribed at lower left: *A. W. Terror
Gallorum.*
Gift of Mrs. P. H. B. Frelinghuysen
1963.4.1

Francisco de Goya
SPANISH, 1746 – 1828
The Bookseller's Wife, c. 1805
Canvas, 1.099 x .782 (43 1/4 x 30 3/4)
Inscribed at lower left: *Goya*
Gift of Mrs. P. H. B. Frelinghuysen
1963.4.2

Francisco de Goya
SPANISH, 1746 – 1828
Condesa de Chinchón, 1783
Canvas, 1.347 x 1.175 (53 x 46 1/4)
Inscribed at lower left: LA S.D. MARIA
TERESA / HIXA DEL SER. INFANTE / D. LUIS /
DE EDAD DE DOS AÑOS Y NUEVE MESES.;
B.; at lower right inventory numbers: 15, 5
Ailsa Mellon Bruce Collection
1970.17.123

Attributed to Francisco de Goya
SPANISH, 1746 — 1828
The Bullfight, c. 1827
Canvas, .739 x 1.099 (29 x 43 1/4)
Gift of Arthur Sachs
1954.10.1

Jan van Goyen
DUTCH, 1596 — 1656
View of Dordrecht from the Dordtse Kil,
1644
Wood, .647 x .959 (25 1/2 x 37 3/4)
Inscribed at lower center on boat:
VGOYEN 1644
Ailsa Mellon Bruce Fund
1978.11.1

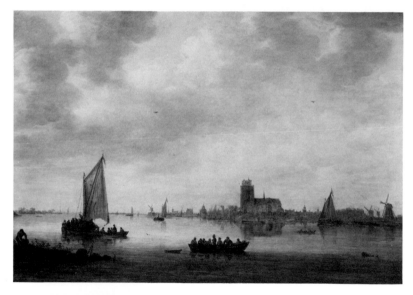

Benozzo Gozzoli
FLORENTINE, 1420 — 1497
Saint Ursula with Angels and Donor,
c. 1455
Wood, .470 x .286 (18 1/2 x 11 1/4)
Inscribed on the halos: ·SANCTA
·VREVLA·VIRGO·; ·ANGELVS·; and ·ANGELVS·;
below the nun: *Su°ra ·Ginevera·*
Samuel H. Kress Collection
1939.1.265

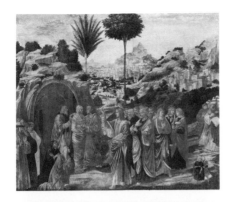

Benozzo Gozzoli
FLORENTINE, 1420 – 1497
The Raising of Lazarus, probably 1497
Canvas, .655 x .805 (25 3/4 x 31 3/4)
Widener Collection
1942.9.24

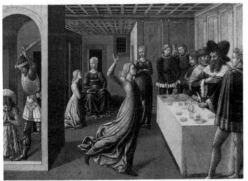

Benozzo Gozzoli
FLORENTINE, 1420 – 1497
The Dance of Salome, 1461/1462
Wood, .238 x .343 (9 3/8 x 13 1/2)
Samuel H. Kress Collection
1952.2.3

El Greco (Domenikos Theotokopoulos)
SPANISH, 1541 – 1614
Saint Ildefonso, c. 1600/1605
Canvas, 1.124 x .654 (44 1/4 x 25 3/4)
Inscribed at lower left: illegible
Andrew W. Mellon Collection
1937.1.83

El Greco (Domenikos Theotokopoulos)
SPANISH, 1541 – 1614
Saint Martin and the Beggar, 1604/1614
Canvas, 1.041 x .600 (41 x 23 5/8)
Inscribed at lower right an inventory
number: 387
Andrew W. Mellon Collection
1937.1.84

El Greco (Domenikos Theotokopoulos)
SPANISH, 1541 – 1614
Saint Martin and the Beggar, 1597/1599
Canvas, 1.935 x 1.030 (76 1/8 x 40 1/2)
Inscribed at lower right in Greek letters:
Domenikos Theotokopoulos made it
Widener Collection
1942.9.25

El Greco (Domenikos Theotokopoulos)
SPANISH, 1541 – 1614
*Madonna and Child with Saint Martina
and Saint Agnes,* 1597/1599
Canvas, 1.935 x 1.030 (76 1/8 x 40 1/2)
Inscribed at lower center on lion's head in
Greek letters: *D Th*
Widener Collection
1942.9.26

El Greco (Domenikos Theotokopoulos)
SPANISH, 1541 – 1614
Saint Jerome, c. 1610/1614
Canvas, 1.680 x 1.105 (66 1/4 x 43 1/2)
Chester Dale Collection
1943.7.6

El Greco (Domenikos Theotokopoulos)
SPANISH, 1541 – 1614
Laocoön, c. 1610
Canvas, 1.375 x 1.725 (54 1/8 x 67 7/8)
Inscribed at lower left an inventory
number: 104
Samuel H. Kress Collection
1946.18.1

El Greco (Domenikos Theotokopoulos)
SPANISH, 1541 – 1614
Christ Cleansing the Temple, c. 1570
Wood, .654 x .832 (25 3/4 x 32 3/4)
Inscribed at lower left in Greek letters:
DOMENIKOS THEOTOKOPOULOS / KRES
(Cretan)
Samuel H. Kress Collection
1957.14.4

El Greco (Domenikos Theotokopoulos)
SPANISH, 1541 – 1614
The Holy Family, probably c. 1590/1600
Canvas, .532 x .344 (20 7/8 x 13 1/2)
Samuel H. Kress Collection
1959.9.4

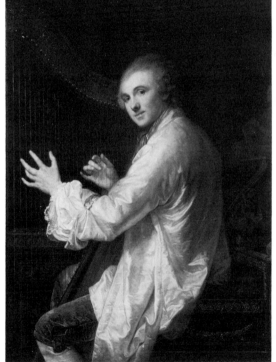

Jean-Baptiste Greuze
FRENCH, 1725 – 1805
Ange-Laurent de Lalive de Jully,
probably 1759
Canvas, 1.170 x .885 (46 x 34 7/8)
Samuel H. Kress Collection
1946.7.8

Jean-Baptiste Greuze
FRENCH, 1725 – 1805
Girl with Birds
Canvas, oval, .614 x .520 (24 1/8 x 20 1/2)
Timken Collection
1960.6.19

After Jean-Baptiste Greuze
FRENCH
Girl with Folded Arms
Canvas, .563 x .470 (22 1/8 x 18 1/2)
Timken Collection
1960.6.20

After Jean-Baptiste Greuze
FRENCH
Benjamin Franklin
Canvas, .727 x .575 (28 5/8 x 22 5/8)
Gift of Adele Lewisohn Lehman
1971.93.1

Abel Grimmer
FLEMISH, C. 1570 – before 1619
The Marketplace in Bergen op Zoom, 1597
Wood, .638 x .822 (25 1/8 x 32 3/8)
Inscribed at lower left: *1597*
Gift of Mr. and Mrs. Earl H. Look
1979.50.1

Juan Gris
SPANISH, 1887 – 1927
Fantômas, 1915
Canvas, .598 x .733 (23 1/2 x 28 7/8)
Inscribed at lower left: *Juan Gris / 8-1915*
Chester Dale Fund
1976.59.1

Marcel Gromaire
FRENCH, 1892 – 1971
Vendor of Ices, 1928
Canvas, .813 x .648 (32 x 25 1/2)
Inscribed at lower left: *Gromaire / 1928*
Chester Dale Collection
1963.10.74

Baron Antoine-Jean Gros
FRENCH, 1771 – 1835
Dr. Vignardonne, 1827
Canvas, .810 x .643 (31 7/8 x 25 1/4)
Inscribed at lower left: *Gros*
Chester Dale Collection
1963.10.154

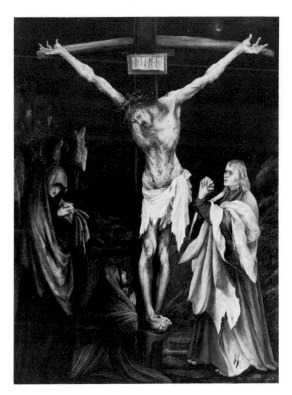

Mathis Grünewald (Mathis Gothart Neithart)
GERMAN, C. 1470/1475 – 1528
The Small Crucifixion, c. 1510
Wood, .616 x .460 (24 1/4 x 18 1/8)
Inscribed at upper center on plaque: INRI
Samuel H. Kress Collection
1961.9.19

Francesco Guardi
VENETIAN, 1712 – 1793
View on the Cannaregio, Venice, c. 1770
Canvas, .476 x .743 (18 3/4 x 29 1/4)
Samuel H. Kress Collection
1939.1.113

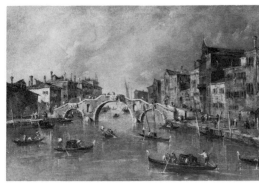

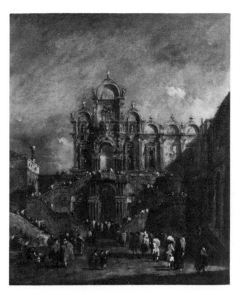

Francesco Guardi
VENETIAN, 1712 – 1793
Campo San Zanipolo, 1782
Canvas, .375 x .315 (14 3/4 x 12 3/8)
Samuel H. Kress Collection
1939.1.129

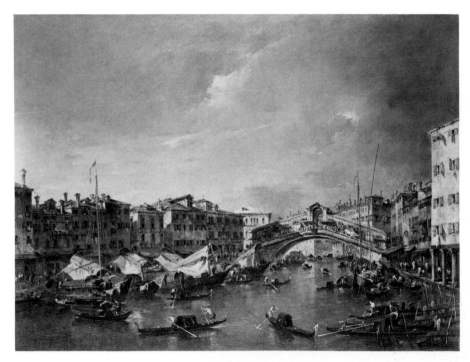

Francesco Guardi
VENETIAN, 1712 – 1793
View of the Rialto, probably c. 1780
Canvas, .685 x .915 (27 x 36)
Widener Collection
1942.9.27

Francesco Guardi
VENETIAN, 1712 – 1793
A Seaport and Classic Ruins in Italy, 1730s
Canvas, 1.219 x 1.778 (48 x 70)
Samuel H. Kress Collection
1943.4.50

Francesco Guardi
VENETIAN, 1712 – 1793
The Rialto Bridge, c. 1775/1780
Wood, .191 x .303 (7 1/2 x 11 7/8)
Gift of R. Horace Gallatin
1949.1.6

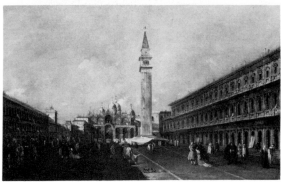

Francesco Guardi
VENETIAN, 1712 – 1793
Castel Sant'Angelo, c. 1760/1770
Canvas, .468 x .763 (18 3/8 x 31)
Gift of Howard Sturges
1956.9.2

Follower of Francesco Guardi
VENETIAN
Piazza San Marco
Canvas, .486 x .840 (19 1/8 x 33 1/8)
Gift of Lewis Einstein
1958.7.1

Gian Antonio Guardi and Francesco Guardi
VENETIAN, 1698 or 1699 – 1760; 1712 – 1793
Carlo and Ubaldo Resisting the Enchantments of Armida's Nymphs, 1750/1755
Canvas, 2.502 x 4.598 (98 1/2 x 181)
Ailsa Mellon Bruce Fund
1964.21.1

Gian Antonio Guardi and Francesco Guardi
VENETIAN, 1698 or 1699 – 1760; 1712 – 1793
Erminia and the Shepherds, 1750/1755
Canvas, 2.515 x 4.422 (99 x 174 1/8)
Ailsa Mellon Bruce Fund
1964.21.2

Guercino
BOLOGNESE, 1591 – 1666
Cardinal Francesco Cennini, c. 1625
Canvas, 1.174 x .962 (46 1/4 x 37 7/8)
Samuel H. Kress Collection
1961.9.20

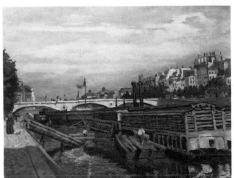

Jean-Baptiste-Armand Guillaumin
FRENCH, 1841 – 1927
The Bridge of Louis Philippe, 1875
Canvas, .458 x .605 (18 x 23 3/4)
Inscribed at lower left: *Guillaumin / 75*
Chester Dale Collection
1963.10.155

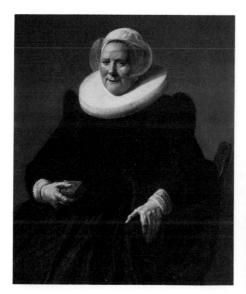

Frans Hals
DUTCH, c. 1580 – 1666
Portrait of an Elderly Lady, 1633
Canvas, 1.030 x .864 (40 1/4 x 34)
Inscribed at center left: AETAT SVAE 60 /
AN° 1633
Andrew W. Mellon Collection
1937.1.67

Frans Hals
DUTCH, c. 1580 – 1666
Portrait of an Officer, c. 1640
Canvas, .857 x .686 (33 3/4 x 27)
Andrew W. Mellon Collection
1937.1.68

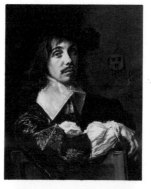

Frans Hals
DUTCH, c. 1580 – 1666
Willem Coymans, 1645
Canvas, .768 x .635 (30 1/4 x 25)
Inscribed at center right: AETA SVAE .22
(last 2 changed to 6)
Andrew W. Mellon Collection
1937.1.69

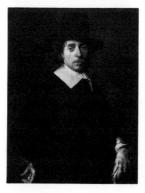

Frans Hals
DUTCH, c. 1580 – 1666
Adriaen van Ostade, c. 1650/1652
Canvas, .940 x .749 (37 x 29 1/2)
Andrew W. Mellon Collection
1937.1.70

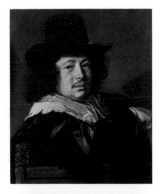

Frans Hals
DUTCH, c. 1580 – 1666
Portrait of a Young Man, c. 1645
Canvas, .683 x .556 (26 7/8 x 21 7/8)
Inscribed at center right with double
monogram: FHFH
Andrew W. Mellon Collection
1937.1.71

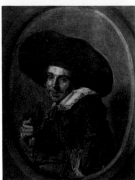

Frans Hals
DUTCH, c. 1580 – 1666
A Young Man in a Large Hat,
c. 1628/1630
Wood, .292 x .232 (11 1/2 x 9 1/8)
Andrew W. Mellon Collection
1940.1.12

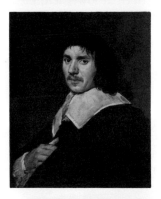

Frans Hals
DUTCH, c. 1580 – 1666
Portrait of a Man, c. 1655/1660
Canvas, .635 x .535 (25 x 21)
Inscribed at lower left in monogram: FH
Widener Collection
1942.9.28

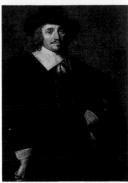

Frans Hals
DUTCH, c. 1580 – 1666
Portrait of a Gentleman, c. 1650/1652
Canvas, 1.143 x .851 (45 x 33 1/2)
Widener Collection
1942.9.29

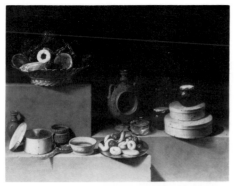

Juan van der Hamen y León
SPANISH, 1596 – 1631
Still Life, 1627
Canvas, .842 x 1.128 (33 1/8 x 44 3/8)
Inscribed at lower right: *Ju^{an} vanderHamen i Leon / fa^t 1627*
Samuel H. Kress Collection
1961.9.75

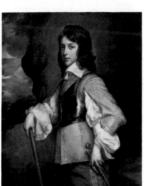

Adriaen Hanneman
DUTCH, probably 1604 – 1671
Henry, Duke of Gloucester, c. 1653
Canvas, 1.048 x .870 (41 1/4 x 34 1/4)
Andrew W. Mellon Collection
1937.1.51

Henri-Joseph Harpignies
FRENCH, 1819 – 1916
Landscape, 1898
Canvas, .502 x .616 (19 3/4 x 24 1/8)
Inscribed at lower left: *hiharpignies. 98*
Gift of R. Horace Gallatin
1949.1.7

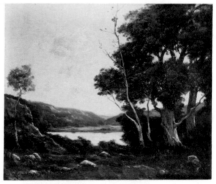

Hans Hartung
FRENCH, b. 1904
Composition, 1952
Canvas, 1.000 x .238 (39 3/8 x 9 3/8)
Inscribed at lower left: *Hartung 52*
Gift of Mr. and Mrs. Burton Tremaine
1971.87.3

Hans Hartung
FRENCH, b. 1904
T.51.6, 1951
Canvas, .970 x 1.463 (38 1/4 x 57 5/8)
Inscribed at lower left: *Hartung 51*
Gift of Mr. and Mrs. Morton G. Neumann
1981.85.1

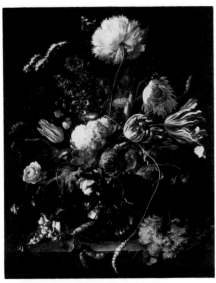

Jan Davidsz. de Heem
DUTCH, 1606 – 1683 or 1684
Vase of Flowers, c. 1645
Canvas, .696 x .565 (27 3/8 x 22 1/4)
Inscribed at lower left on parapet: *J.D. De Heem f.*
Andrew W. Mellon Fund
1961.6.1

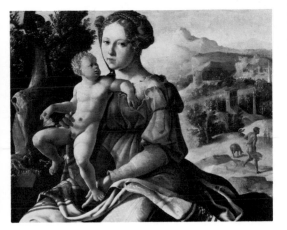

Maerten van Heemskerck
NORTH NETHERLANDISH, 1498 – 1574
The Rest on the Flight into Egypt, c. 1530
Wood, .577 x .747 (22 3/4 x 29)
Samuel H. Kress Collection
1961.9.36

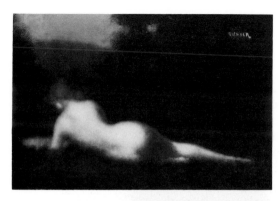

Jean-Jacques Henner
FRENCH, 1829 – 1905
Reclining Nude
Canvas, .274 x .415 (10 3/4 x 16 3/8)
Inscribed at upper right: HENNER
Timken Collection
1960.6.22

Jean-Jacques Henner
FRENCH, 1829 – 1905
Alsatian Girl, 1873
Wood, .272 x .187 (10 3/4 x 7 3/8)
Inscribed at upper left: 1873; at upper
right: J J HENNER
Chester Dale Collection
1963.10.32

Jean-Jacques Henner
FRENCH, 1829 – 1905
Madame Uhring, 1890
Wood, .273 x .187 (10 3/4 x 7 3/8)
Chester Dale Collection
1963.10.33

John Frederick Herring
BRITISH, 1795 – 1865
Horses (not illustrated)
Canvas, .405 x .410 (16 x 16 1/8)
Timken Collection
1960.6.23

Jan van der Heyden
DUTCH, 1637 – 1712
An Architectural Fantasy, c. 1670
Wood, .496 x .705 (19 1/2 x 27 3/4)
Ailsa Mellon Bruce Fund
1968.13.1

Joseph Highmore
BRITISH, 1692 – 1780
A Scholar of Merton College, Oxford,
c. 1750
Canvas, 1.277 x 1.021 (50 1/8 x 40 1/8)
Gift of Mrs. Richard Southgate
1951.7.1

Meindert Hobbema
DUTCH, 1638 – 1709
A Farm in the Sunlight, 1660/1670
Canvas, .813 x .657 (32 x 25 7/8)
Andrew W. Mellon Collection
1937.1.60

Meindert Hobbema
DUTCH, 1638 – 1709
A Wooded Landscape, 1663
Canvas, .953 x 1.305 (37 1/2 x 51 3/8)
Inscribed at lower right: *meÿndert;*
hobbema; / fc 1663
Andrew W. Mellon Collection
1937.1.61

Meindert Hobbema
DUTCH, 1638 – 1709
A View on a High Road, 1665
Canvas, .934 x 1.283 (36 3/4 x 50 1/2)
Inscribed at lower left: *m. hobbema. / 1665*
Andrew W. Mellon Collection
1937.1.62

Meindert Hobbema
DUTCH, 1638 – 1709
Hut Among Trees, c. 1665
Canvas, .965 x 1.080 (38 x 42 1/2)
Inscribed at lower left: *m. hobbema.*
Widener Collection
1942.9.30

Meindert Hobbema
DUTCH, 1638 – 1709
The Travelers, 1663
Canvas, 1.013 x 1.448 (39 7/8 x 57)
Inscribed at lower right: *m. hobbema. fc*
1663
Widener Collection
1942.9.31

Meindert Hobbema
DUTCH, 1638 – 1709
Village near a Pool, c. 1665
Canvas, .813 x 1.067 (32 x 42)
Widener Collection
1942.9.32

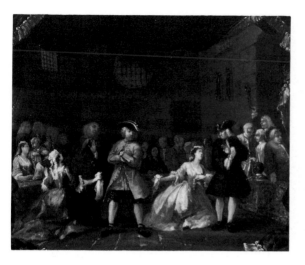

William Hogarth
BRITISH, 1697 – 1764
A Scene from The Beggar's Opera, c. 1728
Canvas, .511 x .612 (20 1/8 x 24 1/8)
Paul Mellon Collection
1983.1.42

Hans Holbein, the Younger
GERMAN, 1497 – 1543
Edward VI as a Child, probably 1538
Wood, .568 x .441 (22 3/8 x 17 3/8)
Inscribed across bottom: PARVVLE
PATRISSA, PATRIAE VIRTVTIS ET HAERES /
ESTO, NIHIL MAIVS MAXIMVS ORBIS
HABET. / GNATVM VIX POSSVNT COELVM ET
NATVRA DEDISSE, / HVIVS QVEM PATRIS,
VICTVS HONORET HONOS. / AEQVATO
TANTVM, TANTI TV FACTA PARENTIS, / VOTA
HOMINVM, VIX QVO PROGREDIANTVR,
HABENT / VINCITO, VICISTI. QVOT REGES
PRISCVS ADORAT / ORBIS, NEC TE QVI
VINCERE POSSIT, ERIT.
Ricard: Morysini. Car.:
(Little one, emulate thy father and be the
heir of his virtue; the world contains
nothing greater. Heaven and earth could
scarcely produce a son whose glory would
surpass that of such a father. Do thou but
equal the deeds of thy parent and men can
ask no more. Shouldst thou surpass him,
Thou has outstript all kings the world has
revered in ages past.)
Andrew W. Mellon Collection
1937.1.64

Hans Holbein, the Younger
GERMAN, 1497 – 1543
Sir Brian Tuke, c. 1527
Wood, .492 x .387 (19 3/8 x 15 1/4)
Inscribed at lower left on folded paper:
NVNQVID NON PAVCITAS DIERVM / MEORVM
FINIETVR BREVI? (Are not the days of my
life few?) from Job 10:20; across top:
BRIANVS TVKE, MILES, AN° ETATIS SVAE,
L̅V̅I̅I̅; across center the sitter's motto:
.DROIT ET AVANT. (Upright and forward)
Andrew W. Mellon Collection
1937.1.65

Hans Holbein, the Younger
GERMAN, 1497 – 1543
Portrait of a Young Man, c. 1520
Wood, .219 x .170 (8 5/8 x 6 3/4)
Samuel H. Kress Collection
1961.9.21

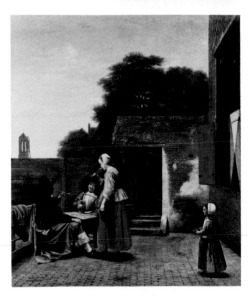

Pieter de Hooch
DUTCH, 1629 – 1684
A Dutch Courtyard, c. 1660
Canvas, .680 x .584 (26 3/4 x 23)
Andrew W. Mellon Collection
1937.1.56

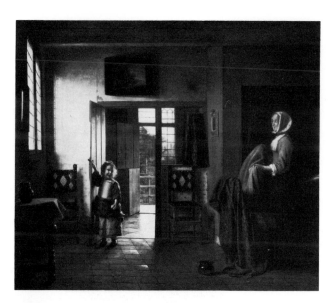

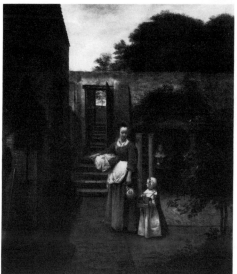

Pieter de Hooch
DUTCH, 1629 – 1684
The Bedroom, c. 1660
Canvas, .505 X .597 (20 X 23 1/2)
Widener Collection
1942.9.33

Pieter de Hooch
DUTCH, 1629 – 1684
Woman and Child in a Courtyard, c. 1660
Canvas, .735 X .660 (29 X 26)
Inscribed at lower left on trough: P. D
HOOCH
Widener Collection
1942.9.34

John Hoppner
BRITISH, 1758 – 1810
The Frankland Sisters, 1795
Canvas, 1.549 X 1.251 (61 X 49 1/4)
Inscribed at lower left by later hand:
MARIANNE & AMELIA / DAUGHTERS OF SIR T.
FRANKLAND OB 1795 & 1800; at lower right:
HOPNER
Andrew W. Mellon Collection
1937.1.111

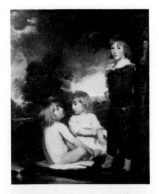

John Hoppner
BRITISH, 1758 – 1810
The Hoppner Children, c. 1790
Canvas, 1.525 x 1.270 (60 x 50)
Widener Collection
1942.9.35

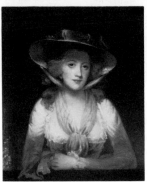

John Hoppner
BRITISH, 1758 – 1810
Lady Harriet Cunliffe, 1782
Canvas, .767 x .640 (30 1/4 x 25 1/4)
Gift of Josephine Tompkins
1979.65.1

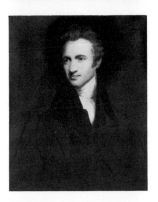

Attributed to John Hoppner
BRITISH, 1758 – 1810
Portrait of a Man, 1790/1800
Canvas, .765 x .633 (30 1/8 x 24 7/8)
Gift of Howard Sturges
1956.9.3

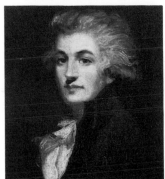

Style of John Hoppner
BRITISH
Portrait of a Man, c. 1785
Canvas, .206 x .153 (8 1/8 x 6)
Ailsa Mellon Bruce Collection
1970.17.106

Jan van Huysum
DUTCH, 1682 – 1749
Flowers in an Urn, c. 1720
Wood, .799 x .600 (31 3/8 x 23 5/8)
Inscribed at lower left: *Jan Van Huysum
fecit*
Adolph Caspar Miller Fund
1977.7.1

Jean-Auguste-Dominique Ingres
FRENCH, 1780 – 1867
Madame Moitessier, 1851
Canvas, 1.467 x 1.003 (57 3/4 x 39 1/2)
Inscribed at center left: I.A.D. INGRES P.XIT
AN° 1851; at upper right: M.E INES
MOITESSIER / NÈE [sic] DE FOUCAULD
Samuel H. Kress Collection
1946.7.18

Jean-Auguste-Dominique Ingres
FRENCH, 1780 – 1867
Pope Pius VII in the Sistine Chapel, 1810
Canvas, .745 x .927 (29 1/4 x 36 1/2)
Inscribed at lower right: *Ingres 1810 /* ROM.
Samuel H. Kress Collection
1952.2.23

Jean-Auguste-Dominique Ingres
FRENCH, 1780 – 1867
Monsieur Marcotte, 1810
Canvas, .935 x .693 (36 3/4 x 27 1/4)
Inscribed at lower right: *Ingres.Pinx.Rom. /
1810*
Samuel H. Kress Collection
1952.2.24

Jean-Auguste-Dominique Ingres
FRENCH, 1780 – 1867
Ulysses, c. 1827
Canvas on wood, .249 x .185 (9 3/4 x
7 1/4)
Inscribed at lower right: *Ingres.*
Chester Dale Collection
1963.10.34

Adriaen Isenbrant
BRUGES, active 1510 – 1551
The Adoration of the Shepherds,
probably 1520/1540
Wood, .746 x .570 (29 7/16 x 22 7/16)
Inscribed at center right at base of
ornament on square column at right: N21
Ailsa Mellon Bruce Fund
1978.46.1

Alexej von Jawlensky
RUSSIAN, 1864 – 1941
Easter Sunday, 1932
Hardboard, .349 x .254 (13 3/4 x 10)
Inscribed at lower left: *A. J.;* on reverse: *A.
Jawlensky / A.K. 27 Ostersonntag / 1932 /
34.4 x 24.8*
Gift of Virginia Steele Scott
1973.2.1

Alexej von Jawlensky
RUSSIAN, 1864 – 1941
Murnau, 1910
Hardboard, .329 x .423 (13 x 16 5/8)
Inscribed at lower right: *A. Jawlensky*
Gift of Mr. and Mrs. Ralph F. Colin
1973.69.1

Augustus John
BRITISH, 1878 – 1961
Mrs. Alexander H. McLanahan, c. 1927
Canvas, 1.220 x .915 (48 x 36)
Inscribed at lower right: *John*
Gift of Mrs. Alexander H. McLanahan
1970.18.1

Jacob Jordaens
FLEMISH, 1593 – 1678
Portrait of a Man, c. 1624
Wood, 1.055 x .735 (41 1/2 x 29)
Ailsa Mellon Bruce Fund
1969.2.1

Juan de Flandes
HISPANO-FLEMISH, active 1496 – 1519
The Annunciation, c. 1510
Wood, painted surface: 1.102 x .784 (43 3/8
x 30 7/8); panel: 1.102 x .810 (43 3/8 x
31 7/8)
Samuel H. Kress Collection
1961.9.22

Juan de Flandes
HISPANO-FLEMISH, active 1496 – 1519
The Nativity, c. 1510
Wood, painted surface: 1.105 x .793
(43 1/2 x 31 1/4); panel: 1.118 x .806
(44 x 31 3/4)
Inscribed at upper right on angel's
banderole: GLOR/[I]A...INECELSIS DEO
ED.../...
Samuel H. Kress Collection
1961.9.23

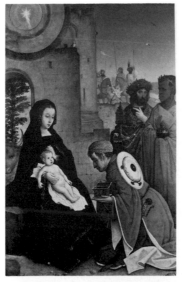

Juan de Flandes
HISPANO-FLEMISH, active 1496 – 1519
The Adoration of the Magi, c. 1510
Wood, painted surface: 1.247 x .790
(49 1/8 x 31 1/8); panel: 1.261 x .826
(49 5/8 x 32 1/2)
Samuel H. Kress Collection
1961.9.24

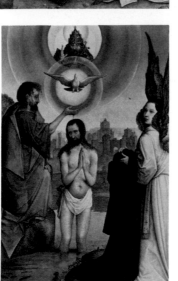

Juan de Flandes
HISPANO-FLEMISH, active 1496 – 1519
The Baptism of Christ, c. 1510
Wood, painted surface: 1.242 x .790 (49 x
31 1/16); panel: 1.253 x .811 (49 3/8 x
31 7/8)
Samuel H. Kress Collection
1961.9.25

Juan de Flandes
HISPANO-FLEMISH, active 1496 – 1519
The Temptation of Christ, c. 1500/1504
Wood, painted surface: .210 x .155 (8 1/4
x 6 1/8); panel: .213 x .160 (8 3/8 x 6 5/16)
Ailsa Mellon Bruce Fund
1967.7.1

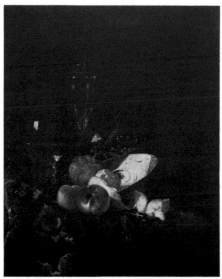

Willem Kalf
DUTCH, 1619 – 1693
Still Life, probably c. 1665
Canvas, .645 x .540 (25 3/8 x 21 1/4)
Chester Dale Collection
1943.7.8

Willem Kalf
DUTCH, 1619 – 1693
Still Life with Nautilus Cup
Canvas, .682 x .580 (26 7/8 x 22 7/8)
Inscribed at lower left on edge of table:
W.Kalf.
Gift of Robert H. and Clarice Smith
1974.109.1

Wassily Kandinsky
RUSSIAN, 1866 – 1944
Improvisation 31 (Sea Battle), 1913
Canvas, 1.451 x 1.197 (55 3/8 x 47 1/8)
Ailsa Mellon Bruce Fund
1978.48.1

Angelica Kauffmann
SWISS, 1741 – 1807
Franciska Krasinska, Duchess of Courland,
c. 1785
Canvas, painted oval, .629 x .495 (24 3/4
x 19 1/2)
Gift of Miss Alice Preston
1954.5.1

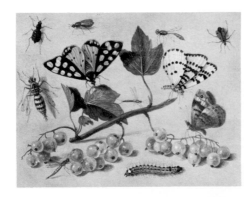

Jan van Kessel
FLEMISH, 1626 − 1679
Study of Butterflies and Insects, c. 1655
Copper, .110 x .148 (4 5/16 x 5 13/16)
Gift of John Dimick
1983.19.3

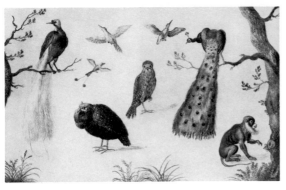

Attributed to Jan van Kessel
FLEMISH, 1626 − 1679
Study of Birds and Monkey, 1660/1670
Copper, .105 x .173 (4 1/8 x 6 13/16)
Gift of John Dimick
1983.19.1

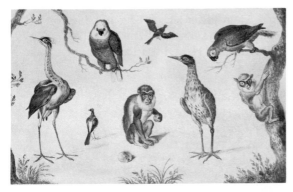

Attributed to Jan van Kessel
FLEMISH, 1626 − 1679
Study of Birds and Monkeys, 1660/1670
Copper, .104 x .172 (4 1/16 x 6 3/4)
Gift of John Dimick
1983.19.2

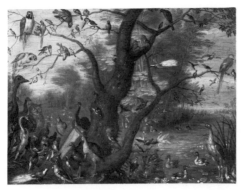

Attributed to Jan van Kessel
FLEMISH, 1626 − 1679
Concert of Birds, 1660/1670
Copper, .130 x .180 (5 1/8 x 7 1/16)
Gift of John Dimick
1983.19.4

Joseph Bartholomew Kidd after John James Audubon
BRITISH, probably 1808 – 1889
Sharp-Tailed Sparrow, 1832/1833
Millboard, .483 x .299 (19 x 11 3/4)
Gift of E. J. L. Hallstrom
1951.9.5

Joseph Bartholomew Kidd after John James Audubon
BRITISH, probably 1808 – 1889
Black-Backed Three-Toed Woodpecker,
1832/1833
Canvas, .667 x .524 (26 1/4 x 20 5/8)
Gift of E. J. L. Hallstrom
1951.9.6

Joseph Bartholomew Kidd after John James Audubon
BRITISH, probably 1808 – 1889
Orchard Oriole, 1831
Canvas, .664 x .521 (26 1/8 x 20 1/2)
Gift of E. J. L. Hallstrom
1951.9.7

Joseph Bartholomew Kidd after John James Audubon
BRITISH, probably 1808 – 1889
Yellow Warbler, 1831/1832
Millboard, .482 x .297 (19 x 11 3/4)
Gift of E. J. L. Hallstrom
1951.9.8

Ernst Ludwig Kirchner
GERMAN, 1880 – 1938
Two Nudes, 1907
Canvas, 1.961 x .654 (77 1/4 x 25 3/4)
Anonymous Gift
1979.66.1.a-b

Paul Klee
SWISS, 1879 – 1940
The White House
Gouache on canvas, .364 x .464 (14 3/8 x
18 1/4)
Collection of Mr. and Mrs. Paul Mellon
1983.1.22

Gustav Klimt
AUSTRIAN, 1862 – 1918
Baby (Cradle), 1917/1918
Canvas, 1.109 x 1.104 (43 5/8 x 43 1/2)
Gift of Otto and Franciska Kallir with the
help of the Carol and Edwin Gaines
Fullinwider Fund
1978.41.1

Johann Koerbecke
GERMAN, possibly 1407 – 1491
The Ascension, 1457
Wood, .926 x .648 (36 1/2 x 25 1/2)
Samuel H. Kress Collection
1959.9.5

Philip van Kouwenbergh
DUTCH, 1669 or 1770 – 1729
Flowers in a Vase
Canvas, .673 x .505 (26 1/2 x 19 7/8)
Inscribed at lower right: *[P] Kouwe..be...h*
Gift of Mr. and Mrs. William Draper Blair
1976.26.2

Nicolaus Kremer
GERMAN, C. 1500 – 1553
Portrait of a Nobleman, 1529
Wood, .599 x .445 (23 1/2 x 17 3/8)
Inscribed at upper left: 1529 / ·NK·
Ralph and Mary Booth Collection
1947.6.3

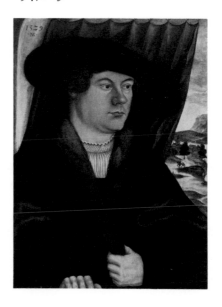

František Kupka
Czechoslovakian, 1871 – 1957
Organization of Graphic Motifs II, 1912/
1913
Canvas, 2.000 x 1.940 (78 3/4 x 76 3/8)
Inscribed at lower left: *Kupka*
Ailsa Mellon Bruce Fund and gift of Jan
and Meda Mladek
1984.51.1

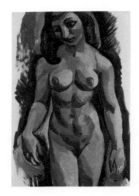

Roger de La Fresnaye
FRENCH, 1885 – 1925
Nude, 1910
Cardboard, .872 x .620 (34 3/8 x 24 3/8)
Inscribed at lower right: *RdelaFresnaye /
1910*
Chester Dale Collection
1963.10.75

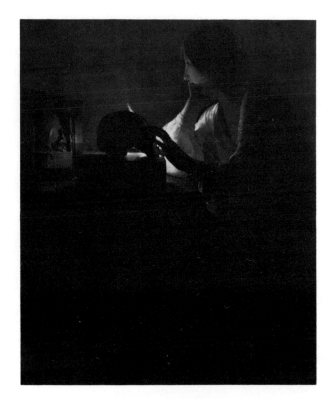

Georges du Mesnil de La Tour
FRENCH, 1593 – 1652
The Repentant Magdalene, c. 1640
Canvas, 1.130 x .927 (44 1/2 x 36 1/2)
Ailsa Mellon Bruce Fund
1974.52.1

Maurice-Quentin de La Tour
FRENCH, 1704 – 1788
Claude Dupouch, probably 1739
Pastel on paper, .594 x .494 (23 3/8 x
19 3/8)
Samuel H. Kress Collection
1961.9.76

Nicolas Lancret
FRENCH, 1690 – 1743
La Camargo Dancing, c. 1730
Canvas, .762 x 1.067 (30 x 42)
Andrew W. Mellon Collection
1937.1.89

Nicolas Lancret
FRENCH, 1690 – 1743
The Picnic after the Hunt,
probably c. 1740
Canvas, .615 x .748 (24 1/8 x 29 3/8)
Samuel H. Kress Collection
1952.2.22

Nicolas de Largillière
FRENCH, 1656 – 1746
A Young Man with His Tutor, 1685
Canvas, 1.460 x 1.148 (57 1/2 x 45 1/8)
Inscribed at lower right: *N. De /*
Largillierre / F. 1685.
Samuel H. Kress Collection
1961.9.26

Nicolas de Largillière
FRENCH, 1656 – 1746
Elizabeth Throckmorton, 1729
Canvas, .813 x .657 (32 x 25 7/8)
Inscribed across top: ELIZABETH DAUGHTER
OF S^R ROB^T THROCKMORTON BAR^T on
reverse: *peint par N de Largillierre / 1729*
Ailsa Mellon Bruce Fund
1964.20.1

Marie Laurencin
FRENCH, 1885 – 1956
Girl with a Dove, 1928
Canvas, .463 x .384 (18 1/4 x 15 1/8)
Inscribed at lower left: *Marie Laurencin /
1928*
Chester Dale Collection
1963.10.35

Marie Laurencın
FRENCH, 1885 – 1956
In the Park, 1924
Canvas, .921 x .654 (36 1/4 x 25 3/4)
Inscribed at lower right: *Marie Laurencin /
1924*
Chester Dale Collection
1963.10.158

Sir Thomas Lawrence
BRITISH, 1769 – 1830
Lady Templetown and Her Son, c. 1801
Canvas, 2.153 x 1.489 (84 3/4 x 58 5/8)
Andrew W. Mellon Collection
1937.1.96

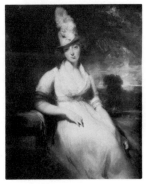

Sir Thomas Lawrence
BRITISH, 1769 – 1830
Lady Robinson, c. 1827
Canvas, 1.270 x 1.015 (50 x 40)
Widener Collection
1942.9.37

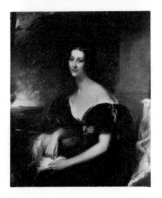

Sir Thomas Lawrence
BRITISH, 1769 – 1830
Marquis of Hertford, c. 1825
Canvas, 1.285 x 1.022 (50 5/8 x 40 1/4)
Gift of G. Grant Mason, Jr.
1968.6.2

Follower of Sir Thomas Lawrence
BRITISH
Portrait of a Lady, c. 1828/1830
Canvas, 1.263 x 1.020 (49 3/4 x 40 1/8)
Gift of G. Grant Mason, Jr.
1968.6.1

Fernand Léger
FRENCH, 1881 – 1955
Maud Dale, 1935
Canvas, 1.004 x .797 (41 1/4 x 31 3/8)
Inscribed on reverse at upper left:
F. LEGER. / N.Y.35
Chester Dale Collection
1963.10.36

Fernand Léger
FRENCH, 1881 – 1955
Woman with a Mirror, 1929
Canvas, .924 x .600 (36 3/8 x 23 5/8)
Inscribed at lower right: F.LEGER.29
Chester Dale Collection
1963.10.159

Alphonse Legros
FRENCH, 1837 – 1911
Portrait of an Old Man
Canvas, .467 x .385 (18 3/8 x 15 1/8)
Inscribed at upper left: A.L.
George Matthew Adams Collection
1947.19.1

Alphonse Legros
FRENCH, 1837 – 1911
Head of a Man with Upturned Eyes
Canvas, .405 x .287 (16 x 11 1/8)
Inscribed at center right: A. L.
Gift of George Matthew Adams in memory
of his mother, Lydia Havens Adams
1949.13.1

Alphonse Legros
FRENCH, 1837 – 1911
Memory Copy of Holbein's Erasmus
Wood, .445 x .394 (17 1/2 x 15 1/2)
George Matthew Adams Collection
1956.14.1

Alphonse Legros
FRENCH, 1837 – 1911
Hampstead Heath
Canvas, .404 x .611 (15 7/8 x 24)
Inscribed at lower right: A.L.
George Matthew Adams Collection
1963.1.1

Alphonse Legros
FRENCH, 1837 – 1911
Portrait of a Woman, 1875
Canvas, .534 x .438 (21 x 17 1/4)
Inscribed at upper right: *A. Legros / 1875*
George Matthew Adams Collection
1963.1.2

Sir Peter Lely
BRITISH, 1618 – 1680
Barbara Villiers, Duchess of Cleveland,
c. 1662
Canvas, 1.261 x 1.015 (49 5/8 x 40)
Timken Collection
1960.6.26

Louis Le Nain
FRENCH, 1593 – 1648
Landscape with Peasants, c. 1640
Canvas, .465 x .570 (18 3/8 x 22 1/2)
Samuel H. Kress Collection
1946.7.11

Louis Le Nain
FRENCH, 1593 – 1648
A French Interior, c. 1645
Canvas, .556 x .647 (21 7/8 x 25 3/8)
Samuel H. Kress Collection
1952.2.20

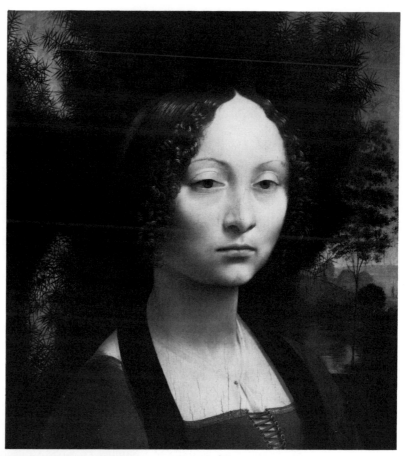

Leonardo da Vinci
FLORENTINE, 1452 – 1519
Ginevra de' Benci, c. 1474
Wood, obverse: .388 x .367 (15 1/4 x
14 1/2); reverse: .382 x .367 (15 x 14 1/2)
Inscribed on reverse across bottom on
scroll, the beginning of a hexameter:
VIRTVTEM FOR/MA DECORAT (She adorns
her virtue with beauty)
Ailsa Mellon Bruce Fund
1967.6.1.a-b

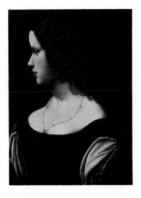

Studio of Leonardo da Vinci
FLORENTINE
Portrait of a Young Lady, early 16th
century
Transferred from wood to hardboard, .473
x .343 (18 5/8 x 13 1/2)
Samuel H. Kress Collection
1952.5.66

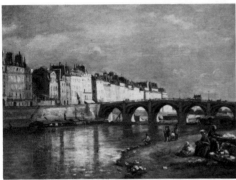

Stanislas Victor Edouard Lépine
FRENCH, 1835 – 1892
Pont de la Tournelle, Paris, 1862
Canvas, .402 x .551 (15 7/8 x 21 3/4)
Inscribed at lower right: *S. Lépine – 62.*
Ailsa Mellon Bruce Collection
1970.17.35

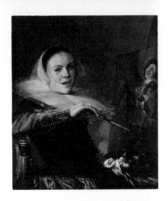

Judith Leyster
DUTCH, 1609 – 1660
Self-Portrait, c. 1635
Canvas, .723 x .653 (29 3/8 x 25 5/8)
Gift of Mr. and Mrs. Robert Woods Bliss
1949.6.1

Jacques Lipchitz
FRENCH, 1891 – 1973
Still Life, 1918
Canvas, .550 x .331 (21 5/8 x 13)
Inscribed at upper left: *J. Lipchitz*
Gift of Mr. and Mrs. Burton Tremaine
1973.71.1

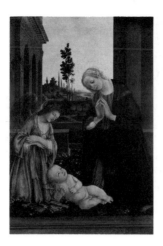

Filippino Lippi
FLORENTINE, C. 1457 – 1504
The Adoration of the Child, c. 1480
Wood, .813 x .563 (32 x 22 1/8)
Andrew W. Mellon Collection
1937.1.18

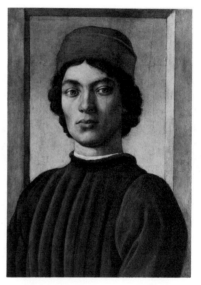

Filippino Lippi
FLORENTINE, C. 1457 – 1504
Portrait of a Youth, c. 1485
Wood, .510 x .355 (20 x 13 7/8)
Andrew W. Mellon Collection
1937.1.20

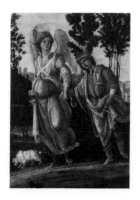

Filippino Lippi
FLORENTINE, C. 1457 – 1504
Tobias and the Angel, probably c. 1480
Wood, .325 x .235 (12 7/8 x 9 1/4)
Samuel H. Kress Collection
1939.1.229

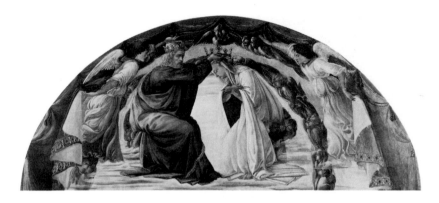

Filippino Lippi
FLORENTINE, C. 1457 – 1504
The Coronation of the Virgin, c. 1480
Wood, .902 x 2.223 (35 1/2 x 87 1/2)
Samuel H. Kress Collection
1943.4.36

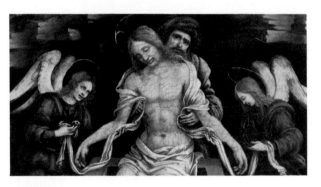

Filippino Lippi
FLORENTINE, C. 1457 – 1504
Pietà, c. 1490
Wood, .175 x .337 (6 7/8 x 13 1/4)
Samuel H. Kress Collection
1952.5.86

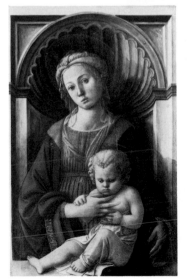

Filippo Lippi
FLORENTINE, C. 1406 – 1469
Madonna and Child, 1440/1445
Wood, .797 x .511 (31 3/8 x 20 1/8)
Samuel H. Kress Collection
1939.1.290

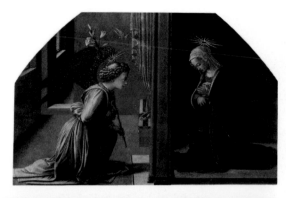

Filippo Lippi
FLORENTINE, C. 1406 – 1469
The Annunciation, probably after 1440
Wood, 1.029 x 1.626 (40 1/2 x 64)
Samuel H. Kress Collection
1943.4.35

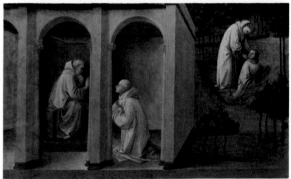

Filippo Lippi
FLORENTINE, C. 1406 – 1469
*Saint Benedict Orders Saint Maurus to the
Rescue of Saint Placidus*, c. 1445
Wood, .416 x .711 (16 3/8 x 28)
Samuel H. Kress Collection
1952.5.10

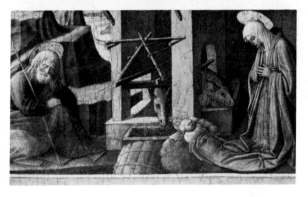

Filippo Lippi and Workshop
FLORENTINE, C. 1406 – 1469
The Nativity, probably c. 1445
Wood, .234 x .538 (9 1/2 x 21 1/8)
Samuel H. Kress Collection
1939.1.279

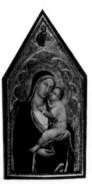

Lippo Memmi
SIENESE, active 1317 – 1347
Madonna and Child with Donor,
probably c. 1335
Wood, .565 x .241 (22 1/4 x 9 1/2)
Andrew W. Mellon Collection
1937.1.11

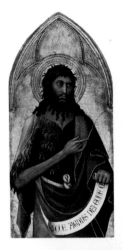

Lippo Memmi
SIENESE, active 1317 – 1347
Saint John the Baptist, probably c. 1325
Wood, .946 x .457 (37 1/4 x 18)
Inscribed at lower right on scroll: ECCE
AGNUS DEI·ECCE Q[UI] (Behold the Lamb of
God; behold Him who [taketh away the
sins of the world]) from John 1:29
Samuel H. Kress Collection
1939.1.291

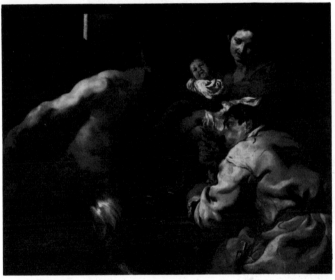

Johann Liss
GERMAN, c. 1597 – before 1630
The Satyr and the Peasant,
probably c. 1620
Canvas, 1.335 x 1.665 (52 1/2 x 65 1/2)
Widener Collection
1942.9.39

Follower of Alessandro Longhi
VENETIAN
Portrait of a Man
Canvas, .762 x .609 (30 x 24)
Gift of Mrs. S. W. DuBois
1946.13.1

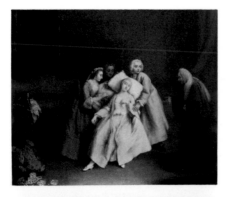

Pietro Longhi
VENETIAN, 1702 – 1785
The Simulated Faint, c. 1745
Canvas, .489 x .610 (19 1/4 x 24)
Samuel H. Kress Collection
1939.1.63

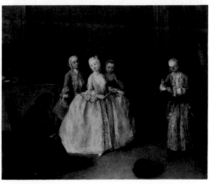

Pietro Longhi
VENETIAN, 1702 – 1785
Blindman's Buff, c. 1745
Canvas, .489 x .610 (19 1/4 x 24)
Samuel H. Kress Collection
1939.1.64

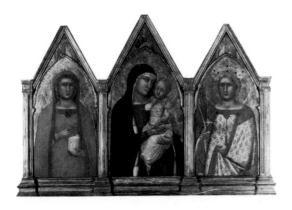

Pietro Lorenzetti
SIENESE, active c. 1306 – probably 1348
*Madonna and Child with Saint Mary
Magdalene and Saint Catherine,*
c. 1330/1340
Transferred from wood to canvas, middle
panel: 1.105 x .591 (43 1/2 x 23 1/4); side
panels, each: 1.016 x .495 (40 x
19 1/2)
Inscribed across bottom on a fragment of
the old frame set into the new frame
(nearly indecipherable): [PETR]US
LAURENTII DESENIS M[E] PĪXIT [AÑ] DŃI
MCCCXXI (date uncertain)
Gift of Frieda Schiff Warburg in memory
of her husband Felix M. Warburg
1941.5.1.a-c

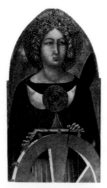

"Ugolino Lorenzetti"
SIENESE, active c. 1320 – 1360
Saint Catherine of Alexandria,
probably c. 1335
Wood, .737 x .419 (29 x 16 1/2)
Inscribed at center on morse: S KATERINA
Samuel H. Kress Collection
1943.4.20

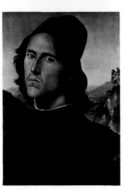

Lorenzo di Credi
FLORENTINE, C. 1458 – 1537
Self-Portrait, 1488
Transferred from wood to canvas, .460 x
.325 (18 x 12 3/4)
Inscribed on reverse: LORENZO DI *Credi
Pittore ecc^{mo}* MCCCCLXXXVIII AETATIS SVE
XXXII ME VIII (Lorenzo di Credi, most
excellent painter, 1488, age 32 years, 8
months)
Widener Collection
1942.9.38

Lorenzo Monaco
FLORENTINE, 1370/1371 – after 1422
Madonna and Child, 1413
Wood, 1.168 x .553 (46 x 21 3/4)
Inscribed at center on the Child's scroll:
EGO S[VM LV]X M[VNDI] (I am the light of
the world) from John 8:12; across bottom:
...ANO MCCCCXIII
Samuel H. Kress Collection
1943.4.13

Lorenzo Lotto
VENETIAN, C. 1480 – 1556
Saint Catherine, 1522
Wood, .572 x .502 (22 1/2 x 19 3/4)
Inscribed at lower right on wheel:
Laurentius Lotus / 1522
Samuel H. Kress Collection
1939.1.117

Lorenzo Lotto
VENETIAN, C. 1480 – 1556
A Maiden's Dream, c. 1505
Wood, .429 x .337 (16 7/8 x 13 1/4)
Samuel H. Kress Collection
1939.1.147

Lorenzo Lotto
VENETIAN, C. 1480 – 1556
Allegory, 1505
Wood, .565 x .422 (22 1/4 x 16 5/8)
Formerly inscribed on reverse: BERNARD.
RVBEVS / BERCETI COM. PONT / TARVIS.
NAT. / ANN. XXXVI. MENS. X.D.V. / LAVRENT.
LOTVS P. CAL. / IVL. M.D.V (Bernardo Rossi
of Berceto, Papal Count [Bishop] of
Treviso, age 36 years, 10 months, 5 days.
Painted by Lorenzo Lotto, July 1, 1505)
Samuel H. Kress Collection
1939.1.156

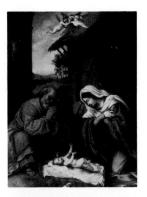

Lorenzo Lotto
VENETIAN, C. 1480 – 1556
The Nativity, 1523
Wood, .460 x .359 (18 1/8 x 14 1/8)
Inscribed at lower right: *L. Lotus.* / *1523*
Samuel H. Kress Collection
1939.1.288

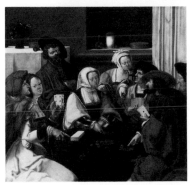

After Lucas van Leyden
NORTH NETHERLANDISH
The Card Players, probably c. 1550/1599
Wood, .552 x .609 (21 3/4 x 24)
Samuel H. Kress Collection
1961.9.27

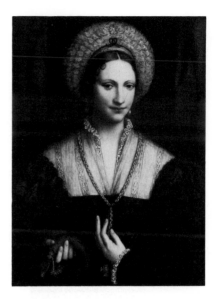

Bernardino Luini
MILANESE, C. 1480 – 1532
Portrait of a Lady, c. 1520/1525
Wood, .770 x .575 (30 3/8 x 22 1/2)
Andrew W. Mellon Collection
1937.1.37

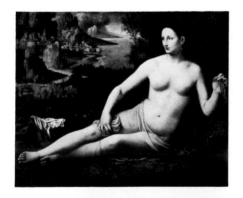

Bernardino Luini
MILANESE, C. 1480 – 1532
Venus, c. 1530
Wood, 1.067 x 1.359 (42 x 53 1/2)
Samuel H. Kress Collection
1939.1.120

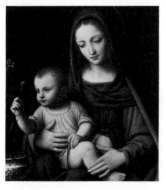

Bernardino Luini
MILANESE, C. 1480 – 1532
The Madonna of the Carnation, c. 1515
Wood, .438 x .403 (17 1/4 x 15 7/8)
Samuel H. Kress Collection
1939.1.152

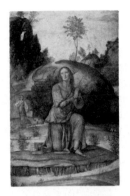

Bernardino Luini
MILANESE, C. 1480 – 1532
Procris' Prayer to Diana, c. 1522/1523
Transferred from fresco to canvas, 2.286 x
1.403 (90 x 55 1/4)
Samuel H. Kress Collection
1943.4.52

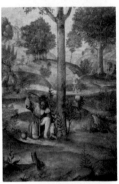

Bernardino Luini
MILANESE, C. 1480 – 1532
Cephalus Hiding the Jewels, c. 1522/1523
Transferred from fresco to canvas, 2.216 x
1.502 (87 1/4 x 59 1/8)
Samuel H. Kress Collection
1943.4.53

Bernardino Luini
MILANESE, C. 1480 – 1532
Cephalus and Pan at the Temple, c. 1522/
1523
Transferred from fresco to canvas, 2.260 x
1.035 (89 x 40 3/4)
Inscribed at center on entablature of
temple: VIRGINITAS
Samuel H. Kress Collection
1943.4.54

Bernardino Luini
MILANESE, C. 1480 – 1532
Cephalus at the Hunt, c. 1522/1523
Transferred from fresco to canvas, 2.114 x
1.103 (83 1/4 x 43 5/8)
Samuel H. Kress Collection
1943.4.55

Bernardino Luini
MILANESE, C. 1480 – 1532
Procris Pierced by Cephalus' Javelin,
c. 1522/1523
Transferred from fresco to canvas, 1.441 x
1.232 (56 3/4 x 48 1/2)
Samuel H. Kress Collection
1943.4.56

Bernardino Luini
MILANESE, C. 1480 – 1532
The Illusion of Cephalus, c. 1522/1523
Transferred from fresco to canvas, 2.280 x
1.245 (89 3/4 x 49)
Samuel H. Kress Collection
1943.4.57

Bernardino Luini
MILANESE, C. 1480 – 1532
The Despair of Cephalus, c. 1522/1523
Transferred from fresco to canvas, 1.819 x
1.184 (71 5/8 x 46 5/8)
Samuel H. Kress Collection
1943.4.58

Bernardino Luini
MILANESE, C. 1480 – 1532
The Misfortunes of Cephalus, c. 1522/1523
Transferred from fresco to canvas, 1.762 x
1.073 (69 3/8 x 42 1/4)
Samuel H. Kress Collection
1943.4.59

Bernardino Luini
MILANESE, C. 1480 – 1532
Procris and the Unicorn, c. 1522/1523
Transferred from fresco to canvas, 2.286 x
1.080 (90 x 42 1/2)
Samuel H. Kress Collection
1943.4.60

Bernardino Luini
MILANESE, C. 1480 – 1532
The Magdalene, c. 1525
Wood, .588 x .478 (23 1/8 x 18 7/8)
Samuel H. Kress Collection
1961.9.56

Madeleine Luka
FRENCH, b. 1900
Jean Pierre, du Pré Clos
Canvas, .494 x .391 (19 1/2 x 15 3/8)
Inscribed at lower right: *Madeleine Luka;*
on reverse: *Jean Pierre, du / Pré Clos ainsi
[...] il a l'age / de 18 mois, tenant /
beaucoup plus en ressemblance / de sa
bonne mere qui / ... son père leopold de /
Fermier Madeleine Luka / 28 Rue de Liege /
Paris*
Chester Dale Collection
1964.19.5

Jean Lurçat
FRENCH, 1892 – 1966
Chester Dale, 1928
Canvas, 1.447 x .962 (57 x 37 7/8)
Inscribed at lower left: *For Chester Dale /
his Friend / Lurçat / 28 / N.Y.*
Chester Dale Collection
1963.10.37

Jean Lurçat
FRENCH, 1892 – 1966
Maud Dale, 1928
Canvas, 1.192 x .711 (46 7/8 x 28)
Inscribed at lower right: *pour Madame
Maud Dale / en signe d'affection /
lurçat / 28*
Chester Dale Collection
1963.10.38

Jean Lurçat
FRENCH, 1892 – 1966
The Big Cloud, 1929
Canvas, .972 x 1.464 (38 1/4 x 57 5/8)
Inscribed at lower right: *Lurçat 29*
Chester Dale Collection
1963.10.160

Nicolaes Maes
DUTCH, 1632 or 1634 – 1693
An Old Woman Dozing over a Book,
c. 1655
Canvas, .822 x .670 (32 3/8 x 26 3/8)
Inscribed at upper right above keys:
N. MAES
Andrew W. Mellon Collection
1937.1.63

Alessandro Magnasco
GENOESE, probably 1667 – 1749
The Baptism of Christ, c. 1740
Canvas, 1.175 x 1.467 (46 1/4 x 57 3/4)
Samuel H. Kress Collection
1943.4.27

Alessandro Magnasco
GENOESE, probably 1667 – 1749
Christ at the Sea of Galilee, c. 1740
Canvas, 1.181 x 1.467 (46 1/2 x 57 3/4)
Samuel H. Kress Collection
1943.4.31

Alessandro Magnasco
GENOESE, probably 1667 – 1749
The Choristers
Canvas, .682 x .546 (26 7/8 x 21 1/2)
Gift of Emily Floyd Gardiner
1972.17.1

Edouard Manet
FRENCH, 1832 – 1883
The Dead Toreador, probably 1864
Canvas, .759 x 1.533 (29 7/8 x 60 3/8)
Inscribed at lower right: *Manet*
Widener Collection
1942.9.40

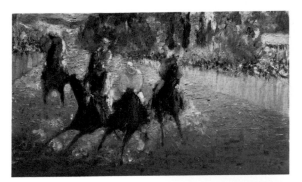

Edouard Manet
FRENCH, 1832 – 1883
At the Races, c. 1875
Wood, .125 x .215 (5 x 8 1/2)
Inscribed at lower right: *Manet*
Widener Collection
1942.9.41

Edouard Manet
FRENCH, 1832 – 1883
Portrait of a Lady, c. 1879
Wood, .150 x .115 (5 3/4 x 4 1/2)
Gift of Mrs. Charles S. Carstairs
1952.9.1

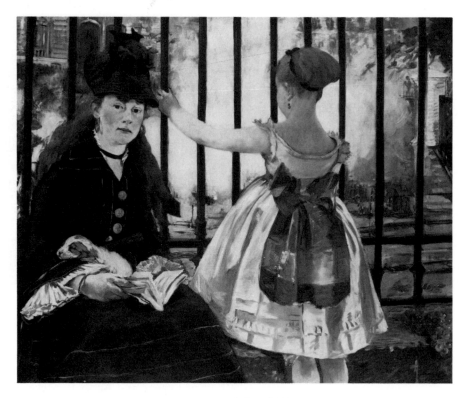

Edouard Manet
FRENCH, 1832 – 1883
Gare Saint-Lazare, 1873
Canvas, .933 x 1.115 (36 3/4 x 43 7/8)
Inscribed at lower right: *Manet / 1873*
Gift of Horace Havemeyer in memory of
his mother, Louisine W. Havemeyer
1956.10.1

Edouard Manet
FRENCH, 1832 – 1883
The Tragic Actor (Rouvière as Hamlet),
1866
Canvas, 1.872 x 1.081 (73 3/4 x 42 1/2)
Inscribed at lower right: *Manet*
Gift of Edith Stuyvesant Gerry
1959.3.1

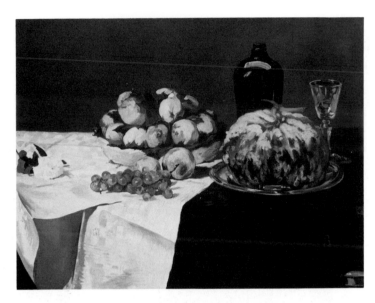

Edouard Manet
FRENCH, 1832 – 1883
Still Life with Melon and Peaches, c. 1866
Canvas, .690 x .922 (27 1/8 x 36 1/4)
Inscribed at lower right: *Manet*
Gift of Eugene and Agnes E. Meyer
1960.1.1

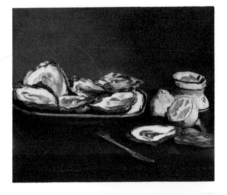

Edouard Manet
FRENCH, 1832 – 1883
Oysters, 1862
Canvas, .391 x .467 (15 3/8 x 18 3/8)
Inscribed at lower left: *Ed. Manet*
Gift of the Adele R. Levy Fund, Inc.
1962.3.1

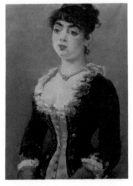

Edouard Manet
FRENCH, 1832 – 1883
Madame Michel-Lévy, 1882
Canvas, .744 x .510 (29 1/4 x 20 1/8)
Inscribed at lower left: *Manet / 1882*
Chester Dale Collection
1963.10.161

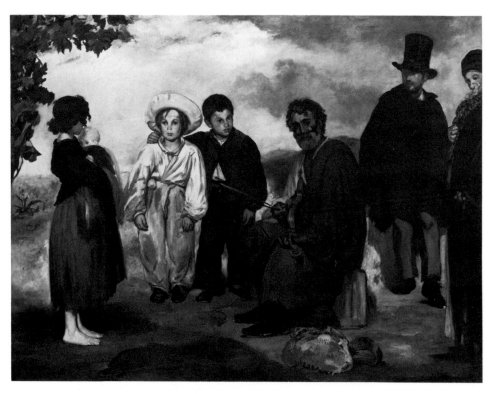

Edouard Manet
FRENCH, 1832 – 1883
The Old Musician, 1862
Canvas, 1.874 x 2.483 (73 3/4 x 97 3/4)
Inscribed at lower right: *éd. Manet 1862*
Chester Dale Collection
1963.10.162

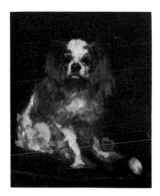

Edouard Manet
FRENCH, 1832 – 1883
A King Charles Spaniel, c. 1866
Canvas, .464 x .382 (18 1/4 x 15)
Inscribed at lower right: *éd. Manet*
Ailsa Mellon Bruce Collection
1970.17.36

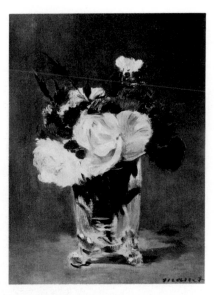

Edouard Manet
FRENCH, 1832 – 1883
Flowers in a Crystal Vase, c. 1882
Canvas, .326 x .243 (12 7/8 x 9 5/8)
Inscribed at lower right: *Manet*
Ailsa Mellon Bruce Collection
1970.17.37

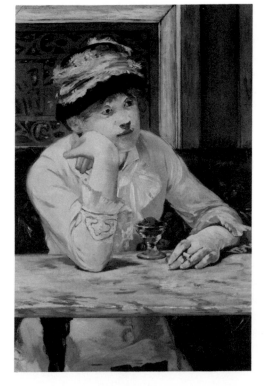

Edouard Manet
FRENCH, 1832 – 1883
The Plum, c. 1877
Canvas, .736 x .502 (29 x 19 3/4)
Inscribed at lower left on table: *manet*
Collection of Mr. and Mrs. Paul Mellon
1971.85.1

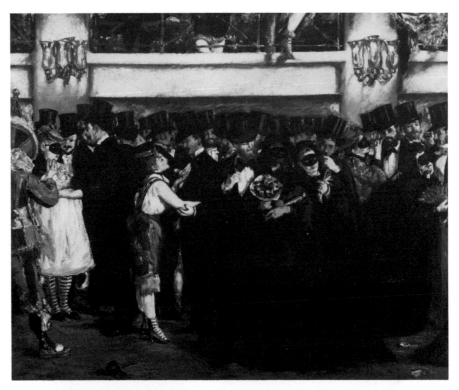

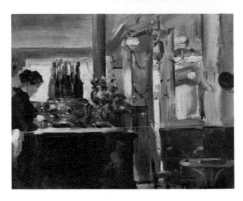

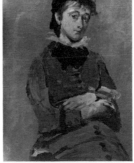

Edouard Manet
FRENCH, 1832 – 1883
Ball at the Opera, 1873
Canvas, .590 x .725 (23 1/4 x 28 1/2)
Inscribed at lower right: *Manet*
Gift of Mrs. Horace Havemeyer in memory
of her mother-in-law, Louisine W.
Havemeyer
1982.75.1

Follower of Edouard Manet
FRENCH
Madame Lépine
Canvas, .322 x .242 (12 3/4 x 9 1/2)
Ailsa Mellon Bruce Collection
1970.17.39

Style of Edouard Manet
FRENCH
Bon Bock Café, 1881
Wood, .266 x .349 (10 1/2 x 13 3/4)
Inscribed at lower left: *Juin 1881*
Ailsa Mellon Bruce Collection
1970.17.38

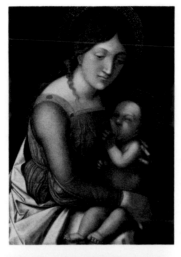

Andrea Mantegna
PADUAN, 1431 – 1506
Madonna and Child, c. 1505
Canvas, .562 x .410 (22 1/8 x 16 1/8)
Samuel H. Kress Collection
1939.1.266

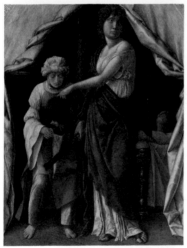

Andrea Mantegna
PADUAN, 1431 – 1506
Judith and Holofernes, c. 1495
Wood, .302 x .181 (11 7/8 x 7 1/8)
Inscribed on reverse on gesso surface: AN:
MANTEGNA
Widener Collection
1942.9.42

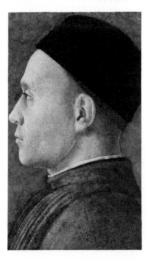

Andrea Mantegna
PADUAN, 1431 – 1506
Portrait of a Man, probably c. 1460
Transferred from canvas to hardboard,
.243 x .191 (9 1/2 x 7 1/2)
Samuel H. Kress Collection
1952.2.5

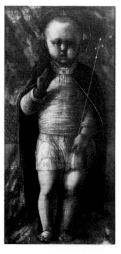

Andrea Mantegna
PADUAN, 1431 – 1506
The Christ Child Blessing,
probably c. 1480/1490
Canvas, .703 x .350 (27 5/8 x 13 3/4)
Samuel H. Kress Collection
1952.5.67

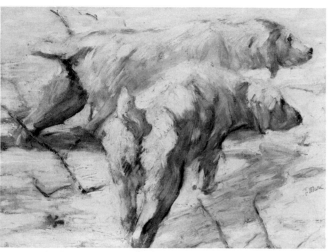

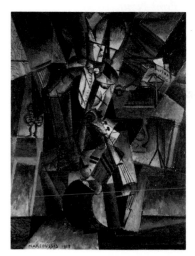

Franz Marc
GERMAN, 1880 – 1916
Siberian Dogs in the Snow, 1909/1910
Canvas, .805 x 1.140 (31 5/8 x 44 7/8)
Inscribed at lower right: *F Marc*
Gift of Mr. and Mrs. Stephen M. Kellen
1983.97.1

Louis Casimir Ladislas Marcoussis
FRENCH, 1883 – 1941
The Musician, 1914
Canvas, 1.460 x 1.143 (57 1/2 x 45)
Inscribed at lower left: MARCOUSSIS 1914
Chester Dale Collection
1963.10.163

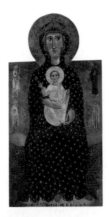

Margaritone d'Arezzo
AREZZO, active second half 13th century
Madonna and Child Enthroned, c. 1270
Wood, .970 x .495 (38 1/8 x 19 1/2)
Inscribed across bottom: MARGARIT' [DE
A]RITIO ME FECIT (Margaritus of Arezzo
made me)
Samuel H. Kress Collection
1952.5.12

Studio of Simon Marmion
FRENCH
A Miracle of Saint Benedict, c. 1480
Wood, .911 x .775 (35 7/8 x 30 1/2)
Samuel H. Kress Collection
1952.5.45

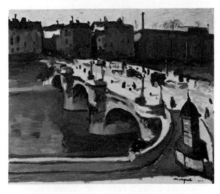

Albert Marquet
FRENCH, 1875 – 1947
The Pont Neuf, 1906
Canvas, .502 x .613 (19 3/4 x 24 1/8)
Inscribed at lower right: *Marquet 1906*
Chester Dale Collection
1963.10.164

Attributed to Benjamin Marshall
BRITISH, 1767 – 1835
Race Horse and Trainer, c. 1825
Canvas, .333 x .435 (13 1/8 x 17 1/8)
Ailsa Mellon Bruce Collection
1970.17.125

Attributed to Martino di Bartolomeo di Biago
SIENESE, active 1389 – 1434 or 1435
Madonna and Child with Saint Peter and Saint Stephen, c. 1400
Wood, left panel: .924 x .445 (36 3/8 x 17 1/2); middle panel: 1.060 x .543 (41 3/4 x 21 3/8); right panel: .934 x .451 (36 3/4 x 17 3/4)
Inscribed on middle panel at upper center on Christ's book: EGO SUM LUX MUNDI ET VIA VERITAS ET VITA
(I am the light of the world and the way, the truth and the life), a conflation of John 8:12 and 14:6
Gift of Samuel L. Fuller
1950.11.1.a-c

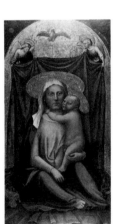

Attributed to Masaccio
FLORENTINE, 1401 – probably 1428
The Madonna of Humility
Wood, 1.051 x .537 (41 3/8 x 21 1/8)
Inscribed across bottom: AVE: MARIA: GRATIA: PLENA: DO[MINVS TECVM] (Hail, Mary, full of grace, the Lord is with thee) from Luke 1:28
Andrew W. Mellon Collection
1937.1.7

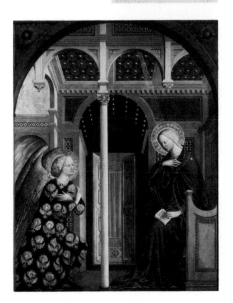

Masolino da Panicale
FLORENTINE, 1383 – probably 1440/1447
The Annunciation, probably c. 1425/1430
Wood, 1.480 x 1.149 (58 1/4 x 45 1/4)
Andrew W. Mellon Collection
1937.1.16

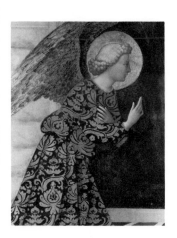

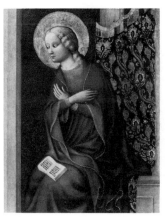

Masolino da Panicale
FLORENTINE, 1383 – probably 1440/1447
The Archangel Gabriel, probably c. 1420/
1430
Wood, .762 x .575 (30 x 22 5/8)
Samuel H. Kress Collection
1939.1.225

Masolino da Panicale
FLORENTINE, 1383 – probably 1440/1447
The Virgin Annunciate, probably c. 1420/
1430
Wood, .762 x .575 (30 x 22 5/8)
Inscribed at lower left on open book on
Virgin's lap: *Ecce Virgo...,* from Isaiah
7:14-15
Samuel H. Kress Collection
1939.1.226

Quentin Massys
ANTWERP, 1465 or 1466 – 1530
Ill-Matched Lovers, c. 1520/1525
Wood, .432 x .630 (17 x 24 13/16)
Ailsa Mellon Bruce Fund
1971.55.1

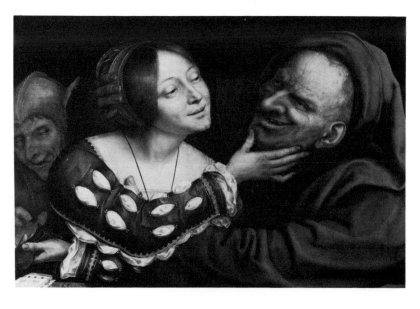

Master of the Barberini Panels
UMBRIAN-FLORENTINE, active third quarter
15th century
The Annunciation, c. 1450
Wood, .876 x .629 (34 1/2 x 24 3/4)
Samuel H. Kress Collection
1939.1.218

Master of the Franciscan Crucifixes
UMBRIAN, active second half 13th century
The Mourning Madonna, c. 1272
Wood, .810 x .315 (31 7/8 12 3/8)
Samuel H. Kress Collection
1952.5.13

Master of the Franciscan Crucifixes
UMBRIAN, active second half 13th century
Saint John the Evangelist, c. 1272
Wood, .805 x .315 (31 5/8 x 12 1/2)
Samuel H. Kress Collection
1952.5.14

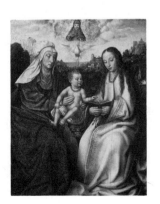

Master of Frankfurt
ANTWERP, active c. 1490 – 1520
*Saint Anne with the Virgin and Christ
Child*, c. 1511/1515
Wood, painted surface: .725 x .567 (28 3/4
x 22 3/8); panel: .735 x .575 (28 11/16 x
20 5/8)
Gift of Mr. and Mrs. Sidney K. Lafoon
1976.67.1

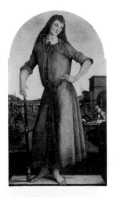

Master of the Griselda Legend
UMBRIAN-SIENESE, active late 15th century
Eunostos of Tanagra, c. 1495/1500
Transferred from wood to canvas, .885 x
.525 (34 7/8 x 20 5/8)
Samuel H. Kress Collection
1952.5.2

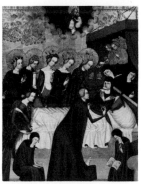

Master of Heiligenkreuz
AUSTRIAN, active early 15th century
The Death of Saint Clare, c. 1410
Wood, .664 x .545 (26 1/8 x 21 3/8)
Samuel H. Kress Collection
1952.5.83

Master of the Kress Landscapes
FLORENTINE, active c. 1505 – 1530
Scenes from a Legend, probably c. 1515/
1520
Canvas, lower panel: .279 x .889 (11 x
35); upper left and right panels, each: .279
x .419 (11 x 16 1/2)
Samuel H. Kress Collection
1939.1.344.a-c

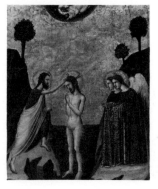

Master of the Life of Saint John the Baptist
RIMINI, active second quarter 14th century
The Baptism of Christ, probably c. 1330/
1340
Wood, .490 x .405 (19 1/4 x 16)
Samuel H. Kress Collection
1939.1.131

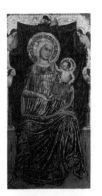

Master of the Life of Saint John the Baptist
RIMINI, active second quarter 14th century
Madonna and Child with Angels,
probably c. 1330/1340
Wood, 1.005 x .480 (39 5/8 x 18 7/8)
Inscribed at upper center on the Virgin's
halo: AVE·MARIA·GRAT[IA] PLENA· DN̄S:
(Hail, Mary, full of grace, the Lord is with
thee) from Luke 1:28
Samuel H. Kress Collection
1943.4.45

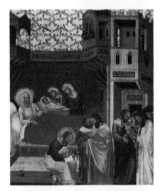

Master of the Life of Saint John the Baptist
RIMINI, active second quarter 14th century
*Scenes from the Life of Saint John the
Baptist,* probably c. 1330/1340
Wood, .491 x .408 (19 1/4 x 16)
Inscribed at lower center on scroll: NOMEN /
E[S]T IO/HA[NN]ES (The name is John)
Samuel H. Kress Collection
1952.5.68

Master of the Prado Adoration of the Magi
NETHERLANDISH, probably active last third
15th century
The Presentation in the Temple, c. 1470/
1480
Wood, painted surface: .579 x .478
(22 13/16 x 18 13/16); panel: .595 x .481
(23 7/16 x 18 15/16)
Samuel H. Kress Collection
1961.9.28

Master of the Retable of the Reyes Católicos
HISPANO-FLEMISH, active late 15th century
The Marriage at Cana, c. 1495/1500
Wood, 1.534 x .926 (60 3/8 x 36 3/8)
Samuel H. Kress Collection
1952.5.42

Master of the Retable of the Reyes Católicos
HISPANO-FLEMISH, active late 15th century
Christ among the Doctors, c. 1495/1500
Wood, 1.563 x .940 (61 1/2 x 37)
Samuel H. Kress Collection
1952.5.43

Master of the Saint Bartholomew Altar
COLOGNE, active c. 1480 – 1510
The Baptism of Christ, c. 1500
Wood, 1.061 x 1.705 (41 3/4 x 67 1/8)
Inscribed on banderolle: HIC EST FILIVS
MEVS DILECTV IN QVO MICHI CON[P]LICVI:
(This is my beloved son with whom I am
well pleased) from Matthew 3:17
Samuel H. Kress Collection
1961.9.78

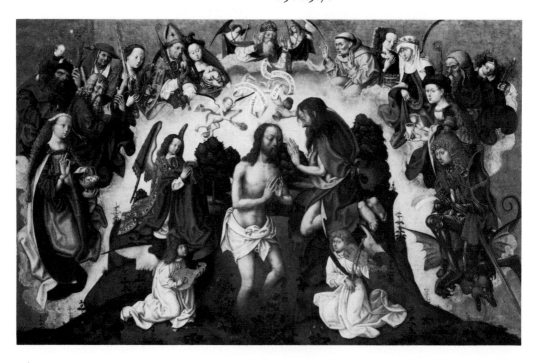

Master of Saint Francis
UMBRIAN, active second half 13th century
Saint James Minor, probably c. 1270/1280
Wood, .495 x .241 (19 5/8 x 9 1/2)
Inscribed across top on arch: SANCTUS
IACOB [A]LPHEI Q COGNOMINAT[UR] [EIUS]
Samuel H. Kress Collection
1952.5.15

Master of Saint Francis
UMBRIAN, active second half 13th century
Saint John the Evangelist,
probably c. 1270/1280
Wood, .495 x .240 (19 1/2 x 9 1/2)
Inscribed across top on arch: SANCTUS
[IO]HANES ...S SU...
Samuel H. Kress Collection
1952.5.16

Master of Saint Giles
FRANCO-FLEMISH, active c. 1500
The Baptism of Clovis, c. 1500
Wood, painted surface: .615 x .455 (24 1/4
x 18); panel: .633 x .467 (24 7/8 x 18 3/8)
Samuel H. Kress Collection
1952.2.15

Master of Saint Giles and Assistant

FRANCO-FLEMISH, active c. 1500
Episodes from the Life of a Bishop Saint,
c. 1500
Wood, painted surface: .615 x .470 (24 1/4
x 18 1/2); panel: .632 x .475 (24 7/8 x
18 11/16)
Inscribed at upper right under paint layer
on wall of Hotel-Dieu: *[L?]oste..*
Samuel H. Kress Collection
1952.2.14

Master of the Saint Lucy Legend

BRUGES, active 1480 – 1490
Mary, Queen of Heaven, c. 1485/1500
Wood, painted surface: 1.992 x 1.618
(78 7/16 x 63 3/4); panel: 2.015 x 1.638
(79 3/8 x 64 1/2)
Inscribed at upper center on sheets of
music held by angels: *A/ve / regina celorum
mr regis [?]; and A / Tenor e / regina*
Samuel H. Kress Collection
1952.2.13

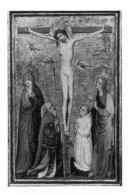

Master of Saint Veronica
COLOGNE, active early 15th century
The Crucifixion, c. 1400/1410
Wood, .460 x .314 (18 1/8 x 12 3/8)
Inscribed at upper center: I.N.R.I.
Samuel H. Kress Collection
1961.9.29

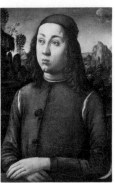

Master of Santo Spirito
FLORENTINE, active early 16th century
Portrait of a Youth, c. 1505
Transferred from wood to canvas and
novaply, .516 x .340 (20 3/8 x 13 3/8)
Samuel H. Kress Collection
1939.1.294

Henri Matisse
FRENCH, 1869 – 1954
Lorette, 1917
Wood, .613 x .494 (24 1/8 x 19 1/2)
Inscribed at upper left: *Henri-Matisse
1917.*
Chester Dale Collection
1963.10.39

Henri Matisse
FRENCH, 1869 – 1954
Moorish Woman, 1922
Canvas, .356 x .244 (14 x 9 5/8)
Inscribed at lower right: *Henri-Matisse*
Chester Dale Collection
1963.10.40

Henri Matisse
FRENCH, 1869 – 1954
Pot of Geraniums, 1912
Canvas, .413 x .333 (16 1/4 x 13 1/8)
Inscribed at lower right: *Henri-Matisse*
Chester Dale Collection
1963.10.41

Henri Matisse
FRENCH, 1869 – 1954
La Coiffure, 1901
Canvas, .952 x .801 (37 1/2 x 31 1/2)
Inscribed at lower left: *Henri Matisse*
Chester Dale Collection
1963.10.165

Henri Matisse
FRENCH, 1869 – 1954
Les Gorges du Loup, 1920/1925
Canvas, .502 x .609 (19 3/4 x 24)
Inscribed at lower left: *Henri-Matisse*
Chester Dale Collection
1963.10.166

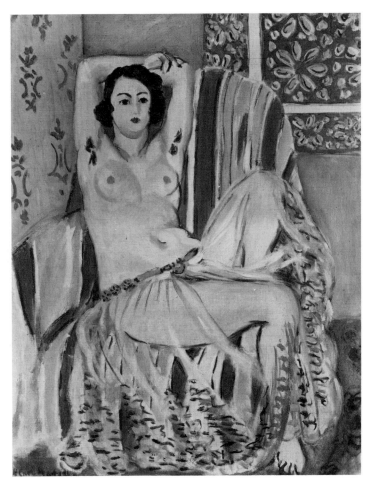

Henri Matisse
FRENCH, 1869 – 1954
Odalisque with Raised Arms, 1923
Canvas, .651 x .502 (25 5/8 x 19 3/4)
Inscribed at lower left: *Henri Matisse*
Chester Dale Collection
1963.10.167

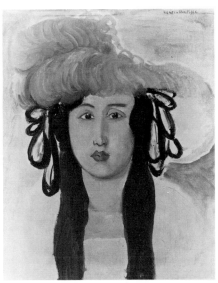

Henri Matisse
FRENCH, 1869 – 1954
The Plumed Hat, 1919
Canvas, .477 x .381 (18 3/4 x 15)
Inscribed at upper right: *Henri-Matisse*
Chester Dale Collection
1963.10.168

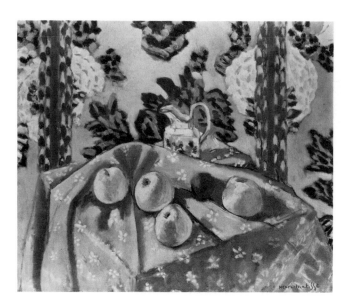

Henri Matisse
FRENCH, 1869 – 1954
Still Life: Apples on Pink Tablecloth,
c. 1922
Canvas, .604 x .730 (23 3/4 x 28 3/4)
Inscribed at lower right: *Henri-Matisse*
Chester Dale Collection
1963.10.169

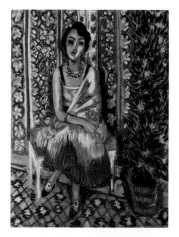

Henri Matisse
FRENCH, 1869 – 1954
Woman with Exotic Plant, c. 1925
Pastel on paper, .661 x .514 (26 x 20 1/4)
Inscribed at lower left: *Henri Matisse*
Chester Dale Collection
1963.10.170

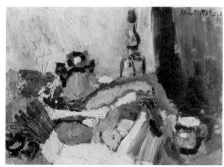

Henri Matisse
FRENCH, 1869 – 1954
Still Life, c. 1905
Cardboard on wood, .170 x .248 (6 3/4 x
9 3/4)
Inscribed at upper right: *Henri-Matisse*
Ailsa Mellon Bruce Collection
1970.17.40

Henri Matisse
FRENCH, 1869 – 1954
Still Life with Pineapple, 1924
Canvas, .505 x .615 (19 7/8 x 24 1/4)
Inscribed at lower right: *Henri-Matisse*
Gift of the W. Averell Harriman
Foundation in memory of Marie N.
Harriman
1972.9.18

Henri Matisse
FRENCH, 1869 – 1954
La Négresse, 1952
Collage on canvas, 4.539 x 6.233 (178 3/4
x 245 1/2)
Ailsa Mellon Bruce Fund
1973.6.1

Henri Matisse
FRENCH, 1869 – 1954
Large Composition with Masks, 1953
Collage on canvas, 3.536 x 9.964 (139 1/4 x 392 1/2)
Inscribed at lower right: HM 53/53
Ailsa Mellon Bruce Fund
1973.17.1

Henri Matisse
FRENCH, 1869 – 1954
Beasts of the Sea, 1950
Collage on canvas, 2.955 x 1.540 (116 3/8 x 60 5/8)
Inscribed across bottom: *les bêtes de la mer... /*; at lower right: *H. Matisse 50*
Ailsa Mellon Bruce Fund
1973.18.1

Henri Matisse
FRENCH, 1869 – 1954
Venus, 1952
Collage on canvas, 1.012 x .765 (39 7/8 x 30 1/8)
Inscribed at lower right: HM
Ailsa Mellon Bruce Fund
1973.18.2

Henri Matisse
FRENCH, 1869 – 1954
Woman with Amphora and Pomegranates,
1953
Collage on canvas, 2.436 x .963 (96 x
37 7/8)
Ailsa Mellon Bruce Fund
1973.18.3

Henri Matisse
FRENCH, 1869 – 1954
Palm Leaf, Tangier, 1912
Canvas, 1.175 x .819 (46 1/4 x 32 1/4)
Inscribed at lower right: *Henri-Matisse*
Chester Dale Fund
1978.73.1

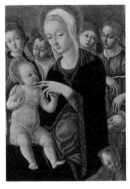

Matteo di Giovanni
SIENESE, C. 1430 – 1495
*Madonna and Child with Angels and
Cherubim,* before 1470
Wood, .787 x .584 (31 x 23)
Inscribed at upper center on the Virgin's
halo: REGINA CELI LETAR[E] (O Queen of
Heaven, rejoice!)
Andrew W. Mellon Collection
1937.1.9

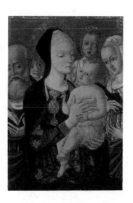

Matteo di Giovanni
SIENESE, C. 1430 – 1495
*Madonna and Child with Saints and
Angels,* c. 1470
Wood, .660 x .441 (26 x 17 3/8)
Inscribed at upper center on Virgin's halo:
AVE GRATIA PLENA DO[MINVS TECVM] (Hail,
full of grace, the Lord is with thee) from
Luke 1:28
Samuel H. Kress Collection
1939.1.297

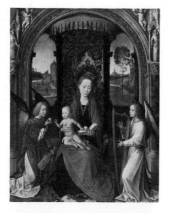

Hans Memling
BRUGES, active c. 1465 – 1494
Madonna and Child with Angels, after
1479
Wood, painted surface: .576 x .464 (22 5/8
x 18 3/8); panel: .588 x .480 (23 1/8 x
18 7/8)
Andrew W. Mellon Collection
1937.1.41

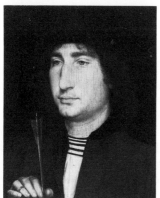

Hans Memling
BRUGES, active c. 1465 – 1494
Portrait of a Man with an Arrow,
1470/1475
Wood, painted surface: .313 x .251 (12 5/16
x 9 7/8); panel: .319 x .258 (12 3/4 x
10 3/16)
Andrew W. Mellon Collection
1937.1.42

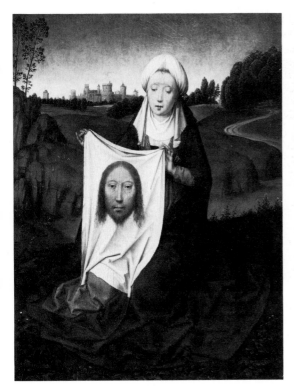

Hans Memling
BRUGES, active c. 1465 – 1494
*Saint Veronica; reverse: Chalice of Saint
John the Evangelist,* c. 1470/1479
Wood, painted surface obverse: .303 x
.228 (11 15/16 x 9); panel: .312 x .244
(12 1/4 x 9 3/4); painted surface reverse:
.302 x .230 (11 7/8 x 9 1/16)
Samuel H. Kress Collection
1952.5.46.a-b

Hugues Merle
FRENCH, 1823 – 1881
Children Playing in a Park, c. 1850
Canvas, .328 x .409 (12 7/8 x 16 1/8)
Inscribed at lower left in monogram: HM
Ailsa Mellon Bruce Collection
1970.17.101

Gabriel Metsu
DUTCH, 1629 – 1667
The Intruder, c. 1660
Wood, .667 x .597 (26 1/4 x 23 1/2)
Inscribed at lower center on bed: *G. Metsu*
Andrew W. Mellon Collection
1937.1.57

Michiel van Miereveld
DUTCH, 1567 – 1641
Portrait of a Lady with a Ruff, 1638
Wood, .705 x .578 (27 3/4 x 22 3/4)
Inscribed at center right: *AEtatis, 26 / Aº
1638. / M. Miereveld*
Gift of The Coe Foundation
1961.5.4

Manolo Millares
SPANISH, 1926 – 1972
Cuadro 78, 1959
Canvas and wood, 1.297 x 1.618 (51 x
63 3/4)
Inscribed at lower right: MILLARES
Gift of Mr. and Mrs. Burton Tremaine
1971.87.7

Jean-François Millet
FRENCH, 1814 – 1875
The Bather, c. 1848
Wood, .184 x .242 (7 1/4 x 9 1/2)
Inscribed at lower right: *J.F. Millet*
Gift of R. Horace Gallatin
1949.1.9

Jean-François Millet
FRENCH, 1814 – 1875
Leconte de Lisle, probably 1842
Canvas, 1.171 x .812 (46 1/8 x 32)
Inscribed at lower right: F. MILLET.
Chester Dale Collection
1963.10.42

Jean-François Millet
FRENCH, 1814 – 1875
Portrait of a Man, probably 1845
Canvas, .406 x .323 (16 x 12 3/4)
Inscribed at lower left: *F. Millet*
Chester Dale Collection
1963.10.43

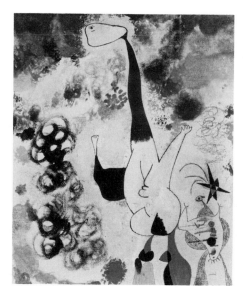

Joan Miró
SPANISH, 1893 – 1983
Shooting Star, 1936
Canvas, .652 x .544 (25 5/8 x 21 3/8)
Inscribed at lower right: *miró*
Gift of Joseph H. Hazen
1970.36.1

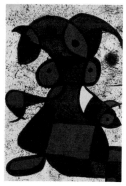

Joan Miró
SPANISH, 1893 – 1983
Woman, 1976
Canvas, 2.444 x 1.695 (96 1/4 x 66 3/4)
Inscribed at lower right: *miró*
Gift of George L. Erion
1977.45.1

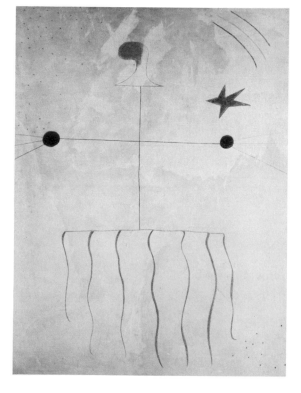

Joan Miró
SPANISH, 1893 – 1983
Head of a Catalan Peasant, 1924
Canvas, 1.460 x 1.142 (57 1/2 x 45)
Inscribed at lower right: *Miró / 1924;* on
reverse: *Joan Miró, Tête de Paysan
Catalan, 1924*
Gift of the Collectors Committee
1981.9.1

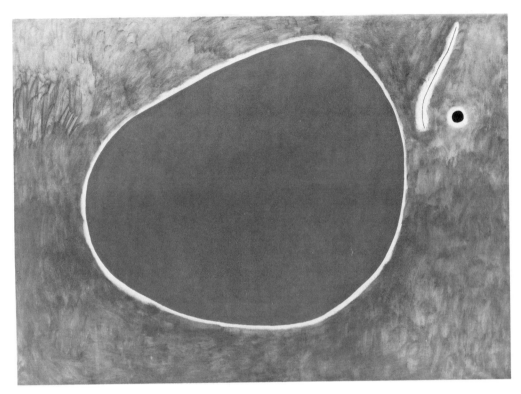

Joan Miró
SPANISH, 1893 – 1983
The Flight of the Dragonfly before the Sun,
1968
Canvas, 1.739 x 2.438 (68 1/2 x 96)
Inscribed on reverse: *MIRO 26/1/68 / LE
VOL DE LA / LIBELLULE / DEVANT
LE / SOLEIL; NO. 119*
Collection of Mr. and Mrs. Paul Mellon
1983.1.23

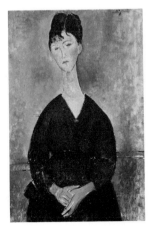

Amedeo Modigliani
ITALIAN, 1884 – 1920
Café Singer, 1917
Canvas, .924 x .603 (36 3/8 x 23 3/4)
Inscribed at upper right: *modigliani.*
Chester Dale Collection
1963.10.44

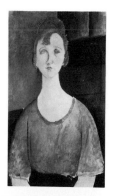

Amedeo Modigliani
ITALIAN, 1884 – 1920
Girl in a Green Blouse, 1917
Canvas, .813 x .460 (32 x 18 1/8)
Inscribed at upper right: *modigliani*
Chester Dale Collection
1963.10.45

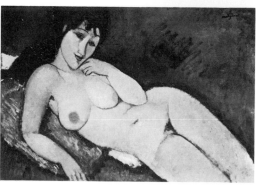

Amedeo Modigliani
ITALIAN, 1884 – 1920
Nude on a Blue Cushion, 1917
Canvas, .654 x 1.009 (25 3/4 x 39 3/4)
Inscribed at upper right: *modigliani*
Chester Dale Collection
1963.10.46

Amedeo Modigliani
ITALIAN, 1884 – 1920
Chaim Soutine, 1917
Canvas, .917 x .597 (36 1/8 x 23 1/2)
Inscribed at upper right: *modigliani*
Chester Dale Collection
1963.10.47

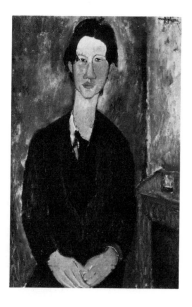

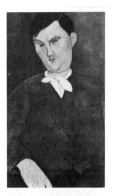

Amedeo Modigliani
ITALIAN, 1884 – 1920
Monsieur Deleu, 1916
Canvas, .811 x .467 (31 7/8 x 18 3/8)
Chester Dale Collection
1963.10.76

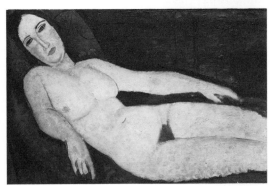

Amedeo Modigliani
ITALIAN, 1884 – 1920
Nude on a Divan, 1918
Canvas, .602 x .917 (23 5/8 x 36 1/8)
Inscribed at upper right: *modigliani*
Chester Dale Collection
1963.10.77

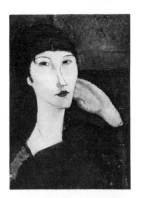

Amedeo Modigliani
ITALIAN, 1884 – 1920
Adrienne (Woman with Bangs), 1917
Canvas, .553 x .381 (21 3/4 x 15)
Inscribed at upper right: *Modigliani*
Chester Dale Collection
1963.10.171

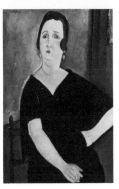

Amedeo Modigliani
ITALIAN, 1884 – 1920
Madame Amédée (Woman with Cigarette),
1918
Canvas, 1.003 x .648 (39 1/2 x 25 1/2)
Inscribed at upper left: *modigliani*
Chester Dale Collection
1963.10.172

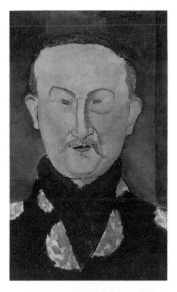

Amedeo Modigliani
ITALIAN, 1884 – 1920
Léon Bakst, 1917
Canvas, .553 x .330 (21 3/4 x 13)
Inscribed at upper right: *modigliani*
Chester Dale Collection
1963.10.173

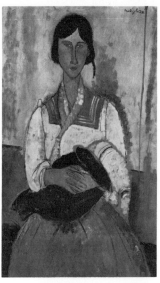

Amedeo Modigliani
ITALIAN, 1884 – 1920
Gypsy Woman with Baby, 1919
Canvas, 1.159 x .730 (45 5/8 x 28 3/4)
Inscribed at upper right: *modigliani*
Chester Dale Collection
1963.10.174

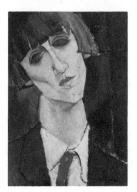

Amedeo Modigliani
ITALIAN, 1884 – 1920
Madame Kisling, c. 1917
Canvas, .462 x .332 (18 1/4 x 13 1/8)
Inscribed at lower right: *modigliani*
Chester Dale Collection
1963.10.175

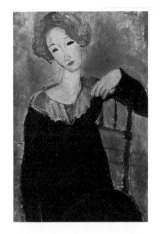

Amedeo Modigliani
ITALIAN, 1884 – 1920
Woman with Red Hair, 1917
Canvas, .921 x .607 (36 1/4 x 23 7/8)
Inscribed at upper right: *modigliani*
Chester Dale Collection
1963.10.176

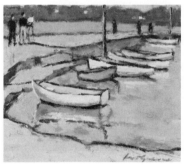

Edward Molyneux
BRITISH, 1894 – 1974
Artist on a Quay, 1962/1964
Fiberboard, .219 x .269 (8 5/8 x 10 5/8)
Inscribed at lower right: *Molyneux*
Ailsa Mellon Bruce Collection
1970.17.126

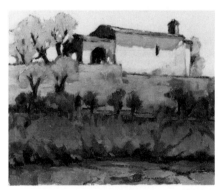

Edward Molyneux
BRITISH, 1894 – 1974
Chapel in Provence, 1962/1964
Canvas, .331 x .407 (13 x 16)
Inscribed at lower right: *Molyneux*
Ailsa Mellon Bruce Collection
1970.17.127

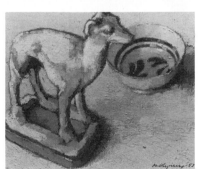

Edward Molyneux
BRITISH, 1894 – 1974
Chinese Statue of a Dog, 1953
Canvas, .203 x .242 (8 x 9 1/2)
Inscribed at lower right: *Molyneux '53*
Ailsa Mellon Bruce Collection
1970.17.128

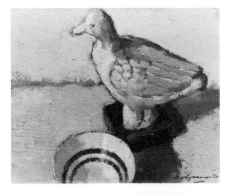

Edward Molyneux
BRITISH, 1894 – 1974
Chinese Statue of a Bird, 1953
Canvas, .197 x .242 (7 3/4 x 9 1/2)
Inscribed at lower right: *Molyneux '53*
Ailsa Mellon Bruce Collection
1970.17.129

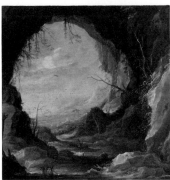

Joos de Momper II
FLEMISH, 1564 – 1635
Vista from a Grotto, c. 1625
Wood, .509 x .517 (20 x 20 3/8)
Ailsa Mellon Bruce Fund
1971.56.1

Piet Mondrian
DUTCH, 1872 – 1944
Diamond Painting in Red, Yellow, and Blue, c. 1921/1925
Canvas on hardboard, diagonals: 1.428 x 1.423 (56 1/4 x 56)
Inscribed at lower center: PM
Gift of Herbert and Nannette Rothschild
1971.51.1

Claude Monet
FRENCH, 1840 – 1926
Morning Haze, 1888
Canvas, .740 x .929 (29 1/8 x 36 5/8)
Inscribed at lower left: *Claude Monet*
Chester Dale Collection
1958.12.1

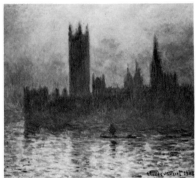

Claude Monet
FRENCH, 1840 – 1926
The Houses of Parliament, Sunset, 1903
Canvas, .813 x .925 (32 x 36 3/8)
Inscribed at lower right: *Claude Monet*
1903
Chester Dale Collection
1963.10.48

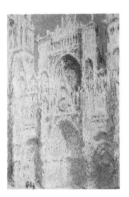

Claude Monet
FRENCH, 1840 – 1926
Rouen Cathedral, West Façade, 1894
Canvas, 1.004 x .660 (39 1/2 x 26)
Inscribed at lower left: *Claude Monet 94*
Chester Dale Collection
1963.10.49

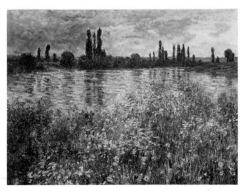

Claude Monet
FRENCH, 1840 – 1926
Banks of the Seine, Vétheuil, 1880
Canvas, .734 x 1.005 (28 7/8 x 39 5/8)
Inscribed at lower right: *Claude Monet 80*
Chester Dale Collection
1963.10.177

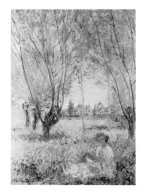

Claude Monet
FRENCH, 1840 – 1926
Woman Seated under the Willows, 1880
Canvas, .811 x .600 (31 7/8 x 23 5/8)
Inscribed at lower left: *1880 Claude Monet*
Chester Dale Collection
1963.10.178

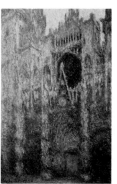

Claude Monet
FRENCH, 1840 – 1926
Rouen Cathedral, West Façade, Sunlight,
1894
Canvas, 1.002 x .660 (39 1/2 x 26)
Inscribed at lower right: *Claude Monet '94*
Chester Dale Collection
1963.10.179

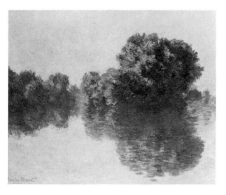

Claude Monet
FRENCH, 1840 – 1926
The Seine at Giverny, 1897
Canvas, .816 x 1.003 (32 1/8 x 39 5/8)
Inscribed at lower left: *Claude Monet*
Chester Dale Collection
1963.10.180

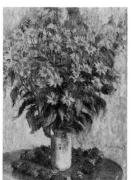

Claude Monet
FRENCH, 1840 – 1926
Vase of Chrysanthemums, 1880
Canvas, .996 x .730 (39 1/4 x 28 3/4)
Inscribed at lower right: *Claude Monet /*
1880
Chester Dale Collection
1963.10.181

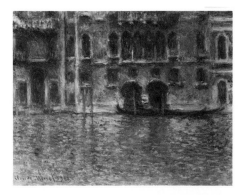

Claude Monet
FRENCH, 1840 – 1926
Palazzo da Mula, Venice, 1908
Canvas, .620 x .811 (24 1/2 x 31 7/8)
Inscribed at lower left: *Claude Monet 1908*
Chester Dale Collection
1963.10.182

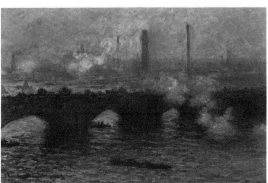

Claude Monet
FRENCH, 1840 – 1926
Waterloo Bridge, Gray Day, 1903
Canvas, .651 x 1.000 (25 3/8 x 39 3/8)
Inscribed at lower left: *Claude Monet 1903*
Chester Dale Collection
1963.10.183

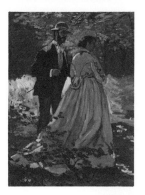

Claude Monet
FRENCH, 1840 – 1926
Bazille and Camille, 1865
Canvas, .930 x .689 (36 5/8 x 27 1/8)
Inscribed at lower right: *Claude Monet*
Ailsa Mellon Bruce Collection
1970.17.41

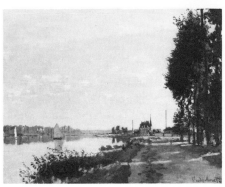

Claude Monet
FRENCH, 1840 – 1926
Argenteuil, c. 1872
Canvas, .504 x .652 (19 7/8 x 25 5/8)
Inscribed at lower right: *Claude Monet.*
Ailsa Mellon Bruce Collection
1970.17.42

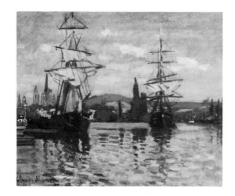

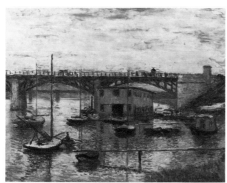

Claude Monet
FRENCH, 1840 – 1926
Ships Riding on the Seine at Rouen,
1872/1873
Canvas, .378 x .466 (14 7/8 x 18 3/8)
Inscribed at lower left: *Claude Monet*
Ailsa Mellon Bruce Collection
1970.17.43

Claude Monet
FRENCH, 1840 – 1926
Bridge at Argenteuil on a Gray Day,
c. 1876
Canvas, .610 x .803 (24 x 31 5/8)
Inscribed at lower right: *Claude Monet*
Ailsa Mellon Bruce Collection
1970.17.44

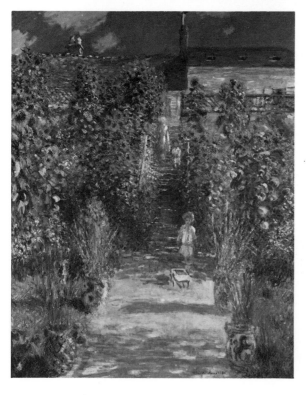

Claude Monet
FRENCH, 1840 – 1926
The Artist's Garden at Vétheuil, 1880
Canvas, 1.514 x 1.210 (59 5/8 x 47 5/8)
Inscribed at lower right: *Claude Monet 80*
Ailsa Mellon Bruce Collection
1970.17.45

Claude Monet
FRENCH, 1840 – 1926
The Bridge at Argenteuil, 1874
Canvas, .600 x .797 (23 5/8 x 31 3/8)
Inscribed at lower right: *Claude Monet*
Collection of Mr. and Mrs. Paul Mellon
1983.1.24

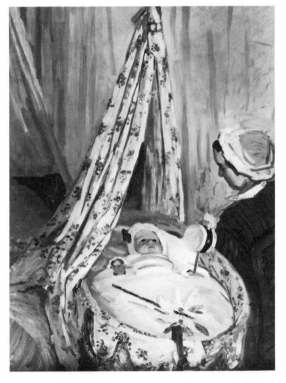

Claude Monet
FRENCH, 1840 – 1926
*The Cradle – Camille with the Artist's Son
Jean,* 1867
Canvas, 1.168 x .889 (46 x 35)
Collection of Mr. and Mrs. Paul Mellon
1983.1.25

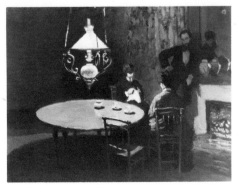

Claude Monet
FRENCH, 1840 – 1926
Interior, after Dinner, 1868/1869
Canvas, .505 x .657 (19 7/8 x 25 7/8)
Inscribed at lower left: *Claude Monet*
Collection of Mr. and Mrs. Paul Mellon
1983.1.26

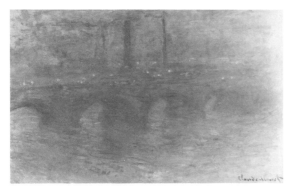

Claude Monet
FRENCH, 1840 – 1926
Waterloo Bridge, London, at Dusk, 1904
Canvas, .657 x 1.016 (25 7/8 x 40)
Inscribed at lower right: *Claude Monet*
Collection of Mr. and Mrs. Paul Mellon
1983.1.27

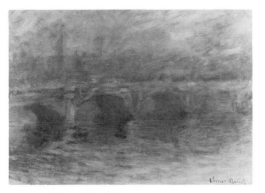

Claude Monet
FRENCH, 1840 – 1926
Waterloo Bridge, London, at Sunset, 1904
Canvas, .655 x .927 (25 3/4 x 36 1/2)
Inscribed at lower right: *Claude Monet*
Collection of Mr. and Mrs. Paul Mellon
1983.1.28

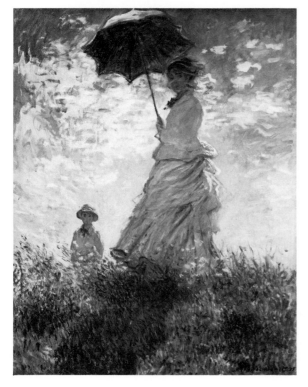

Claude Monet
FRENCH, 1840 – 1926
*Woman with a Parasol – Madame Monet
and Her Son*, 1875
Canvas, 1.000 x .810 (39 3/8 x 31 7/8)
Inscribed at lower right: *Claude Monet 75*
Collection of Mr. and Mrs. Paul Mellon
1983.1.29

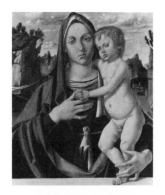

Bartolomeo Montagna
VICENZA, probably 1453/1454 – 1523
Madonna and Child, 1480s
Wood, .562 x .457 (22 1/8 x 18)
Samuel H. Kress Collection
1939.1.29

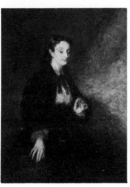

Adolphe Monticelli
FRENCH, 1824 – 1886
Madame Cahen, 1869
Canvas, 1.318 x .979 (51 7/8 x 38 1/2)
Inscribed at center right: *Monticelli / 1869.*
Chester Dale Collection
1963.10.184

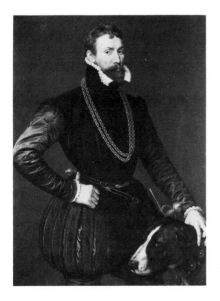

Anthonis Mor
NORTH NETHERLANDISH, c. 1516/1520 –
1575 or 1576
Portrait of a Gentleman, 1569
Transferred from wood to canvas, 1.197 x
.883 (47 1/8 x 34 3/4)
Inscribed at upper left: *Antonius mor
pingebat a. 1569*
Andrew W. Mellon Collection
1937.1.52

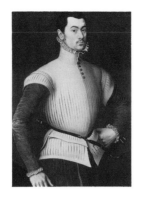

Follower of Anthonis Mor
NETHERLANDISH
Portrait of a Young Man, 1558
Wood, .975 x .699 (38 3/8 x 27 1/2)
Inscribed at upper left: ·AE·S·20 / A⁰·1558
Samuel H. Kress Collection
1961.9.79

Henri Moret
FRENCH, 1856 – 1913
The Island of Raguenez, Brittany,
1890/1895
Canvas, .540 x .648 (21 1/4 x 25 1/2)
Inscribed at lower right: *Moret;* falsely at
lower left: *P. Go*
Ailsa Mellon Bruce Collection
1970.17.46

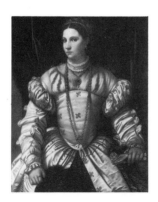

Moretto da Brescia
BRESCIAN, 1498 – 1554
Portrait of a Lady in White, c. 1540
Canvas, 1.064 x .876 (41 7/8 x 34 1/2)
Samuel H. Kress Collection
1939.1.230

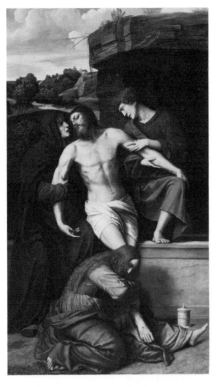

Moretto da Brescia
BRESCIAN, 1498 – 1554
Pietà, 1520s
Wood, 1.758 x .985 (69 1/8 x 38 3/4)
Samuel H. Kress Collection
1952.2.10

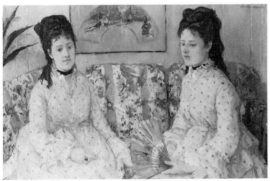

Berthe Morisot
FRENCH, 1841 – 1895
The Sisters, 1869
Canvas, .521 x .813 (20 1/2 x 32)
Inscribed at upper right: *Berthe Morisot*
Gift of Mrs. Charles S. Carstairs
1952.9.2

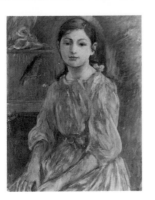

Berthe Morisot
FRENCH, 1841 – 1895
The Artist's Daughter with a Parakeet,
1890
Canvas, .656 x .524 (25 3/4 x 20 5/8)
Inscribed at lower right: *Berthe Morisot*
Chester Dale Collection
1963.10.50

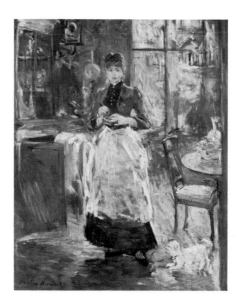

Berthe Morisot
FRENCH, 1841 – 1895
In the Dining Room, 1886
Canvas, .613 x .500 (24 1/8 x 19 3/4)
Inscribed at lower left: *Berthe Morisot*
Chester Dale Collection
1963.10.185

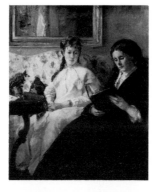

Berthe Morisot
FRENCH, 1841 – 1895
The Mother and Sister of the Artist,
1869/1870
Canvas, 1.010 x .818 (39 1/2 x 32 1/4)
Chester Dale Collection
1963.10.186

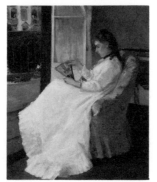

Berthe Morisot
FRENCH, 1841 – 1895
The Artist's Sister at a Window, 1869
Canvas, .548 x .463 (21 5/8 x 18 1/4)
Ailsa Mellon Bruce Collection
1970.17.47

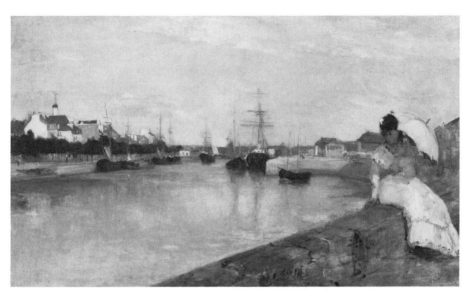

Berthe Morisot
FRENCH, 1841 – 1895
The Harbor at Lorient, 1869
Canvas, .435 x .730 (17 1/8 x 28 3/4)
Inscribed at lower center: *B Morisot*
Ailsa Mellon Bruce Collection
1970.17.48

Berthe Morisot
FRENCH, 1841 – 1895
Young Woman with a Straw Hat, 1884
Canvas, .555 x .467 (21 7/8 x 18 3/8)
Ailsa Mellon Bruce Collection
1970.17.49

Berthe Morisot
FRENCH, 1841 – 1895
Girl in a Boat with Geese, c. 1889
Canvas, .654 x .546 (25 3/4 x 21 1/2)
Inscribed at lower left: *B. Morisot*
Ailsa Mellon Bruce Collection
1970.17.50

George Morland
BRITISH, 1763 – 1804
The End of the Hunt, c. 1794
Canvas, 1.422 x 1.880 (56 x 74)
Inscribed at lower right: *G. Morland /
Pinx*[t]
Widener Collection
1942.9.43

Giovanni Battista Moroni
BRESCIAN, c. 1525 – 1578
*A Gentleman in Adoration before the
Madonna*, c. 1560
Canvas, .597 x .648 (23 1/2 x 25 1/2)
Samuel H. Kress Collection
1939.1.114

Giovanni Battista Moroni
BRESCIAN, c. 1525 – 1578
"Titian's Schoolmaster," c. 1575
Canvas, .968 x .743 (38 1/8 x 29 1/4)
Widener Collection
1942.9.45

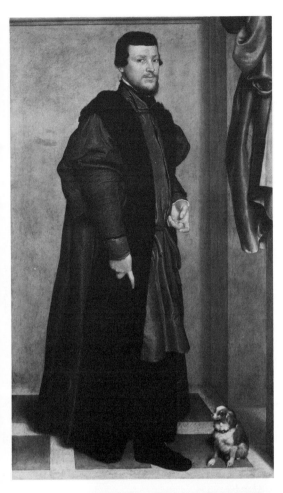

Giovanni Battista Moroni
BRESCIAN, C. 1525 – 1578
Gian Federico Madruzzo, c. 1560
Canvas, 2.019 x 1.168 (79 1/2 x 46)
Timken Collection
1960.6.27

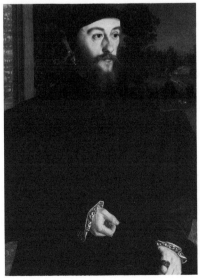

Hans Muelich
GERMAN, 1516 – 1573
Portrait of a Member of the Fröschl
Family, c. 1539/1540
Wood, .616 x .470 (24 1/4 x 18 1/2)
Inscribed on reverse at center: ·E·G·[V]·Z·;
the coat of arms of the Fröschl family of
Wasserburg
Gift of David Edward Finley and Margaret
Eustis Finley
1984.66.1

Gabriele Münter
GERMAN, 1877 – 1962
Christmas Still Life, 1937
Cardboard, .495 x .647 (19 1/4 x 25 1/2)
Inscribed at lower right: *Münter;* on
reverse: *44/37 Weihnachstilleben 1; S-100*
Gift of Virginia Steele Scott
1973.2.2

Bartolomé Esteban Murillo
SPANISH, 1617 – 1682
A Girl and Her Duenna, c. 1670
Canvas, 1.277 x 1.061 (50 1/4 x 41 3/4)
Widener Collection
1942.9.46

Bartolomé Esteban Murillo
SPANISH, 1617 – 1682
The Return of the Prodigal Son, 1670/1674
Canvas, 2.363 x 2.610 (93 x 102 3/4)
Gift of the Avalon Foundation
1948.12.1

Nardo di Cione
FLORENTINE, active 1343 – 1365 or 1366
*Madonna and Child with Saint Peter and
Saint John the Evangelist,* probably c. 1360
Wood, middle panel: .762 x .394 (30 x
15 1/2); side panels, each: .495 x .178
(19 1/2 x 7)
Inscribed across bottom on base of frame:
AVE·GRATIA·PLENA·DO[MINVS TECVM] (Hail,
full of grace, the Lord is with thee) from
Luke 1:28
Samuel H. Kress Collection
1939.1.261.a-c

Jean-Marc Nattier
FRENCH, 1685 – 1766
Madame de Caumartin as Hebe, 1753
Canvas, 1.025 x .815 (40 3/8 x 32)
Inscribed at lower left: *Nattier pinxit. /*
1753.
Samuel H. Kress Collection
1946.7.13

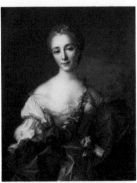

Jean-Marc Nattier
FRENCH, 1685 – 1766
Portrait of a Lady
Canvas, .809 x .645 (31 7/8 x 25 3/8)
Timken Collection
1960.6.28

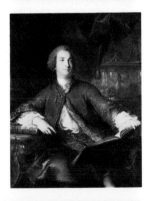

Jean-Marc Nattier
FRENCH, 1685 – 1766
Joseph Bonnier de la Mosson, 1745
Canvas, 1.379 x 1.054 (54 1/4 x 41 1/2)
Inscribed at center left at base of column:
Nattier / 1745
Samuel H. Kress Collection
1961.9.30

Peeter Neeffs I
FLEMISH, C. 1578 – 1656/1661
Interior of a Church, c. 1630
Copper, .465 x .591 (18 1/4 x 23 1/4)
Gift of Theodore Francis Green
1948.10.1

Peeter Neeffs I
FLEMISH, C. 1578 – 1656/1661
Antwerp Cathedral, c. 1636
Copper, .150 X .229 (5 7/8 x 9)
Inscribed at center left on base of column:
P. NEEFFS
Timken Collection
1960.6.29

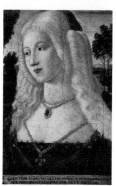

Neroccio de' Landi
SIENESE, 1447 – 1500
Portrait of a Lady, c. 1490
Wood, .465 x .305 (18 3/8 x 12)
Inscribed across bottom:
QVANTVM ·HOMINI · FAS · EST · MIRA ·
LICET · ASSEQVAR · ARTE · / NIL · AGO:
MORTALIS · EMVLOR · ARTE · DEOS ·
(Although I achieve with wondrous art
what man may, I get nowhere, a mortal
competing with gods); at lower left in
triangle: A·P·; at lower right in triangle:
NER
Widener Collection
1942.9.47

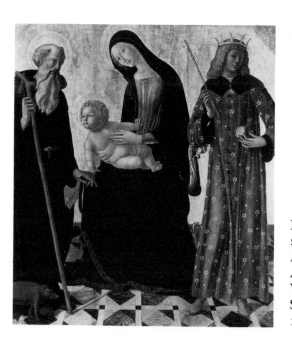

Neroccio de' Landi
SIENESE, 1447 – 1500
*Madonna and Child with Saint Anthony
Abbot and Saint Sigismund,* c. 1495
Wood, 1.585 x 1.420 (62 3/8 x 55 7/8)
Samuel H. Kress Collection
1952.5.17

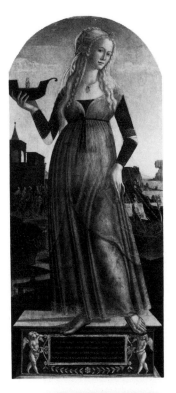

Neroccio de' Landi and Master of the Griselda Legend
SIENESE, 1447 – 1500; active late 15th century
Claudia Quinta, c. 1494
Wood, 1.048 x .460 (41 1/4 x 18 1/8)
Inscribed at lower center on pedestal:
CLAVDIA CASTA FVI NEC VVLGVS CREDIDIT
AMEN / ET TAMEN ID QVOD ERAM TESTIS
MIHI PRORA PROBAVIT / CONSILIVM ET
VIRTVS SVPERANT MATERQVE DEORVM /
ALMA PLACET POPVLO ET PER ME HVNC
ORATA TVETVR (I was Claudia the chaste,
but men trusted not in my troth. And yet
that which I was, the prow proved as my
witness. Prudence and virtue triumph, and
the Mother of the Gods, she, the gracious
one, is pleasing to the people and protects
them when invoked through me.)
Andrew W. Mellon Collection
1937.1.12

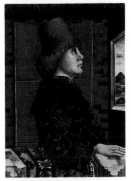

North Italian 15th Century
Portrait of a Man, c. 1460
Wood, .565 x .400 (22 1/4 x 15 3/4)
Samuel H. Kress Collection
1952.5.71

North Netherlandish 15th Century
Adoration of the Magi, fourth quarter of
the 15th century
Transferred from wood to canvas, 1.830 x
1.645 (72 x 64 3/4)
Samuel H. Kress Collection
1952.5.41

Orcagna and Jacopo di Cione

FLORENTINE, active 1343 – 1368;
active 1365 – 1398
Madonna and Child with Angels, before
1370
Wood, 1.410 x .689 (55 1/2 x 27 1/8)
Samuel H. Kress Collection
1952.5.18

Bernard van Orley

BRUSSELS, C. 1488 – 1541
Christ Among the Doctors; reverse: *Putto
with Arms of Jacques Coëne,* c. 1513
Wood, painted surface obverse: .544 x
.329 (21 7/16 x 13) top; x .333 (x 13 1/8)
bottom; panel: .549 x .333 (21 5/8 x
13 1/8); painted surface reverse: .544 x 326
(21 7/16 x 12 7/8) top; x .329 (x 13)
bottom
Inscribed on obverse at center right on red
robe of seated figure: NVLLE ION. NE. M.··
Samuel H. Kress Collection
1952.5.47.a-b

Bernard van Orley

BRUSSELS, C. 1488 – 1541
The Marriage of the Virgin, c. 1513
Wood, painted surface: .544 x .330 (21 7/16
x 13) top; x .351 (x 13 1/4) bottom; panel:
.555 x .340 (21 7/8 x 13 3/8)
Samuel H. Kress Collection
1952.5.48

Sir William Orpen
BRITISH, 1878 – 1931
Mrs. Charles S. Carstairs, 1914
Canvas, 1.000 x .817 (39 3/8 x 32 1/8)
Inscribed at lower right: ORPEN
Gift of Mrs. Charles S. Carstairs
1952.9.3

Adriaen van Ostade
DUTCH, 1610 – 1685
The Cottage Dooryard, 1673
Canvas, .440 x .395 (17 3/8 x 15 5/8)
Inscribed at lower center: *Av. Ostade.*
1673. (Av in ligature)
Widener Collection
1942.9.48

Adriaen van Ostade
DUTCH, 1610 – 1685
Tavern Scene, probably 1660
Wood, .238 x .204 (9 3/8 x 8)
Inscribed at lower left: *Av. Ostade. /*
166[0?]
Gift of John Russell Mason
1977.21.1

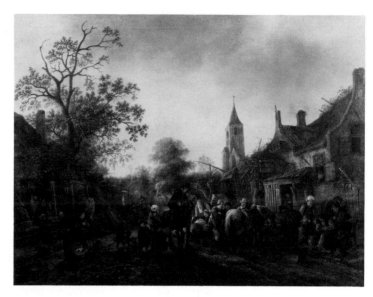

Isack van Ostade
DUTCH, 1621 – 1649
The Halt at the Inn, probably c. 1645
Canvas, .495 x .660 (19 1/2 x 26)
Inscribed at lower right: *Isack van
Os[tade]* / 164[?]
Widener Collection
1942.9.49

Roland Oudot
FRENCH, b. 1897
Matador in White, 1928
Canvas, .923 x .730 (36 3/8 x 28 3/4)
Inscribed at lower right: *Roland Oudot
1928*
Chester Dale Collection
1963.10.51

Roland Oudot
FRENCH, b. 1897
The Market, 1929
Canvas, 1.464 x 1.143 (57 5/8 x 45)
Inscribed at lower right: *Roland Oudot
1929*
Chester Dale Collection
1963.10.187

Follower of Michael Pacher
TYROL
Saint Alban of Mainz, late 15th century
Wood, 1.552 x .517 (61 1/8 x 20 3/8)
Inscribed across bottom:
.Sanctus·Albannus·
Gift of Joanne Freedman
1972.73.1

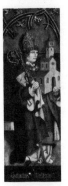

Follower of Michael Pacher
TYROL
Saint Wolfgang, late 15th century
Wood, 1.552 x .516 (61 1/8 x 20 3/8)
Inscribed across bottom:
.Sanctus·Wolfgang.
Gift of Joanne Freedman
1972.73.2

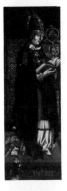

Follower of Michael Pacher
TYROL
Saint Valentine, late 15th century
Wood, 1.552 x .517 (61 1/8 x 20 3/8)
Inscribed across bottom: *.S...us.Vallentin'.*
Gift of Joanne Freedman
1972.73.3

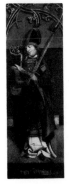

Follower of Michael Pacher
TYROL
Saint Alcuin, late 15th century
Wood, 1.552 x .515 (61 1/8 x 20 1/4)
Inscribed across bottom: *. Sanctus·Alcuinus*
Gift of Joanne Freedman
1972.73.4

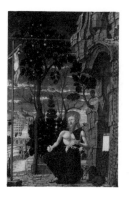

Paduan 15th Century
Saint Jerome in the Wilderness,
c. 1450/1460
Wood, .805 x .550 (31 3/4 x 21 5/8)
Andrew W. Mellon Collection
1937.1.32

Giovanni Paolo Pannini
ROMAN, 1691 or 1692 – 1765
The Interior of the Pantheon, c. 1740
Canvas, 1.283 x .991 (50 1/2 x 39)
Samuel H. Kress Collection
1939.1.24

Giovanni Paolo Pannini
ROMAN, 1691 or 1692 – 1765
Interior of Saint Peter's, Rome, 1746/1754
Canvas, 1.544 x 1.970 (60 3/4 x 77 1/2)
Ailsa Mellon Bruce Fund
1968.13.2

Paolo di Giovanni Fei
SIENESE, mentioned 1369 – 1411
The Presentation of the Virgin, c. 1400
Transferred from wood to hardboard,
1.471 x 1.404 (57 7/8 x 55 1/4)
Samuel H. Kress Collection
1961.9.4

Paolo di Giovanni Fei
SIENESE, mentioned 1369 – 1411
The Assumption of the Virgin,
probably c. 1385
Wood, .667 x .381 (26 1/4 x 15)
Samuel H. Kress Collection
1961.9.71

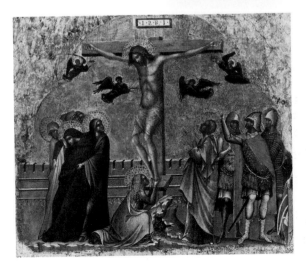

Paolo Veneziano
VENETIAN, active 1333 – 1358/1362
The Crucifixion, c. 1340
Wood, .318 x .375 (12 1/2 x 14 3/4)
Inscribed at upper center: I.N.R.I. (Jesus of
Nazareth, King of the Jews)
Samuel H. Kress Collection
1939.1.143

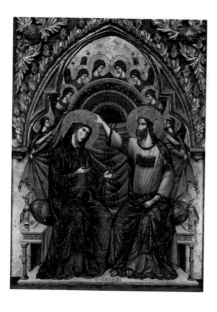

Paolo Veneziano
VENETIAN, active 1333 – 1358/1362
The Coronation of the Virgin, 1324
Wood, .991 x .775 (39 x 30 1/2)
Inscribed at lower center: MCCCXXIIII
Samuel H. Kress Collection
1952.5.87

Jean-Baptiste Joseph Pater
FRENCH, 1695 – 1736
Fête Champêtre, c. 1730
Canvas, .745 x .925 (29 3/8 x 36 1/2)
Samuel H. Kress Collection
1946.7.19

Jean-Baptiste Joseph Pater
FRENCH, 1695 – 1736
On the Terrace, probably c. 1730/1735
Canvas, .718 x 1.000 (28 1/4 x 39 3/8)
Gift of Mr. and Mrs. William D. Vogel in
memory of her father and mother Mr. and
Mrs. Ralph Harmon Booth
1955.3.1

After Jean-Baptiste Joseph Pater
FRENCH
The Gift of the Fishermen
Canvas, .385 x .483 (15 1/4 x 19 1/8)
Gift of Lewis Einstein
1954.17.1

After Jean-Baptiste Joseph Pater
FRENCH
Fête Champêtre
Canvas, .381 x .470 (15 x 18 1/2)
Timken Collection
1960.6.14

Follower of Joachim Patinir
NETHERLANDISH
The Flight into Egypt, c. 1550/1575
Wood, .236 x .150 (9 5/16 x 5 7/8)
Samuel H. Kress Collection
1961.9.81

Perino del Vaga
CENTRAL ITALIAN, 1501 – 1547
The Nativity, 1534
Transferred from wood to canvas, 2.744 x
2.211 (108 1/4 x 87 1/8)
Inscribed at lower center on tablet:
· M · D · XXXIIII · / · PERINO BONAC /
CORSSI · FLORĒNTIN / OPVS FACEBA[T]
(followed by a double monogram
combining the letters of PERINO)
Samuel H. Kress Collection
1961.9.31

Perugino
UMBRIAN, probably 1445 – 1523
*The Crucifixion with the Virgin, Saint
John, Saint Jerome and Saint Mary
Magdalene,* c. 1485
Transferred from wood to canvas, middle
panel: 1.013 x .565 (39 7/8 x 22 1/4); side
panels, each: .952 x .305 (37 1/2 x 12)
Andrew W. Mellon Collection
1937.1.27.a-c

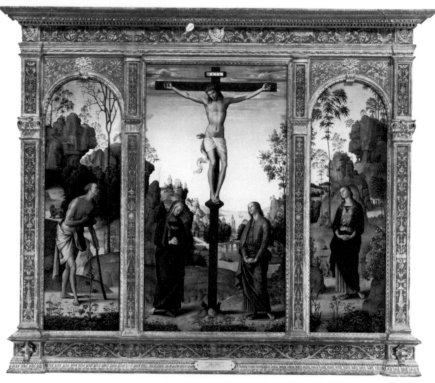

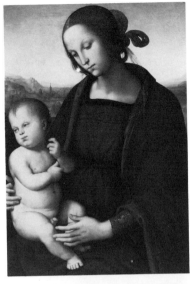

Perugino
UMBRIAN, probably 1445 – 1523
Madonna and Child, after 1500
Wood, .702 x .508 (27 5/8 x 20)
Samuel H. Kress Collection
1939.1.215

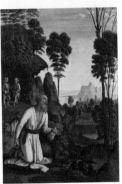

Follower of Perugino
UMBRIAN
Saint Jerome in the Wilderness, c. 1480/
1490
Wood, .626 x .419 (24 5/8 x 16 1/2)
Samuel H. Kress Collection
1939.1.280

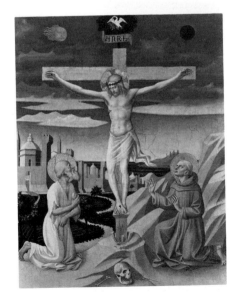

Pesellino
FLORENTINE, 1422 – 1457
*The Crucifixion with Saint Jerome and
Saint Francis*, probably c. 1440/1445
Wood, .622 x .483 (24 1/2 x 19)
Inscribed at upper center on scroll: INRI
Samuel H. Kress Collection
1939.1.109

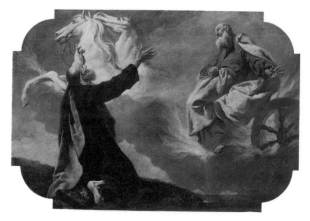

Giovanni Battista Piazzetta
VENETIAN, 1682 or 1683 – 1754
Elijah Taken Up in a Chariot of Fire,
c. 1745
Canvas, 1.746 x 2.648 (68 3/4 x 104 1/4)
Samuel H. Kress Collection
1952.5.70

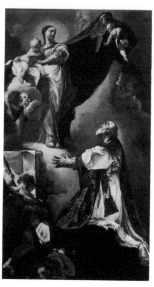

Giovanni Battista Piazzetta
VENETIAN, 1682 or 1683 – 1754
*Madonna and Child Appearing to San
Filippo Neri,* probably 1724
Canvas, 1.120 x .634 (44 1/8 x 25)
Samuel H. Kress Collection
1961.9.82

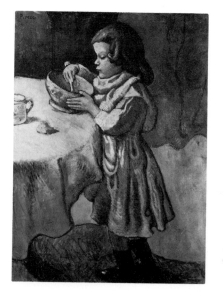

Pablo Picasso
SPANISH, 1881 – 1973
Le Gourmet, 1901
Canvas, .928 x .683 (36 1/2 x 26 7/8)
Inscribed at upper left: *Picasso*
Chester Dale Collection
1963.10.52

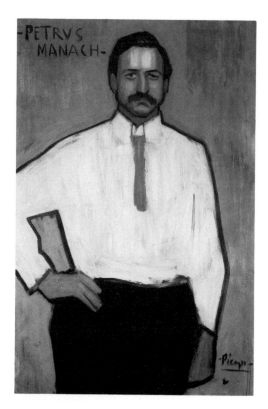

Pablo Picasso
SPANISH, 1881 – 1973
Pedro Mañach, 1901
Canvas, 1.055 x .670 (41 1/2 x 27 1/2)
Inscribed at upper left: -PETRVS MANACH- ;
at lower right: ·*Picasso*–
Chester Dale Collection
1963.10.53

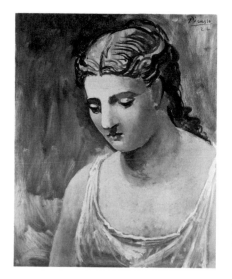

Pablo Picasso
SPANISH, 1881 – 1973
Classical Head, 1922
Canvas, .610 x .502 (24 x 19 3/4)
Inscribed at upper right: *Picasso* / 22
Chester Dale Collection
1963.10.189

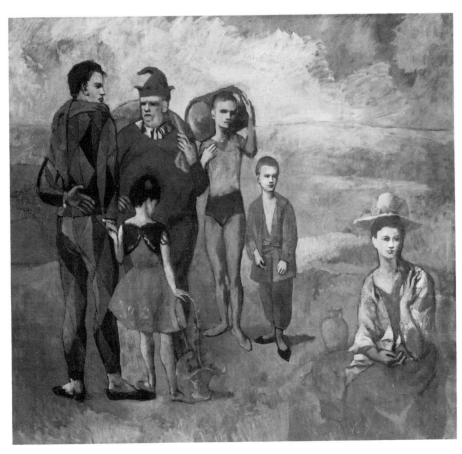

Pablo Picasso
SPANISH, 1881 – 1973
Family of Saltimbanques, 1905
Canvas, 2.128 x 2.296 (83 3/4 x 90 3/8)
Inscribed at lower right: *Picasso*
Chester Dale Collection
1963.10.190

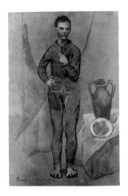

Pablo Picasso
SPANISH, 1881 – 1973
Juggler with Still Life, 1905
Gouache on cardboard, 1.000 x .699
(39 3/8 x 27 1/2)
Inscribed at lower left: *Picasso*
Chester Dale Collection
1963.10.191

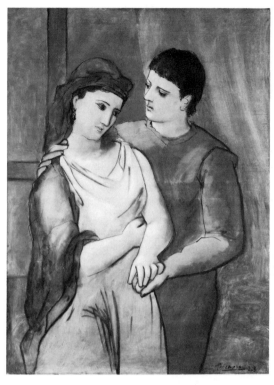

Pablo Picasso
SPANISH, 1881 – 1973
The Lovers, 1923
Canvas, 1.302 x .972 (51 1/4 x 38 1/4)
Inscribed at lower right: *Picasso 23*
Chester Dale Collection
1963.10.192

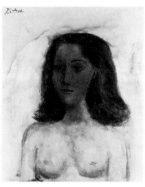

Pablo Picasso
SPANISH, 1881 – 1973
Dora Maar, 1941
Canvas, .730 x .602 (28 3/4 x 23 3/4)
Inscribed at upper left: *Picasso;* on
stretcher bar: *20 Août 41.*
Chester Dale Collection
1963.10.193

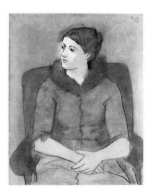

Pablo Picasso
SPANISH, 1881 – 1973
Madame Picasso, 1923
Canvas, 1.003 x .820 (39 7/8 x 32 1/4)
Inscribed at upper right: *Picasso / 23*
Chester Dale Collection
1963.10.194

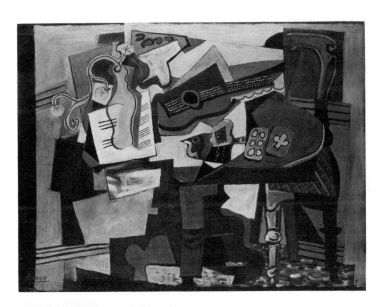

Pablo Picasso
SPANISH, 1881 – 1973
Still Life, 1918
Canvas, .972 x 1.302 (38 1/4 x 51 1/4)
Inscribed at lower left: *Picasso*
Chester Dale Collection
1963.10.195

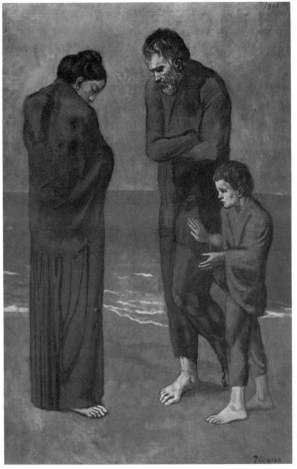

Pablo Picasso
SPANISH, 1881 – 1973
The Tragedy, 1903
Wood, 1.054 x .690 (41 1/2 x 27 1/8)
Inscribed at lower right: *Picasso;* at upper
right: *1903*
Chester Dale Collection
1963.10.196

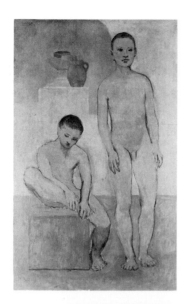

Pablo Picasso
SPANISH, 1881 – 1973
Two Youths, 1905
Canvas, 1.515 x .937 (59 5/8 x 36 7/8)
Inscribed at upper left: *Picasso*
Chester Dale Collection
1963.10.197

Pablo Picasso
SPANISH, 1881 – 1973
Lady with a Fan, 1905
Canvas, 1.003 x .812 (39 1/2 x 32)
Inscribed at lower right: *Picasso / 1905*
Gift of the W. Averell Harriman
Foundation in memory of Marie N.
Harriman
1972.9.19

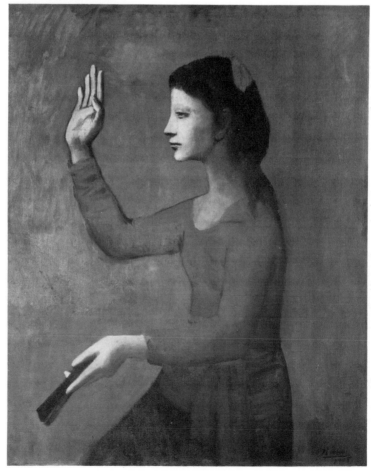

Pablo Picasso
SPANISH, 1881 – 1973
Nude Woman, 1910
Canvas, 1.873 x .610 (73 3/4 x 24)
Inscribed at lower center: *Picasso*
Ailsa Mellon Bruce Fund
1972.46.1

Pablo Picasso
SPANISH, 1881 – 1973
Peonies, 1901
Hardboard on plywood, .578 x .393
(22 3/4 x 15 1/2)
Inscribed at lower right: -*Piicasso* [sic]
Gift of Mrs. Gilbert W. Chapman
1981.41.1

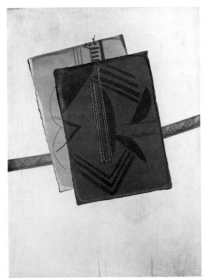

Pablo Picasso
SPANISH, 1881 – 1973
Guitar, 1926
Collage on wood, 1.300 x .970
(51 1/4 x 38 1/4)
Chester Dale Fund
1982.8.1

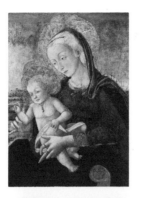

Pier Francesco Fiorentino
FLORENTINE, active 1474 – 1497
Madonna and Child, fourth quarter of the
15th century
Transferred from wood to canvas, .750 x
.545 (29 1/2 x 21 1/2)
Samuel H. Kress Collection
1939.1.214

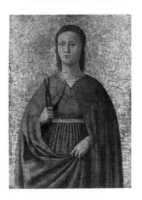

Pseudo Pier Francesco Fiorentino
FLORENTINE, active second half 15th
century
Madonna and Child
Wood, .690 x .465 (27 1/4 x 18 1/4)
Widener Collection
1942.9.50

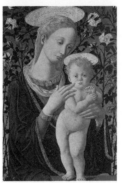

Workshop of Piero della Francesca
UMBRIAN
Saint Apollonia, before 1470
Wood, .387 x .279 (15 1/4 x 11)
Samuel H. Kress Collection
1952.5.19

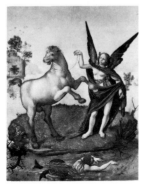

Piero di Cosimo
FLORENTINE, 1462 – 1521
Allegory, c. 1500
Wood, .562 x .441 (22 1/8 x 17 3/8)
Samuel H. Kress Collection
1939.1.160

Piero di Cosimo
FLORENTINE, 1462 – 1521
*The Visitation with Saint Nicholas and
Saint Anthony Abbot,* c. 1490
Wood, 1.842 x 1.886 (72 1/2 x 74 1/4)
Samuel H. Kress Collection
1939.1.361

Piero di Cosimo
FLORENTINE, 1462 – 1521
The Nativity with the Infant Saint John,
c. 1500
Canvas, diameter 1.457 (57 3/8)
Samuel H. Kress Collection
1939.1.371

Camille Pissarro
FRENCH, 1830 – 1903
The Bather, 1895
Canvas, .353 x .273 (13 7/8 x 10 3/4)
Inscribed at lower left: *C.Pissarro.95*
Chester Dale Collection
1963.10.54

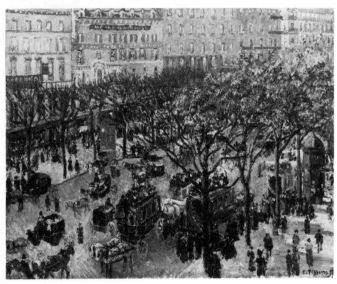

Camille Pissarro
FRENCH, 1830 – 1903
Boulevard des Italiens, Morning, Sunlight,
1897
Canvas, .732 x .921 (28 7/8 x 36 1/4)
Inscribed at lower right: *C.Pissarro.97*
Chester Dale Collection
1963.10.198

Camille Pissarro
FRENCH, 1830 – 1903
Peasant Woman, 1880
Canvas, .731 x .600 (28 3/4 x 23 5/8)
Inscribed at lower right: *C.Pissarro.80*
Chester Dale Collection
1963.10.199

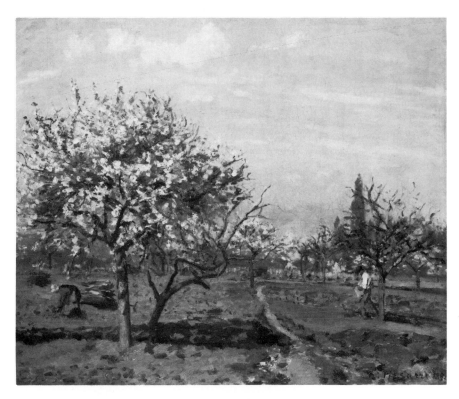

Camille Pissarro
FRENCH, 1830 – 1903
Orchard in Bloom, Louveciennes, 1872
Canvas, .451 x .549 (17 3/4 x 21 5/8)
Inscribed at lower right: C. *Pissarro 1872*
Ailsa Mellon Bruce Collection
1970.17.51

Camille Pissarro
FRENCH, 1830 – 1903
Peasant Girl with a Straw Hat, 1881
Canvas, .734 x .596 (28 7/8 x 23 1/2)
Inscribed at lower right: C. *Pissarro 81*
Ailsa Mellon Bruce Collection
1970.17.52

Camille Pissarro
FRENCH, 1830 – 1903
Hampton Court Green, 1891
Canvas, .543 x .730 (21 3/8 x 28 3/4)
Inscribed at lower left: *C. Pissarro.1891*
Ailsa Mellon Bruce Collection
1970.17.53

Camille Pissarro
FRENCH, 1830 – 1903
The Artist's Garden at Eragny, 1898
Canvas, .736 x .923 (29 x 36 3/8)
Inscribed at lower left: *C. Pissarro.1898*
Ailsa Mellon Bruce Collection
1970.17.54

Camille Pissarro
FRENCH, 1830 – 1903
Place du Carrousel, Paris, 1900
Canvas, .549 x .654 (21 5/8 x 25 3/4)
Inscribed at lower left: *C. Pissarro.1900*
Ailsa Mellon Bruce Collection
1970.17.55

Polidoro Lanzani
VENETIAN, 1515 – 1565
Madonna and Child and the Infant Saint John in a Landscape, c. 1540/1550
Canvas, .279 x .578 (11 x 22 3/4)
Andrew W. Mellon Collection
1937.1.36

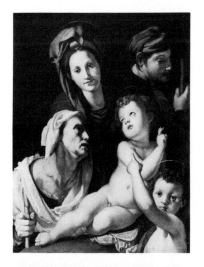

Pontormo
FLORENTINE, 1494 – 1556 or 1557
The Holy Family, c. 1525
Wood, 1.013 x .787 (39 7/8 x 31)
Samuel H. Kress Collection
1939.1.387

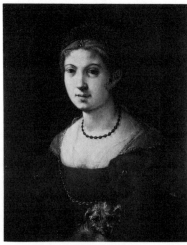

Pontormo
FLORENTINE, 1494 – 1556 or 1557
Portrait of a Young Woman, c. 1535
Wood, .559 x .432 (22 x 17)
Widener Collection
1942.9.51

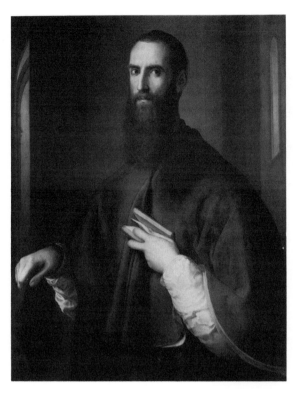

Pontormo
FLORENTINE, 1494 – 1556 or 1557
Monsignor della Casa, probably 1541/1544
Wood, 1.021 x .788 (40 1/8 x 31)
Samuel H. Kress Collection
1961.9.83

Paulus Potter
DUTCH, 1625 – 1654
A Farrier's Shop, 1648
Wood, .483 x .457 (19 x 18)
Inscribed at center left on upper door
frame: *Paulus Potter F. 1648*
Widener Collection
1942.9.52

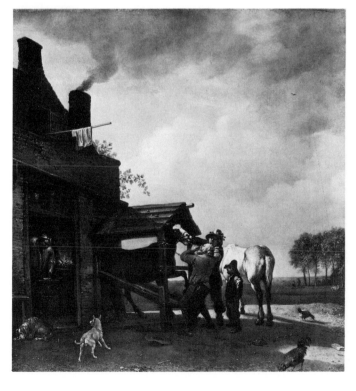

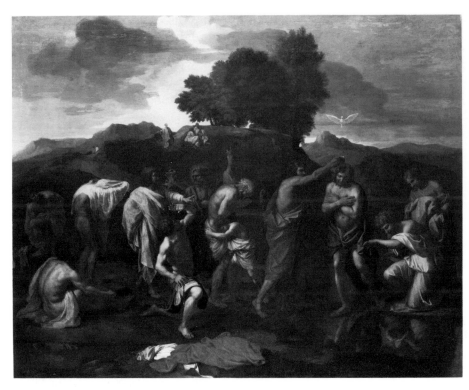

Nicolas Poussin
FRENCH, 1594 – 1665
The Baptism of Christ, 1641/1642
Canvas, .955 x 1.210 (37 5/8 x 47 5/8)
Samuel H. Kress Collection
1946.7.14

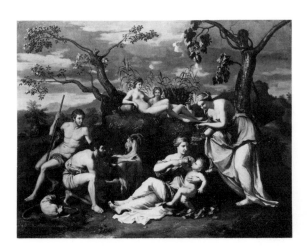

Nicolas Poussin
FRENCH, 1594 – 1665
The Feeding of the Child Jupiter, c. 1640
Canvas, 1.174 x 1.553 (46 1/8 x 61 1/8)
Samuel H. Kress Collection
1952.2.21

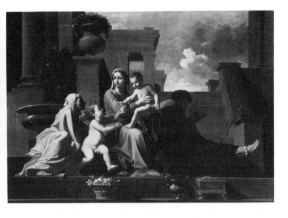

Nicolas Poussin

FRENCH, 1594 – 1665
Holy Family on the Steps, 1648
Canvas, .686 x .978 (27 x 38 1/2)
Samuel H. Kress Collection
1952.5.49

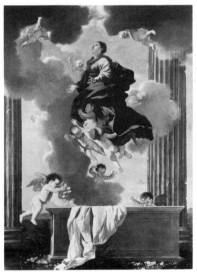

Nicolas Poussin

FRENCH, 1594 – 1665
The Assumption of the Virgin, c. 1626
Canvas, 1.344 x .981 (52 7/8 x 38 5/8)
Ailsa Mellon Bruce Fund
1963.5.1

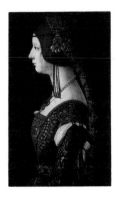

Ambrogio de Predis

MILANESE, C. 1455 – after 1508
Bianca Maria Sforza, probably 1493
Wood, .510 x .325 (20 x 12 3/4)
Inscribed at upper center on headdress is
the Sforza motto: MERITO ET TEMPORE
(With merit and time)
Widener Collection
1942.9.53

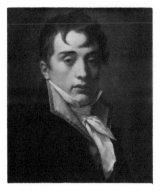

Pierre Paul Prud'hon
FRENCH, 1758 – 1823
David Johnston, 1808
Canvas, .550 x .466 (21 5/8 x 18 3/8)
Inscribed at lower right: *Prudhon / 1808*
Samuel H. Kress Collection
1961.9.84

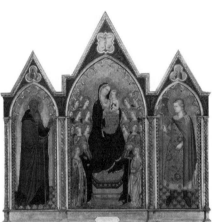

Puccio di Simone and Allegretto Nuzi
FLORENTINE, mid-14th century; and
UMBRIAN, C. 1315 – 1373
Madonna Enthroned with Saints, c. 1354
Wood, left panel: .908 x .343 (35 3/4 x
13 1/2); middle panel: 1.086 x .594
(42 3/4 x 23 3/8); right panel: .902 x .350
(35 1/2 x 13 3/4)
Inscribed on left panel at upper center on
Saint Anthony's nimbus:
·SCS·ANTONIVS·DI·VIENA (Saint Anthony of
Vienne); inscribed on middle panel at
upper center on the Virgin's nimbus:
·SCA·MARIA·MATER·DEI; on Christ's: HS ·
XRO · [LVX] M[VNDI]; across bottom:
[MCCC]LIIII QVESTA TA[VOLA F]ATTA F[A]RE
FRATE GIOVANNI ... (1354 this picture was
commissioned by Fra Giovanni); inscribed
on right panel at upper center on Saint
Venantius' nimbus: ·SCS·VENANCIVS
M[A]RTIRI (Saint Venantius Martyr)
Andrew W. Mellon Collection
1937.1.6.a-c

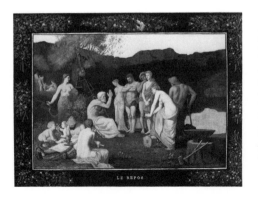

Pierre Puvis de Chavannes
FRENCH, 1824 – 1898
Rest, c. 1863
Canvas, 1.085 x 1.480 (42 3/4 x 58 1/4)
Inscribed at lower left: P.PUVIS DE
CHAVANNES; at lower center in border of
fruits, flowers, and musical instruments: LE
REPOS
Widener Collection
1942.9.54

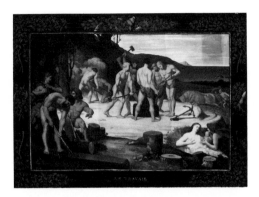

Pierre Puvis de Chavannes
FRENCH, 1824 – 1898
Work, c. 1863
Canvas, 1.085 x 1.480 (42 3/4 x 58 1/4)
Inscribed at lower left: P.PUVIS DE
CHAVANNES; at lower center in border of
oak branches and laborer's tools: LE
TRAVAIL
Widener Collection
1942.9.55

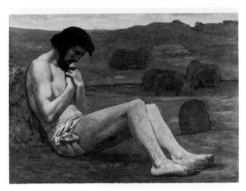

Pierre Puvis de Chavannes
FRENCH, 1824 – 1898
The Prodigal Son, probably c. 1879
Canvas, 1.065 x 1.467 (41 7/8 x 57 3/4)
Chester Dale Collection
1963.10.200

Adam Pynacker
DUTCH, 1622 – 1673
Wooded Landscape with Travelers
Canvas, .570 x .480 (22 1/2 x 18 7/8)
Gift of Ruth B. Benedict and Bertha B.
Leubsdorf in memory of Sophie and Carl
Boschwitz
1979.27.1

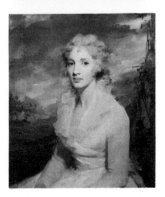

Sir Henry Raeburn
BRITISH, 1756 – 1823
Miss Eleanor Urquhart, c. 1793
Canvas, .746 x .616 (29 3/8 x 24 1/4)
Andrew W. Mellon Collection
1937.1.101

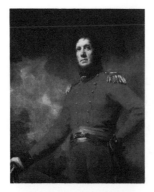

Sir Henry Raeburn
BRITISH, 1756 – 1823
Colonel Francis James Scott, c. 1800
Canvas, 1.276 x 1.016 (50 1/4 x 40)
Andrew W. Mellon Collection
1937.1.102

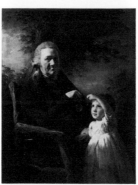

Sir Henry Raeburn
BRITISH, 1756 – 1823
John Tait and His Grandson, c. 1793
Canvas, 1.257 x 1.010 (49 1/2 x 39 3/4)
Andrew W. Mellon Collection
1937.1.103

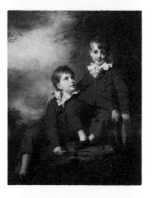

Sir Henry Raeburn
BRITISH, 1756 – 1823
The Binning Children, c. 1811
Canvas, 1.288 x 1.027 (50 5/8 x 40 3/8)
Given in memory of John Woodruff
Simpson
1942.5.2

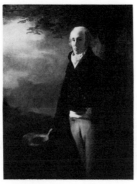

Sir Henry Raeburn
BRITISH, 1756 – 1823
David Anderson, probably c. 1790
Canvas, 1.525 x 1.075 (60 x 46 1/4)
Widener Collection
1942.9.56

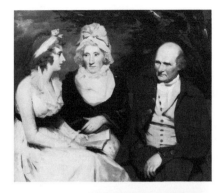

Sir Henry Raeburn
BRITISH, 1756 – 1823
John Johnstone of Alva, His Sister and His Niece, c. 1805
Canvas, 1.016 x 1.200 (40 x 47 1/4)
Gift of Mrs. Robert W. Schuette
1945.10.3

Sir Henry Raeburn
BRITISH, 1756 – 1823
Captain Patrick Miller, c. 1795
Canvas, 1.672 x 1.328 (66 x 52 1/4)
Gift of Pauline Sabin Davis
1948.19.1

Sir Henry Raeburn
BRITISH, 1756 – 1823
Jean Christie, c. 1820
Canvas, .769 x .642 (30 1/4 x 25 1/4)
Gift of Jean McGinley Draper
1954.9.1

Sir Henry Raeburn
BRITISH, 1756 – 1823
Mrs. George Hill, c. 1796
Canvas, .969 x .766 (38 1/8 x 30 1/8)
Ailsa Mellon Bruce Collection
1970.17.130

Attributed to Sir Henry Raeburn
BRITISH, 1756 – 1823
Miss Davidson Reid, c. 1806
Canvas, .755 x .640 (29 3/4 x 25 1/4)
Ailsa Mellon Bruce Collection
1970.17.131

Jean François Raffaëlli
FRENCH, 1850 – 1924
The Flower Vendor
Canvas, .808 x .650 (31 7/8 x 25 1/2)
Inscribed at lower right: JFRAFFAËLLI
Chester Dale Collection
1963.10.55

After James Ramsay
BRITISH
Master Betty, 1804 or after
Pastel on paper mounted on canvas, .406 x
.356 (16 x 14)
Falsely inscribed at lower left: *W. Dunlap*
Andrew W. Mellon Collection
1947.17.36

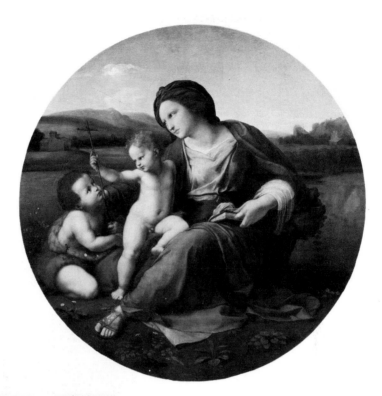

Raphael
UMBRIAN, 1483 – 1520
The Alba Madonna, c. 1510
Transferred from wood to canvas,
diameter: .945 (37 1/4)
Andrew W. Mellon Collection
1937.1.24

Raphael
UMBRIAN, 1483 – 1520
The Niccolini-Cowper Madonna, 1508
Wood, .807 x .575 (31 3/4 x 22 5/8)
Inscribed at center right on border of the
Madonna's bodice: MDVIII·R·V·PIN (1508
Raphael of Urbino painted it)
Andrew W. Mellon Collection
1937.1.25

Raphael

UMBRIAN, 1483 – 1520
Saint George and the Dragon, c. 1506
Wood, .285 x .215 (11 1/8 x 8 3/8)
Inscribed across center on breast strap of
horse: RAPHELLO / ·V· (Raphael of Urbino);
on garter: HONI (beginning of the motto of
the Order of the Garter, *Honi soit qui mal
y pense,* Disgraced be he who thinks ill of it)
Andrew W. Mellon Collection
1937.1.26

Raphael

UMBRIAN, 1483 – 1520
The Small Cowper Madonna, c. 1505
Wood, .595 x .440 (23 3/8 x 17 3/8)
Widener Collection
1942.9.57

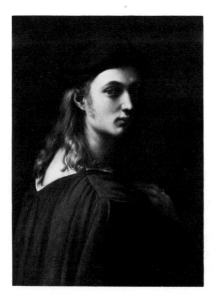

Raphael

UMBRIAN, 1483 – 1520
Bindo Altoviti, c. 1515
Wood, .597 x .438 (23 1/2 x 17 1/4)
Samuel H. Kress Collection
1943.4.33

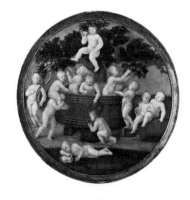

Follower of Raphael
UMBRIAN
Putti with a Wine Press, c. 1500
Wood, diameter: .333 (13 1/8)
Samuel H. Kress Collection
1952.5.72

Odilon Redon
FRENCH, 1840 – 1916
Pandora, 1910/1912
Canvas, 1.436 x .629 (56 1/2 x 24 3/4)
Inscribed at lower right: ODILON REDON
Chester Dale Collection
1963.10.56

Odilon Redon
FRENCH, 1840 – 1916
Saint Sebastian, 1910/1912
Canvas, 1.440 x .628 (56 3/4 x 24 3/4)
Inscribed at lower left: ODILON REDON
Chester Dale Collection
1963.10.57

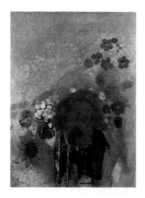

Odilon Redon
FRENCH, 1840 – 1916
Evocation of Roussel, c. 1912
Canvas, .734 x .543 (28 7/8 x 21 3/8)
Inscribed at lower left: ODILON REDON
Chester Dale Collection
1963.10.203

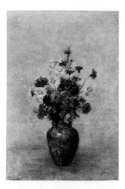

Odilon Redon
FRENCH, 1840 – 1916
Flowers in a Vase, c. 1910
Canvas, .559 x .394 (22 x 15 1/2)
Inscribed at lower right: ODILON REDON
Ailsa Mellon Bruce Collection
1970.17.56

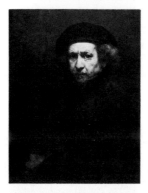

Rembrandt van Rijn
DUTCH, 1606 – 1669
Self-Portrait, 1659
Canvas, .845 x .660 (33 1/4 x 26)
Inscribed at center left: *Rembrandt f. 1659*
Andrew W. Mellon Collection
1937.1.72

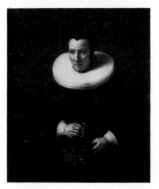

Rembrandt van Rijn
DUTCH, 1606 – 1669
An Old Lady with a Book, 1647
Canvas, 1.097 x .915 (43 1/4 x 36)
Inscribed at lower left: *Rembr[an]dt /*
16[4]7
Andrew W. Mellon Collection
1937.1.73

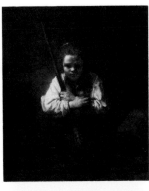

Rembrandt van Rijn
DUTCH, 1606 – 1669
A Girl with a Broom, 1651
Canvas, 1.073 x .914 (42 1/4 x 36)
Inscribed at lower left on rim of well:
Rembrandt f. 1651
Andrew W. Mellon Collection
1937.1.74

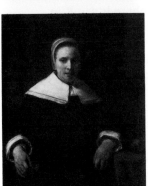

Rembrandt van Rijn
DUTCH, 1606 – 1669
A Woman Holding a Pink, 1656
Canvas, 1.026 x .857 (40 3/8 x 33 3/4)
Inscribed at upper right: *Rembrandt. /
f.1656*
Andrew W. Mellon Collection
1937.1.75

Rembrandt van Rijn
DUTCH, 1606 – 1669
Lucretia, 1664
Canvas, 1.200 x 1.010 (47 1/4 x 39 3/4)
Inscribed at center left: *Rembrandt / 1664*
Andrew W. Mellon Collection
1937.1.76

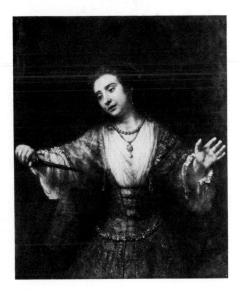

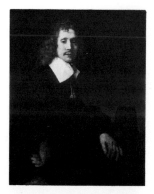

Rembrandt van Rijn
DUTCH, 1606 – 1669
*A Young Man Seated at a Table, 1662/
1663*
Canvas, 1.099 x .895 (43 1/4 x 35 1/4)
Inscribed at center right: *Rembrandt 166[2
or 3]*
Andrew W. Mellon Collection
1937.1.77

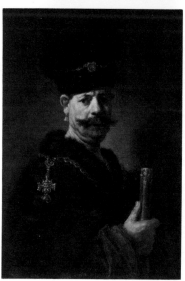

Rembrandt van Rijn
DUTCH, 1606 – 1669
A Polish Nobleman, 1637
Wood, .968 x .660 (38 1/8 x 26)
Inscribed at upper right: *Rembrandt. f.
/1637*
Andrew W. Mellon Collection
1937.1.78

Rembrandt van Rijn
DUTCH, 1606 – 1669
Joseph Accused by Potiphar's Wife, 1655
Canvas, 1.057 x .978 (41 5/8 x 38 1/2)
Inscribed at lower right: *Rembrandt. f.
1655*
Andrew W. Mellon Collection
1937.1.79

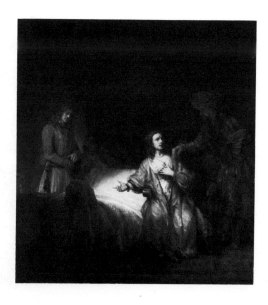

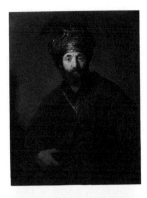

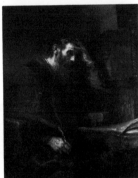

Rembrandt van Rijn
DUTCH, 1606 – 1669
A Turk, c. 1630/1635
Canvas, .984 x .740 (38 3/4 x 29 1/8)
Inscribed at center left: *[R]embrandt. ft.*
Andrew W. Mellon Collection
1940.1.13

Rembrandt van Rijn
DUTCH, 1606 – 1669
The Apostle Paul, probably 1657
Canvas, 1.289 x 1.019 (50 3/4 x 40 1/8)
Inscribed at lower right on desk:
Rembrandt. f
Widener Collection
1942.9.59

Rembrandt van Rijn
DUTCH, 1606 – 1669
The Circumcision, 1661
Canvas, .565 x .750 (22 1/4 x 29 1/2)
Inscribed at lower right: *Rembrandt f /*
1661
Widener Collection
1942.9.60

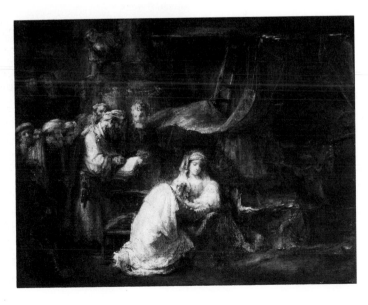

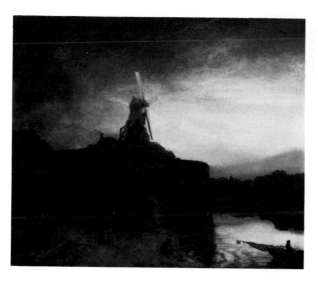

Rembrandt van Rijn
DUTCH, 1606 – 1669
The Mill, c. 1650
Canvas, .876 x 1.056 (34 1/2 x 41 5/8)
Widener Collection
1942.9.62

Rembrandt van Rijn
DUTCH, 1606 – 1669
Philemon and Baucis, 1658
Wood, .545 x .685 (21 1/2 x 27)
Inscribed at lower left: *Rembrandt f. 1658*
Widener Collection
1942.9.65

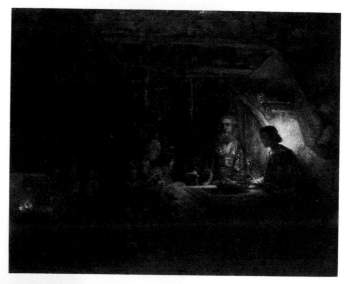

Rembrandt van Rijn
DUTCH, 1606 – 1669
*Portrait of a Gentleman with a Tall Hat
and Gloves,* c. 1660
Canvas, .995 x .825 (39 1/8 x 32 1/2)
Widener Collection
1942.9.67

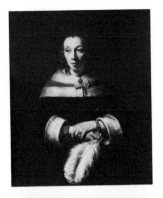

Rembrandt van Rijn
DUTCH, 1606 – 1669
Portrait of a Lady with an Ostrich-Feather Fan, c. 1660
Canvas, .995 x .830 (39 1/4 x 32 5/8)
Inscribed at lower left: *Rembrandt*
Widener Collection
1942.9.68

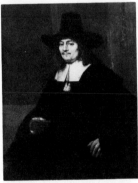

Rembrandt van Rijn
DUTCH, 1606 – 1669
Portrait of a Man in a Tall Hat, c. 1662
Canvas, 1.213 x .940 (47 3/4 x 37)
Widener Collection
1942.9.69

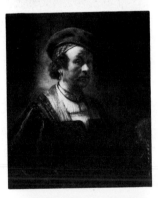

Rembrandt van Rijn
DUTCH, 1606 – 1669
Self-Portrait, 1650
Canvas, .920 x .755 (36 1/4 x 29 3/4)
Inscribed at center right: *Rembrandt / f.*
1650
Widener Collection
1942.9.70

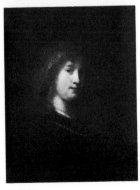

Rembrandt van Rijn
DUTCH, 1606 – 1669
Saskia van Uylenburgh, the Wife of the Artist, probably 1633
Wood, .605 x .490 (23 3/4 x 19 1/4)
Widener Collection
1942.9.71

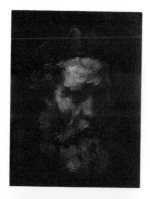

Follower of Rembrandt van Rijn
DUTCH
Head of Saint Matthew, probably 1660/
1670
Wood, .250 x .195 (9 7/8 x 7 3/4)
Widener Collection
1942.9.58

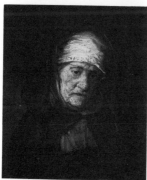

Follower of Rembrandt van Rijn
DUTCH
Head of an Aged Woman, c. 1645
Wood, .210 x .172 (8 1/4 x 6 3/4)
Inscribed at center left by a later hand:
Rembrandt / f. 1657
Widener Collection
1942.9.64

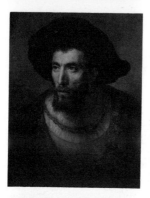

**Follower of Rembrandt van Rijn
(Possibly Willem Drost)**
DUTCH, active c. 1650 – 1655
The Philosopher, c. 1655
Wood, .615 x .495 (24 1/4 x 19 1/2)
Widener Collection
1942.9.66

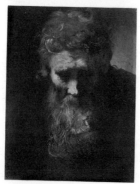

Style of Rembrandt van Rijn
DUTCH
Study of an Old Man, possibly 18th
century
Wood, .280 x .215 (11 1/8 x 8 1/2)
Widener Collection
1942.9.63

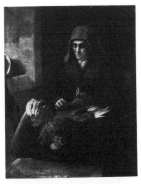

Style of Rembrandt van Rijn
DUTCH
Old Woman Plucking a Fowl
Canvas, 1.330 x 1.047 (52 3/8 x 41 1/4)
Gift of Dr. and Mrs. Walter Timme
1956.1.1

After Rembrandt van Rijn
DUTCH
The Descent from the Cross, c. 1655
Canvas, 1.429 x 1.111 (56 1/4 x 43 3/4)
Falsely inscribed at lower center:
Rembrandt f. 165[1?]
Widener Collection
1942.9.61

Auguste Renoir
FRENCH, 1841 – 1919
The Dancer, 1874
Canvas, 1.425 x .945 (56 1/8 x 37 1/8)
Inscribed at lower right: *A. Renoir. 74.*
Widener Collection
1942.9.72

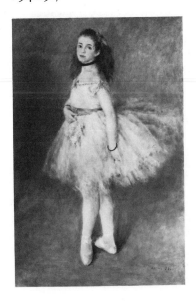

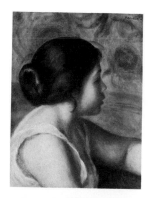

Auguste Renoir
FRENCH, 1841 – 1919
Head of a Young Girl, c. 1890
Canvas, .426 x .333 (16 3/4 x 13 1/8)
Inscribed at upper right: *Renoir.*
Gift of Vladimir Horowitz
1948.18.1

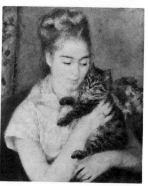

Auguste Renoir
FRENCH, 1841 – 1919
Woman with a Cat, c. 1875
Canvas, .560 x .464 (22 x 18 1/4)
Inscribed at lower left: *Renoir.*
Gift of Mr. and Mrs. Benjamin E. Levy
1950.12.1

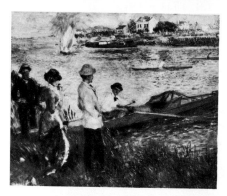

Auguste Renoir
FRENCH, 1841 – 1919
Oarsmen at Chatou, 1879
Canvas, .813 x 1.003 (32 x 39 1/2)
Inscribed at lower right: *A.Renoir. 79*
Gift of Sam A. Lewisohn
1951.5.2

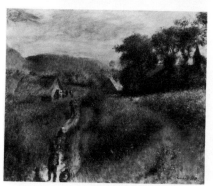

Auguste Renoir
FRENCH, 1841 – 1919
The Vintagers, 1879
Canvas, .542 x .654 (21 1/4 x 25 3/4)
Inscribed at lower right: *Renoir. 79.*
Gift of Margaret Seligman Lewisohn in
memory of her husband, Sam A. Lewisohn
1954.8.1

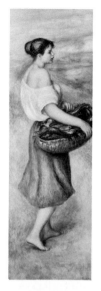

Auguste Renoir
FRENCH, 1841 – 1919
Girl with a Basket of Fish, c. 1889
Canvas, 1.307 x .418 (51 1/2 x 16 1/2)
Inscribed at lower right: *Renoir*
Gift of William Robertson Coe
1956.4.1

Auguste Renoir
FRENCH, 1841 – 1919
Girl with a Basket of Oranges, c. 1889
Canvas, 1.307 x .420 (51 1/2 x 16 1/2)
Inscribed at lower right: *Renoir*
Gift of William Robertson Coe
1956.4.2

Auguste Renoir
FRENCH, 1841 – 1919
Madame Henriot, c. 1876
Canvas, .659 x .498 (26 x 19 5/8)
Inscribed at lower left: *Renoir.*
Gift of the Adele R. Levy Fund, Inc.
1961.3.1

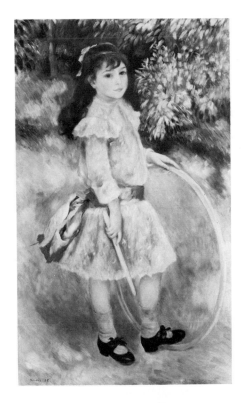

Auguste Renoir
FRENCH, 1841 – 1919
Girl with a Hoop, 1885
Canvas, 1.257 x .766 (49 1/2 x 30 1/8)
Inscribed at lower left: *Renoir. 85.*
Chester Dale Collection
1963.10.58

Auguste Renoir
FRENCH, 1841 – 1919
Marie Murer, 1877
Canvas, oval, .676 x .571 (26 5/8 x 22 1/2)
Inscribed at center left: *Renoir.*
Chester Dale Collection
1963.10.59

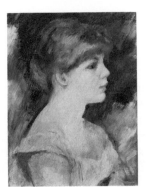

Auguste Renoir
FRENCH, 1841 – 1919
Suzanne Valadon, c. 1885
Canvas, .412 x .318 (16 1/4 x 12 1/2)
Inscribed at upper right: *renoir*
Chester Dale Collection
1963.10.60

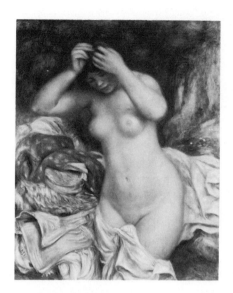

Auguste Renoir
FRENCH, 1841 – 1919
Bather Arranging Her Hair, 1893
Canvas, .922 x .739 (36 3/8 x 29 1/8)
Inscribed at lower right: *Renoir.*
Chester Dale Collection
1963.10.204

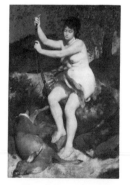

Auguste Renoir
FRENCH, 1841 – 1919
Diana, 1867
Canvas, 1.995 x 1.295 (77 x 51 1/4)
Inscribed at lower right: A. RENOIR 1867
Chester Dale Collection
1963.10.205

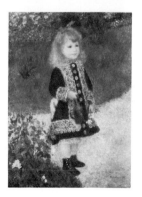

Auguste Renoir
FRENCH, 1841 – 1919
A Girl with a Watering Can, 1876
Canvas, 1.003 x .732 (39 1/2 x 28 3/4)
Inscribed at lower right: *Renoir. 76.*
Chester Dale Collection
1963.10.206

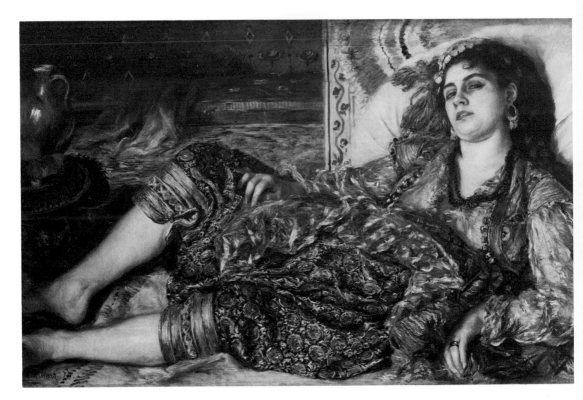

Auguste Renoir
FRENCH, 1841 – 1919
Odalisque, 1870
Canvas, .692 x 1.226 (27 1/4 x 48 1/4)
Inscribed at lower left: *A. Renoir. 70.*
Chester Dale Collection
1963.10.207

Auguste Renoir
FRENCH, 1841 – 1919
Caroline Rémy ("Séverine"), c. 1885
Pastel on paper, .623 x .508 (24 1/2 x 20)
Inscribed at lower left: *Renoir*
Chester Dale Collection
1963.10.208

Auguste Renoir
FRENCH, 1841 – 1919
Mademoiselle Sicot, 1865
Canvas, 1.160 x .895 (45 3/4 x 35 1/4)
Inscribed at center right: A. RENOIR / 1865
Chester Dale Collection
1963.10.209

Auguste Renoir
FRENCH, 1841 – 1919
Nude, c. 1895
Canvas, .843 x .671 (33 1/4 x 26 1/2)
Inscribed at upper right: *Renoir.*
Gift of Eugene and Agnes E. Meyer
1967.13.1

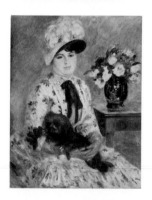

Auguste Renoir
FRENCH, 1841 – 1919
Madame Hagen, 1883
Canvas, .921 x .730 (36 1/4 x 28 3/4)
Inscribed at center right: *Renoir. 83.*
Gift of Angelika Wertheim Frink
1969.10.1

Auguste Renoir
FRENCH, 1841 – 1919
Head of a Dog, 1870
Canvas, .219 x .200 (8 5/8 x 7 7/8)
Inscribed at lower left: *.Renoir.*
Ailsa Mellon Bruce Collection
1970.17.57

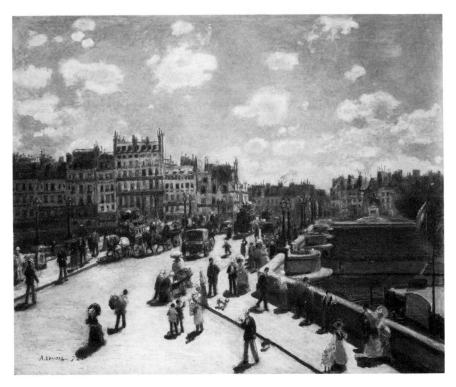

Auguste Renoir
FRENCH, 1841 – 1919
Pont Neuf, Paris, 1872
Canvas, .753 x .937 (29 5/8 x 36 7/8)
Inscribed at lower left: *A. Renoir. 72.*
Ailsa Mellon Bruce Collection
1970.17.58

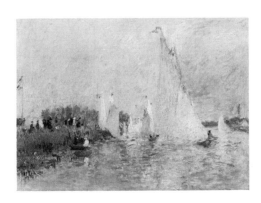

Auguste Renoir
FRENCH, 1841 – 1919
Regatta at Argenteuil, 1874
Canvas, .324 x 456 (12 3/4 x 18)
Ailsa Mellon Bruce Collection
1970.17.59

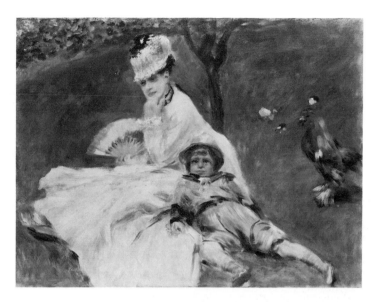

Auguste Renoir
FRENCH, 1841 — 1919
Madame Monet and Her Son, 1874
Canvas, .504 x .680 (19 7/8 x 26 3/4)
Ailsa Mellon Bruce Collection
1970.17.60

Auguste Renoir
FRENCH, 1841 — 1919
Picking Flowers, 1875
Canvas, .543 x .652 (21 3/8 x 25 5/8)
Inscribed at lower right: *Renoir ·*
Ailsa Mellon Bruce Collection
1970.17.61

Auguste Renoir
FRENCH, 1841 — 1919
Young Woman Braiding Her Hair, 1876
Canvas, .556 x .464 (21 7/8 x 18 1/4)
Inscribed at lower left: *Renoir.76*
Ailsa Mellon Bruce Collection
1970.17.63

Auguste Renoir
FRENCH, 1841 – 1919
Georges Rivière, 1877
Cement, .368 x .293 (14 1/2 x 11 1/2)
Inscribed at lower left: *Renoir.77*
Ailsa Mellon Bruce Collection
1970.17.64

Auguste Renoir
FRENCH, 1841 – 1919
Landscape between Storms, 1874/1875
Canvas, .244 x .327 (9 5/8 x 12 7/8)
Inscribed at lower left: *renoir*
Ailsa Mellon Bruce Collection
1970.17.65

Auguste Renoir
FRENCH, 1841 – 1919
Woman by a Fence, 1866
Canvas, .250 x .161 (9 7/8 x 6 3/8)
Inscribed at lower left: AR.
Ailsa Mellon Bruce Collection
1970.17.66

Auguste Renoir
FRENCH, 1841 – 1919
Woman Standing by a Tree, 1866
Canvas, .252 x .159 (9 7/8 x 6 1/4)
Inscribed at lower left: AR
Ailsa Mellon Bruce Collection
1970.17.67

Auguste Renoir
FRENCH, 1841 – 1919
Woman in a Park, 1870
Canvas, .261 x .161 (10 1/4 x 6 3/8)
Inscribed at lower right: R
Ailsa Mellon Bruce Collection
1970.17.68

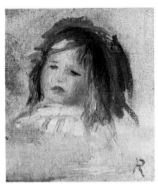

Auguste Renoir
FRENCH, 1841 – 1919
Child with Blond Hair, 1895/1900
Canvas, .097 x .085 (3 3/4 x 3 3/8)
Inscribed at lower right: R
Ailsa Mellon Bruce Collection
1970.17.69

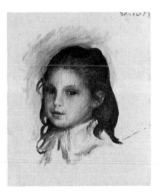

Auguste Renoir
FRENCH, 1841 – 1919
Child with Brown Hair, 1887/1888
Canvas, .118 x .102 (4 5/8 x 4)
Inscribed at upper right: *renoir*
Ailsa Mellon Bruce Collection
1970.17.70

Auguste Renoir
FRENCH, 1841 – 1919
Young Girl Reading, c. 1888
Canvas, .156 x 112 (6 1/8 x 4 3/8)
Inscribed at lower left: R.
Ailsa Mellon Bruce Collection
1970.17.71

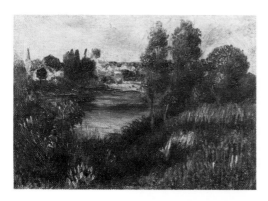

Auguste Renoir
FRENCH, 1841 – 1919
Landscape at Vétheuil, c. 1890
Canvas, .115 x .165 (4 1/2 x 6 1/2)
Inscribed at lower center: *renoir*
Ailsa Mellon Bruce Collection
1970.17.72

Auguste Renoir
FRENCH, 1841 – 1919
Small Study for a Nude, 1882
Canvas, .133 x .103 (5 1/8 x 4)
Inscribed at lower right: R.
Ailsa Mellon Bruce Collection
1970.17.73

Auguste Renoir
FRENCH, 1841 – 1919
Nude with Figure in Background, c. 1882
Canvas, .128 x .083 (5 x 3 1/4)
Inscribed at lower right: *renoir.*
Ailsa Mellon Bruce Collection
1970.17.74

Auguste Renoir
FRENCH, 1841 – 1919
The Blue River, c. 1890/1900
Canvas, .080 x .096 (3 1/8 x 3 3/4)
Inscribed at lower right: *renoir*
Ailsa Mellon Bruce Collection
1970.17.75

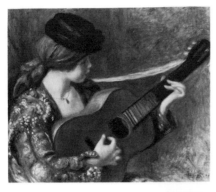

Auguste Renoir
FRENCH, 1841 – 1919
Young Spanish Woman with a Guitar,
1898
Canvas, .556 x .652 (21 7/8 x 25 5/8)
Inscribed at lower right: *Renoir.98.*
Ailsa Mellon Bruce Collection
1970.17.76

Auguste Renoir
FRENCH, 1841 – 1919
Maison de la Poste, Cagnes, 1906/1907
Canvas, .133 x .225 (5 1/4 x 8 7/8)
Inscribed at lower left: *Renoir.*
Ailsa Mellon Bruce Collection
1970.17.77

Auguste Renoir
FRENCH, 1841 – 1919
Jeanne Samary, 1878
Canvas, .191 x .181 (7 1/2 x 7 1/8)
Inscribed at upper left in monogram: AR
Ailsa Mellon Bruce Collection
1970.17.78

Auguste Renoir
FRENCH, 1841 – 1919
Peaches on a Plate, 1902/1905
Canvas, .222 x .356 (8 3/4 x 14)
Atelier stamp at lower left: *Renoir*
Ailsa Mellon Bruce Collection
1970.17.79

Auguste Renoir
FRENCH, 1841 – 1919
Flowers in a Vase, c. 1866
Canvas, .813 x .651 (32 x 25 5/8)
Collection of Mr. and Mrs. Paul Mellon
1983.1.32

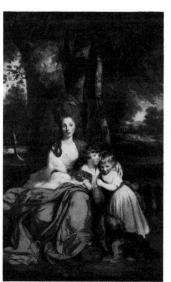

Sir Joshua Reynolds
BRITISH, 1723 – 1792
Lady Elizabeth Delmé and Her Children,
1777/1780
Canvas, 2.392 x 1.478 (94 x 58 1/8)
Andrew W. Mellon Collection
1937.1.95

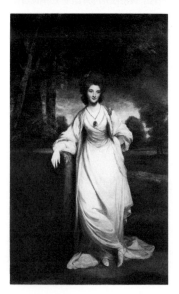

Sir Joshua Reynolds
BRITISH, 1723 – 1792
Lady Elizabeth Compton, 1781
Canvas, 2.400 x 1.486 (94 1/2 x 58 1/2)
Andrew W. Mellon Collection
1937.1.97

Sir Joshua Reynolds
BRITISH, 1723 – 1792
Lady Caroline Howard, c. 1778
Canvas, 1.429 x 1.130 (56 1/4 x 44 1/2)
Inscribed at lower right: *Lady Caroline Howard / Lady Cawdor.*
Andrew W. Mellon Collection
1937.1.106

Sir Joshua Reynolds
BRITISH, 1723 – 1792
Lady Cornewall, c. 1785
Canvas, 1.270 x 1.016 (50 x 40)
Widener Collection
1942.9.74

Sir Joshua Reynolds
BRITISH, 1723 – 1792
Lady Betty Hamilton, 1758
Canvas, 1.168 x .838 (46 x 33)
Widener Collection
1942.9.75

Sir Joshua Reynolds
BRITISH, 1723 – 1792
Squire Musters, 1777/1780
Canvas, 2.385 x 1.473 (93 7/8 x 58)
Given in memory of Governor Alvan
T. Fuller by The Fuller Foundation, Inc.
1961.2.2

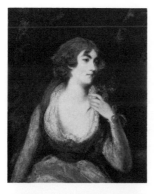

Follower of Sir Joshua Reynolds
BRITISH
The Honorable Mrs. Gray
Canvas, .760 x .635 (30 x 25)
Widener Collection
1942.9.73

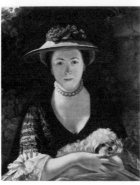

After Sir Joshua Reynolds
BRITISH
Nelly O'Brien, 19th century
Canvas, .760 x .635 (30 x 25)
Widener Collection
1942.9.76

Augustin Théodule Ribot
FRENCH, 1823 – 1891
Portrait of a Man
Cardboard on wood, .153 x .114 (6 x 4 1/2)
Inscribed at lower left: *tRibot.*
Chester Dale Collection
1963.10.61

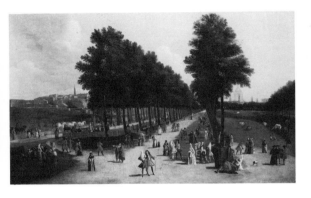

Attributed to Marco Ricci
VENETIAN, 1676 – 1729
A View of the Mall from Saint James's Park, c. 1710
Canvas, 1.141 x 1.952 (45 x 76 7/8)
Ailsa Mellon Bruce Collection
1970.17.132

Sebastiano Ricci
VENETIAN, 1659 – 1734
A Miracle of Saint Francis of Paola, probably 1733/1734
Canvas, .838 x .349 (33 x 13 3/4)
Samuel H. Kress Collection
1939.1.71

Sebastiano Ricci
VENETIAN, 1659 – 1734
The Finding of the True Cross, probably 1733/1734
Canvas, .838 x .349 (33 x 13 3/4)
Samuel H. Kress Collection
1939.1.72

Sebastiano Ricci
VENETIAN, 1659 – 1734
The Last Supper, 1713/1714
Canvas, .673 x 1.038 (26 1/2 x 40 7/8)
Samuel H. Kress Collection
1943.4.32

Sebastiano Ricci and Marco Ricci
VENETIAN, 1676 – 1729; 1659 – 1734
*Memorial to Admiral Sir Clowdisley
Shovell,* c. 1725
Canvas, 2.223 x 1.588 (87 1/2 x 62 1/2)
Inscribed at lower left on stone: B. / M.
RICCI / *Faciebant* (Bastiano and Marco
Ricci made it)
Samuel H. Kress Collection
1961.9.58

Bridget Riley
BRITISH, b. 1931
Balm, 1964
Canvas, 1.950 x 1.950 (76 3/4 x 76 3/4)
Gift of Mr. and Mrs. Burton Tremaine
1970.37.2

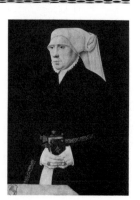

Ludger tom Ring, the Elder
GERMAN, 1496 – 1547
Portrait of a Lady, 1532
Wood, .445 x .320 (17 1/2 x 12 1/2)
Inscribed across top: *Bloes bin ich auss
muther leib kome. Bloes werd ich wider
hin g.../Anno 1532 Aetatis sŭae 45* (Naked
came I out of my mother's womb, and
naked shall I return thither) from Job 1:21
(year 1532, age 45)
Chester Dale Collection
1942.16.3

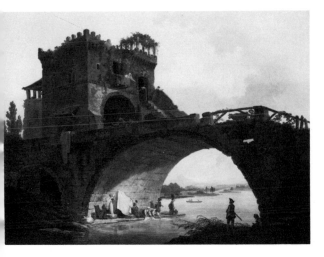

Hubert Robert
FRENCH, 1733 – 1808
The Old Bridge, probably c. 1775
Canvas, .913 x 1.210 (35 7/8 x 47 5/8)
Samuel H. Kress Collection
1952.5.50

Ercole de' Roberti
FERRARESE, 1451/1456 – 1496
Giovanni II Bentivoglio, c. 1480
Wood, .537 x .381 (21 1/8 x 15)
Samuel H. Kress Collection
1939.1.219

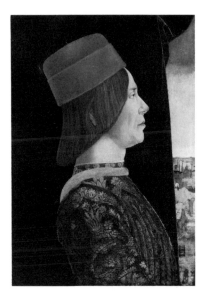 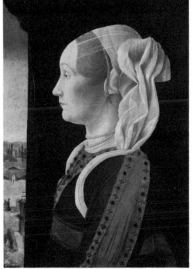

Ercole de' Roberti
FERRARESE, 1451/1456 – 1496
Ginevra Bentivoglio, c. 1480
Wood, .537 x .387 (21 1/8 x 15 1/4)
Samuel H. Kress Collection
1939.1.220

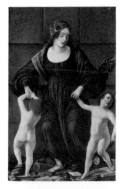

Ercole de' Roberti
FERRARESE, 1451/1456 – 1496
The Wife of Hasdrubal and Her Children,
c. 1480/1490
Wood, .471 x .306 (18 1/2 x 12)
Ailsa Mellon Bruce Fund
1965.7.1

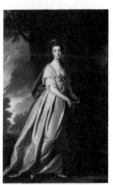

George Romney
BRITISH, 1734 – 1802
Lady Broughton, 1770/1773
Canvas, 2.388 x 1.473 (94 x 58)
Andrew W. Mellon Collection
1937.1.94

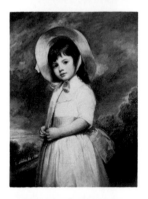

George Romney
BRITISH, 1734 – 1802
Miss Willoughby, 1781/1783
Canvas, .921 x .715 (36 1/4 x 28 1/8)
Andrew W. Mellon Collection
1937.1.104

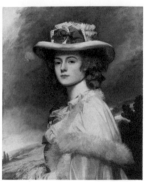

George Romney
BRITISH, 1734 – 1802
Mrs. Davenport, 1782/1784
Canvas, .765 x .640 (30 1/8 x 25 1/8)
Andrew W. Mellon Collection
1937.1.105

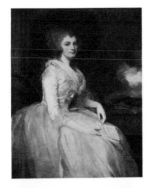

George Romney
BRITISH, 1734 – 1802
Mrs. Blair, 1787/1789
Canvas, 1.270 x 1.015 (50 x 40)
Widener Collection
1942.9.77

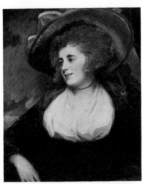

George Romney
BRITISH, 1734 – 1802
Lady Arabella Ward, 1783/1788
Canvas, .760 x .635 (30 x 25)
Widener Collection
1942.9.78

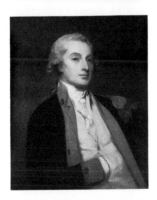

George Romney
BRITISH, 1734 – 1802
Mr. Forbes, c. 1780/1790
Canvas, .764 x .635 (30 x 25)
Gift of Pauline Sabin Davis
1954.14.1

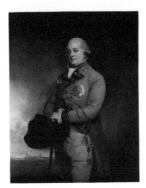

George Romney
BRITISH, 1734 – 1802
Sir Archibald Campbell, probably 1792
Canvas, 1.534 x 1.239 (60 3/8 x 48 3/4)
Timken Collection
1960.6.31

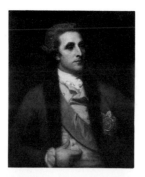

George Romney
BRITISH, 1734 – 1802
Sir William Hamilton, probably 1783
Canvas, .768 x .651 (30 1/4 x 25 5/8)
Ailsa Mellon Bruce Collection
1970.17.133

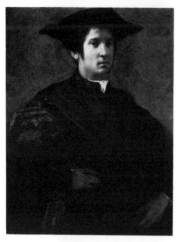

Rosso Fiorentino
FLORENTINE, 1494 – 1540
Portrait of a Man, early 1520s
Wood, .887 x .679 (34 7/8 x 26 3/4)
Samuel H. Kress Collection
1961.9.59

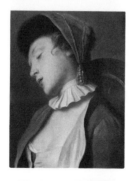

Pietro Rotari
VENETIAN, 1707 – 1762
A Sleeping Girl, 1756/1762
Canvas, .445 x .343 (17 1/2 x 13 1/2)
Samuel H. Kress Collection
1939.1.107

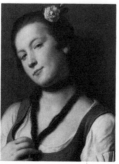

Pietro Rotari
VENETIAN, 1707 – 1762
A Girl with a Flower in Her Hair,
1756/1762
Canvas, .445 x .343 (17 1/2 x 13 1/2)
Samuel H. Kress Collection
1939.1.108

Georges Rouault
FRENCH, 1871 – 1958
Café Scene, 1906
Gouache on paper, .386 x .286 (15 1/4 x
11 1/4)
Inscribed at upper right: *G. Rouault / 1906*
Chester Dale Collection
1963.10.210

Georges Rouault
FRENCH, 1871 – 1958
Nude with Upraised Arms, 1906
Gouache on paper, .628 x .476 (24 3/4 x
18 3/4)
Inscribed at lower left: *G. Rouault / 1906*
Chester Dale Collection
1963.10.211

Georges Rouault
FRENCH, 1871 – 1958
Christ and the Doctor, c. 1935
Canvas, .087 x .108 (3 3/8 x 4 1/4)
Inscribed at lower left: *Rouault.*
Ailsa Mellon Bruce Collection
1970.17.80

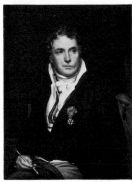

Georges Rouget
FRENCH, 1784 – 1869
Jacques-Louis David, probably c. 1815
Canvas, .892 x .678 (35 1/8 x 26 3/4)
Chester Dale Collection
1963.10.212

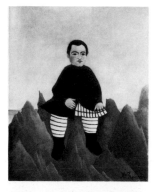

Henri Rousseau
FRENCH, 1844 – 1910
Boy on the Rocks, 1895/1897
Canvas, .554 x .457 (21 3/4 x 18)
Inscribed at lower right: *H. Rousseau*
Chester Dale Collection
1963.10.63

Henri Rousseau
FRENCH, 1844 – 1910
The Equatorial Jungle, 1909
Canvas, 1.406 x 1.295 (55 1/4 x 51)
Inscribed at lower right: *Henri Julien
Rousseau / 1909*
Chester Dale Collection
1963.10.213

Henri Rousseau
FRENCH, 1844 – 1910
Rendezvous in the Forest, 1889
Canvas, .920 x .730 (36 1/4 x 28 3/4)
Inscribed at lower right: *Henri Rousseau*
Gift of the W. Averell Harriman
Foundation in memory of Marie
N. Harriman
1972.9.20

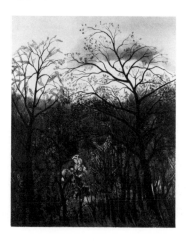

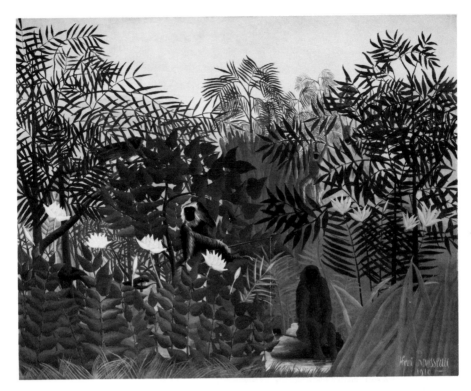

Henri Rousseau
FRENCH, 1844 – 1910
Tropical Forest with Monkeys, 1910
Canvas, 1.295 X 1.626 (51 X 64)
Inscribed at lower right: *Henri Rousseau /
1910*
John Hay Whitney Collection
1982.76.7

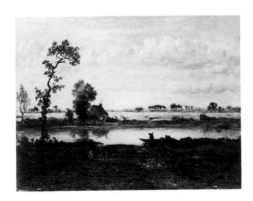

Théodore Rousseau
FRENCH, 1812 – 1867
Landscape with Boatman, c. 1860
Wood, .191 X .268 (7 1/2 X 10 1/4)
Inscribed at lower left: *TH.Rousseau.*
Gift of R. Horace Gallatin
1949.1.10

Sir Peter Paul Rubens
FLEMISH, 1577 – 1640
Head of One of the Three Kings, c. 1615
Transferred from wood to canvas, .665 x
515 (26 1/4 x 20 1/4)
Chester Dale Collection
1943.7.9

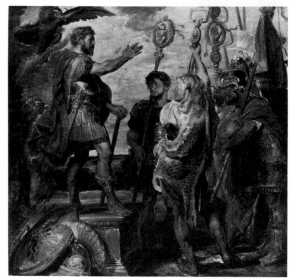

Sir Peter Paul Rubens
FLEMISH, 1577 – 1640
Decius Mus Addressing the Legions,
probably 1617
Wood, .807 x .845 (31 3/4 x 33 1/4)
Samuel H. Kress Collection
1957.14.2

Sir Peter Paul Rubens
FLEMISH, 1577 – 1640
The Meeting of Abraham and Melchizedek,
c. 1625
Wood, .660 x .825 (26 x 32 1/2)
Gift of Syma Busiel
1958.4.1

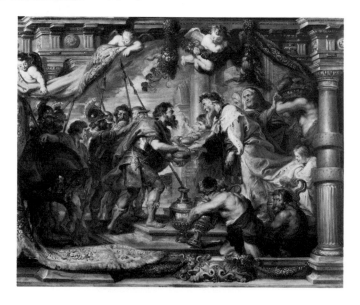

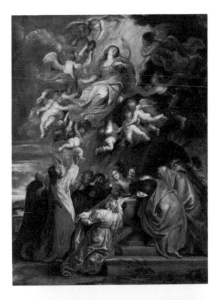

Sir Peter Paul Rubens
FLEMISH, 1577 – 1640
The Assumption of the Virgin, c. 1626
Wood, 1.254 x .942 (49 3/8 x 37 1/8)
Samuel H. Kress Collection
1961.9.32

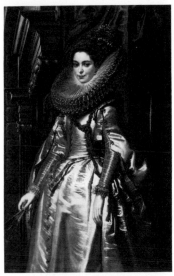

Sir Peter Paul Rubens
FLEMISH, 1577 – 1640
Marchesa Brigida Spinola Doria, 1606
Canvas, 1.522 x .987 (60 x 38 7/8)
On reverse transcribed from front by later
hand before painting was trimmed:
BRIGIDA. SPINVLA. DORIA/ANN: SAL: 1606. /
AET:SVAE ·22· /P.P. RVBENS f ᵗ (Brigida
Spinola Doria. Aged 22 in the year of our
Lord 1606. Made by P.P. Rubens)
Samuel H. Kress Collection
1961.9.60

Sir Peter Paul Rubens
FLEMISH, 1577 – 1640
Tiberius and Agrippina, c. 1614
Wood, .666 x .571 (26 1/4 x 22 1/2)
Inscribed at lower left with inventory
number: 19
Andrew W. Mellon Fund
1963.8.1

Sir Peter Paul Rubens
FLEMISH, 1577 – 1640
Daniel in the Lions' Den, c. 1615
Canvas, 2.243 x 3.304 (88 1/4 x 130 1/8)
Ailsa Mellon Bruce Fund
1965.13.1

Sir Peter Paul Rubens
FLEMISH, 1577 – 1640
*Deborah Kip, Wife of Sir Balthasar
Gerbier, and Her Children*, 1629/1630
Canvas, 1.658 x 1.778 (65 1/4 x 70)
Andrew W. Mellon Fund
1971.18.1

Studio of Sir Peter Paul Rubens
FLEMISH
Saint Peter, c. 1612/1613
Wood, .922 x .671 (36 1/4 x 26 3/8)
Timken Collection
1960.6.32

Studio of Sir Peter Paul Rubens
FLEMISH
Peter Paul Rubens, c. 1615
Wood, .412 x .335 (16 1/4 x 13 1/4)
Timken Collection
1960.6.33

Jacob van Ruisdael
DUTCH, 1628 or 1629 – 1682
Forest Scene, c. 1660/1665
Canvas, 1.055 x 1.310 (41 1/2 x 51 1/2)
Inscribed at lower right: *JvRuisdael* (*JvR* in
ligature)
Widener Collection
1942.9.80

Jacob van Ruisdael
DUTCH, 1628 or 1629 – 1682
Park with a Country House, c. 1680
Canvas, .763 x .975 (30 x 38 3/8)
Inscribed at lower left: *JvRuisdael (JvR* in
ligature)
Gift of Rupert L. Joseph
1960.2.1

Jacob van Ruisdael
DUTCH, 1628 or 1629 – 1682
Landscape, probably c. 1655/1660
Canvas, .532 x .600 (21 x 23 5/8)
Inscribed at lower center: *JvRuisdael (JvR*
in ligature)
Samuel H. Kress Collection
1961.9.85

Pieter Jansz. Saenredam
DUTCH, 1597 – 1665
*Cathedral of Saint John at
's-Hertogenbosch,* 1646
Wood, 1.288 x .870 (50 5/8 x 34 1/4)
Inscribed at lower left on choir stall: *Aᵒ*
*1646 / pieter Saenredam, dit geschildert / de
sintjans kerck in shartogenbosch;* at center
on memorial plaque: *ALBERTO*
AVSTRIACD / 1621 / PATRI PATRIAE /
SILVA≈DUCIS / DICAT CONSECRAT
Samuel H. Kress Collection
1961.9.33

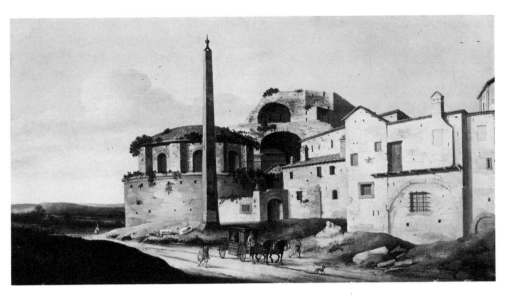

Pieter Jansz. Saenredam
DUTCH, 1597 – 1665
*Church of Santa Maria della Febbre,
Rome,* 1629
Wood, .378 x .705 (14 7/8 x 27 3/4)
Inscribed at lower center on obelisk shaft:
P. Saenredā.fē. / Aº 1629.
Samuel H. Kress Collection
1961.9.34

Henri de Saint-Jean
FRENCH, active 20th century
Still Life: Flowers
Canvas, .565 x .498 (22 1/4 x 19 5/8)
Inscribed at lower center: *H. ST.JEAN*
Chester Dale Collection
1964.19.6

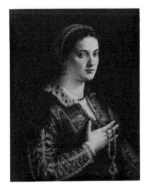

Francesco Salviati
FLORENTINE, 1510 – 1563
Portrait of a Lady, c. 1555
Wood, .673 x .523 (26 3/8 x 20 1/2)
Gift of Samuel L. Fuller
1952.6.1

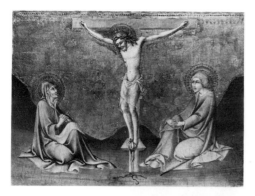

Sano di Pietro
SIENESE, 1406 – 1481
The Crucifixion, probably c. 1445/1450
Wood, .235 x .327 (9 1/4 x 12 7/8)
Samuel H. Kress Collection
1939.1.45

Sano di Pietro
SIENESE, 1406 – 1481
*Madonna and Child with Saints and
Angels,* c. 1471
Wood, .648 x .438 (25 1/2 x 17 1/4)
Inscribed at upper center on Virgin's halo:
AVE GRATIA PLENA DO[MINVS TECVM] (Hail,
full of grace, the Lord is with thee) from
Luke 1:28
Samuel H. Kress Collection
1939.1.274

Andrea del Sarto
FLORENTINE, 1486 – 1530
Charity, before 1530
Wood, 1.200 x .927 (47 1/4 x 36 1/2)
Samuel H. Kress Collection
1957.14.5

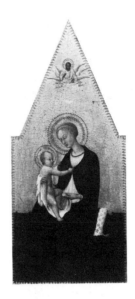

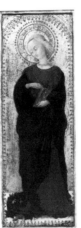

Sassetta
SIENESE, probably 1392 – 1450
Madonna and Child, c. 1435
Wood, .482 x .212 (19 x 8 3/8)
Samuel H. Kress Collection
1939.1.246

Attributed to Sassetta
SIENESE, probably 1392 – 1450
Saint Margaret, c. 1435
Wood, .279 x .098 (11 x 3 7/8)
Samuel H. Kress Collection
1943.4.4

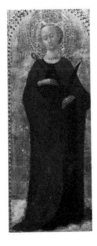

Attributed to Sassetta
SIENESE, probably 1392 – 1450
Saint Apollonia, c. 1435
Wood, .279 x .104 (11 x 4 1/8)
Samuel H. Kress Collection
1943.4.5

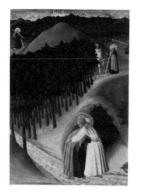

Sassetta and Workshop
SIENESE, probably 1392 – 1450
The Meeting of Saint Anthony and Saint Paul, c. 1440
Wood, .475 x .345 (18 3/4 x 13 5/8)
Samuel H. Kress Collection
1939.1.293

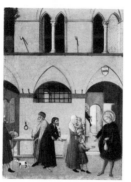

Sassetta and Workshop
SIENESE, probably 1392 – 1450
Saint Anthony Distributing His Wealth to the Poor, c. 1440
Wood, .475 x .345 (18 5/8 x 13 5/8)
Samuel H. Kress Collection
1952.5.20

Sassetta and Workshop
SIENESE, probably 1392 – 1450
Saint Anthony Leaving His Monastery, c. 1440
Wood, .470 x .349 (18 1/2 x 13 3/4)
Samuel H. Kress Collection
1952.5.21

Sassetta and Workshop
SIENESE, probably 1392 – 1450
The Death of Saint Anthony, c. 1440
Wood, .365 x .383 (14 3/8 x 15 1/8)
Samuel H. Kress Collection
1952.5.73

Giovanni Girolamo Savoldo
BRESCIAN, c. 1480 – after 1548
Portrait of a Knight, c. 1525
Canvas, .883 x .734 (34 3/4 x 28 7/8)
Samuel H. Kress Collection
1952.5.74

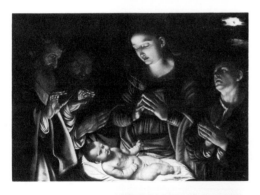

Giovanni Girolamo Savoldo
BRESCIAN, c. 1480 – after 1548
Elijah Fed by the Raven, c. 1510
Transferred from wood to canvas, 1.680 x
1.356 (66 1/8 x 53 3/8)
Samuel H. Kress Collection
1961.9.35

Giovanni Girolamo Savoldo
BRESCIAN, c. 1480 – after 1548
The Adoration of the Shepherds, 1530s
Wood, .845 x 1.197 (33 1/4 x 47 1/8)
Samuel H. Kress Collection
1961.9.86

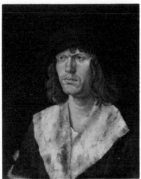

Hans Leonhard Schäufelein
GERMAN, c. 1480/1485 – 1538/1540
Portrait of a Man, 1507
Wood, .399 x .314 (15 5/8 x 12 5/8)
Falsely inscribed at upper left in monogram
by later hand: AD; at upper right: 1507
Andrew W. Mellon Collection
1937.1.66

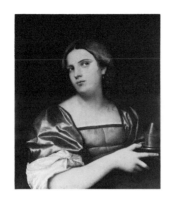

Sebastiano del Piombo
VENETIAN, 1485 – 1547
Portrait of a Young Woman as a Wise Virgin, c. 1510
Wood, .534 x .462 (21 x 18 1/8)
Inscribed at lower right below hand:
V. [C]OLONNA
Samuel H. Kress Collection
1952.2.9

Sebastiano del Piombo
VENETIAN, 1485 – 1547
Cardinal Bandinello Sauli, His Secretary and Two Geographers, 1516
Transferred from wood to canvas, 1.218 x 1.504 (48 x 59 1/4)
Inscribed at lower right on folded paper: 1516; and the signature: *...S Faciebat;* at center right on bell near top: EN · TO · R · ; on bell near bottom: B · DE · SAVLIS · CAR; (abbreviation for *Bandinellus de Saulis Cardinalis)*
Samuel H. Kress Collection
1961.9.37

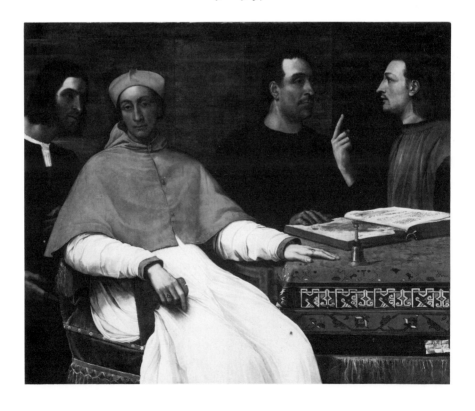

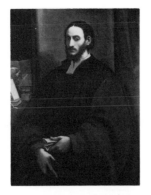

Sebastiano del Piombo
VENETIAN, 1485 – 1547
Portrait of a Humanist, c. 1520
Wood on hardboard, 1.347 x 1.010 (53 x 39 3/4)
Samuel H. Kress Collection
1961.9.38

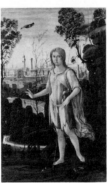

Jacopo del Sellaio
FLORENTINE, 1441 or 1442 – 1493
Saint John the Baptist, probably c. 1480
Wood, .518 x .327 (20 3/8 x 12 7/8)
Samuel H. Kress Collection
1939.1.283

Georges Seurat
FRENCH, 1859 – 1891
Study for "La Grande Jatte," 1884/1885
Wood, .159 x .250 (6 1/4 x 9 7/8)
Inscribed at lower left with atelier stamp:
Seurat
Ailsa Mellon Bruce Collection
1970.17.81

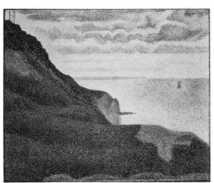

Georges Seurat
FRENCH, 1859 – 1891
Seascape at Port-en-Bessin, Normandy, 1888
Canvas, .651 x .809 (25 5/8 x 31 7/8)
Inscribed at lower right: *Seurat*
Gift of the W. Averell Harriman Foundation in memory of Marie N. Harriman
1972.9.21

Georges Seurat
FRENCH, 1859 – 1891
The Lighthouse at Honfleur, 1886
Canvas, .667 x .819 (26 1/4 x 32 1/4)
Inscribed at lower left: *Seurat*
Collection of Mr. and Mrs. Paul Mellon
1983.1.33

Luca Signorelli
UMBRIAN, probably 1441 – 1523
Calvary, probably c. 1505
Wood, .721 x 1.004 (28 3/8 x 39 1/2)
Samuel H. Kress Collection
1952.5.75

Luca Signorelli
UMBRIAN, probably 1441 – 1523
The Marriage of the Virgin, c. 1491
Wood, 0.216 x 0.482 (8 1/2 x 19)
Samuel H. Kress Collection
1961.9.39

Luca Signorelli
UMBRIAN, probably 1441 – 1523
*Madonna and Child with Saints and
Angels,* c. 1515
Transferred from wood to hardboard,
1.557 x 1.356 (61 3/8 x 53 3/8)
Samuel H. Kress Collection
1961.9.87

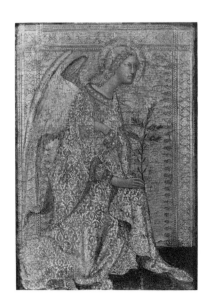

Simone Martini
SIENESE, c. 1284 – 1344
The Angel of the Annunciation, c. 1333
Wood, .308 x .216 (12 1/8 x 8 1/2)
Samuel H. Kress Collection
1939.1.216

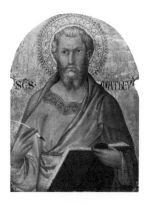

Workshop of Simone Martini
SIENESE
Saint Matthew, probably c. 1320
Wood, .308 x .232 (12 1/8 x 9 1/8)
Inscribed across center: ·SCS·MATHEV͡S·
Samuel H. Kress Collection
1952.5.23

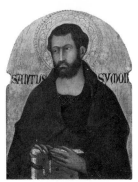

Workshop of Simone Martini
SIENESE
Saint Simon, probably c. 1320
Wood, .308 x .232 (12 1/8 x 9 1/8)
Inscribed across center: SANTUS SYMON
Samuel H. Kress Collection
1952.5.24

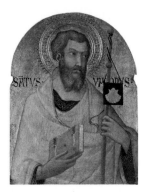

Workshop of Simone Martini
SIENESE
Saint James Major, probably c. 1320
Wood, .308 x .232 (12 1/8 x 9 1/8)
Inscribed across center: ·SĀTVS·YACOBVS·
Samuel H. Kress Collection
1952.5.25

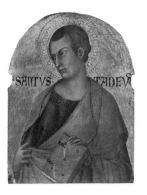

Workshop of Simone Martini
SIENESE
Saint Thaddeus, probably c. 1320
Wood, .308 x .232 (12 1/8 x 9 1/8)
Inscribed across center: ·SANTVS·TADEV^S·
Samuel H. Kress Collection
1952.5.26

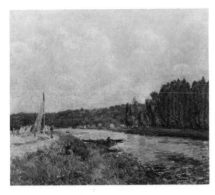

Alfred Sisley
FRENCH, 1839 – 1899
The Banks of the Oise, 1877/1878
Canvas, .543 x .647 (21 3/8 x 25 1/2)
Inscribed at lower left: *Sisley.*
Chester Dale Collection
1963.10.214

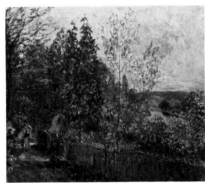

Alfred Sisley
FRENCH, 1839 – 1899
The Road in the Woods, 1879
Canvas, .463 x .558 (18 1/4 x 22)
Inscribed at lower right: *Sisley*
Chester Dale Collection
1963.10.215

Alfred Sisley
FRENCH, 1839 – 1899
Boulevard Héloïse, Argenteuil, 1872
Canvas, .395 x .596 (15 1/2 x 23 1/2)
Inscribed at lower left: *Sisley. 72.*
Ailsa Mellon Bruce Collection
1970.17.82

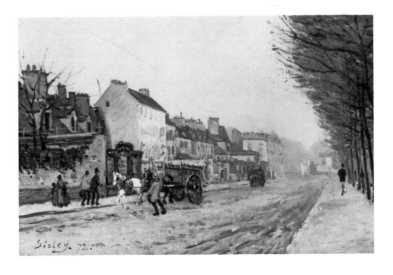

Alfred Sisley
FRENCH, 1839 – 1899
Meadow, 1875
Canvas, .549 x .730 (21 5/8 x 28 3/4)
Inscribed at lower right: *Sisley.75*
Ailsa Mellon Bruce Collection
1970.17.83

Alfred Sisley
FRENCH, 1839 – 1899
First Snow at Veneux-Nadon, 1878
Canvas, .495 x .654 (19 1/2 x 25 3/4)
Inscribed at lower left: *Sisley.*
Gift of Lili-Charlotte Sarnoff in memory of
her grandfather, Mr. Louis Koch
1983.98.1

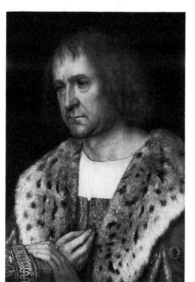

Michel Sittow
NETHERLANDISH, c. 1469 – 1525 or 1526
Portrait of Diego de Guevara (?),
c. 1515/1518
Wood, .336 x .237 (13 1/4 x 9 5/16)
Andrew W. Mellon Collection
1937.1.46

Michel Sittow
NETHERLANDISH, C. 1469 – 1525 or 1526
The Assumption of the Virgin, c. 1500
Wood, painted surface: .211 x .162 (8 5/16
x 6 3/8); panel: .213 x .167 (8 3/8 x 6 3/4)
Ailsa Mellon Bruce Fund
1965.1.1

William Smith
BRITISH, 1707 – 1764
Mr. Tucker of Yeovil, c. 1760
Canvas, .913 x .714 (36 x 28 1/8)
Gift of Dr. and Mrs. Henry L. Feffer
1976.62.1

Sodoma
SIENESE, 1477 – 1549
*Madonna and Child with the Infant Saint
John,* c. 1505
Wood, .787 x .648 (31 x 25 1/2)
Samuel H. Kress Collection
1939.1.305

Sodoma
SIENESE, 1477 – 1549
Saint George and the Dragon,
probably 1518
Wood, 1.378 x .976 (55 1/2 x 38 3/8)
Samuel H. Kress Collection
1952.5.76

Gerard Soest
BRITISH, c. 1600 – 1681
Portrait of a Woman, c. 1665
Canvas, 1.270 x 1.032 (50 x 40 5/8)
Gift of Mr. and Mrs. Gordon Gray
1977.63.1

Andrea Solario
MILANESE, active 1495 – 1524
Pietà, c. 1515
Wood, 1.686 x 1.520 (66 3/8 x 59 7/8)
Inscribed at lower right on cartello in
nearly effaced letters: ANDREAS...
Samuel H. Kress Collection
1961.9.40

Giovanni Sons
PARMESE, 1553 – 1611 or 1614
The Judgment of Paris, late 16th century
Canvas, 1.213 x 1.654 (47 3/4 x 65 1/8)
Samuel H. Kress Collection
1961.9.80

Pierre Soulages
FRENCH, b. 1919
Composition, 1955
Canvas, 1.940 x 1.297 (76 3/8 x 51)
Inscribed at lower right: *soulages / 55*
Gift of Mr. and Mrs. Burton Tremaine
1971.87.8

Pierre Soulages
FRENCH, b. 1919
6 March 1955, 1955
Canvas, 1.298 x .887 (51 1/8 x 35)
Inscribed at lower left: *soulages;* at upper
right on reverse: *6.3.55 / SOULAGES*
Gift of Mr. and Mrs. Ralph F. Colin
1975.97.1

Pierre Soulages
FRENCH, b. 1919
Painting, 1957
Canvas, 1.948 x 1.298 (76 3/4 x 51 1/8)
Inscribed at lower left: *soulages;* on
reverse: *3 octobre 1957*
Gift of Morton G. Neumann
1979.67.1

Chaim Soutine
RUSSIAN, 1893 – 1943
Portrait of a Boy, 1928
Canvas, .921 x .651 (36 1/4 x 25 5/8)
Inscribed at lower left: *Soutine*
Chester Dale Collection
1963.10.216

Chaim Soutine
RUSSIAN, 1893 – 1943
Pastry Chef, c. 1923
Canvas, .645 x .483 (25 3/8 x 19)
Inscribed at upper right: *Soutine*
Gift of the Joseph H. Hazen Foundation,
Inc.
1971.2.2

Nicolas de Staël
FRENCH, 1914 – 1955
Ballet, 1952
Canvas, 2.006 x 3.504 (79 x 138)
Collection of Mr. and Mrs. Paul Mellon
1983.1.34

Jan Steen
DUTCH, 1626 – 1679
The Dancing Couple, 1663
Canvas, 1.025 x 1.425 (40 3/8 x 56 1/8)
Inscribed at lower left: *JSteen. 1663 (JS in ligature)*
Widener Collection
1942.9.81

Théophile Alexandre Steinlen
FRENCH, 1859 – 1923
The Laundresses, 1899
Canvas, .832 x .682 (33 3/4 x 26 7/8)
Inscribed at lower left: *Steinlen;* on reverse: *1899*
Chester Dale Collection
1954.4.4

Alfred Stevens
BELGIAN, 1823 – 1906
Young Woman in White Holding a Bouquet, c. 1865/1875
Wood, .287 x .205 (11 1/4 x 8 1/8)
Inscribed at lower right in monogram: AS
Chester Dale Collection
1963.10.65

Alfred Stevens

BELGIAN, 1823 – 1906
Study of a Model
Wood, .407 x .266 (16 x 10 1/2)
Inscribed at lower left in monogram: AS
Chester Dale Collection
1964.19.7

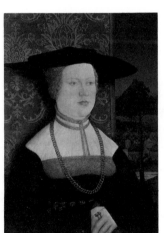

Bernhard Strigel

GERMAN, 1460 or 1461 – 1528
Margaret Vöhlin, Wife of Hans Rott, 1527
Wood, .438 x .311 (17 1/4 x 12 1/4)
Inscribed across bottom on original frame:
*Tausend und funfhŭndert iar, Aŭch siben
und zwaintzge das is war, / Zallt man, do
hett ich zwaintzg iar wol, Am tag
Margrethe ich sagen sol.* (One thousand
and five hundred years, with seven and
twenty, that is true as men count, then was
I full twenty years old on St. Margaret's
day, so I should say.) On the back of the
cradled panel is a coat of arms showing the
device of the Vöhlin family.
Ralph and Mary Booth Collection
1947.6.5.a-b

Bernhard Strigel

GERMAN, 1460 or 1461 – 1528
Hans Rott, Patrician of Memmingen, 1527
Wood, .438 x .311 (17 1/4 x 12 1/4)
Inscribed across bottom on original frame:
*Gleich in gemeldtem iar ăch ich, do liess
ich contrefeten mich. 1527. / Und ward
Octobris sechtzehn tag. Alt
sechsŭndzwaintzg iar wie ich sag* (In the
same year I too had myself portrayed.
1527. And it was the sixteenth day of
October. I was twenty-six, as I say.) On
the forefinger of his hand is a signet ring
with the initials HR and a coat of arms
showing, on dexter, a unicorn rampant;
and on sinister, two bars sable on argent.
On the back of the cradled panel appears
the same coat of arms.
Ralph and Mary Booth Collection
1947.6.4.a-b

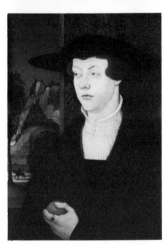

Bernhard Strigel
GERMAN, 1460 or 1461 – 1528
Saint Mary Cleophas and Her Family,
c. 1520/1528
Wood, 1.244 x .629 (49 x 24 3/4)
Inscribed at center on halos:
SANCTA·MARIA·CLEOP[H]E;
SANCTVS·IVDAS·XPI·APOSTOLV;
SCTVS·SIMON; STV[S]·SANCTVS· IOSEPHI;
SANCTVS·IACOBVS·MINOR A..HE
Samuel H. Kress Collection
1961.9.88

Bernhard Strigel
GERMAN, 1460 or 1461 – 1528
Saint Mary Salome and Her Family,
1520/1528
Wood, 1.244 x .629 (49 x 25 3/4)
Inscribed on halos: SANCTA·MARIA·SALOME;
SANCTVS·IACOBVS·MA; SANCTV[S]·
IOHANES·EWAN
Samuel H. Kress Collection
1961.9.89

Bernardo Strozzi
GENOESE-VENETIAN, 1581 – 1644
Bishop Alvise Grimani, probably c. 1633
Canvas, 1.467 x .951 (57 3/4 x 37 3/8)
Samuel H. Kress Collection
1961.9.41

George Stubbs
BRITISH, 1724 – 1806
Captain Pocklington with His Wife and Sister, 1769
Canvas, 1.002 x 1.266 (39 3/8 x 49 3/4)
Inscribed at lower right: *Geo. Stubbs / pinxit 1769*
Gift of Mrs. Charles S. Carstairs in memory of her husband, Charles Stewart Carstairs
1952.9.4

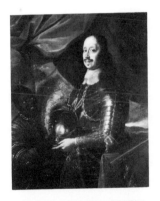

Attributed to Justus Sustermans
FLEMISH, 1597 – 1681
Mattias de' Medici, c. 1660
Canvas, 1.283 x 1.042 (50 1/2 x 41)
Gift of Ursula H. Baird and Sally H. Dieke
in memory of their grandmother,
Constance Cary Harrison
1950.10.1

Graham Sutherland
BRITISH, 1903 – 1980
Palm Palisades, 1947
Canvas, 1.089 x .908 (42 7/8 x 35 3/4)
Inscribed at lower right: *Sutherland 1947*
Gift of Mr. and Mrs. Burton Tremaine
1971.87.9

Yves Tanguy
FRENCH, 1900 – 1955
The Look of Amber, 1929
Canvas, 1.000 x .810 (39 3/8 x 31 7/8)
Inscribed at lower right: YVES TANGUY 29
Chester Dale Fund
1984.75.1

Tanzio da Varallo
PIEDMONTESE, C. 1575 – C. 1635
Saint Sebastian, c. 1620/1630
Canvas, 1.181 x .940 (46 1/2 x 37)
Samuel H. Kress Collection
1939.1.191

David Teniers II
FLEMISH, 1610 – 1690
Peasants Celebrating Twelfth Night, 1635
Wood, .472 x .699 (18 5/8 x 27 1/2)
Inscribed at lower left on table's edge: D.
TENIERS F 1635
Ailsa Mellon Bruce Fund
1972.10.1

David Teniers II
FLEMISH, 1610 – 1690
Tavern Scene, 1658
Wood, .486 x .687 (19 1/8 x 27)
Inscribed at upper left on paper: *An 1658*
(*An* in ligature); at lower right:
.D·TENIERS · FEC.
Gift of Robert H. and Clarice Smith
1975.77.1

Gerard Terborch II
DUTCH, 1617 – 1681
The Suitor's Visit, c. 1658
Canvas, .800 x .753 (31 1/2 x 29 5/8)
Andrew W. Mellon Collection
1937.1.58

Studio of Gerard Terborch II
DUTCH
The Concert
Canvas, .690 x .551 (27 1/8 x 21 3/4)
Timken Collection
1960.6.10

Frits Thaulow
NORWEGIAN, 1847 – 1906
River Scene
Wood, .536 x .651 (21 1/8 x 25 5/8)
Inscribed at lower left: *Frits Thaulow.*
Ailsa Mellon Bruce Collection
1970.17.134

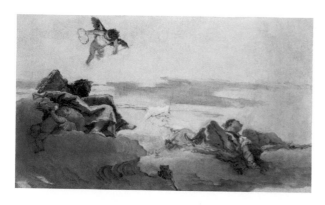

Giovanni Battista Tiepolo
VENETIAN, 1696 – 1770
The Apotheosis of a Poet, c. 1750
Canvas, .273 x .489 (10 3/4 x 19 1/4)
Samuel H. Kress Collection
1939.1.100

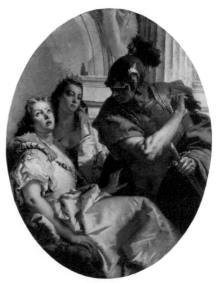

Giovanni Battista Tiepolo
VENETIAN, 1696 – 1770
Timocleia and The Thracian Commander,
c. 1750
Canvas, oval, 1.403 x 1.093 (55 1/4 x 43)
Samuel H. Kress Collection
1939.1.365

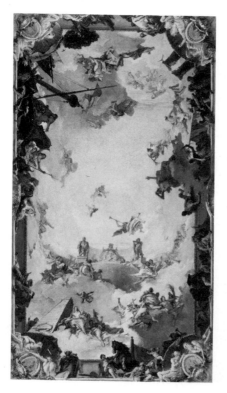

Giovanni Battista Tiepolo
VENETIAN, 1696 – 1770
The World Pays Homage to Spain,
probably 1762
Canvas, 1.810 x 1.045 (71 1/2 x 41 1/8)
Samuel H. Kress Collection
1943.4.39

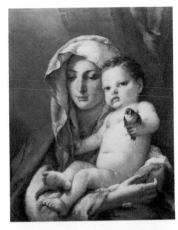

Giovanni Battista Tiepolo
VENETIAN, 1696 – 1770
Madonna of the Goldfinch, c. 1760
Canvas, .632 x .502 (24 7/8 x 19 3/4)
Samuel H. Kress Collection
1943.4.40

Giovanni Battista Tiepolo
VENETIAN, 1696 – 1770
A Young Lady in Domino and Tricorne,
c. 1760
Canvas, .619 x .492 (24 3/8 x 19 3/8)
Samuel H. Kress Collection
1952.5.77

Giovanni Battista Tiepolo
VENETIAN, 1696 – 1770
Apollo Pursuing Daphne, c. 1755/1760
Canvas, .688 x .872 (27 x 34 1/2)
Inscribed at lower left: *Gio. B. Tiepolo*
Samuel H. Kress Collection
1952.5.78

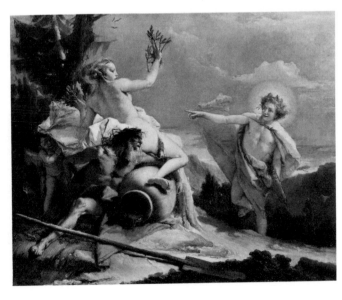

Giovanni Battista Tiepolo
VENETIAN, 1696 – 1770
The Apotheosis of a Saint, c. 1750/1760
Canvas, .414 x .338 (16 1/4 x 13 1/4)
Gift of Howard Sturges
1956.9.16

Giovanni Battista Tiepolo
VENETIAN, 1696 – 1770
Bacchus and Ariadne, c. 1740
Canvas, 2.134 x 2.318 (84 x 91 1/4)
Timken Collection
1960.6.36

Giovanni Battista Tiepolo
VENETIAN, 1696 – 1770
Queen Zenobia Addressing Her Soldiers,
c. 1730
Canvas, 2.614 x 3.658 (102 7/8 x 144)
Samuel H. Kress Collection
1961.9.42

Tiberio Tinelli
VENETIAN, 1586 – 1638
Count Lodovico Vidmano, c. 1630
Canvas, 2.061 x 1.375 (81 1/8 x 54 1/8)
Inscribed at center left at top of bas relief:
.TINELLI.
Gift of Samuel L. Fuller
1946.6.1

Jacopo Tintoretto
VENETIAN, 1518 – 1594
Portrait of a Man as Saint George,
c. 1540/1550
Canvas, .838 x .711 (33 x 28)
Samuel H. Kress Collection
1939.1.98

Jacopo Tintoretto
VENETIAN, 1518 – 1594
The Worship of the Golden Calf, c. 1560
Canvas, 1.591 x 2.718 (62 5/8 x 107)
Samuel H. Kress Collection
1939.1.180

Jacopo Tintoretto
VENETIAN, 1518 – 1594
Susanna, c. 1575
Canvas, 1.502 x 1.026 (59 1/8 x 40 3/8)
Samuel H. Kress Collection
1939.1.231

Jacopo Tintoretto
VENETIAN, 1518 – 1594
Portrait of a Venetian Senator, c. 1570
Canvas, 1.105 x .880 (43 1/2 x 34 3/4)
Chester Dale Collection
1943.7.10

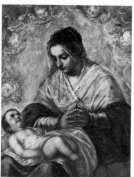

Jacopo Tintoretto
VENETIAN, 1518 – 1594
The Madonna of the Stars, second half of
the 16th century
Canvas, .927 x .727 (36 1/2 x 28 5/8)
Ralph and Mary Booth Collection
1947.6.6

Jacopo Tintoretto
VENETIAN, 1518 – 1594
Christ at the Sea of Galilee, c. 1575/1580
Canvas, 1.170 x 1.685 (46 x 66 1/4)
Samuel H. Kress Collection
1952.5.27

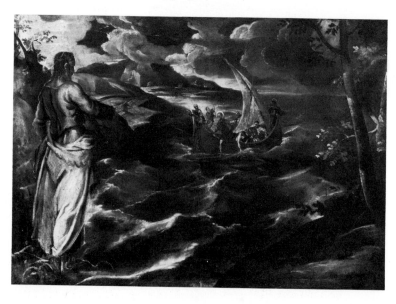

Jacopo Tintoretto
VENETIAN, 1518 – 1594
A Procurator of Saint Mark's,
c. 1575/1585
Canvas, 1.387 x 1.013 (54 1/2 x 39 7/8)
Samuel H. Kress Collection
1952.5.79

Jacopo Tintoretto
VENETIAN, 1518 – 1594
The Conversion of Saint Paul, c. 1545
Canvas, 1.524 x 2.362 (60 x 92 7/8)
Samuel H. Kress Collection
1961.9.43

Jacopo Tintoretto
VENETIAN, 1518 – 1594
*Doge Alvise Mocenigo and Family before
the Madonna and Child,* probably 1573
Canvas, 2.161 x 4.165 (85 1/8 x 164)
Samuel H. Kress Collection
1961.9.44

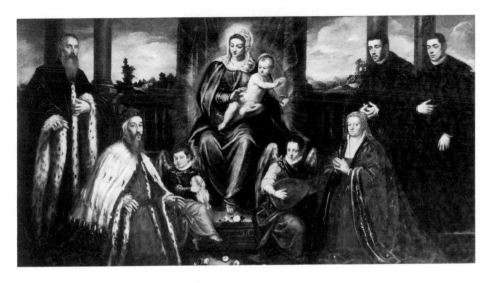

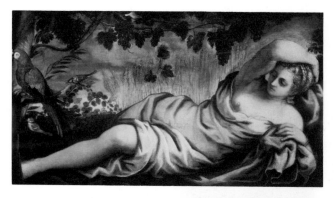

Jacopo Tintoretto
VENETIAN, 1518 – 1594
Summer, c. 1555
Canvas, 1.057 x 1.930 (41 5/8 x 76)
Samuel H. Kress Collection
1961.9.90

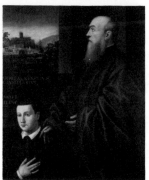

Follower of Jacopo Tintoretto
VENETIAN
Portrait of a Man and Boy
Canvas, 1.130 x .943 (44 1/2 x 37 1/8)
Inscribed at center left: ANDREAS.
RENERIVS. / CONSILLARIVS. / DANIEL· /
FILIVS
Gift of Samuel L. Fuller
1951.15.1

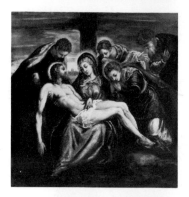

Marco Tintoretto
VENETIAN, c. 1560 – 1637
Pietà
Canvas, .650 x .657 (25 5/8 x 25 7/8)
Timken Collection
1960.6.37

James Jacques Joseph Tissot
FRENCH, 1836 – 1902
Hide and Seek, c. 1877
Wood, .734 x .539 (28 7/8 x 21 1/4)
Inscribed at lower right near border of
carpet: *J.J.Tissot*
Chester Dale Fund
1978.47.1

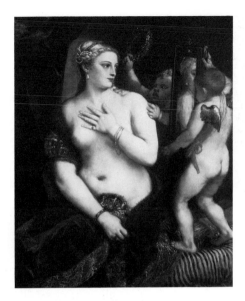

Titian
VENETIAN, C. 1488 – 1576
Venus with a Mirror, c. 1555
Canvas, 1.245 x 1.055 (49 x 41 1/2)
Andrew W. Mellon Collection
1937.1.34

Titian
VENETIAN, C. 1488 – 1576
Cupid with the Wheel of Fortune, c. 1520
Canvas, .660 x .553 (26 x 21 3/4)
Samuel H. Kress Collection
1939.1.213

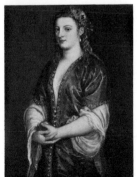

Titian
VENETIAN, C. 1488 – 1576
Portrait of a Lady, c. 1555
Canvas, .978 x .740 (38 1/2 x 29 1/8)
Samuel H. Kress Collection
1939.1.292

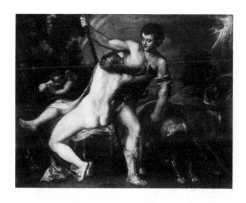

Titian
VENETIAN, C. 1488 – 1576
Venus and Adonis, c. 1560
Canvas, 1.068 x 1.360 (42 x 53 1/2)
Widener Collection
1942.9.84

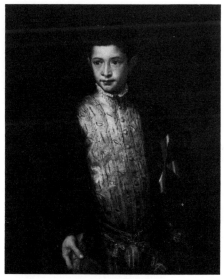

Titian
VENETIAN, C. 1488 – 1576
Ranuccio Farnese, 1542
Canvas, .897 x .736 (35 1/4 x 29)
Inscribed at center right: TITIANVS / .F.
Samuel H. Kress Collection
1952.2.11

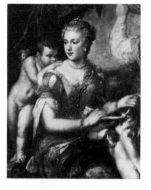

Titian
VENETIAN, C. 1488 – 1576
*Portrait of a Young Lady as Venus Binding
the Eyes of Cupid,* c. 1555
Canvas, 1.224 x .973 (48 1/8 x 38 1/4)
Samuel H. Kress Collection
1952.2.12

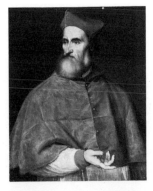

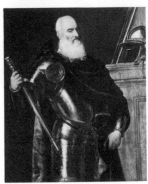

Titian
VENETIAN, C. 1488 — 1576
Cardinal Pietro Bembo, c. 1540
Canvas, .945 x .765 (37 1/8 x 30 1/8)
Samuel H. Kress Collection
1952.5.28

Titian
VENETIAN, C. 1488 — 1576
Vincenzo Capello, probably c. 1540
Canvas, 1.410 x 1.181 (55 1/2 x 46 1/2)
Samuel H. Kress Collection
1957.14.3

Titian
VENETIAN, C. 1488 — 1576
Saint John the Evangelist on Patmos,
probably 1544
Canvas, 2.376 x 2.630 (93 1/2 x 103 1/2)
Samuel H. Kress Collection
1957.14.6

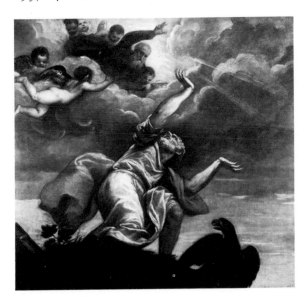

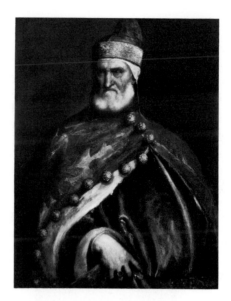

Titian
VENETIAN, C. 1488 – 1576
Doge Andrea Gritti, c. 1535/1540
Canvas, 1.336 x 1.032 (52 1/2 x 40 5/8)
Inscribed at upper left: ANDREAS GRITI
DOGE / DI VENETIA; at center right:
TITIANVS E. F. (Titian, Knight, made it)
Samuel H. Kress Collection
1961.9.45

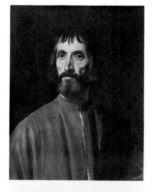

Attributed to Titian
VENETIAN, C. 1488 – 1576
Andrea dei Franceschi, c. 1530/1540
Canvas, .648 x .506 (25 1/2 x 20)
Inscribed at upper left on tablet: ...TIS/
...OIX
Andrew W. Mellon Collection
1937.1.35

Attributed to Titian
VENETIAN, C. 1488 – 1576
Self-Portrait, probably 1561
Canvas, 1.122 x .937 (44 1/8 x 36 7/8)
Inscribed at lower right on wood block
held by sitter: T. VECELLIVS P./
AET.LXXXIV. / ANNO MDLXI.
Timken Collection
1960.6.39

Titian and Workshop
VENETIAN, c. 1488 – 1576
Girolamo and Cardinal Marco Corner
Investing Marco, Abbot of Carrara, with
His Benefice, c. 1520
Canvas, .998 x 1.321 (39 1/2 x 52)
Timken Collection
1960.6.38

Follower of Titian
VENETIAN
Allegory (Alfonso d'Este and Laura
Dianti?)
Canvas, .914 x .819 (36 x 32 1/4)
Samuel H. Kress Collection
1939.1.259

Follower of Titian
VENETIAN
Emilia di Spilimbergo, c. 1560
Canvas, 1.220 x 1.065 (48 x 42)
Widener Collection
1942.9.82

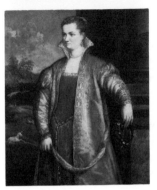

Follower of Titian
VENETIAN
Irene di Spilimbergo, c. 1560
Canvas, 1.220 x 1.065 (48 x 42)
Inscribed at lower right on base of column:
SI FATA / TVLISSENT (If the fates had
allowed)
Widener Collection
1942.9.83

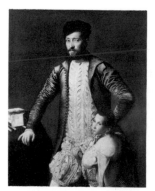

Follower of Titian
ITALIAN
Alessandro Alberti with a Page,
mid-16th century
Canvas, 1.242 x 1.027 (48 7/8 x 40 3/8)
Inscribed at center left on folded paper:
*Alessandro Alberti l'anno XXX / della sua
età ... / s [or l] ritrasse nel 15 ... / In
Venetia.* (Alessandro Alberti the thirtieth
year of his age ... portrayed in 15 ... In
Venice)
Samuel H. Kress Collection
1952.5.80

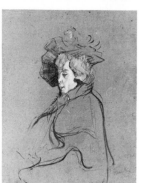

Henri de Toulouse-Lautrec
FRENCH, 1864 – 1901
Jane Avril, 1892
Cardboard on wood, .678 x .529 (26 3/4 x
20 7/8)
Inscribed at lower right: *HTLautrec (HTL
in ligature)*
Chester Dale Collection
1963.10.66

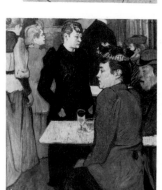

Henri de Toulouse-Lautrec
FRENCH, 1864 – 1901
A Corner of the Moulin de la Galette,
1892
Cardboard on wood, 1.003 x .891 (39 1/2
x 35 1/8)
Inscribed at upper right: *HTLautrec (HTL
in ligature)*
Chester Dale Collection
1963.10.67

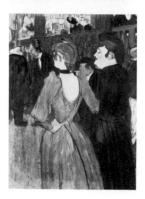

Henri de Toulouse-Lautrec
FRENCH, 1864 – 1901
La Goulue and Her Sister
Gouache on cardboard, .474 x .365
(18 5/8 x 14 3/8)
Chester Dale Collection
1963.10.68

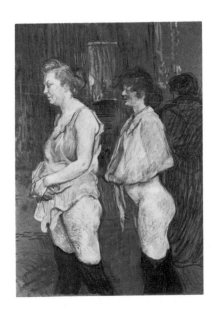

Henri de Toulouse-Lautrec
FRENCH, 1864 – 1901
Rue des Moulins, 1894, 1894
Cardboard on wood, .835 x .614 (32 7/8 x
24 1/8)
Inscribed at lower right in circle in
monogram: HTL
Chester Dale Collection
1963.10.69

Henri de Toulouse-Lautrec
FRENCH, 1864 – 1901
Maxime Dethomas, 1896
Gouache on cardboard, .673 x .527
(26 1/2 x 20 3/4)
Inscribed at upper right: *HTLautrec / 96*
(HTL in ligature)
Chester Dale Collection
1963.10.219

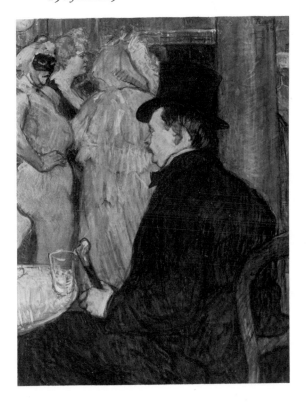

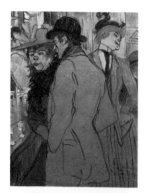

Henri de Toulouse-Lautrec
FRENCH, 1864 – 1901
Alfred la Guigne, 1894
Gouache on cardboard, .656 x .504
(25 3/4 x 19 3/4)
Inscribed at lower right: *pour Métenier /
d'aprés* [sic] / *son Alfred la Guigne /
HTLautrec* (HTL in ligature)
Chester Dale Collection
1963.10.220

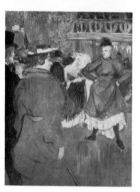

Henri de Toulouse-Lautrec
FRENCH, 1864 – 1901
Quadrille at the Moulin Rouge, 1892
Cardboard, .801 x .605 (31 1/2 x 23 3/4)
Inscribed at lower right in circle in
monogram: HTL
Chester Dale Collection
1963.10.221

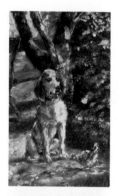

Henri de Toulouse-Lautrec
FRENCH, 1864 – 1901
The Artist's Dog Flèche, c. 1881
Wood, .234 x .141 (9 1/4 x 5 1/2)
Inscribed at lower right: HTL (in
monogram) LA FLECHE
Ailsa Mellon Bruce Collection
1970.17.84

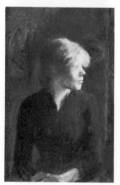

Henri de Toulouse-Lautrec
FRENCH, 1864 – 1901
Carmen Gaudin, 1885
Wood, .238 x .149 (9 3/8 x 5 7/8)
Ailsa Mellon Bruce Collection
1970.17.85

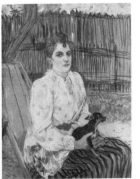

Henri de Toulouse-Lautrec
FRENCH, 1864 – 1901
Lady with a Dog, 1891
Cardboard, .750 x .572 (29 1/2 x 22 1/2)
Inscribed at lower right: *T-Lautrec / 91*
Gift of the W. Averell Harriman
Foundation in memory of Marie N.
Harriman
1972.9.22

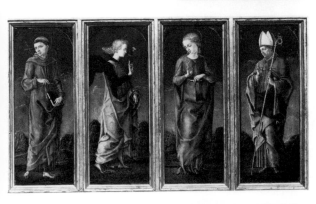

Cosimo Tura
FERRARESE, before 1430 – 1495
*The Annunciation with Saint Francis and
Saint Maurelius*, c. 1475
Wood, each panel: .305 x .118 (12 x 4 5/8)
Samuel H. Kress Collection
1952.2.6.a-d

Cosimo Tura
FERRARESE, before 1430 – 1495
Madonna and Child in a Garden, c. 1455
Wood, .527 x .372 (20 3/4 x 14 5/8)
Samuel H. Kress Collection
1952.5.29

Attributed to Cosimo Tura
FERRARESE, before 1430 – 1495
Portrait of a Man, c. 1475/1485
Wood, .355 x .255 (14 x 10)
Samuel H. Kress Collection
1939.1.357

Joseph Mallord William Turner
BRITISH, 1775 – 1851
Mortlake Terrace, c. 1826
Canvas, .921 x 1.222 (36 1/4 x 48 1/4)
Andrew W. Mellon Collection
1937.1.109

Joseph Mallord William Turner
BRITISH, 1775 – 1851
Approach to Venice, c. 1843
Canvas, .622 x .940 (24 1/2 x 37)
Andrew W. Mellon Collection
1937.1.110

Joseph Mallord William Turner
BRITISH, 1775 – 1851
*Venice: Dogana and San Giorgio
Maggiore,* probably 1834
Canvas, .915 x 1.220 (36 x 48)
Widener Collection
1942.9.85

Joseph Mallord William Turner
BRITISH, 1775 – 1851
Keelmen Heaving in Coals by Moonlight,
probably 1835
Canvas, .923 x 1.228 (36 1/4 x 48 1/4)
Inscribed at lower left on buoy: JMWT
Widener Collection
1942.9.86

Joseph Mallord William Turner
BRITISH, 1775 – 1851
The Junction of the Thames and the Medway, c. 1805/1808
Canvas, 1.088 x 1.437 (42 3/4 x 56 1/2)
Widener Collection
1942.9.87

Joseph Mallord William Turner
BRITISH, 1775 – 1851
The Rape of Proserpine, 1839
Canvas, .926 x 1.237 (36 3/8 x 48 5/8)
Gift of Mrs. Watson B. Dickerman
1951.18.1

Joseph Mallord William Turner
BRITISH, 1775 – 1851
The Evening of the Deluge, c. 1843
Canvas, .760 x .760 (29 7/8 x 29 7/8)
Timken Collection
1960.6.40

Joseph Mallord William Turner
BRITISH, 1775 – 1851
The Dogana and Santa Maria della Salute, Venice, probably 1843
Canvas, .619 x .930 (24 3/8 x 36 5/8)
Inscribed at lower right: JMWT
Given in memory of Governor Alvan T. Fuller by The Fuller Foundation, Inc.
1961.2.3

Joseph Mallord William Turner
BRITISH, 1775 — 1851
Van Tromp's Shallop, c. 1832
Canvas, .923 x 1.225 (36 3/8 x 48 1/4)
Ailsa Mellon Bruce Collection
1970.17.135

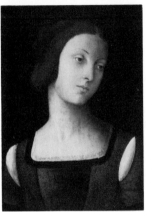

Umbrian 15th Century
Head of a Woman, c. 1500
Wood, .397 x .283 (15 5/8 x 11 1/8)
Inscribed on reverse: *Dianora B[ella?]*
Timken Collection
1960.6.24

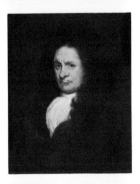

Unknown Nationality 17th Century
Portrait of a Man, late 17th century
Canvas, .724 x .584 (28 1/2 x 23)
Andrew W. Mellon Collection
1947.17.34

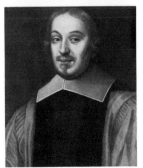

Unknown Nationality 17th Century
Portrait of a Man, mid-17th century
Canvas, .559 x .479 (22 x 18 7/8)
Andrew W. Mellon Collection
1947.17.91

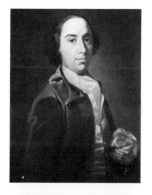

Unknown Nationality 18th Century
Portrait of a Man, c. 1765
Canvas, .711 x .559 (28 x 22)
Andrew W. Mellon Collection
1942.8.1

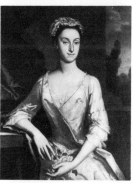

Unknown Nationality 18th Century
Portrait of a Lady, c. 1740
Canvas, .918 x .711 (36 1/8 x 28)
Falsely inscribed at lower left: *R F Pinx /
1746*
Andrew W. Mellon Collection
1942.8.5

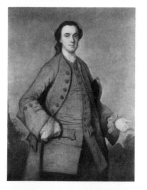

Unknown Nationality 18th Century
Portrait of a Man, mid-18th century
Canvas, 1.276 x 1.032 (50 1/4 x 40 5/8)
Falsely inscribed at center left: *J. Hefselius
Pinx / 1768*
Andrew W. Mellon Collection
1947.17.15

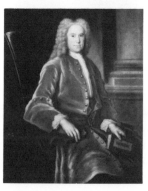

Unknown Nationality 18th Century
Portrait of a Man, after 1726
Canvas, 1.273 x 1.016 (50 1/8 x 40)
Andrew W. Mellon Collection
1947.17.22

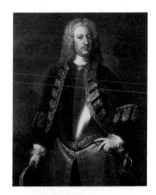

Unknown Nationality 18th Century
Portrait of an Officer, c. 1700
Canvas, 1.276 x 1.022 (50 1/4 x 40 1/4)
Andrew W. Mellon Collection
1947.17.26

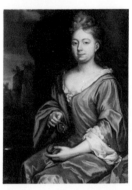

Unknown Nationality 18th Century
Portrait of a Lady, after 1705
Canvas, 1.045 x .765 (41 1/8 x 30 1/8)
Andrew W. Mellon Collection
1947.17.27

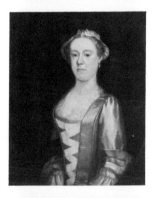

Unknown Nationality 18th Century
Portrait of a Lady, mid-18th century
Canvas, .765 x .635 (30 1/8 x 25)
Andrew W. Mellon Collection
1947.17.31

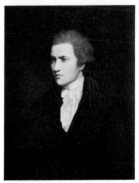

Unknown Nationality 18th Century
Portrait of a Man, c. 1785
Canvas, .876 x .699 (34 1/2 x 27 1/2)
Andrew W. Mellon Collection
1947.17.32

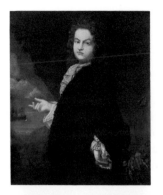

Unknown Nationality 18th Century
Portrait of a Man, first quarter of the
18th century
Canvas, .727 x .603 (28 5/8 x 23 3/4)
Andrew W. Mellon Collection
1947.17.33

Unknown Nationality 18th Century
Portrait of a Man, c. 1795
Canvas, .489 x .384 (19 1/4 x 15 1/8)
Andrew W. Mellon Collection
1947.17.35

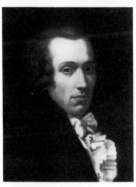

Unknown Nationality 18th Century
Portrait of a Man, first quarter of the
18th century
Canvas, .765 x .638 (30 1/8 x 25 1/8)
Falsely inscribed at center right: Æ 50 E.D.
Andrew W. Mellon Collection
1947.17.38

Unknown Nationality 18th Century
Portrait of a Lady, c. 1700
Canvas, .762 x .638 (30 x 25 1/8)
Andrew W. Mellon Collection
1947.17.39

Unknown Nationality 18th Century
Portrait of a Man, first quarter of the
18th century
Canvas, .762 x .638 (30 x 25 1/8)
Andrew W. Mellon Collection
1947.17.40

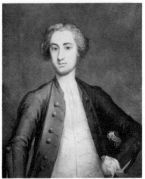

Unknown Nationality 18th Century
Portrait of a Man, c. 1765
Canvas, .756 x .626 (29 3/4 x 24 5/8)
Falsely inscribed at lower right: *Edward
Truman*
Andrew W. Mellon Collection
1947.17.43

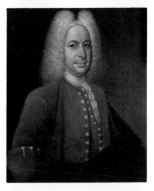

Unknown Nationality 18th Century
Portrait of a Man, second quarter of the
18th century
Canvas, .762 x .657 (30 x 25 7/8)
Andrew W. Mellon Collection
1947.17.47

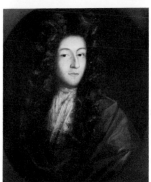

Unknown Nationality 18th Century
Portrait of a Man
Canvas, .746 x .641 (29 3/8 x 25 1/4)
Falsely inscribed at lower right: *Henrietta
Johnston Fecit Ao 1718*
Andrew W. Mellon Collection
1947.17.64

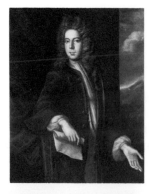

Unknown Nationality 18th Century
Portrait of a Man, c. 1710
Canvas, 1.149 x .921 (45 1/4 x 36 1/4)
Andrew W. Mellon Collection
1947.17.86

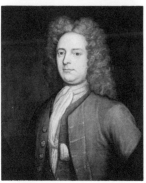

Unknown Nationality 18th Century
Portrait of a Man, c. 1715
Canvas, .762 x .638 (30 x 25 1/8)
Falsely inscribed at lower right: *P Pelham
pinx. 1729*
Andrew W. Mellon Collection
1947.17.87

Unknown Nationality 18th Century
Portrait of a Man, second quarter of the
18th century
Canvas, .762 x .635 (30 x 25)
Andrew W. Mellon Collection
1947.17.88

Unknown Nationality 18th Century
Portrait of a Man, c. 1775
Canvas, 1.273 x 1.013 (50 1/8 x 39 7/8)
Andrew W. Mellon Collection
1947.17.90

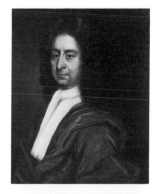

Unknown Nationality 18th Century
Portrait of a Man, first quarter of the
18th century
Canvas, .762 x .635 (30 x 25)
Andrew W. Mellon Collection
1947.17.94

Unknown Nationality 18th Century
Portrait of a Man, third quarter of the
18th century
Canvas, .654 x .914 (25 3/4 x 20 1/4)
Andrew W. Mellon Collection
1947.17.100

Unknown Nationality 18th Century
Portrait of a Man, mid-18th century
Canvas, .718 x .603 (28 1/4 x 23 3/4)
Andrew W. Mellon Collection
1947.17.113

Unknown Nationality 18th Century
Portrait of a Man, c. 1775
Canvas, 1.013 x .772 (39 7/8 x 30 3/8)
Andrew W. Mellon Collection
1954.1.3

Unknown Nationality 18th Century
Portrait of a Man, c. 1790
Canvas, .711 x .559 (28 x 22)
Andrew W. Mellon Collection
1954.1.4

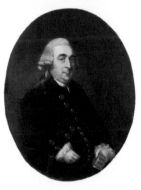

Unknown Nationality 18th Century
Portrait of a Man, c. 1785
Canvas, .375 x .302 (14 3/4 x 11 7/8)
Falsely inscribed at lower left: *Henry*
Pelham pinx
Andrew W. Mellon Collection
1954.1.7

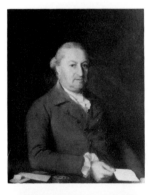

Unknown Nationality 19th Century
Robert Thew (?)
Canvas, .900 x .710 (35 1/2 x 28)
Andrew W. Mellon Collection
1942.8.24

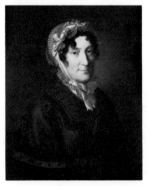

Unknown Nationality 19th Century
Portrait of a Lady, probably c. 1820
Canvas, .657 x .527 (25 7/8 x 20 3/4)
Andrew W. Mellon Collection
1942.8.37

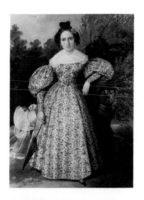

Unknown Nationality 19th Century
Portrait of a Young Lady, c. 1835
Canvas, .613 x .460 (24 1/8 x 18 1/8)
Falsely inscribed at lower left: *JJAudubon*
Andrew W. Mellon Collection
1947.17.1

Unknown Nationality 19th Century
An Artist's Studio, c. 1835
Canvas, .352 x .432 (13 7/8 x 17)
Andrew W. Mellon Collection
1947.17.19

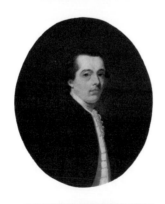

Unknown Nationality 19th Century
Portrait of a Man
Canvas, .295 x .248 (11 5/8 x 9 3/4)
Andrew W. Mellon Collection
1947.17.83

Maurice Utrillo
FRENCH, 1883 – 1955
The Church of Saint-Séverin, c. 1913
Canvas, .730 x .540 (28 3/4 x 21 1/4)
Inscribed at lower left: *Maurice Utrillo. V.*
Chester Dale Collection
1963.10.222

Maurice Utrillo
FRENCH, 1883 – 1955
Marizy-Sainte-Geneviève, c. 1910
Canvas, .597 x .810 (23 1/2 x 31 7/8)
Inscribed at lower left: *Maurice Utrillo. V.*
Chester Dale Collection
1963.10.223

Maurice Utrillo
FRENCH, 1883 – 1955
Row of Houses at Pierrefitte, c. 1905
Cardboard on wood, .239 x .342 (9 3/8 x
13 1/2)
Inscribed at lower right: *Maurice Utrillo.V.*
Ailsa Mellon Bruce Collection
1970.17.86

Maurice Utrillo
FRENCH, 1883 – 1955
Landscape, Pierrefitte, c. 1907
Cardboard on wood, .251 x .345 (9 7/8 x
13 5/8)
Inscribed at lower right: *Maurice Utrillo.V.*
Ailsa Mellon Bruce Collection
1970.17.87

Maurice Utrillo
FRENCH, 1883 – 1955
Rue Cortot, Montmartre, 1909
Cardboard, .457 x .336 (18 x 13 1/4)
Inscribed at lower left: *Maurice Utrillo.V. /
1909*
Ailsa Mellon Bruce Collection
1970.17.88

Maurice Utrillo
FRENCH, 1883 – 1955
Street at Corté, Corsica, 1913
Canvas, .608 x .807 (24 x 31 3/4)
Inscribed at lower left: *Maurice Utrillo.V.*
Ailsa Mellon Bruce Collection
1970.17.89

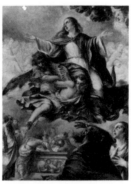

Juan de Valdés Leal
SPANISH, 1622 – 1690
The Assumption of the Virgin, c. 1670
Canvas, 2.151 x 1.563 (84 5/8 x 61 1/2)
Inscribed at lower center: BALDS LEA (BAL
in ligature)
Samuel H. Kress Collection
1961.9.46

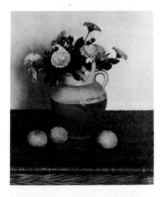

Félix Edouard Vallotton
SWISS, 1865 – 1925
Marigolds and Tangerines, 1924
Canvas, .653 x .542 (25 3/4 x 21 3/8)
Inscribed at lower right: F. VALLOTTON.24
Chester Dale Collection
1963.10.78

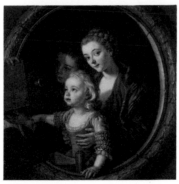

Charles Amédée Philippe Vanloo
FRENCH, 1719 – 1795
The Magic Lantern, 1764
Canvas, .886 x .886 (34 7/8 x 34 7/8)
Inscribed at lower left: *Amedee Van Loo. /
1764*
Gift of Mrs. Robert W. Schuette
1945.10.1

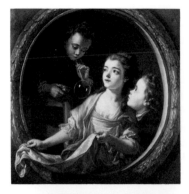

Charles Amédée Philippe Vanloo
FRENCH, 1719 – 1795
Soap Bubbles, 1764
Canvas, .886 x .886 (34 7/8 x 34 7/8)
Inscribed at lower left: *Amedee Van Loo. /
1764*
Gift of Mrs. Robert W. Schuette
1945.10.2

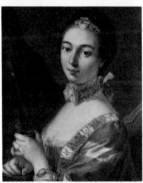

Follower of Louis Michel Vanloo
FRENCH
Portrait of a Lady
Canvas, .560 x .465 (22 x 18 3/8)
Gift of Lewis Einstein
1953.13.1

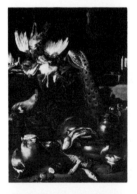

Anton Maria Vassallo
GENOESE, 1615 – probably 1654
The Larder, probably c. 1650/1660
Canvas, 2.292 x 1.632 (90 1/4 x 64 1/4)
Samuel H. Kress Collection
1961.9.91

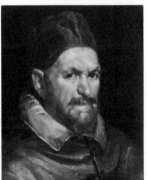

Diego Velázquez
SPANISH, 1599 – 1660
Pope Innocent X, c. 1650
Canvas, .495 x .413 (19 1/2 x 16 1/4)
Andrew W. Mellon Collection
1937.1.80

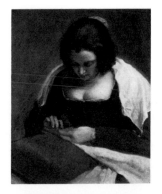

Diego Velázquez
SPANISH, 1599 – 1660
The Needlewoman, c. 1640
Canvas, .740 x .600 (29 1/8 x 23 5/8)
Andrew W. Mellon Collection
1937.1.81

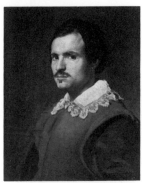

Follower of Diego Velázquez
SPANISH
Portrait of a Young Man
Canvas, .591 x .479 (23 1/4 x 18 7/8)
Andrew W. Mellon Collection
1937.1.82

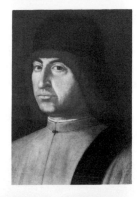

Venetian 15th Century
Portrait of a Man, late 15th century
Wood, .265 x .191 (10 3/8 x 7 1/2)
Timken Collection
1960.6.1

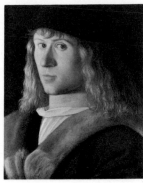

Venetian 16th Century
Portrait of a Young Man, c. 1505
Wood, .279 x .229 (11 x 9)
Widener Collection
1942.9.96

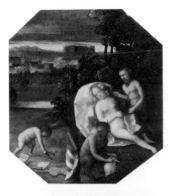

Venetian 16th Century
Allegory, c. 1530
Wood, .430 x .392 (17 x 15 3/8)
Gift of Dr. and Mrs. G. H. Alexander
Clowes
1948.17.1

Venetian 18th Century
Before the Masked Ball, third quarter of
the 18th century
Canvas, 1.664 x 1.270 (65 1/2 x 50)
Samuel H. Kress Collection
1961.9.92

Johannes Vermeer
DUTCH, 1632 – 1675
The Girl with the Red Hat, c. 1665
Wood, .232 x .181 (9 1/8 x 7 1/8)
Inscribed at upper center on figured
tapestry with monogram: IVM
Andrew W. Mellon Collection
1937.1.53

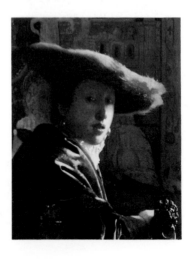

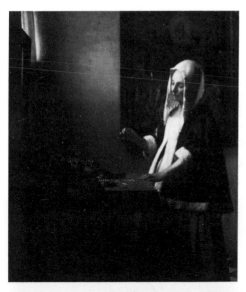

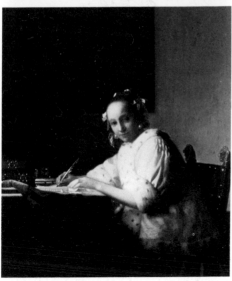

Johannes Vermeer
DUTCH, 1632 – 1675
Woman Holding a Balance, c. 1664
Canvas, .425 x .380 (16 3/4 x 15)
Widener Collection
1942.9.97

Johannes Vermeer
DUTCH, 1632 – 1675
A Lady Writing, c. 1665
Canvas, .450 x .399 (17 3/4 x 15 3/4)
Inscribed at center left on bottom of
picture frame: *IVMeer (IVM* in ligature)
Gift of Harry Waldron Havemeyer and
Horace Havemeyer, Jr. in memory of their
father, Horace Havemeyer
1962.10.1

Attributed to Johannes Vermeer
DUTCH, 1632 – 1675
Young Girl with a Flute, c. 1665
Wood, .200 x .178 (7 7/8 x 7)
Widener Collection
1942.9.98

Veronese
VENETIAN, 1528 – 1588
The Finding of Moses, probably 1570/1575
Canvas, .580 x .445 (22 3/4 x 17 1/2)
Andrew W. Mellon Collection
1937.1.38

Veronese
VENETIAN, 1528 – 1588
Rebecca at the Well, 1580/1585
Canvas, 1.455 x 2.827 (57 1/4 x 111 1/4)
Samuel H. Kress Collection
1952.5.82

Veronese
VENETIAN, 1528 – 1588
The Annunciation, c. 1580
Canvas, .984 x .753 (38 3/4 x 29 5/8)
Samuel H. Kress Collection
1959.9.6

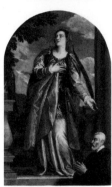

Veronese
VENETIAN, 1528 – 1588
Saint Jerome in the Wilderness, c. 1580
Canvas, 1.080 x .841 (42 1/2 x 33 1/8)
Samuel H. Kress Collection
1961.9.47

Veronese
VENETIAN, 1528 – 1588
Saint Lucy and a Donor, probably c. 1580
Canvas, 1.806 x 1.153 (71 1/8 x 45 3/8)
Samuel H. Kress Collection
1961.9.48

Veronese
VENETIAN, 1528 – 1588
*The Martyrdom and Last Communion of
Saint Lucy,* c. 1582
Canvas, 1.397 x 1.734 (55 x 68 1/4)
The Morris and Gwendolyn Cafritz
Foundation and Ailsa Mellon Bruce Fund
1984.28.1

Follower of Veronese
VENETIAN
Agostino Barbarigo
Canvas, 1.028 x 1.024 (40 1/2 x 40 3/8)
Gift of Lewis Einstein
1957.8.1

**Workshop of Andrea del Verrocchio
(Possibly Leonardo da Vinci)**
FLORENTINE, 1452 – 1519
Madonna and Child with a Pomegranate,
c. 1470/1475
Wood, .157 x .128 (6 1/8 x 5)
Samuel H. Kress Collection
1952.5.65

Style of Andrea del Verrocchio
FLORENTINE
Madonna and Child
Wood, .781 x .540 (30 3/4 x 21 1/4)
Samuel H. Kress Collection
1943.4.1

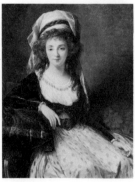

Elisabeth Vigée-Lebrun
FRENCH, 1755 – 1842
Portrait of a Lady, 1789
Wood, 1.070 x .832 (42 1/8 x 32 3/4)
Inscribed at upper right: *M^de. LeBrun /
1789*
Samuel H. Kress Collection
1946.7.16

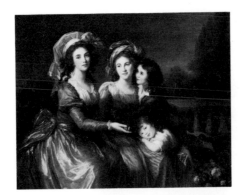

Elisabeth Vigée-Lebrun
FRENCH, 1755 – 1842
The Marquise de Pezé and the Marquise de Rouget with Her Two Children, 1787
Canvas, 1.234 x 1.559 (48 5/8 x 61 3/8)
Gift of the Bay Foundation in memory of Josephine Bay Paul and Ambassador Charles Ulrick Bay
1964.11.1

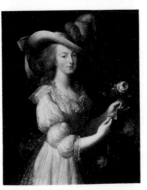

Attributed to Elisabeth Vigée-Lebrun
FRENCH, 1755 – 1842
Marie-Antoinette, c. 1783
Canvas, .927 x .731 (36 1/2 x 28 3/4)
Timken Collection
1960.6.41

Jacques Villon
FRENCH, 1875 – 1963
From Wheat to Straw, 1946
Canvas, .640 x 1.405 (25 1/4 x 55 3/8)
Inscribed at lower right: *Jacques Villon*; at upper left on reverse: *Jacques Villon 46 / Du Blé a la Paille*
Collection of Mr. and Mrs. Paul Mellon
1983.1.35

Jacques Villon
FRENCH, 1875 – 1963
Drink to the Chimera, 1947
Canvas, .730 x .594 (28 3/4 x 23 5/8)
Inscribed at lower right: *Jacques Villon / 47*
Collection of Mr. and Mrs. Paul Mellon
1983.1.36

Jacques Villon
FRENCH, 1875 – 1963
The Bridge of Beaugency, 1944
Canvas, 1.000 x .816 (39 3/8 x 32 1/8)
Inscribed at lower left: *Jacques Villon*
Collection of Mr. and Mrs. Paul Mellon
1983.1.37

Alvise Vivarini
VENETIAN, C. 1445 – 1503/1505
Saint Jerome Reading, c. 1475/1480
Wood, .314 x .251 (12 3/8 x 9 7/8)
Inscribed at lower right on a cartello with
the artist's signature: LVDVVICVS VIVA/
RINVS · PINXIT
Samuel H. Kress Collection
1939.1.311

Alvise Vivarini
VENETIAN, C. 1445 – 1503/1505
Portrait of a Senator, c. 1500
Wood, .349 x .308 (13 3/4 x 12 1/8)
Samuel H. Kress Collection
1939.1.355

Antonio Vivarini
VENETIAN, C. 1415 – 1476/1484
Saint Apollonia Destroys a Pagan Idol,
c. 1450
Wood, .597 x .343 (23 1/2 x 13 1/2)
Inscribed at upper right on balcony
parapet: EVSEBIV[S]
Samuel H. Kress Collection
1939.1.7

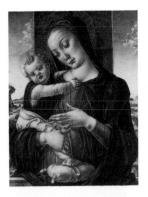

Bartolomeo Vivarini
VENETIAN, C. 1432 – C. 1499
Madonna and Child, c. 1475
Wood, .533 x .419 (21 x 16 1/2)
Samuel H. Kress Collection
1939.1.118

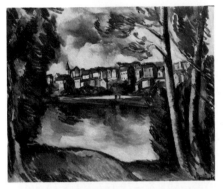

Maurice de Vlaminck
FRENCH, 1876 – 1958
Carrières-Saint-Denis, 1918/1920
Canvas, .734 x .921 (28 7/8 x 36 1/4)
Inscribed at lower right: *Vlaminck*
Chester Dale Collection
1963.10.224

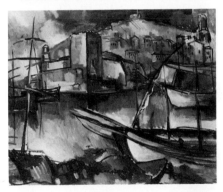

Maurice de Vlaminck
FRENCH, 1876 – 1958
The Old Port of Marseille, 1913
Canvas, .730 x .904 (28 3/4 x 35 5/8)
Inscribed at lower right: *Vlaminck*
Chester Dale Collection
1963.10.225

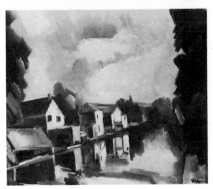

Maurice de Vlaminck
FRENCH, 1876 – 1958
The River, c. 1910
Canvas, .600 x .730 (23 5/8 x 28 3/4)
Inscribed at lower right: *Vlaminck*
Chester Dale Collection
1963.10.226

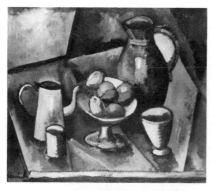

Maurice de Vlaminck
FRENCH, 1876 – 1958
Still Life with Lemons, 1913/1914
Canvas, .604 x .730 (23 3/4 x 28 3/4)
Inscribed at lower left: *Vlaminck*
Chester Dale Collection
1963.10.227

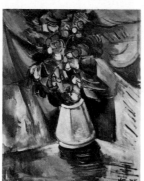

Maurice de Vlaminck
FRENCH, 1876 – 1958
Vase of Flowers, 1910 or before
Canvas, .730 x .604 (28 3/4 x 23 3/4)
Inscribed at lower right: *Vlaminck*
Chester Dale Collection
1963.10.228

Maurice de Vlaminck
FRENCH, 1876 – 1958
Woman with a Hat, 1905
Canvas, .565 x .476 (22 1/4 x 18 3/4)
Inscribed at lower right: *Vlaminck*
Gift of Lili-Charlotte Sarnoff in memory of
Robert and Martha von Hirsch
1981.84.1

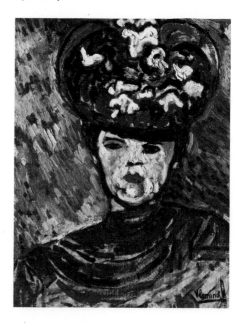

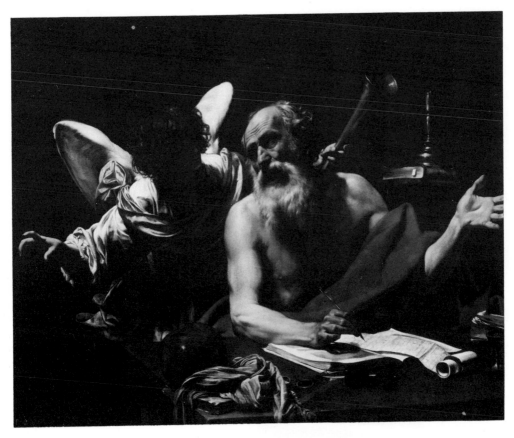

Simon Vouet
FRENCH, 1590 – 1649
Saint Jerome and the Angel, c. 1625
Canvas, 1.448 x 1.798 (57 x 70 3/4)
Inscribed at lower left an inventory
number: 523
Samuel H. Kress Collection
1961.9.52

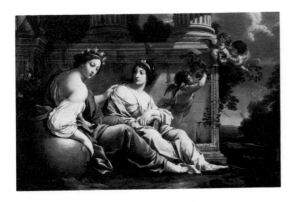

Simon Vouet
FRENCH, 1590 – 1649
The Muses Urania and Calliope, c. 1634
Wood, .798 x 1.250 (31 1/8 x 49 3/8)
Samuel H. Kress Collection
1961.9.61

Edouard Vuillard
FRENCH, 1868 – 1940
Théodore Duret, 1912
Cardboard on wood, .952 x .748 (37 1/2 x 29 1/2)
Inscribed at lower left: *E. Vuillard* / *1912*
Chester Dale Collection
1963.10.70

Edouard Vuillard
FRENCH, 1868 – 1940
Repast in a Garden, 1898
Gouache on cardboard, .543 x .531 (21 3/8 x 20 7/8)
Inscribed at lower left: *E Vuillard*
Chester Dale Collection
1963.10.229

Edouard Vuillard
FRENCH, 1868 – 1940
The Visit, 1931
Canvas, 1.001 x 1.364 (39 3/8 x 53 3/4)
Inscribed at lower right: *E. Vuillard*
Chester Dale Collection
1963.10.230

Edouard Vuillard
FRENCH, 1868 – 1940
Child Wearing a Red Scarf, c. 1891
Cardboard on wood, .292 x .175 (11 1/2 x 6 7/8)
Inscribed at upper right with atelier stamp: *E Vuillard*
Ailsa Mellon Bruce Collection
1970.17.90

Edouard Vuillard
FRENCH, 1868 – 1940
Woman at Her Toilette, c. 1891
Cardboard on wood, .225 x .209 (8 7/8 x 8 1/4)
Inscribed at lower right with atelier stamp: *E Vuillard*
Ailsa Mellon Bruce Collection
1970.17.91

Edouard Vuillard
FRENCH, 1868 – 1940
The Conversation, 1891
Canvas, .238 x .334 (9 3/8 x 13 1/8)
Inscribed at lower left with atelier stamp: *E Vuillard*
Ailsa Mellon Bruce Collection
1970.17.92

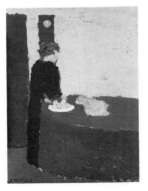

Edouard Vuillard
FRENCH, 1868 – 1940
Woman in Black, c. 1891
Cardboard, .268 x .219 (10 1/2 x 8 5/8)
Inscribed at lower left with atelier stamp: *E Vuillard*
Ailsa Mellon Bruce Collection
1970.17.93

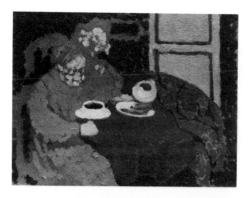

Edouard Vuillard
FRENCH, 1868 – 1940
Two Women Drinking Coffee, c. 1893
Cardboard on wood, .215 x .288 (8 1/2 x
11 3/8)
Ailsa Mellon Bruce Collection
1970.17.94

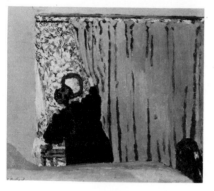

Edouard Vuillard
FRENCH, 1868 – 1940
The Yellow Curtain, c. 1893
Canvas, .349 x .390 (13 3/4 x 15 3/8)
Inscribed at lower left with atelier stamp:
E Vuillard
Ailsa Mellon Bruce Collection
1970.17.95

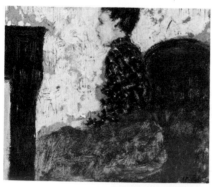

Edouard Vuillard
FRENCH, 1868 – 1940
Woman Sitting by the Fireside, c. 1894
Cardboard, .213 x .261 (8 3/8 x 10 1/4)
Inscribed at lower right: *E Vuillard*
Ailsa Mellon Bruce Collection
1970.17.96

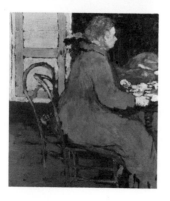

Edouard Vuillard
FRENCH, 1868 – 1940
Breakfast, 1894
Cardboard on wood, .269 x .229 (10 5/8
x 9)
Inscribed at lower left: *E Vuillard 94*
Ailsa Mellon Bruce Collection
1970.17.97

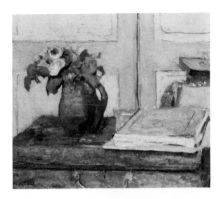

Edouard Vuillard
FRENCH, 1868 – 1940
The Artist's Paint Box and Moss Roses,
1898
Cardboard, .361 x .429 (14 1/4 x 16 7/8)
Inscribed at lower left: *E Vuillard*
Ailsa Mellon Bruce Collection
1970.17.98

Edouard Vuillard
FRENCH, 1868 – 1940
Vase of Flowers on a Mantelpiece, c. 1900
Cardboard on wood, .362 x .295 (14 1/4 x
11 5/8)
Inscribed at upper right: *E Vuillard*
Ailsa Mellon Bruce Collection
1970.17.99

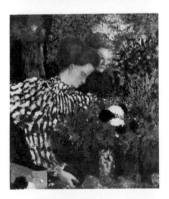

Edouard Vuillard
FRENCH, 1868 – 1940
Woman in a Striped Dress, 1895
Canvas, .657 x .587 (25 7/8 x 23 1/8)
Inscribed at lower right: *E. Vuillard*
Collection of Mr. and Mrs. Paul Mellon
1983.1.38

L. de Vuillemin
FRENCH, probably active 19th century
Portrait of an Old Woman
Canvas, .325 x .245 (12 3/4 x 9 5/8)
Chester Dale Collection
1964.19.8

L. de Vuillemin
FRENCH, probably active 19th century
Portrait of a Young Woman, 1849
Canvas, .325 x .246 (12 3/4 x 9 5/8)
Inscribed at lower left: *L. de Vuillemin /
1849*
Chester Dale Collection
1964.19.9

John Walker
BRITISH, b. 1939
Untitled (Oxford), 1977/1978
Canvas, 3.050 x 2.438 (120 1/8 x 96)
Inscribed on reverse: *Walker 77-78 /
untitled Oxford / mixed media / acrylic
chalk / & oil paint*
Gift of Mr. and Mrs. E. W. R. Templeton
1978.62.1

Antoine Watteau
FRENCH, 1684 – 1721
Italian Comedians, probably 1720
Canvas, .638 x .762 (25 1/8 x 30)
Samuel H. Kress Collection
1946.7.9

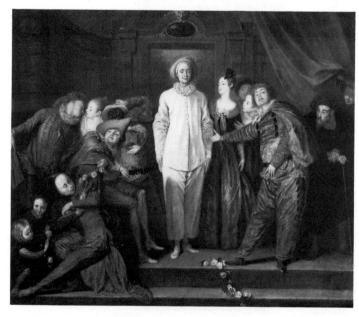

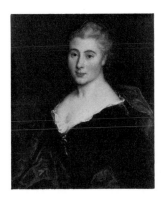

Antoine Watteau
FRENCH, 1684 – 1721
"Sylvia" (Jeanne-Rose-Guyonne Benozzi),
c. 1720
Canvas, .692 x .587 (27 1/4 x 23 1/8)
Samuel H. Kress Collection
1946.7.17

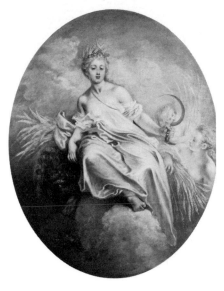

Antoine Watteau
FRENCH, 1684 – 1721
Ceres (Summer), c. 1712
Canvas, oval, 1.416 x 1.160 (55 3/4 x
45 5/8)
Samuel H. Kress Collection
1961.9.50

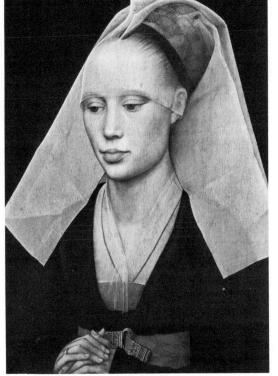

Rogier van der Weyden
NETHERLANDISH, 1399 or 1400 – 1464
Portrait of a Lady, c. 1460
Wood, painted surface: .340 x .255 (13 3/8
x 10 1/16); panel: .368 x .273 (14 1/2 x
10 3/4)
Andrew W. Mellon Collection
1937.1.44

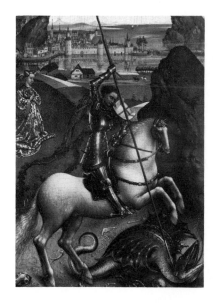

Rogier van der Weyden
NETHERLANDISH, 1399 or 1400 – 1464
Saint George and the Dragon,
c. 1432/1435
Wood, painted surface: .143 x .105 (5 5/8
x 4 1/8); panel: .152 x .118 (6 x 4 5/8)
Ailsa Mellon Bruce Fund
1966.1.1

Follower of Rogier van der Weyden
NETHERLANDISH
Christ Appearing to the Virgin, c. 1475
Wood, 1.626 x .930 (64 x 36 5/8)
Andrew W. Mellon Collection
1937.1.45

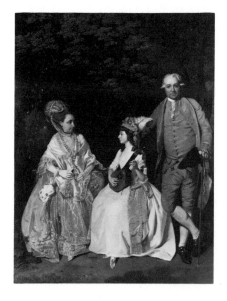

Francis Wheatley
BRITISH, 1747 – 1801
Family Group, c. 1775/1776
Canvas, .917 x .714 (36 1/8 x 28 1/8)
Paul Mellon Collection
1983.1.43

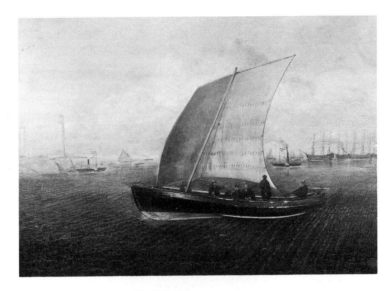

W. Wheldon
BRITISH, active 1863
Two Brothers, 1863
Wood, boat in relief, .733 x 1.070 (28 7/8
x 42 1/8)
Inscribed at center on boat: TWO
BROTHERS.G35; at lower right: PAINTED /
BY W. WHELDON / 1863.
Gift of Edgar William and Bernice Chrysler
Garbisch
1953.5.39

Beatrix Godwin Whistler
BRITISH, 1857 – 1896
Peach Blossom, c. 1890
Wood, .237 x .138 (9 1/4 x 5 3/8)
Rosenwald Collection
1943.11.8

Sir David Wilkie
BRITISH, 1785 – 1841
Camping Gypsies, 1841
Wood, .257 x .190 (10 1/8 x 7 1/2)
Inscribed at lower right: *David Wilkie ft. /
1841.*
Timken Collection
1960.6.42

Richard Wilson
BRITISH, 1714 – 1782
Lake Albano, 1762
Canvas, 1.219 x 1.704 (48 x 67 1/8)
Inscribed at lower center: *RW. 1762 (RW*
in ligature)
Paul Mellon Collection
1983.1.44

Richard Wilson
BRITISH, 1714 – 1782
Solitude, after 1774
Canvas, 1.421 x 2.101 (56 x 82 3/4)
Paul Mellon Collection
1983.1.45

Franz Xaver Winterhalter
GERMAN, 1805 – 1873
Queen Victoria, c. 1841
Canvas, 1.280 x .959 (50 3/8 x 37 3/4)
Gift of the children of the late William H.
Donner
1954.3.1

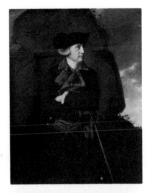

Joseph Wright
BRITISH, 1734 – 1797
Richard, Earl Howe (?), early 1770s
Canvas, 1.276 x 1.016 (50 1/4 x 40)
Andrew W. Mellon Collection
1940.1.11

Joseph Wright
BRITISH, 1734 – 1797
Portrait of a Man, c. 1760
Canvas, .765 x .639 (30 1/8 x 25 1/8)
Andrew W. Mellon Collection
1947.17.112

Joseph Wright
BRITISH, 1734 – 1797
The Corinthian Maid, 1783/1784
Canvas, 1.063 x 1.308 (41 7/8 x 51 1/2)
Paul Mellon Collection
1983.1.46

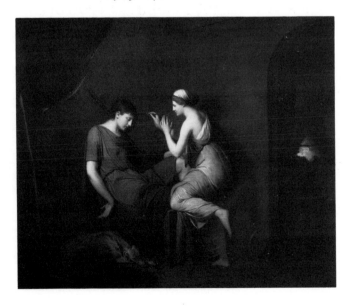

Joseph Wright
BRITISH, 1734 – 1797
Italian Landscape, 1790
Canvas, 1.035 x 1.304 (40 3/4 x 51 3/8)
Inscribed at lower left: *I. Wright / pinx. /
1790*
Paul Mellon Collection
1983.1.47

After Joseph Wright
BRITISH
The Widow of an Indian Chief, 1785
or after
Canvas, .632 x .755 (24 7/8 x 29 3/4)
Chester Dale Collection
1963.10.79

Joachim Antonisz. Wtewael
DUTCH, c. 1566 – 1638
Moses Striking the Rock, 1624
Wood, .445 x .665 (17 1/2 x 26 1/4)
Inscribed at lower left: *Jo Wtt / wael.fecit /
Anno . 1624 (Jo* in ligature)
Ailsa Mellon Bruce Fund
1972.11.1

Eugene Zak
POLISH, 1884 – 1926
The Nun
Canvas, .997 x .795 (39 1/4 x 31 1/4)
Inscribed at upper right: *Eug. Zak*
Chester Dale Collection
1964.19.10

Johann Zoffany
BRITISH, 1733 – 1810
The Lavie Children, c. 1760/1772
Canvas, 1.025 x 1.276 (40 3/8 x 50 1/4)
Paul Mellon Collection
1983.1.48

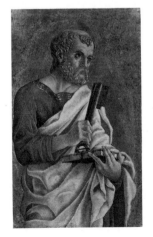

Marco Zoppo
PADUAN, 1433 – 1478
Saint Peter, c. 1470
Wood, .483 x .305 (19 1/4 x 12)
Samuel H. Kress Collection
1939.1.271

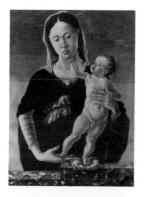

Marco Zoppo
PADUAN, 1433 – 1478
Madonna and Child, c. 1470
Wood, .408 x .299 (16 1/8 x 11 3/4)
Inscribed at lower center on parapet:
MARCO.ZOPPO.DA BOLOGNA / OPVS
Samuel H. Kress Collection
1961.9.51

Anders Zorn
SWEDISH, 1860 – 1920
Hugo Reisinger, 1907
Canvas, 1.355 x 1.005 (53 3/8 x 39 1/2)
Inscribed at lower right: *i min verstad* (in
my studio) / *Stockholm aug 1907 / Zorn*
Gift of Curt H. Reisinger
1957.4.3

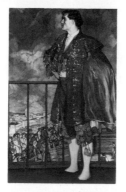

Ignacio Zuloaga
SPANISH, 1870 – 1945
Achieta, 1911/1913
Canvas, 1.956 x 1.244 (77 x 49)
Inscribed at lower left: *I. Zuloaga*
Chester Dale Collection
1963.10.231

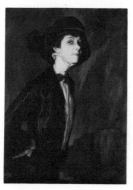

Ignacio Zuloaga
SPANISH, 1870 – 1945
Mrs. Philip Lydig, 1912
Canvas, .987 x .723 (38 7/8 x 28 1/2)
Inscribed at lower right: *I. Zuloaga*
Chester Dale Collection
1963.10.232

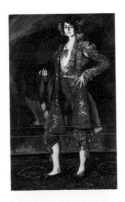

Ignacio Zuloaga
SPANISH, 1870 – 1945
Merceditas, 1911/1913
Canvas, 1.959 x 1.216 (77 1/8 x 47 7/8)
Inscribed at lower left: *I. Zuloaga*
Chester Dale Collection
1963.10.233

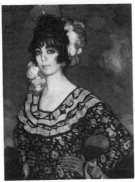

Ignacio Zuloaga
SPANISH, 1870 – 1945
Woman in Andalusian Dress, 1911/1913
Canvas, .870 x .667 (34 1/4 x 26 1/4)
Inscribed at lower right: *I. Zuloaga*
Chester Dale Collection
1963.10.234

Ignacio Zuloaga
SPANISH, 1870 – 1945
Sepúlveda, 1909
Canvas, .579 x .621 (22 3/4 x 24 1/2)
Inscribed at lower left: *I. Zuloaga*
Chester Dale Collection
1963.10.235

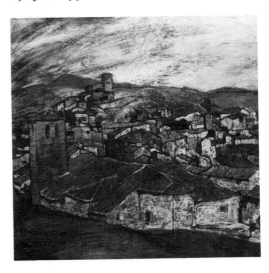

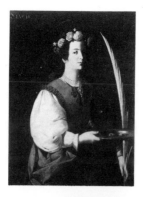

Francisco de Zurbarán
SPANISH, 1598 – 1664
Santa Lucia, c. 1625
Canvas, 1.041 x .772 (41 x 30 3/8)
Inscribed at upper left: S. LVCIA
Chester Dale Collection
1943.7.11

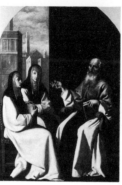

Francisco de Zurbarán
SPANISH, 1598 – 1664
Saint Jerome with Saint Paula and Saint Eustochium, c. 1640
Canvas, 2.451 x 1.730 (96 1/2 x 68 1/8)
Samuel H. Kress Collection
1952.5.88

Changes in attribution, titles, and nomenclature since the 1975 catalogue (arranged alphabetically by former attribution)

Formerly	Currently
1110	1952.5.31.a-c
Albrecht Altdorfer	Albrecht Altdorfer, Workshop of
The Fall of Man	*The Fall of Man*
890	1947.3.1
Hendrick van Anthonissen, Circle of	Hendrick van Anthonissen, Style of
Ships in the Scheldt Estuary	*Ships in the Scheldt Estuary*
335	1939.1.224
Giovanni Bellini	Giovanni Bellini
Portrait of a Condottiere	*Giovanni Emo*
894	1946.19.1
Giovanni Bellini	Giovanni Bellini
Madonna and Child	*Madonna and Child in a Landscape*
373	1939.1.262
Giovanni Bellini and Assistant	Giovanni Bellini and Workshop
Madonna and Child in a Landscape	*Madonna and Child in a Landscape*
1553	1960.6.1
Giovanni Bellini, Attributed to	Venetian 15th Century
Portrait of a Man	*Portrait of a Man*
1177	1953.3.3.a-b
Ambrosius Benson	Antwerp 16th Century, Attributed to
Niclaes de Hondecoeter	*A Member of the de Hondecoeter Family*
1178	1953.3.4
Ambrosius Benson	Antwerp 16th Century, Attributed to
Wife of Niclaes de Hondecoeter	*Wife of a Member of the de Hondecoeter Family*
2374	1970.17.2
Jean Béraud	Jean Béraud
Paris Street Scene	*Paris, rue du Havre*

indicates paintings which were not illustrated in the 1975 catalogue

Formerly	Currently
1632	1961.9.80
Bertoia	Giovanni Sons
Judgment of Paris	*Judgment of Paris*
2390	1970.17.18
Eugène Boudin, Manner of	Eugène Boudin, Style of
Beach at Deauville	*Beach at Deauville*
1618	1961.9.66
Dirck Bouts	Dirck Bouts, Follower of
Portrait of a Donor	*Portrait of a Donor*
1101	1925.2.18
Pieter Bruegel the Elder	Antwerp 16th Century (possibly Matthys
The Martyrdom of Saint Catherine	Cock)
	The Martyrdom of Saint Catherine
1102	1952.2.19
Pieter Bruegel the Elder	Pieter Bruegel the Elder, Follower of
The Temptation of Saint Anthony	*The Temptation of Saint Anthony*
1	1937.1.1
Byzantine School	Anonymous Byzantine 13th Century
Enthroned Madonna and Child	*Madonna and Child on a Curved Throne*
270	1939.1.159
Michelangelo Caravaggio	Michelangelo Merisi da Caravaggio,
Still Life	Follower of
	Still Life
1525	1959.2.1
Paul Cézanne	Paul Cézanne
The Sailor	*The Gardener Vallier*
1768	1963.10.104
Paul Cézanne	Paul Cézanne
Still Life	*Still Life with Peppermint Bottle*
1769	1963.10.105
Paul Cézanne	Paul Cézanne
Vase of Flowers	*Flowers in a Rococo Vase*
740	1943.7.3
Jean-Baptiste-Siméon Chardin	Jean Siméon Chardin, Follower of
Etienne Jeaurat	*Portrait of a Man*
741	1943.7.4
Jean-Baptiste-Siméon Chardin	Jean Siméon Chardin
Still Life	*Fruit, Jug and a Glass*

Formerly	*Currently*
780	1946.7.10
Jean-Baptiste-Siméon Chardin	Anonymous French 18th Century
Portrait of an Old Woman	*Portrait of an Old Woman*
1115	1952.5.36
Jean-Baptiste-Siméon Chardin	Jean Siméon Chardin
Still Life	*Still Life with Game*
1367	1961.9.10
Petrus Christus	Petrus Christus
A Donor and His Wife	*Portrait of a Male Donor*
1368	1961.9.11
Petrus Christus	Petrus Christus
A Donor and His Wife	*Portrait of a Female Donor*
2	1937.1.2.a-c
Cimabue, Attributed to	Cimabue, Follower of
Christ between Saint Peter	*Christ between Saint Peter*
and Saint James Major	*and Saint James Major*
1662	1962.9.1
Joos van Cleve	Joos van Cleve
Joris W. Vezeler	*Joris Vezeleer*
1663	1962.9.2
Joos van Cleve	Joos van Cleve
Margaretha Boghe, Wife of	*Margaretha Boghe, Wife of Joris Vezeleer*
Joris W. Vezeler	
1557	1960.6.5
Coreggio, Attributed to	Correggio, After
Madonna and Child with the	*Madonna and Child with the Infant*
Infant Saint John	*Saint John*
1558	1960.6.6
Francis Cotes, Circle of	Francis Cotes, Style of
Portrait of a Lady	*Portrait of a Lady*
1559	1960.6.7
Francis Cotes, Circle of	Francis Cotes, Style of
Portrait of a Lady	*Portrait of a Lady*
1621	1961.9.69
Lucas Cranach, the Elder	Lucas Cranach, the Elder
The Crucifixion with Longinus	*The Crucifixion with the Converted*
	Centurion

	Formerly	Currently
	2396	1970.17.24
	Honoré Daumier, Manner of	Honoré Daumier, Style of
	Study of Clowns	*Study of Clowns*
	613	1942.9.17.a-c
	Gerard David	Gerard David and Workshop
	The Saint Anne Altarpiece	*The Saint Anne Altarpiece*
	1782	1963.10.118
	Jacques-Louis David, Circle of	Jacques-Louis David, Follower of
	Portrait of a Young Woman in White	*Portrait of a Young Woman in White*
	1789	1963.10.125
	Edgar Degas	Edgar Degas
	Duke and Duchess of Morbilli	*Edmondo and Thérèse Morbilli*
	1911	1964.2.3
	Arthur Devis	Arthur Devis
	Lord Brand of Hurndall Park	*Portrait of a Gentleman Netting Game Birds*
	15	1937.1.15
	Domenico Veneziano	Florentine 15th Century
	Matteo Olivieri	*Matteo Olivieri*
	209	1939.1.98
	Dosso Dossi	Jacopo Tintoretto
	The Standard Bearer	*Portrait of a Man as Saint George*
	51	1937.1.51
	Sir Anthony van Dyck	Hanneman, Adriaen
	William II of Nassau and Orange	*Henry, Duke of Gloucester*
	687	1942.9.91
	Sir Anthony van Dyck	Sir Anthony van Dyck
	Paola Adorno, Marchesa Brignole Sale, and Her Son	*Portrait of an Italian Noblewoman and Her Son*
	1573	1960.6.21
	Sir Anthony van Dyck, School of	Sir Anthony van Dyck, After
	Group of Four Boys	*Group of Four Boys*
	1563	1960.6.11
	Sir Anthony van Dyck, Manner of, and later, School of	Sir Anthony van Dyck, After
	*Twelve Apostles**	*Twelve Apostles*

Formerly	Currently
699	1942.16.2.a-b
Flemish, late 15th Century	Flemish 15th Century, Imitator of
Saint Bernard with Donor;	*Saint Bernard (?) with Donor;*
reverse: *Saint Margaret**	reverse: *Saint Margaret*
1447	1956.3.2
Flemish School	Antwerp 16th Century
Goosen van Bonhuysen	*Portrait of an Almoner of Antwerp*
443	1939.1.350
Florentine School	Michelangelo Anselmi
Apollo and Marsyas	*Apollo and Marsyas*
1446	1956.3.1
French School, XVIII Century	Michel-François Dandré-Bardon
The Adoration of the Skulls	*The Adoration of the Skulls*
1448	1956.9.1
Thomas Gainsborough	Thomas Barker
Shepherd Boys and Dog Sheltering	*Shepherd Boys and Dog Sheltering from*
*from Storm**	*Storm*
2493	1970.17.121
Thomas Gainsborough	Thomas Gainsborough
Seascape	*Seashore with Fishermen*
2491	1970.17.119
Thomas Gainsborough, After	Gainsborough Dupont
Georgiana, Duchess of Devonshire	*Georgiana, Duchess of Devonshire*
2492	1970.17.120
Thomas Gainsborough, After	Gainsborough Dupont
William Pitt	*William Pitt*
2494	1970.17.122
Thomas Gainsborough, After	Gainsborough Dupont
Mrs. Richard Brinsley Sheridan	*Mrs. Richard Brinsley Sheridan*
2598	1972.9.12
Paul Gauguin	Paul Gauguin
Words of the Devil, and later,	*Parau na te Varua ino (Words of*
Parau na te Varua ino (Talk	*the Devil)*
about the Evil Spirit)	
2674	1974.87.1
Giorgione, Circle of	Giorgione, Attributed to
Giovanni Borgherini and His Tutor	*Giovanni Borgherini and His Tutor*

Formerly	Currently
1817	1963.10.153
Vincent van Gogh	Vincent van Gogh, Imitator of
Self-Portrait	*Portrait of van Gogh*
2316	1967.4.1
Jan Gossaert (Mabuse)	Jan Gossaert
Portrait of a Banker	*Portrait of a Merchant*
622	1942.9.26
El Greco	El Greco
The Virgin with Saint Inés	*Madonna and Child with Saint Martina*
and Saint Tecla	*ᵓnd Saint Agnes*
1572	1960.6.20
Jean-Baptiste Greuze	Jean-Baptiste Greuze, After
Girl With Folded Arms	*Girl with Folded Arms*
1507	1958.7.1
Francesco Guardi, School of	Francesco Guardi, Follower of
Piazza San Marco	*Piazza San Marco*
69	1937.1.69
Frans Hals	Frans Hals
Balthasar Coymans	*Willem Coymans*
70	1937.1.70
Frans Hals	Frans Hals
Portrait of a Man	*Adriaen van Ostade*
744	1943.7.7
Jan van Hemessen	Anonymous Netherlandish 16th Century
"Arise, and Take up Thy Bed, and Walk"	*The Healing of the Paralytic*
1120	1952.5.41
Hispano-Dutch School	North Netherlandish 15th Century
The Adoration of the Magi	*Adoration of the Magi*
2478	1970.17.106
John Hoppner, Circle of	John Hoppner, Style of
Portrait of a Man	*Portrait of a Man*
.632	1942.9.36
Italian 16th Century	Giuliano Bugiardini
Baldassare Castiglione	*Portrait of a Man*
1576	1960.6.24
Italian School	Umbrian 15th Century
*Head of a Woman**	*Head of a Woman*

Formerly	*Currently*
1577 Italian School *The Adoration of the Shepherds**	1960.6.25 Florentine 15th Century *The Adoration of the Shepherds*
1073 Joseph Bartholomew Kidd *Sharp-Tailed Sparrow*	1951.9.5 Joseph Bartholomew Kidd After John James Audubon *Sharp-Tailed Sparrow*
1074 Joseph Bartholomew Kidd *Black-Backed Three-Toed Woodpecker*	1951.9.6 Joseph Bartholomew Kidd After John James Audubon *Black-Backed Three-Toed Woodpecker*
1075 Joseph Bartholomew Kidd *Orchard Oriole*	1951.9.7 Joseph Bartholomew Kidd After John James Audubon *Orchard Oriole*
1076 Joseph Bartholomew Kidd *Yellow Warbler*	1951.9.8 Joseph Bartholomew Kidd After John James Audubon *Yellow Warbler*
2709 Sir Peter Lely *Portrait of a Woman*	1977.63.1 Gerard Soest *Portrait of a Woman*
390 Filippo Lippi and Assistant *The Nativity*	1939.1.279 Filippo Lippi and Workshop *The Nativity*
888 Alessandro Longhi, School of *Portrait of a Man**	1946.13.1 Alessandro Longhi, Follower of *Portrait of a Man*
1339 Louis-Michel van Loo, School of *Portrait of a Lady*	1953.13.1 Louis Michel Vanloo, Follower of *Portrait of a Lady*
1040 Claude Lorrain, School of *Harbor at Sunset*	1949.1.8 Claude Lorrain, Follower of *Harbor at Sunset*
1387 Lucas van Leyden *The Card Players*	1961.9.27 Lucas van Leyden, After *The Card Players*

Formerly	Currently
1530	1959.3.1
Edouard Manet	Edouard Manet
The Tragedian (Rouvière as Hamlet)	*The Tragic Actor (Rouvière as Hamlet)*
32	1937.1.32
Andrea Mantegna	Paduan 15th Century
Saint Jerome in the Wilderness	*Saint Jerome in the Wilderness*
289	1939.1.178
Andrea Mantegna, Circle of	Andrea Mantegna, Follower of
Judith with the Head of Holofernes	*Judith with the Head of Holofernes*
14	1937.1.14
Masaccio	Florentine 15th Century
Profile Portrait of a Young Man	*Profile Portrait of a Young Man*
1388	1959.9.3
Master of Flémalle and Assistants	Robert Campin, Follower of
Madonna and Child with Saints in the Enclosed Garden	*Madonna and Child with Saints in the Enclosed Garden*
1097	1952.2.14
Master of Saint Gilles	Master of Saint Giles and Assistant
The Conversion of an Arian by Saint Rémy and later Saint Leu Healing the Children	*Episodes from the Life of a Bishop Saint*
6	1937.1.6.a-c
Master of the Fabriano Altarpierce and Allegretto Nuzi	Puccio di Simone and Allegretto Nuzi
Madonna Enthroned with Saints	*Madonna Enthroned with Saints*
1389	1961.9.28
Hans Memling	Master of the Prado Adoration of the Magi
The Presentation in the Temple	*The Presentation in the Temple*
2563	1971.51.1
Piet Mondrian	Piet Mondrian
Lozenge in Red, Yellow and Blue	*Diamond Painting in Red, Yellow, and Blue*
2415	1970.17.43
Claude Monet	Claude Monet
Ships at Anchor on the Seine	*Ships Riding on the Seine at Rouen*
1631	1961.9.79
Antonis Mor	Antonis Mor, Follower of
Portrait of a Young Man	*Portrait of a Young Man*

Formerly	Currently
2643 Gabriele Münter *Advent Bouquets*	1973.2.2 Gabriele Münter *Christmas Still Life*
1126 Bernaert van Orley *Christ Among the Doctors*; reverse: *Putto with Shield*	1952.5.47.a-b Bernard van Orley *Christ Among the Doctors*; reverse: *Putto* *with Arms of Jacques Coëne*
1082 Parmigianino, School of *Allegorical Landscape*	1952.4.1 Giovanni Andrea Donducci (Mastelletta) *Allegorical Landscape*
266 Pietro Perugino *The Annunciation*	1939.1.155 Giannicola di Paolo *The Annunciation*
391 Perugino *Saint Jerome in the Wilderness*	1939.1.280 Perugino, Follower of *Saint Jerome in the Wilderness*
190 Pontormo *Ugolino Martelli*	1939.1.79 Florentine 16th Century *Ugolino Martelli*
1151 Raphael, Circle of *Putti with a Wine Press*	1952.5.72 Raphael, Follower of *Putti with a Wine Press*
654 Rembrandt van Ryn *Head of Saint Matthew*	1942.9.58 Rembrandt van Rijn, Follower of *Head of Saint Matthew*
657 Rembrandt van Ryn *The Descent from the Cross*	1942.9.61 Rembrandt van Rijn, After *The Descent from the Cross*
659 Rembrandt van Ryn *Study of an Old Man*	1942.9.63 Rembrandt van Rijn, Style of *Study of an Old Man*
660 Rembrandt van Ryn *Head of an Aged Woman*	1942.9.64 Rembrandt van Rijn, Follower of *Head of an Aged Woman*
662 Rembrandt van Ryn *The Philosopher*	1942.9.66 Rembrandt van Rijn, Follower of (possibly Willem Drost) *The Philosopher*

Formerly	Currently
1443	1956.1.1
Rembrandt van Ryn, Manner of	Rembrandt van Rijn, Style of
Old Woman Plucking a Fowl	*Old Woman Plucking a Fowl*
2445	1970.17.73
Auguste Renoir	Auguste Renoir
Nude	*Small Study for a Nude*
672	1942.9.76
Sir Joshua Reynolds	Sir Joshua Reynolds, After
*Nelly O'Brien**	*Nelly O'Brien*
47	1937.1.47
Sir Peter Paul Rubens	Sir Anthony van Dyck
Isabella Brant	*Isabella Brant*
1584	1960.6.32
Sir Peter Paul Rubens, School of	Sir Peter Paul Rubens, Studio of
Saint Peter	*Saint Peter*
1585	1960.6.33
Sir Peter Paul Rubens, School of	Sir Peter Paul Rubens, Studio of
Peter Paul Rubens	*Peter Paul Rubens*
404	1939.1.293
Sassetta and Assistant	Sassetta and Workshop
The Meeting of Saint Anthony and Saint Paul	*The Meeting of Saint Anthony and Saint Paul*
817	1952.5.20
Sassetta and Assistant	Sassetta and Workshop
Saint Anthony Distributing His Wealth to the Poor	*Saint Anthony Distributing His Wealth to the Poor*
818	1952.5.21
Sassetta and Assistant	Sassetta and Workshop
Saint Anthony Leaving His Monastery	*Saint Anthony Leaving His Monastery*
1152	1952.5.73
Sassetta and Assistant	Sassetta and Workshop
The Death of Saint Anthony	*The Death of Saint Anthony*
1111	1952.5.32
School of Amiens	Anonymous French 15th Century
The Expectant Madonna with Saint Joseph	*The Expectant Madonna with Saint Joseph*

	Formerly	Currently
	1398	1961.9.36
	Jan van Scorel	Maerten van Heemskerck
	The Rest on the Flight into Egypt	*The Rest on the Flight into Egypt*
	820	1952.5.23
	Simone Martini and Assistants	Simone Martini, Workshop of
	Saint Matthew	*Saint Matthew*
	821	1952.5.24
	Simone Martini and Assistants	Simone Martini, Workshop of
	Saint Simon	*Saint Simon*
	822	1952.5.25
	Simone Martini and Assistants	Simone Martini, Workshop of
	Saint James Major	*Saint James Major*
	823	1952.5.26
	Simone Martini and Assistants	Simone Martini, Workshop of
	Saint Thaddeus	*Saint Thaddeus*
	2454	1970.17.82
	Alfred Sisley	Alfred Sisley
	Street at Sèvres	*Boulevard Héloïse, Argenteuil*
	46	1937.1.46
	Miguel Sithium (Michel Sittow)	Michel Sittow
	A Knight of the Order of Calatrava	*Portrait of Diego de Guevara (?)*
	1928	1965.1.1
	Miguel Sithium (Michel Sittow)	Michel Sittow
	Assumption of the Virgin	*Assumption of the Virgin*
	1047	1952.9.4
	George Stubbs	George Stubbs
	Colonel Pocklington with His Sisters	*Captain Pocklington with His Wife and Sister*
	1562	1960.6.10
	Gerard Ter Borch, School of	Gerard Terborch II, Studio of
	The Concert	*The Concert*
	1078	1951.15.1
	Jacopo Tintoretto, School of	Jacopo Tintoretto, Follower of
	Portrait of a Man and Boy	*Portrait of a Man and Boy*
	35	1937.1.35
	Titian	Titian, Attributed to
	Andrea dei Franceschi	*Andrea dei Franceschi*

	Formerly	*Currently*

Formerly	*Currently*
36	1937.1.36
Titian	Polidoro Lanzani
Madonna and Child and the Infant Saint John in a Landscape	*Madonna and Child and the Infant Saint John in a Landscape*
678	1942.9.82
Titian	Titian, Follower of
Emilia di Spilimbergo	*Emilia di Spilimbergo*
679	1942.9.83
Titian	Titian, Follower of
Irene di Spilimbergo	*Irene di Spilimbergo*
1590	1960.6.38
Titian and Assistant	Titian and Workshop
Girolamo and Cardinal Marco Corner Investing Marco, Abbot of Carrara, with His Benefice	*Girolamo and Cardinal Marco Corner Investing Marco, Abbot of Carrara, with His Benefice*
1160	1952.5.81
Umbrian School, early XVI Century	Bacchiacca
The Flagellation of Christ	*The Flagellation of Christ*
82	1937.1.82
Diego Velázquez, Circle of	Diego Velázquez, Follower of
Portrait of a Young Man	*Portrait of a Young Man*
253	1939.1.142
Venetian School (Possibly Giorgione)	Giorgione, Circle of
Venus and Cupid in a Landscape	*Venus and Cupid in a Landscape*
693	1942.9.97
Jan Vermeer	Johannes Vermeer
A Woman Weighing Gold	*A Woman Holding a Balance*
694	1942.9.98
Jan Vermeer, and later, Jan Vermeer, Circle of	Johannes Vermeer, Attributed to
Young Girl with a Flute	*Young Girl with a Flute*
1485	1957.8.1
Paolo Veronese, School of	Veronese, Follower of
Agostino Barbarigo	*Agostino Barbarigo*
1144	1952.5.65
Andrea del Verrocchio, Circle of (possibly Leonardo)	Andrea del Verrocchio, Workshop of (possibly Leonardo da Vinci)
Madonna and Child with a Pomegranate	*Madonna and Child with a Pomegranate*

Formerly	*Currently*
45	1937.1.45
Rogier van der Weyden, Circle of	Rogier van der Weyden, Follower of
Christ Appearing to the Virgin	*Christ Appearing to the Virgin*

Unknown Artists Formerly Considered American

	Currently	Formerly
	Unknown Nationality 18th Century *Portrait of a Man* 1942.8.1	American School *Portrait of a Man** 554
	Unknown Nationality 18th Century *Portrait of a Lady* 1942.8.5	American School *Portrait of a Lady** 558
	Unknown Nationality 18th Century *Portrait of a Man* 1947.17.15	American School *Portrait of a Man** 923
	Unknown Nationality 18th Century *Portrait of a Man* 1947.17.22	American School *Portrait of a Man** 930
	Unknown Nationality 18th Century *Portrait of a Lady* 1947.17.27	American School *Portrait of a Lady** 935
	Unknown Nationality 18th Century *Portrait of a Lady* 1947.17.31	American School *Portrait of a Lady** 939
	Unknown Nationality 18th Century *Portrait of a Man* 1947.17.35	American School *Portrait of a Man** 943
	Unknown Nationality 18th Century *Portrait of a Man* 1947.17.43	American School *Portrait of a Man** 951
	Unknown Nationality 18th Century *Portrait of a Man* 1947.17.64	American School *Portrait of a Man** 972
	Unknown Nationality 18th Century *Portrait of a Man* 1947.17.86	American School *Portrait of a Man** 994

Unknown Nationality 18th Century
Portrait of a Man
1947.17.87

American School
*Portrait of a Man**
995

Unknown Nationality 18th Century
Portrait of a Man
1947.17.88

American School
*Portrait of a Man**
996

Unknown Nationality 18th Century
Portrait of a Man
1947.17.90

American School
*Portrait of a Man**
998

Unknown Nationality 18th Century
Portrait of a Man
1947.17.94

American School
*Portrait of a Man**
1002

Unknown Nationality 18th Century
Portrait of a Man
1954.1.4

American School
*Portrait of a Man**
1188

Unknown Nationality 18th Century
Portrait of a Man
1954.1.7

American School
*Portrait of a Man**
1191

Unknown Nationality 19th Century
Portrait of a Young Lady
1947.17.1

American School
*Portrait of a Young Lady**
909

Unknown Nationality 19th Century
Portrait of a Man
1947.17.83

American School
*Portrait of a Man**
991

not illustrated in previous Summary Catalogue of 1975

Concordance: Old and New Accession Numbers

Old Accession Number	New Accession Number	Artist and Title
1	1937.1.1	Anonymous Byzantine 13th Century *Madonna and Child on a Curved Throne*
2	1937.1.2.a-c	Cimabue, Follower of *Christ between Saint Peter and Saint James Major*
3	1937.1.3	Daddi, Bernardo *Saint Paul*
4	1937.1.4.a-c	Gaddi, Agnolo *Madonna Enthroned with Saints and Angels*
5	1937.1.5	Angelico, Fra *The Madonna of Humility*
6	1937.1.6.a-c	Puccio di Simone *Madonna Enthroned with Saints*
7	1937.1.7	Masaccio, Attributed to *The Madonna of Humility*
8	1937.1.8.a-c	Duccio di Buoninsegna *Nativity with the Prophets Isaiah and Ezekiel*
9	1937.1.9	Matteo di Giovanni *Madonna and Child with Angels and Cherubim*
10	1937.1.10	Benvenuto di Giovanni *The Adoration of the Magi*
11	1937.1.11	Lippo Memmi *Madonna and Child with Donor*
12	1937.1.12	Neroccio de'Landi *Claudia Quinta*
13	1937.1.13	Giovanni di Paolo di Grazia *The Adoration of the Magi*

14	1937.1.14	Florentine 15th Century *Profile Portrait of a Young Man*
15	1937.1.15	Florentine 15th Century *Matteo Olivieri*
16	1937.1.16	Masolino da Panicale *The Annunciation*
17	1937.1.17	Castagno, Andrea del *Portrait of a Man*
18	1937.1.18	Lippi, Filippino *The Adoration of the Child*
19	1937.1.19	Botticelli *Portrait of a Youth*
20	1937.1.20	Lippi, Filippino *Portrait of a Youth*
21	1937.1.21	Botticelli *Madonna and Child*
22	1937.1.22	Botticelli *The Adoration of the Magi*
23	1937.1.23	Franco-Flemish 15th Century *Profile Portrait of a Lady*
24	1937.1.24	Raphael *The Alba Madonna*
25	1937.1.25	Raphael *The Niccolini-Cowper Madonna*
26	1937.1.26	Raphael *Saint George and the Dragon*
27	1937.1.27.a-c	Perugino *The Crucifixion with the Virgin, Saint John, Saint Jerome and Saint Mary Magdalene*
28	1937.1.28	Carpaccio, Vittore *The Flight into Egypt*
29	1937.1.29	Bellini, Giovanni *Portrait of a Young Man in Red*
30	1937.1.30	Antonello da Messina *Madonna and Child*

31	1937.1.31	Antonello da Messina *Portrait of a Young Man*
32	1937.1.32	Paduan 15th Century *Saint Jerome in the Wilderness*
33	1937.1.33	Cima da Conegliano *Madonna and Child with Saint Jerome and Saint John the Baptist*
34	1937.1.34	Titian *Venus with a Mirror*
35	1937.1.35	Titian, Attributed to *Andrea dei Franceschi*
36	1937.1.36	Polidoro Lanzani *Madonna and Child and the Infant Saint John in a Landscape*
37	1937.1.37	Luini, Bernardino *Portrait of a Lady*
38	1937.1.38	Veronese *The Finding of Moses*
39	1937.1.39	Eyck, Jan van *The Annunciation*
40	1937.1.40	Christus, Petrus *The Nativity*
41	1937.1.41	Memling, Hans *Madonna and Child with Angels*
42	1937.1.42	Memling, Hans *Portrait of a Man with an Arrow*
43	1937.1.43	David, Gerard *The Rest on the Flight into Egypt*
44	1937.1.44	Weyden, Rogier van der *Portrait of a Lady*
45	1937.1.45	Weyden, Rogier van der, Follower of *Christ Appearing to the Virgin*
46	1937.1.46	Sittow, Michel *Portrait of Diego de Guevara (?)*
47	1937.1.47	Dyck, Anthony van, Sir *Isabella Brant*

48	1937.1.48	Dyck, Anthony van, Sir *Susanna Fourment and Her Daughter*
49	1937.1.49	Dyck, Anthony van, Sir *Marchesa Balbi*
50	1937.1.50	Dyck, Anthony van, Sir *Philip, Lord Wharton*
51	1937.1.51	Hanneman, Adriaen *Henry, Duke of Gloucester*
52	1937.1.52	Mor, Anthonis *Portrait of a Gentleman*
53	1937.1.53	Vermeer, Johannes *The Girl with the Red Hat*
56	1937.1.56	Hooch, Pieter de *A Dutch Courtyard*
57	1937.1.57	Metsu, Gabriel *The Intruder*
58	1937.1.58	Terborch, Gerard, II *The Suitor's Visit*
59	1937.1.59	Cuyp, Aelbert *Herdsmen Tending Cattle*
60	1937.1.60	Hobbema, Meindert *A Farm in the Sunlight*
61	1937.1.61	Hobbema, Meindert *A Wooded Landscape*
62	1937.1.62	Hobbema, Meindert *A View on a High Road*
63	1937.1.63	Maes, Nicolaes *An Old Woman Dozing over a Book*
64	1937.1.64	Holbein, Hans, the Younger *Edward VI as a Child*
65	1937.1.65	Holbein, Hans, the Younger *Sir Brian Tuke*
66	1937.1.66	Schäufelein, Hans Leonhard *Portrait of a Man*

67	1937.1.67	Hals, Frans, I *Portrait of an Elderly Lady*
68	1937.1.68	Hals, Frans, I *Portrait of an Officer*
69	1937.1.69	Hals, Frans, I *Willem Coymans*
70	1937.1.70	Hals, Frans, I *Adriaen van Ostade*
71	1937.1.71	Hals, Frans, I *Portrait of a Young Man*
72	1937.1.72	Rembrandt van Rijn *Self-Portrait*
73	1937.1.73	Rembrandt van Rijn *An Old Lady with a Book*
74	1937.1.74	Rembrandt van Rijn *A Girl with a Broom*
75	1937.1.75	Rembrandt van Rijn *A Woman Holding a Pink*
76	1937.1.76	Rembrandt van Rijn *Lucretia*
77	1937.1.77	Rembrandt van Rijn *A Young Man Seated at a Table*
78	1937.1.78	Rembrandt van Rijn *A Polish Nobleman*
79	1937.1.79	Rembrandt van Rijn *Joseph Accused by Potiphar's Wife*
80	1937.1.80	Velázquez, Diego *Pope Innocent X*
81	1937.1.81	Velázquez, Diego *The Needlewoman*
82	1937.1.82	Velázquez, Diego, Follower of *Portrait of a Young Man*
83	1937.1.83	Greco, El *Saint Ildefonso*

84	1937.1.84	Greco, El *Saint Martin and the Beggar*
85	1937.1.85	Goya, Francisco de *The Marquesa de Pontejos*
86	1937.1.86	Goya, Francisco de *Carlos IV of Spain as Huntsman*
87	1937.1.87	Goya, Francisco de *Maria Luisa, Queen of Spain*
88	1937.1.88	Goya, Francisco de *Señora Sabasa García*
89	1937.1.89	Lancret, Nicolas *La Camargo Dancing*
90	1937.1.90	Chardin, Jean Siméon *The House of Cards*
91	1937.1.91	Chardin, Jean Siméon *The Young Governess*
92	1937.1.92	Gainsborough, Thomas *Mrs. Richard Brinsely Sheridan*
93	1937.1.93	Gainsborough, Thomas *Georgiana, Duchess of Devonshire*
94	1937.1.94	Romney, George *Lady Broughton*
95	1937.1.95	Reynolds, Joshua, Sir *Lady Elizabeth Delmé and Her Children*
96	1937.1.96	Lawrence, Thomas, Sir *Lady Templetown and Her Son*
97	1937.1.97	Reynolds, Joshua, Sir *Lady Elizabeth Compton*
98	1937.1.98	Gainsborough, Thomas, Studio of *George IV as Prince of Wales*
99	1937.1.99	Gainsborough, Thomas *Miss Catherine Tatton*
100	1937.1.100	Gainsborough, Thomas *Mrs. John Taylor*

101	1937.1.101	Raeburn, Henry, Sir *Miss Eleanor Urquhart*
102	1937.1.102	Raeburn, Henry, Sir *Colonel Francis James Scott*
103	1937.1.103	Raeburn, Henry, Sir *John Tait and His Grandson*
104	1937.1.104	Romney, George *Miss Willoughby*
105	1937.1.105	Romney, George *Mrs. Davenport*
106	1937.1.106	Reynolds, Joshua, Sir *Lady Caroline Howard*
107	1937.1.107	Gainsborough, Thomas *Landscape with a Bridge*
108	1937.1.108	Constable, John *A View of Salisbury Cathedral*
109	1937.1.109	Turner, Joseph Mallord William *Mortlake Terrace*
110	1937.1.110	Turner, Joseph Mallord William *Approach to Venice*
111	1937.1.111	Hoppner, John *The Frankland Sisters*
118	1939.1.7	Vivarini, Antonio *Saint Apollonia Destroys a Pagan Idol*
131	1939.1.20.a-b	Andrea di Bartolo *Madonna and Child; The Crucifixion*
135	1939.1.24	Pannini, Giovanni Paolo *The Interior of the Pantheon*
140	1939.1.29	Montagna, Bartolomeo *Madonna and Child*
142	1939.1.31	Bugiardini, Giuliano *Portrait of a Young Woman*
152	1939.1.41	Andrea di Bartolo *The Presentation of the Virgin*

153	1939.1.42	Andrea di Bartolo *The Nativity of the Virgin*
154	1939.1.43	Andrea di Bartolo *Joachim and the Beggars*
156	1939.1.45	Sano di Pietro *The Crucifixion*
173	1939.1.62	Crespi, Giuseppe Maria *Cupids with Sleeping Nymphs*
174	1939.1.63	Longhi, Pietro *The Simulated Faint*
175	1939.1.64	Longhi, Pietro *Blindman's Buff*
182	1939.1.71	Ricci, Sebastiano *A Miracle of Saint Francis of Paola*
183	1939.1.72	Ricci, Sebastiano *The Finding of the True Cross*
190	1939.1.79	Florentine 16th Century *Ugolino Martelli*
191	1939.1.80	Giambono, Michele *Saint Peter*
194	1939.1.83	Correggio *The Mystic Marriage of Saint Catherine*
199	1939.1.88	Fetti, Domenico *The Parable of Dives and Lazarus*
209	1939.1.98	Tintoretto, Jacopo *Portrait of a Man as Saint George*
211	1939.1.100	Tiepolo, Giovanni Battista *The Apotheosis of a Poet*
213	1939.1.102.	Ghislandi, Giuseppe *Portrait of a Young Man*
218	1939.1.107	Rotari, Pietro *A Sleeping Girl*
219	1939.1.108	Rotari, Pietro *A Girl with a Flower in Her Hair*

220	1939.1.109	Pesellino *The Crucifixion with Saint Jerome and Saint Francis*
224	1939.1.113	Guardi, Francesco *View on the Cannaregio, Venice*
225	1939.1.114	Moroni, Giovanni Battista *A Gentleman in Adoration before the Madonna*
226	1939.1.115	Cossa, Francesco del, Attributed to *Madonna and Child with Angels*
228	1939.1.117	Lotto, Lorenzo *Saint Catherine*
229	1939.1.118	Vivarini, Bartolomeo *Madonna and Child*
231	1939.1.120	Luini, Bernardino *Venus*
237	1939.1.126	Bassano, Jacopo *The Annunciation to the Shepherds*
240	1939.1.129	Guardi, Francesco *Campo San Zanipolo*
242	1939.1.131	Master of the Life of Saint John the Baptist *The Baptism of Christ*
251	1939.1.140	Domenico Veneziano *Saint Francis Receiving the Stigmata*
252	1939.1.141	Duccio di Buoninsegna *The Calling of the Apostles Peter and Andrew*
253	1939.1.142	Giorgione, Circle of *Venus and Cupid in a Landscape*
254	1939.1.143	Paolo Veneziano *The Crucifixion*
255	1939.1.144	Basaiti, Marco *Madonna Adoring the Child*
258	1939.1.147	Lotto, Lorenzo *A Maiden's Dream*
263	1939.1.152	Luini, Bernardino *The Madonna of the Carnation*

264	1939.1.153	Biagio d'Antonio da Firenze *The Triumph of Camillus*
266	1939.1.155	Giannicola di Paolo *The Annunication*
267	1939.1.156	Lotto, Lorenzo *Allegory*
270	1939.1.159	Caravaggio, Michelangelo Merisi da, Follower of *Still Life*
271	1939.1.160	Piero di Cosimo *Allegory*
276	1939.1.165	Barocci, Federico *Quintilia Fischieri*
279	1939.1.168	Cima da Conegliano *Saint Jerome in the Wilderness*
289	1939.1.178	Mantegna, Andrea, Follower of *Judith with the Head of Holofernes*
290	1939.1.179	Biagio d'Antonio da Firenze *Portrait of a Boy*
291	1939.1.180	Tintoretto, Jacopo *The Worship of the Golden Calf*
293	1939.1.182	Bellini, Giovanni *Portrait of a Young Man*
302	1939.1.191	Tanzio da Varallo *Saint Sebastian*
314	1939.1.203	Gaddi, Agnolo *The Coronation of the Virgin*
324	1939.1.213	Titian *Cupid with the Wheel of Fortune*
325	1939.1.214	Pier Francesco Fiorentino *Madonna And Child*
326	1939.1.215	Perugino *Madonna and Child*
327	1939.1.216	Simone Martini *The Angel of the Annunciation*

328	1939.1.217	Bellini, Giovanni *Saint Jerome Reading*
329	1939.1.218	Master of the Barberini Panels *The Annunciation*
330	1939.1.219	Roberti, Ercole de' *Giovanni II Bentivoglio*
331	1939.1.220	Roberti, Ercole de' *Ginevra Bentivoglio*
332	1939.1.221	Domenico Veneziano *Madonna and Child*
334	1939.1.223	Giovanni di Paolo di Grazia *The Annunciation*
335	1939.1.224	Bellini, Giovanni *Giovanni Emo*
336	1939.1.225	Masolino da Panicale *The Archangel Gabriel*
337	1939.1.226	Masolino da Panicale *The Virgin Annunciate*
338	1939.1.227	Cossa, Francesco del *Saint Florian*
339	1939.1.228	Cossa, Francesco del *Saint Lucy*
340	1939.1.229	Lippi, Filippino *Tobias and the Angel*
341	1939.1.230	Moretto da Brescia *Portrait of a Lady in White*
342	1939.1.231	Tintoretto, Jacopo *Susanna*
357	1939.1.246	Sassetta *Madonna and Child*
361	1939.1.250	Dossi, Dosso *Aeneas and Achates on the Libyan Coast*
365	1939.1.254	Bellini, Giovanni *Portrait of a Venetian Gentleman*

366	1939.1.255	Gentile da Fabriano *Madonna and Child*
367	1939.1.256	Giotto *Madonna and Child*
368	1939.1.257	Bartolomeo Veneto *Portrait of a Gentleman*
369	1939.1.258	Giorgione *Portrait of a Venetian Gentleman*
370	1939.1.259	Titian, Follower of *Allegory (Alfonso d'Este and Laura Dianti?)*
371	1939.1.260	Angelico, Fra, Attributed to *The Entombment*
372	1939.1.261. a-c	Nardo di Cione *Madonna and Child with Saint Peter and Saint John the Evangelist*
373	1939.1.262	Bellini, Giovanni *Madonna and Child in a Landscape*
374	1939.1.263	Bellini, Jacopo, Attributed to *Profile Portrait of a Boy*
375	1939.1.264	Crivelli, Carlo *Madonna and Child*
376	1939.1.265	Gozzoli, Benozzo *Saint Ursula with Angels and Donor*
377	1939.1.266	Mantegna, Andrea *Madonna and Child*
379	1939.1.268	Gentile da Fabriano *A Miracle of Saint Nicholas*
382	1939.1.271	Zoppo, Marco *Saint Peter*
385	1939.1.274	Sano di Pietro *Madonna and Child with Saints and Angels*
390	1939.1.279	Lippi, Filippo *The Nativity*
391	1939.1.280	Perugino, Follower of *Saint Jerome in the Wilderness*

394	1939.1.283	Sellaio, Jacopo del *Saint John the Baptist*
399	1939.1.288	Lotto, Lorenzo *The Nativity*
400	1939.1.289	Giorgione *The Adoration of the Shepherds*
401	1939.1.290	Lippi, Filippo *Madonna and Child*
402	1939.1.291	Lippo Memmi *Saint John the Baptist*
403	1939.1.292	Titian *Portrait of a Lady*
404	1939.1.293	Sassetta *The Meeting of Saint Anthony and Saint Paul*
405	1939.1.294	Master of Santo Spirito *Portrait of a Youth*
408	1939.1.297	Matteo di Giovanni *Madonna and Child with Saints and Angels*
414	1961.9.1	Aspertini, Amico *Saint Sebastian*
416	1939.1.305	Sodoma *Madonna and Child with the Infant Saint John*
422	1939.1.311	Vivarini, Alvise *Saint Jerome Reading*
429	1939.1.318	Benvenuto di Giovanni *The Agony in the Garden*
437	1939.1.344. a–c	Master of the Kress Landscapes *Scenes from a Legend*
443	1939.1.350	Anselmi, Michelangelo *Apollo and Marsyas*
445	1939.1.352	Bellini, Giovanni *Madonna and Child*
446	1939.1.353	Girolamo di Benvenuto *Portrait of a Young Woman*

447	1939.1.354	Carpaccio, Vittore *The Virgin Reading*
448	1939.1.355	Vivarini, Alvise *Portrait of a Senator*
450	1939.1.357	Tura, Cosimo, Attributed to *Portrait of a Man*
454	1939.1.361	Piero di Cosimo *The Visitation with Saint Nicholas and Saint Anthony Abbot*
458	1939.1.365	Tiepolo, Giovanni Battista *Timocleia and the Thracian Commander*
464	1939.1.371	Piero di Cosimo *The Nativity with the Infant Saint John*
475	1939.1.382	Girolamo da Carpi *The Apparition of the Virgin*
480	1939.1.387	Pontormo *The Holy Family*
481	1939.1.388	Dossi, Dosso *Saint Lucretia*
497	1940.1.11	Wright, Joseph *Richard, Earl Howe(?)*
498	1940.1.12	Hals, Frans *A Young Man in a Large Hat*
499	1940.1.13	Rembrandt van Rijn *A Turk*
500	1940.1.14	Dyck, Anthony van, Sir *Portrait of a Flemish Lady*
501	1940.2.1	Cuyp, Aelbert *The Maas at Dordrecht*
502	1943.4.1	Verrocchio, Andrea del, Style of *Madonna and Child*
505	1943.4.4	Sassetta, Attributed to *Saint Margaret*
506	1943.4.5	Sassetta, Attributed to *Saint Apollonia*

514	1943.4.13	Lorenzo Monaco *Madonna and Child*
521	1943.4.20	Lorenzetti, Ugolino *Saint Catherine of Alexandria*
528	1943.4.27	Magnasco, Alessandro *The Baptism of Christ*
529	1943.4.28	Beccafumi, Domenico *The Holy Family with Angels*
532	1943.4.31	Magnasco, Alessandro *Christ at the Sea of Galilee*
533	1943.4.32	Ricci, Sebastiano *The Last Supper*
534	1943.4.33	Raphael *Bindo Altoviti*
536	1943.4.35	Lippi, Filippo *The Annunciation*
537	1943.4.36	Lippi, Filippino *The Coronation of the Virgin*
538	1943.4.37	Bellini, Giovanni *Madonna and Child with Saints*
540	1943.4.39	Tiepolo, Giovanni Battista *The World Pays Homage to Spain*
541	1943.4.40	Tiepolo, Giovanni Battista *Madonna of the Goldfinch*
542	1943.4.41	Baldassarre d'Este, Attributed to *Francesco II Gonzaga, Fourth Marquis of* *Mantua*
545	1941.6.1	Daumier, Honoré *Advice to a Young Artist*
546	1941.5.1.a-c	Lorenzetti, Pietro *Madonna and Child with Saint Mary Magdalene* *and Saint Catherine*
547	1941.5.2	Erri, Agnolo degli *A Dominican Preaching*
548	1941.10.1	Goya, Francisco de *Don Bartolomé Sureda*

549	1942.3.1	Goya, Francisco de *Doña Teresa Sureda*
552	1942.5.1	Chardin, Jean Siméon *Soap Bubbles*
553	1942.5.2	Raeburn, Henry, Sir *The Binning Children*
554	1942.8.1	Unknown Nationality 18th Century *Portrait of a Man*
558	1942.8.5	Unknown Nationality 18th Century *Portrait of a Lady*
560	1942.8.7	German 19th Century *An Artist and His Family*
577	1942.8.24	Unknown Nationality 19th Century *Robert Thew (?)*
590	1942.8.37	Unknown Nationality 19th Century *Portrait of a Lady*
597	1942.9.1	Bellini, Giovanni *The Feast of the Gods*
598	1942.9.2	Bellini, Giovanni *Orpheus*
599	1942.9.3	Benvenuto di Giovanni *Madonna with Saint Jerome and Saint Bernardine*
600	1942.9.4	Bonsignori, Francesco *Francesco Sforza*
601	1942.9.5	Bordone, Paris *The Baptism of Christ*
602	1942.9.6	Bronzino, Agnolo *A Young Woman and Her Little Boy*
603	1942.9.7	Canaletto *View in Venice*
604	1942.9.8	Castagno, Andrea del *The Youthful David*
605	1942.9.9	Constable, John *The White Horse*

606	1942.9.10	Constable, John *Wivenhoe Park, Essex*
607	1942.9.11	Corot, Jean-Baptiste-Camille *The Artist's Studio*
608	1942.9.12	Corot, Jean-Baptiste-Camille *The Forest of Coubron*
609	1942.9.13	Corot, Jean-Baptiste-Camille *View near Epernon*
610	1942.9.14	Crome, John, Follower of *Harling Gate, near Norwich*
611	1942.9.15	Cuyp, Aelbert *Lady and Gentleman on Horseback*
612	1942.9.16	Cuyp, Aelbert *Horsemen and Herdsmen with Cattle*
613	1942.9.17.a-c	David, Gerard *The Saint Anne Altarpiece*
614	1942.9.18	Degas, Edgar *The Races*
615	1942.9.19	Degas, Edgar *Before the Ballet*
616	1942.9.20	Gainsborough, Thomas *Mrs. Methuen*
617	1942.9.21	Gainsborough, Thomas *The Honorable Mrs. Graham*
618	1942.9.22	Gainsborough, Thomas *The Earl of Darnley*
619	1942.9.23	Ghirlandaio, Ridolfo *Lucrezia Sommaria*
620	1942.9.24	Gozzoli, Benozzo *The Raising of Lazarus*
621	1942.9.25	Greco, El *Saint Martin and the Beggar*
622	1942.9.26	Greco, El *Madonna and Child with Saint Martina and Saint Agnes*

623	1942.9.27	Guardi, Francesco *View of the Rialto*
624	1942.9.28	Hals, Frans, I *Portrait of a Man*
625	1942.9.29	Hals, Frans, I *Portrait of a Gentleman*
626	1942.9.30	Hobbema, Meindert *Hut Among Trees*
627	1942.9.31	Hobbema, Meindert *The Travelers*
628	1942.9.32	Hobbema, Meindert *Village near a Pool*
629	1942.9.33	Hooch, Pieter de *The Bedroom*
630	1942.9.34	Hooch, Pieter de *Woman and Child in a Courtyard*
631	1942.9.35	Hoppner, John *The Hoppner Children*
632	1942.9.36	Bugiardini, Giuliano *Portrait of a Man*
633	1942.9.37	Lawrence, Thomas, Sir *Lady Robinson*
634	1942.9.38	Lorenzo di Credi *Self-Portrait*
635	1942.9.39	Liss, Johann *The Satyr and the Peasant*
636	1942.9.40	Manet, Edouard *The Dead Toreador*
637	1942.9.41	Manet, Edouard *At the Races*
638	1942.9.42	Mantegna, Andrea *Judith and Holofernes*
639	1942.9.43	Morland, George *The End of the Hunt*

640	1942.9.44	Benaglio, Francesco *Madonna and Child*
641	1942.9.45	Moroni, Giovanni Battista *"Titian's Schoolmaster"*
642	1942.9.46	Murillo, Bartolomé Esteban *A Girl and Her Duenna*
643	1942.9.47	Neroccio de' Landi *Portrait of a Lady*
644	1942.9.48	Ostade, Adriaen van *The Cottage Dooryard*
645	1942.9.49	Ostade, Isack van *The Halt at the Inn*
646	1942.9.50	Pseudo Pier Francesco Fiorentino *Madonna and Child*
647	1942.9.51	Pontormo *Portrait of a Young Woman*
648	1942.9.52	Potter, Paulus *A Farrier's Shop*
649	1942.9.53	Predis, Ambrogio de *Bianca Maria Sforza*
650	1942.9.54	Puvis de Chavannes, Pierre *Rest*
651	1942.9.55	Puvis de Chavannes, Pierre *Work*
652	1942.9.56	Raeburn, Henry, Sir *David Anderson*
653	1942.9.57	Raphael *The Small Cowper Madonna*
654	1942.9.58	Rembrandt van Rijn, Follower of *Head of Saint Matthew*
655	1942.9.59	Rembrandt van Rijn *The Apostle Paul*
656	1942.9.60	Rembrandt van Rijn *The Circumcision*

657	1942.9.61	Rembrandt van Rijn, After *The Descent from the Cross*
658	1942.9.62	Rembrandt van Rijn *The Mill*
659	1942.9.63	Rembrandt van Rijn, Style of *Study of an Old Man*
660	1942.9.64	Rembrandt van Rijn, Follower of *Head of an Aged Woman*
661	1942.9.65	Rembrandt van Rijn *Philemon and Baucis*
662	1942.9.66	Rembrandt van Rijn, Follower of *The Philosopher*
663	1942.9.67	Rembrandt van Rijn *Portrait of a Gentleman with a Tall Hat and Gloves*
664	1942.9.68	Rembrandt van Rijn *Portrait of a Lady with an Ostrich-Feather Fan*
665	1942.9.69	Rembrandt van Rijn *Portrait of a Man in a Tall Hat*
666	1942.9.70	Rembrandt van Rijn *Self-Portrait*
667	1942.9.71	Rembrandt van Rijn *Saskia van Uylenburgh, the Wife of the Artist*
668	1942.9.72	Renoir, Auguste *The Dancer*
669	1942.9.73	Reynolds, Joshua, Sir, Follower of *The Honorable Mrs. Gray*
670	1942.9.74	Reynolds, Joshua, Sir *Lady Cornewall*
671	1942.9.75	Reynolds, Joshua, Sir *Lady Betty Hamilton*
672	1942.9.76	Reynolds, Joshua, Sir *Nelly O'Brien*
673	1942.9.77	Romney, George *Mrs. Blair*

674	1942.9.78	Romney, George *Lady Arabella Ward*
675	1942.9.79	Anonymous French 18th Century *The Rape of the Sabine Women*
676	1942.9.80	Ruisdael, Jacob van *Forest Scene*
677	1942.9.81	Steen, Jan *The Dancing Couple*
678	1942.9.82	Titian, Follower of *Emilia di Spilimbergo*
679	1942.9.83	Titian, Follower of *Irene di Spilimbergo*
680	1942.9.84	Titian *Venus and Adonis*
681	1942.9.85	Turner, Joseph Mallord William *Venice: Dogana and San Giorgio Maggiore*
682	1942.9.86	Turner, Joseph Mallord William *Keelmen Heaving in Coals by Moonlight*
683	1942.9.87	Turner, Joseph Mallord William *The Junction of the Thames and the Medway*
684	1942.9.88	Dyck, Anthony van, Sir *The Assumption of the Virgin*
685	1942.9.89	Dyck, Anthony van, Sir *Giovanni Vincenzo Imperiale*
686	1942.9.90	Dyck, Anthony van, Sir *The Prefect Raphael Racius*
687	1942.9.91	Dyck, Anthony van, Sir *Portrait of an Italian Noblewoman and Her Son*
688	1942.9.92	Dyck, Anthony van, Sir *Marchesa Elena Grimaldi, Wife of Marchese Nicola Cattaneo*
689	1942.9.93	Dyck, Anthony van, Sir *Filippo Cattaneo, Son of Marchesa Elena Grimaldi*

690	1942.9.94	Dyck, Anthony van, Sir *Clelia Cattaneo, Daughter of Marchesa Elena Grimaldi*
691	1942.9.95	Dyck, Anthony van, Sir *Lady d'Aubigny*
692	1942.9.96	Venetian 16th Century *Portrait of a Young Man*
693	1942.9.97	Vermeer, Johannes *Woman Holding a Balance*
694	1942.9.98	Vermeer, Johannes, Attributed to *Young Girl with a Flute*
698	1942.16.1	Anonymous French 16th Century *Portrait of a Nobleman*
699	1942.16.2.a-b	Flemish 15th Century, Imitator of *Saint Bernard with Donor; Saint Margaret*
700	1942.16.3	Ring, Ludger tom, the Elder *Portrait of a Lady*
711	1943.4.45	Master of the Life of Saint John the Baptist *Madonna and Child with Angels*
714	1943.4.47	Botticelli, Attributed to *Madonna and Child with Angels*
715	1943.4.48	Domenico Veneziano *Saint John in the Desert*
716	1943.4.49	Dossi, Dosso *Circe and Her Lovers in a Landscape*
717	1943.4.50	Guardi, Francesco *A Seaport and Classic Ruins in Italy*
720	1943.4.52	Luini, Bernardino *Procris' Prayer to Diana*
721	1943.4.53	Luini, Bernardino *Cephalus Hiding the Jewels*
722	1943.4.54	Luini, Bernardino *Cephalus and Pan at the Temple*
723	1943.4.55	Luini, Bernardino *Cephalus at the Hunt*

724	1943.4.56	Luini, Bernardino *Procris Pierced by Cephalus' Javelin*
725	1943.4.57	Luini, Bernardino *The Illusion of Cephalus*
726	1943.4.58	Luini, Bernardino *The Despair of Cephalus*
727	1943.4.59	Luini, Bernardino *The Misfortunes of Cephalus*
728	1943.4.60	Luini, Bernardino *Procris and the Unicorn*
738	1943.7.1	Boilly, Louis-Léopold *A Painter's Studio*
739	1943.7.2	Boucher, François *Venus Consoling Love*
740	1943.7.3	Chardin, Jean Siméon, Follower of *Portrait of a Man*
741	1943.7.4	Chardin, Jean Siméon *Fruit, Jug and a Glass*
742	1943.7.5	Drouais, Hubert *Portrait of a Lady*
743	1943.7.6	Greco, El *Saint Jerome*
744	1943.7.7	Anonymous Netherlandish 16th Century *The Healing of the Paralytic*
745	1943.7.8	Kalf, Willem *Still Life*
746	1943.7.9	Rubens, Peter Paul, Sir *Head of One of the Three Kings*
747	1943.7.10	Tintoretto, Jacopo *Portrait of a Venetian Senator*
748	1943.7.11	Zurbarán, Francisco de *Santa Lucia*
752	1943.11.1	Daumier, Honoré *In Church*

753	1943.11.2	Daumier, Honoré, Follower of *Feast of the Gods*
754	1943.11.3	Forain, Jean-Louis *Artist and Model*
755	1943.11.4	Forain, Jean-Louis *Behind the Scenes*
756	1943.11.5	Forain, Jean-Louis *The Stockade*
757	1943.11.6	Forain, Jean-Louis *The Petitioner*
759	1943.11.8	Whistler, Beatrix Godwin *Peach Blossom*
761	1943.15.1	Corot, Jean-Baptiste-Camille *The Eel Gatherers*
762	1943.15.2	Courbet, Gustave *The Stream*
763	1943.11.11	Blake, William *Job and His Daughters*
766	1946.7.1	Boucher, François *Allegory of Painting*
767	1946.7.2	Boucher, François *Allegory of Music*
768	1946.7.3	Boucher, François *Madame Bergeret*
769	1946.7.4	Drouais, François-Hubert *Group Portrait*
770	1946.7.5	Fragonard, Jean-Honoré *A Game of Horse and Rider*
771	1946.7.6	Fragonard, Jean-Honoré *A Game of Hot Cockles*
772	1946.7.7	Fragonard, Jean-Honoré *The Visit to the Nursery*
773	1946.7.8	Greuze, Jean-Baptiste *Ange-Laurent de Lalive de Jully*

774	1946.7.9	Watteau, Antoine *Italian Comedians*
780	1946.7.10	Anonymous French 18th Century *Portrait of an Old Woman*
781	1952.5.1	Bergognone *The Resurrection*
782	1952.5.2	Master of the Griselda Legend *Eunostos of Tanagra*
783	1946.7.11	Le Nain, Louis *Landscape with Peasants*
784	1946.7.12	Claude Lorrain *The Herdsman*
785	1946.7.13	Nattier, Jean-Marc *Madame de Caumartin as Hebe*
786	1946.7.14	Poussin, Nicolas *The Baptism of Christ*
788	1946.7.16	Vigée-Lebrun, Elisabeth *Portrait of a Lady*
789	1946.7.17	Watteau, Antoine *"Sylvia" (Jeanne-Rose-Guyonne Benozzi)*
790	1952.5.3	Angelico, Fra *The Healing of Palladia by Saint Cosmas and Saint Damian*
791	1952.5.4	Bacchiacca *The Gathering of Manna*
793	1952.5.5	Cossa, Francesco del *The Crucifixion*
794	1952.5.6	Crivelli, Carlo *Madonna and Child Enthroned with Donor*
795	1961.9.2	Daddi, Bernardo, Attributed to *The Crucifixion*
796	1961.9.3	Domenico de Bartolo *Madonna and Child Enthroned with Saint Peter and Saint Paul*

797	1952.5.7	Fetti, Domenico *The Veil of Veronica*
799	1952.5.8	Francesco di Giorgio Martini *God the Father Surrounded by Angels and Cherubim*
804	1952.5.10	Lippi, Filippo *Saint Benedict Orders Saint Maurus to the Rescue of Saint Placidus*
807	1952.5.12	Margaritone d'Arezzo *Madonna and Child Enthroned*
808	1952.5.13	Master of the Franciscan Crucifixes *The Mourning Madonna*
809	1952.5.14	Master of the Franciscan Crucifixes *Saint John the Evangelist*
810	1952.5.15	Master of Saint Francis *Saint James Minor*
811	1952.5.16	Master of Saint Francis *Saint John the Evangelist*
813	1952.5.17	Neroccio de' Landi *Madonna and Child with Saint Anthony Abbot and Saint Sigismund*
814	1952.5.18	Orcagna *Madonna and Child with Angels*
815	1952.5.19	Piero della Francesca, Workshop of *Saint Apollonia*
817	1952.5.20	Sassetta *Saint Anthony Distributing His Wealth to the Poor*
818	1952.5.21	Sassetta *Saint Anthony Leaving His Monastery*
820	1952.5.23	Simone Martini, Workshop of *Saint Matthew*
821	1952.5.24	Simone Martini, Workshop of *Saint Simon*
822	1952.5.25	Simone Martini, Workshop of *Saint James Major*

823	1952.5.26	Simone Martini, Workshop of *Saint Thaddeus*
825	1952.5.27	Tintoretto, Jacopo *Christ at the Sea of Galilee*
826	1952.5.28	Titian *Cardinal Pietro Bembo*
827	1952.5.29	Tura, Cosimo *Madonna and Child in a Garden*
842	1952.5.30	Crespi, Giuseppe Maria *Lucretia Threatened by Tarquin*
874	1945.15.1	Canaletto, Follower of *The Courtyard, Doge's Palace, with the Procession of the Papal Legate*
875	1945.15.2	Canaletto, Follower of *A Fete Day, Venice*
876	1945.15.3	Canaletto *The Square of Saint Mark's*
877	1945.15.4	Canaletto *Venice, the Quay of the Piazzetta*
880	1945.10.1	Vanloo, Charles Amédée Philippe *The Magic Lantern*
881	1945.10.2	Vanloo, Charles Amédée Philippe *Soap Bubbles*
882	1946.7.18	Ingres, Jean-Auguste-Dominique *Madame Moitessier*
883	1946.7.19	Pater, Jean-Baptiste Joseph *Fête Champêtre*
884	1945.10.3	Raeburn, Henry, Sir *John Johnstone of Alva, His Sister and His Niece*
885	1946.18.1	Greco, El *Laocoön*
887	1946.6.1	Tinelli, Tiberio *Count Lodovico Vidmano*
888	1946.13.1	Longhi, Alessandro, Follower of *Portrait of a Man*

890	1947.3.1	Anthonissen, Hendrick van, Style of *Ships in the Scheldt Estuary*
891	1947.2.1	Fragonard, Jean-Honoré *Love as Folly*
892	1947.2.2	Fragonard, Jean-Honoré *Love as Conqueror*
894	1946.19.1	Bellini, Giovanni *Madonna and Child in a Landscape*
895	1946.19.2	Boltraffio, Giovanni Antonio *Portrait of a Youth*
896	1947.6.1	Cranach, Lucas, the Elder *A Prince of Saxony*
897	1947.6.2	Cranach, Lucas, the Elder *A Princess of Saxony*
898	1947.6.3	Kremer, Nicolaus *Portrait of a Nobleman*
899	1947.6.4.a-b	Strigel, Bernhard *Hans Rott, Patrician of Memmingen*
900	1947.6.5.a-b	Strigel, Bernhard *Margaret Vöhlin, Wife of Hans Rott*
901	1947.6.6	Tintoretto, Jacopo *The Madonna of the Stars*
902	1947.19.1	Legros, Alphonse *Portrait of an Old Man*
908	1947.14.1	Dyck, Anthony van, Sir *Henri II de Lorraine, Duc de Guise*
909	1947.17.1	Unknown Nationality 19th Century *Portrait of a Young Lady*
923	1947.17.15	Unknown Nationality 18th Century *Portrait of a Man*
927	1947.17.19	Unknown Nationality 19th Century *An Artist's Studio*
930	1947.17.22	Unknown Nationality 18th Century *Portrait of a Man*

934	1947.17.26	Unknown Nationality 18th Century *Portrait of an Officer*
935	1947.17.27	Unknown Nationality 18th Century *Portrait of a Lady*
939	1947.17.31	Unknown Nationality 18th Century *Portrait of a Lady*
940	1947.17.32	Unknown Nationality 18th Century *Portrait of a Man*
841	1947.17.33	Unknown Nationality 18th Century *Portrait of a Man*
942	1947.17.34	Unknown Nationality 17th Century *Portrait of a Man*
943	1947.17.35	Unknown Nationality 18th Century *Portrait of a Man*
944	1947.17.36	Ramsay, James, After *Master Betty*
946	1947.17.38	Unknown Nationality 18th Century *Portrait of a Man*
947	1947.17.39	Unknown Nationality 18th Century *Portrait of a Lady*
948	1947.17.40	Unknown Nationality 18th Century *Portrait of a Man*
951	1947.17.43	Unknown Nationality 18th Century *Portrait of a Man*
955	1947.17.47	Unknown Nationality 18th Century *Portrait of a Man*
957	1947.17.49	Anonymous British 18th Century *Portrait of a Man*
972	1947.17.64	Unknown Nationality 18th Century *Portrait of a Man*
977	1947.17.69	Anonymous French 19th Century *Portrait of a Lady*
984	1947.17.76	Anonymous British 19th Century *Portrait of a Man*

991	1947.17.83	Unknown Nationality 19th Century *Portrait of a Man*
994	1947.17.86	Unknown Nationality 18th Century *Portrait of a Man*
995	1947.17.87	Unknown Nationality 18th Century *Portrait of a Man*
996	1947.17.88	Unknown Nationality 18th Century *Portrait of a Man*
998	1947.17.90	Unknown Nationality 18th Century *Portrait of a Man*
999	1947.17.91	Unknown Nationality 17th Century *Portrait of a Man*
1000	1947.17.92	Dutch 18th Century *Portrait of a Man*
1002	1947.17.94	Unknown Nationality 18th Century *Portrait of a Man*
1006	1947.17.98	Dutch 17th Century *Portrait of a Man*
1007	1947.17.99	Anonymous French 17th Century *Portrait of a Man*
1008	1947.17.100	Unknown Nationality 18th Century *Portrait of a Man*
1010	1947.17.102	Anonymous British 18th Century *Honorable Sir Francis N. P. Burton (?)*
1020	1947.17.112	Wright, Joseph *Portrait of a Man*
1021	1947.17.113	Unknown Nationality 18th Century *Portrait of a Man*
1023	1947.18.1	Anonymous British 16th Century *The Earl of Essex*
1024	1948.19.1	Raeburn, Henry, Sir *Captain Patrick Miller*
1027	1948.12.1	Murillo, Bartolomé Esteban *The Return of the Prodigal Son*

1028	1948.17.1	Venetian 16th Century *Allegory*
1032	1948.18.1	Renoir, Auguste *Head of a Young Girl*
1033	1949.1.1	Cazin, Jean-Charles *The Windmill*
1034	1949.1.2	Corot, Jean-Baptiste-Camille *River View*
1035	1949.1.3	Daubigny, Charles-François *Landscape with Figures*
1036	1949.1.4	Diaz de la Peña, Narcisse Virgilio *Forest Scene*
1037	1949.1.5	Dupré, Jules *The Old Oak*
1038	1949.1.6	Guardi, Francesco *The Rialto Bridge*
1039	1949.1.7	Harpignies, Henri-Joseph *Landscape*
1040	1949.1.8	Claude Lorrain, Follower of *Harbor at Sunset*
1041	1949.1.9	Millet, Jean-François *The Bather*
1042	1949.1.10	Rousseau, Theodore *Landscape with Boatman*
1045	1949.13.1	Legros, Alphonse *Head of a Man with Upturned Eyes*
1047	1952.9.4	Stubbs, George *Captain Pocklington with His Wife and Sister*
1048	1949.7.1	Anonymous Byzantine 13th Century *Enthroned Madonna and Child*
1049	1948.10.1	Neeffs, Peeter, I *Interior of a Church*
1050	1949.6.1	Leyster, Judith *Self-Portrait*

1053	1950.10.1	Sustermans, Justus, Attributed to *Mattias de' Medici*
1056	1950.11.1.a-c	Martino di Bartolomeo di Biago, Attributed to *Madonna and Child with Saint Peter and Saint Stephen*
1057	1950.11.2	Cariani *Portrait of a Man With a Dog*
1059	1950.12.1	Renoir, Auguste *Woman with a Cat*
1060	1951.2.1	Degas, Edgar *Madame Dietz-Monnin*
1061	1951.5.1	Gauguin, Paul *The Bathers*
1062	1951.5.2	Renoir, Auguste *Oarsmen at Chatou*
1065	1951.7.1	Highmore, Joseph *A Scholar of Merton College, Oxford*
1073	1951.9.5	Kidd, Joseph Bartholomew *Sharp-Tailed Sparrow*
1074	1951.9.6	Kidd, Joseph Bartholomew *Black-Backed Three-Toed Woodpecker*
1075	1951.9.7	Kidd, Joseph Bartholomew *Orchard Oriole*
1076	1951.9.8	Kidd, Joseph Bartholomew *Yellow Warbler*
1078	1951.15.1	Tintoretto, Jacopo, Follower of *Portrait of a Man and Boy*
1079	1951.16.1	Corot, Jean-Baptiste-Camille *Gypsy Girl with Mandolin*
1080	1951.18.1	Turner, Joseph Mallord William *The Rape of Proserpine*
1082	1952.4.1	Donducci, Giovanni Andrea *Allegorical Landscape*
1083	1952.4.2	Anonymous British 18th Century *The Singing Party*

1085	1952.2.2	Angelico, Fra *The Adoration of the Magi*
1086	1952.2.3	Gozzoli, Benozzo *The Dance of Salome*
1087	1952.2.4	Botticelli *The Virgin Adoring the Child*
1088	1952.2.5	Mantegna, Andrea *Portrait of a Man*
1089	1952.2.6.a-d	Tura, Cosimo *The Annunciation with Saint Francis and Saint Maurelius*
1090	1952.2.7	Bellini, Giovanni *An Episode from the Life of Publius Cornelius Scipio*
1091	1952.2.8	Giorgione *The Holy Family*
1092	1952.2.9	Sebastiano del Piombo *Portrait of a Young Woman as a Wise Virgin*
1093	1952.2.10	Moretto da Brescia *Pietà*
1094	1952.2.11	Titian *Ranuccio Farnese*
1095	1952.2.12	Titian *Portrait of a Young Lady as Venus Binding the Eyes of Cupid*
1096	1952.2.13	Master of the Saint Lucy Legend *Mary, Queen of Heaven*
1097	1952.2.14	Master of Saint Giles *Episodes from the Life of a Bishop Saint*
1098	1952.2.15	Master of Saint Giles *The Baptism of Clovis*
1099	1952.2.16.a-b	Dürer, Albrecht *Madonna and Child; Lot and His Daughters*
1100	1952.2.17	Dürer, Albrecht *Portrait of a Clergyman*

1101	1952.2.18	Antwerp 16th Century *The Martyrdom of Saint Catherine*
1102	1952.2.19	Bruegel, Pieter, the Elder, Follower of *The Temptation of Saint Anthony*
1103	1952.2.20	Le Nain, Louis *A French Interior*
1104	1952.2.21	Poussin, Nicolas *The Feeding of the Child Jupiter*
1105	1952.2.22	Lancret, Nicolas *The Picnic after the Hunt*
1106	1952.2.23	Ingres, Jean-Auguste-Dominique *Pope Pius VII in the Sistine Chapel*
1107	1952.2.24	Ingres, Jean-Auguste-Dominique *Monsieur Marcotte*
1109	1952.6.1	Salviati, Francesco *Portrait of a Lady*
1110	1952.5.31.a-c	Altdorfer, Albrecht, Workshop of *The Fall of Man*
1111	1952.5.32	Anonymous French 15th Century *The Expectant Madonna with Saint Joseph*
1112	1952.5.33	Bosch, Hieronymus *Death and the Miser*
1113	1952.5.34	Bourdon, Sébastien *Countess Ebba Sparre*
1114	1952.5.35	Champaigne, Philippe de *Omer Talon*
1115	1952.5.36	Chardin, Jean Siméon *Still Life with Game*
1116	1952.5.37	Chardin, Jean Siméon *The Attentive Nurse*
1117	1952.5.38	Chardin, Jean Siméon *The Kitchen Maid*
1118	1952.5.39	Dyck, Anthony van, Sir *Queen Henrietta Maria with Her Dwarf*

1119	1952.5.40.a	Gossaert, Jan *Saint Jerome Penitent*
1119	1952.5.40.b	Gossaert, Jan *Saint Jerome Penitent*
1120	1952.5.41	North Netherlandish 15th Century *Adoration of the Magi*
1121	1952.5.42	Master of the Retable of the Reyes Católicos *The Marriage at Cana*
1122	1952.5.43	Master of the Retable of the Reyes Católicos *Christ among the Doctors*
1123	1952.5.44	Claude Lorrain *Landscape with Merchants*
1124	1952.5.45	Marmion, Simon, Studio of *A Miracle of Saint Benedict*
1125	1952.5.46.a-b	Memling, Hans *Saint Veronica; The Chalice of Saint John the Evangelist*
1126	1952.5.47.a-b	Orley, Bernard van *Christ Among the Doctors; Putto with Arms of Jacques Coëne*
1127	1952.5.48	Orley, Bernard van *The Marriage of the Virgin*
1128	1952.5.49	Poussin, Nicolas *Holy Family on the Steps*
1129	1952.5.50	Robert, Hubert *The Old Bridge*
1130	1952.5.51	Benaglio, Francesco *Saint Jerome*
1131	1952.5.52	Benvenuto di Giovanni *Christ Carrying the Cross*
1132	1952.5.53	Benvenuto di Giovanni *The Crucifixion*
1133	1952.5.54	Benvenuto di Giovanni *Christ in Limbo*
1134	1952.5.55	Benvenuto di Giovanni *The Resurrection*

1135	1952.5.56	Botticelli *Giuliano de'Medici*
1137	1952.5.58	Carracci, Annibale *Landscape*
1138	1952.5.59	Carracci, Lodovico *The Dream of Saint Catherine of Alexandria*
1139	1952.5.60	Cimabue, Attributed to *Madonna and Child with Saint John the Baptist and Saint Peter*
1140	1952.5.61	Daddi, Bernardo *Madonna and Child with Saints and Angels*
1141	1952.5.62	Ghirlandaio, Domenico *Lucrezia Tornabuoni*
1142	1952.5.63	Foppa, Vincenzo *Saint Anthony of Padua*
1143	1952.5.64	Francia, Francesco *Bishop Altobello Averoldo*
1144	1952.5.65	Verrocchio, Andrea del, Workshop of *Madonna and Child with a Pomegranate*
1145	1952.5.66	Leonardo da Vinci, Studio of *Portrait of a Young Lady*
1146	1952.5.67	Mantegna, Andrea *The Christ Child Blessing*
1147	1952.5.68	Master of the Life of Saint John the Baptist *Scenes from the Life of Saint John the Baptist*
1149	1952.5.70	Piazzetta, Giovanni Battista *Elijah Taken Up in a Chariot of Fire*
1150	1952.5.71	North Italian 15th Century *Portrait of a Man*
1151	1952.5.72	Raphael, Follower of *Putti with a Wine Press*
1152	1952.5.73	Sassetta *The Death of Saint Anthony*
1153	1952.5.74	Savoldo, Giovanni Girolamo *Portrait of a Knight*

1154	1952.5.75	Signorelli, Luca *Calvary*
1155	1952.5.76	Sodoma *Saint George and the Dragon*
1156	1952.5.77	Tiepolo, Giovanni Battista *A Young Lady in Domino and Tricorne*
1157	1952.5.78	Tiepolo, Giovanni Battista *Apollo Pursuing Daphne*
1158	1952.5.79	Tintoretto, Jacopo *A Procurator of Saint Mark's*
1159	1952.5.80	Titian, Follower of *Allessandro Alberti with a Page*
1160	1952.5.81	Bacchiacca *The Flagellation of Christ*
1161	1952.5.82	Veronese *Rebecca at the Well*
1162	1952.5.83	Master of Heiligenkreuz *The Death of Saint Clare*
1163	1952.5.84	Anonymous German 16th Century *The Crucifixion*
1164	1952.5.85	Anonymous German 16th Century *Christ in Limbo*
1165	1952.5.86	Lippi, Filippino *Pietà*
1166	1952.5.87	Paolo Veneziano *The Coronation of the Virgin*
1167	1952.5.88	Zurbarán, Francisco de *Saint Jerome with Saint Paula and Saint Eustochium*
1169	1952.9.1	Manet, Edouard *Portrait of a Lady*
1170	1952.9.2	Morisot, Berthe *The Sisters*
1171	1952.9.3	Orpen, William, Sir *Mrs. Charles S. Carstairs*

1173	1953.3.1	Cranach, Lucas, the Elder *Madonna and Child*
1174	1953.3.2	Dyck, Anthony van, Sir *Portrait of a Man*
1177	1953.3.3.a-b	Antwerp 16th Century, Attributed to *A Member of the de Hondecoeter Family*
1178	1953.3.4	Antwerp 16th Century, Attributed to *Wife of a Member of the de Hondecoeter Family*
1179	1953.3.5	Bruyn, Bartholomaeus, the Elder *Portrait of a Man*
1187	1954.1.3	Unknown Nationality 18th Century *Portrait of a Man*
1188	1954.1.4	Unknown Nationality 18th Century *Portrait of a Man*
1191	1954.1.7	Unknown Nationality 18th Century *Portrait of a Man*
1192	1954.1.8	Abbott, Lemuel Francis *Captain Robert Calder*
1195	1954.1.11	Anonymous British 18th Century *James Massy Dawson (?)*
1245	1953.5.39	Wheldon, W. *Two Brothers*
1339	1953.13.1	Vanloo, Louis Michel, Follower of *Portrait of a Lady*
1343	1954.4.4	Steinlen, Théophile Alexandre *The Laundresses*
1344	1954.3.1.	Winterhalter, Franz Xaver *Queen Victoria*
1345	1954.6.1	Corot, Jean-Baptiste-Camille *Italian Girl*
1346	1954.5.1	Kauffmann, Angelica *Franciska Krasinska, Duchess of Courland*
1349	1954.8.1	Renoir, Auguste *The Vintagers*

1350	1954.10.1	Goya, Francisco de, Attributed to *The Bullfight*
1351	1954.9.1	Raeburn, Henry, Sir *Jean Christie*
1355	1954.13.1	Blake, William *The Last Supper*
1356	1954.14.1	Romney, George *Mr. Forbes*
1357	1955.3.1	Pater, Jean-Baptiste Joseph *On the Terrace*
1358	1954.17.1	Pater, Jean-Baptiste Joseph, After *The Gift of the Fishermen*
1361	1961.9.4	Paolo di Giovanni Fei *The Presentation of the Virgin*
1362	1961.9.5	Bellini, Giovanni *The Infant Bacchus*
1363	1961.9.6	Creti, Donato *The Quarrel*
1364	1961.9.7	Bronzino, Agnolo *Eleonora di Toledo*
1365	1961.9.8	Carpaccio, Vittore *Madonna and Child*
1366	1961.9.9	Carracci, Annibale *Venus Adorned by the Graces*
1367	1961.9.10	Christus, Petrus *Portrait of a Male Donor*
1368	1961.9.11	Christus, Petrus *Portrait of a Female Donor*
1369	1961.9.12	Cima da Conegliano *Saint Helena*
1370	1961.9.13	Clouet, François *"Diane de Poitiers"*
1371	1959.9.1	Cranach, Lucas, the Elder *Portrait of a Man*

1372	1959.9.2	Cranach, Lucas, the Elder *Portrait of a Woman*
1373	1961.9.14	David, Jacques-Louis *Madame David*
1374	1961.9.15	David, Jacques-Louis *Napoleon in His Study*
1375	1957.14.1	Dyck, Anthony van, Sir *Doña Polyxena Spinola Guzman de Leganés*
1376	1961.9.16	Fragonard, Jean-Honoré *Blindman's Buff*
1377	1961.9.17	Fragonard, Jean-Honoré *The Swing*
1378	1961.9.18	Fragonard, Jean-Honoré *Hubert Robert*
1379	1961.9.19	Grünewald, Mathis *The Small Crucifixion*
1380	1961.9.20	Guercino *Cardinal Francesco Cennini*
1381	1961.9.21	Holbein, Hans, the Younger *Portrait of a Young Man*
1382	1961.9.22	Juan de Flandes *The Annunciation*
1383	1961.9.23	Juan de Flandes *The Nativity*
1384	1961.9.24	Juan de Flandes *The Adoration of the Magi*
1385	1961.9.25	Juan de Flandes *The Baptism of Christ*
1386	1961.9.26	Largillière, Nicolas de *A Young Man with His Tutor*
1387	1961.9.27	Lucas van Leyden, After *The Card Players*
1388	1959.9.3	Campin, Robert, Follower of *Madonna and Child with Saints in the Enclosed Garden*

1389	1961.9.28	Master of the Prado Adoration of the Magi *The Presentation in the Temple*
1390	1961.9.29	Master of Saint Veronica *The Crucifixion*
1391	1961.9.30	Nattier, Jean-Marc *Joseph Bonnier de la Mosson*
1392	1961.9.31	Perino del Vaga *The Nativity*
1393	1961.9.32	Rubens, Peter Paul, Sir *The Assumption of the Virgin*
1394	1957.14.2	Rubens, Peter Paul, Sir *Decius Mus Addressing the Legions*
1395	1961.9.33	Saenredam, Pieter Jansz. *Cathedral of Saint John at 's-Hertogenbosch*
1396	1961.9.34	Saenredam, Pieter Jansz. *Church of Santa Maria della Febbre, Rome*
1397	1961.9.35	Savoldo, Giovanni Girolamo *Elijah Fed by the Raven*
1398	1961.9.36	Heemskerck, Maerten van *The Rest on the Flight into Egypt*
1399	1961.9.37	Sebastiano del Piombo *Cardinal Bandinello Sauli, His Secretary and Two Geographers*
1400	1961.9.38	Sebastiano del Piombo *Portrait of a Humanist*
1401	1961.9.39	Signorelli, Luca *The Marriage of the Virgin*
1402	1961.9.40	Solario, Andrea *Pietà*
1403	1961.9.41	Strozzi, Bernardo *Bishop Alvise Grimani*
1404	1961.9.42	Tiepolo, Giovanni Battista *Queen Zenobia Addressing Her Soldiers*
1405	1961.9.43	Tintoretto, Jacopo *The Conversion of Saint Paul*

1406	1961.9.44	Tintoretto, Jacopo *Doge Alvise Mocenigo and Family before the* *Madonna and Child*
1407	1957.14.3	Titian *Vincenzo Capello*
1408	1961.9.45	Titian *Doge Andrea Gritti*
1409	1961.9.46	Valdés Leal, Juan de *The Assumption of the Virgin*
1410	1961.9.47	Veronese *Saint Jerome in the Wilderness*
1411	1961.9.48	Veronese *Saint Lucy and a Donor*
1412	1961.9.49	Ghirlandaio, Domenico *Madonna and Child*
1413	1961.9.50	Watteau, Antoine *Ceres (Summer)*
1414	1961.9.51	Zoppo, Marco *Madonna and Child*
1415	1961.9.52	Vouet, Simon *Saint Jerome and the Angel*
1416	1955.7.1	Drouais, François-Hubert, Attributed to *Marquis d'Ossun*
1417	1956.9.16	Tiepolo, Giovanni Battista *The Apotheosis of a Saint*
1418	1955.9.1	Corot, Jean-Baptiste-Camille *Ville d'Avray*
1443	1956.1.1	Rembrandt van Rijn, Style of *Old Woman Plucking a Fowl*
1444	1956.4.1	Renoir, Auguste *Girl with a Basket of Fish*
1445	1956.4.2	Renoir, Auguste *Girl with a Basket of Oranges*
1446	1956.3.1	Dandré-Bardon, Michel-François *The Adoration of the Skulls*

1447	1956.3.2	Antwerp 16th Century *Portrait of an Almoner of Antwerp*
1448	1956.9.1	Gainsborough, Thomas *Shepherd Boys and Dog Sheltering from Storm*
1449	1956.9.2	Guardi, Francesco *Castel Sant'Angelo*
1450	1956.9.3	Hoppner, John, Attributed to *Portrait of a Man*
1451	1956.9.4	Anonymous British 18th Century *The Earl of Beverley*
1452	1956.9.5	Anonymous British 18th Century *The Countess of Beverley*
1454	1956.10.1	Manet, Edouard *Gare Saint-Lazare*
1471	1956.11.1	Goya, Francisco de *Victor Guye*
1472	1956.14.1	Legros, Alphonse *Memory Copy of Holbein's Erasmus*
1478	1957.4.1	Besnard, Albert *Nude*
1480	1957.4.3	Zorn, Anders *Hugo Reisinger*
1481	1957.6.1	Courbet, Gustave *La Grotte de la Loue*
1482	1957.14.4	Greco, El *Christ Cleansing the Temple*
1483	1957.14.5	Sarto, Andrea del *Charity*
1484	1957.14.6	Titian *Saint John the Evangelist on Patmos*
1485	1957.8.1	Veronese, Follower of *Agostino Barbarigo*
1497	1957.12.1	Cranach, Lucas, the Elder *The Nymph of the Spring*

1499	1957.7.1	Anonymous French 18th Century *Singerie: The Concert*
1500	1957.7.2	Anonymous French 18th Century *Singerie: The Dance*
1501	1957.7.3	Anonymous French 18th Century *Singerie: The Fisherman*
1502	1957.7.4	Anonymous French 18th Century *Singerie: The Picnic*
1503	1957.7.5	Anonymous French 18th Century *Singerie: The Painter*
1504	1957.7.6	Anonymous French 18th Century *Singerie: The Sculptor*
1506	1958.4.1	Rubens, Peter Paul, Sir *The Meeting of Abraham and Melchizedek*
1507	1958.7.1	Guardi, Francesco, Follower of *Piazza San Marco*
1508	1958.10.1	Cézanne, Paul *Le Château Noir*
1509	1958.10.2	Cézanne, Paul *Vase of Flowers*
1510	1958.12.1	Monet, Claude *Morning Haze*
1525	1959.2.1	Cézanne, Paul *The Sailor*
1526	1959.1.1	Cuitt, George, the Younger *Easby Abbey, near Richmond*
1527	1959.9.4	Greco, El *The Holy Family*
1528	1959.9.5	Koerbecke, Johann *The Ascension*
1529	1959.9.6	Veronese *The Annunciation*
1530	1959.3.1	Manet, Edouard *The Tragic Actor (Rouvière as Hamlet)*

1548	1959.15.1	Cézanne, Paul *Still Life with Apples and Peaches*
1549	1960.1.1	Manet, Edouard *Still Life with Melon and Peaches*
1551	1960.2.1	Ruisdael, Jacob van *Park with a Country House*
1553	1960.6.1	Venetian 15th Century *Portrait of a Man*
1554	1960.6.2	Boucher, François *Diana and Endymion*
1555	1960.6.3	Boucher, François *The Love Letter*
1556	1960.6.4	Corot, Jean-Baptiste-Camille *Saint Sebastian Succored by the Holy Women*
1557	1960.6.5	Correggio, After *Madonna and Child with the Infant Saint John*
1558	1960.6.6	Cotes, Francis, Style of *Portrait of a Lady*
1559	1960.6.7	Cotes, Francis, Style of *Portrait of a Lady*
1560	1960.6.8	Dou, Gerard *The Hermit*
1561	1960.6.9	Drouais, François-Hubert *Madame du Barry*
1562	1960.6.10	Terborch, Gerard, II, Studio of *The Concert*
1563	1960.6.11	Dyck, Anthony van, Sir, After *Twelve Apostles*
1564	1960.6.12	Fragonard, Jean-Honoré *The Happy Family*
1565	1960.6.13	Anonymous French 18th Century *Young Woman and Man*
1566	1960.6.14	Pater, Jean-Baptiste Joseph, After *Fête Champêtre*

1567	1960.6.15	Anonymous French 18th Century *Divertissement*
1571	1960.6.19	Greuze, Jean-Baptiste *Girl with Birds*
1572	1960.6.20	Greuze, Jean-Baptiste, After *Girl with Folded Arms*
1573	1960.6.21	Dyck, Anthony van, Sir, After *Group of Four Boys*
1574	1960.6.22	Henner, Jean-Jacques *Reclining Nude*
1575	1960.6.23	Herring, John Frederick *Horses*
1576	1960.6.24	Anonymous Italian 15th Century *Head of a Woman*
1577	1960.6.25	Florentine 15th Century *The Adoration of the Shepherds*
1578	1960.6.26	Lely, Peter, Sir *Barbara Villiers, Duchess of Cleveland*
1579	1960.6.27	Moroni, Giovanni Battista *Gian Federico Madruzzo*
1580	1960.6.28	Nattier, Jean-Marc *Portrait of a Lady*
1581	1960.6.29	Neeffs, Peeter, I *Antwerp Cathedral*
1582	1960.6.30	Anonymous Portuguese 17th Century *Four-Panel Screen*
1583	1960.6.31	Romney, George *Sir Archibald Campbell*
1584	1960.6.32	Rubens, Peter Paul, Sir, Studio of *Saint Peter*
1585	1960.6.33	Rubens, Peter Paul, Sir, Studio of *Peter Paul Rubens*
1588	1960.6.36	Tiepolo, Giovanni Battista *Bacchus and Ariadne*

1589	1960.6.37	Tintoretto, Marco *Pietà*
1590	1960.6.38	Titian *Girolamo and Cardinal Marco Corner Investing Marco, Abbot of Carrara, with His Benefice*
1591	1960.6.39	Titian, Attributed to *Self-Portrait*
1592	1960.6.40	Turner, Joseph Mallord William *The Evening of the Deluge*
1593	1960.6.41	Vigée-Lebrun, Elisabeth, Attributed to *Marie-Antoinette*
1594	1960.6.42	Wilkie, David, Sir *Camping Gypsies*
1601	1961.3.1	Renoir, Auguste *Madame Henriot*
1602	1961.2.1	Gainsborough, Thomas *Master John Heathcote*
1603	1961.2.2	Reynolds, Joshua, Sir *Squire Musters*
1604	1961.2.3	Turner, Joseph Mallord William *The Dogana and Santa Maria della Salute, Venice*
1605	1961.9.53	Canaletto *The Portello and the Brenta Canal at Padua*
1606	1961.9.54	Anonymous French 15th Century *Portrait of an Ecclesiastic*
1607	1961.9.55	Anonymous French 16th Century *Prince Hercule-François, Duc d'Alençon*
1608	1961.9.56	Luini, Bernardino *The Magdalene*
1609	1961.9.57	Florentine 16th Century *Allegorical Portrait of Dante*
1610	1961.9.58	Ricci, Marco *Memorial to Admiral Sir Clowdisley Shovell*
1611	1961.9.59	Rosso Fiorentino *Portrait of a Man*

1612	1961.9.60	Rubens, Peter Paul, Sir *Marchesa Brigida Spinola Doria*
1613	1961.9.61	Vouet, Simon *The Muses Urania and Calliope*
1614	1961.9.62	Baldung, Hans *Saint Anne with the Christ Child, the Virgin,* *and Saint John the Baptist*
1615	1961.9.63	Bellotto, Bernardo *The Castle of Nymphenburg*
1616	1961.9.64	Bellotto, Bernardo *View of Munich*
1617	1961.9.65	Bourdon, Sébastien *The Finding of Moses*
1618	1961.9.66	Bouts, Dirck, Follower of *Portrait of a Donor*
1619	1961.9.67	Bramantino *The Apparition of Christ among the Apostles*
1620	1961.9.68	Correggio *Salvator Mundi*
1621	1961.9.69	Cranach, Lucas, the Elder *The Crucifixion with the Converted Centurion*
1622	1961.9.70	Diana, Benedetto *The Presentation and Marriage of the Virgin,* *and the Annunciation*
1623	1961.9.71	Paolo di Giovanni Fei *The Assumption of the Virgin*
1624	1961.9.72	Foppa, Vincenzo *Saint Bernardine*
1625	1961.9.73	Gentileschi, Orazio *Saint Cecilia and an Angel*
1626	1961.9.74	Goya, Francisco de *Don Antonio Noriega*
1627	1961.9.75	Hamen y León, Juan van der *Still Life*
1628	1961.9.76	La Tour, Maurice-Quentin de *Claude Dupouch*

1629	1961.9.77	Duccio di Buoninsegna, Follower of *Madonna and Child Enthroned with Angels*
1630	1961.9.78	Master of the Saint Bartholomew Altar *The Baptism of Christ*
1631	1961.9.79	Mor, Anthonis, Follower of *Portrait of a Young Man*
1632	1961.9.80	Sons, Giovanni *The Judgment of Paris*
1633	1961.9.81	Patinir, Joachim, Follower of *The Flight into Egypt*
1634	1961.9.82	Piazzetta, Giovanni Battista *Madonna and Child Appearing to San Filippo Neri*
1635	1961.9.83	Pontormo *Monsignor della Casa*
1636	1961.9.84	Prud'hon, Pierre Paul *David Johnston*
1637	1961.9.85	Ruisdael, Jacob van *Landscape*
1638	1961.9.86	Savoldo, Giovanni Girolamo *The Adoration of the Shepherds*
1639	1961.9.87	Signorelli, Luca *Madonna and Child with Saints and Angels*
1640	1961.9.88	Strigel, Bernhard *Saint Mary Cleophas and Her Family*
1641	1961.9.89	Strigel, Bernhard *Saint Mary Salome and Her Family*
1642	1961.9.90	Tintoretto, Jacopo *Summer*
1643	1961.9.91	Vassallo, Anton Maria *The Larder*
1644	1961.9.92	Venetian 18th Century *Before the Masked Ball*
1645	1961.5.1	Beechey, William, Sir *General Sir Thomas Picton*

1646	1961.5.2	Cotes, Francis *Miss Elizabeth Crewe*
1647	1961.5.3	Gainsborough, Thomas *William Yelverton Davenport*
1648	1961.5.4	Miereveld, Michiel van *Portrait of a Lady with a Ruff*
1649	1961.6.1	Heem, Jan Davidsz. de *Vase of Flowers*
1653	1961.16.1	Fragonard, Jean-Honoré *A Young Girl Reading*
1657	1962.3.1	Manet, Edouard *Oysters*
1661	1962.8.1	Gentileschi, Orazio *The Lute Player*
1662	1962.9.1	Cleve, Joos van *Joris Vezeleer*
1663	1962.9.2	Cleve, Joos van *Margaretha Boghe, Wife of Joris Vezeleer*
1664	1962.10.1	Vermeer, Johannes *A Lady Writing*
1665	1963.10.1	Bastien-Lepage, Jules *Simon Hayem*
1666	1963.10.2	Boilly, Louis-Léopold *Mademoiselle Mortier de Trévise*
1667	1963.10.3	Boilly, Louis-Léopold *Mademoiselle Mortier de Trévise*
1668	1963.10.4	Boudin, Eugène *The Beach at Villerville*
1669	1963.10.5	Boudin, Eugène *On the Beach, Trouville*
1670	1963.10.6	Boudin, Eugène *On the Beach*
1672	1963.10.8	Corot, Jean-Baptiste-Camille *Italian Peasant Boy*

1673	1963.10.9	Corot, Jean-Baptiste-Camille *Portrait of a Young Girl*
1674	1963.10.10	Courbet, Gustave *Beach in Normandy*
1675	1963.10.11	Dali, Salvador *Chester Dale*
1676	1963.10.12	Daumier, Honoré *The Beggars*
1677	1963.10.13	Daumier, Honoré *French Theater*
1678	1963.10.14	Daumier, Honoré *Wandering Saltimbanques*
1679	1963.10.15	David, Charles *Portrait of a Young Horsewoman*
1680	1963.10.16	Degas, Edgar *Ballet Scene*
1681	1963.10.17	Degas, Edgar *Girl in Red*
1682	1963.10.18	Degas, Edgar *Mademoiselle Malo*
1683	1963.10.19	Delacroix, Eugène, Follower of *Michelangelo in His Studio*
1684	1963.10.20	Derain, André *Head of a Woman*
1685	1963.10.21	Derain, André *Portrait of a Girl*
1686	1963.10.22	Dufy, Raoul *The Basket*
1687	1963.10.23	Fantin-Latour, Henri *Duchess de Fitz-James*
1688	1963.10.24	Fantin-Latour, Henri *Mademoiselle de Fitz-James*
1689	1963.10.25	Fantin-Latour, Henri *Self-Portrait*

1690	1963.10.26	Forain, Jean-Louis *The Charleston*
1691	1963.10.27	Gauguin, Paul *Madame Alexandre Kohler*
1692	1963.10.28	Gérard, François, Baron *The Model*
1693	1963.10.29	Géricault, Théodore *Nude Warrior with a Spear*
1694	1963.10.30	Gogh, Vincent van *Girl in White*
1695	1963.10.31	Gogh, Vincent van *Roulin's Baby*
1696	1963.10.32	Henner, Jean-Jacques *Alsatian Girl*
1697	1963.10.33	Henner, Jean-Jacques *Madame Uhring*
1698	1963.10.34	Ingres, Jean-Auguste-Dominique *Ulysses*
1699	1963.10.35	Laurencin, Marie *Girl with a Dove*
1700	1963.10.36	Léger, Fernand *Maud Dale*
1701	1963.10.37	Lurçat, Jean *Chester Dale*
1702	1963.10.38	Lurçat, Jean *Maud Dale*
1703	1963.10.39	Matisse, Henri *Lorette*
1704	1963.10.40	Matisse, Henri *Moorish Woman*
1705	1963.10.41	Matisse, Henri *Pot of Geraniums*
1706	1963.10.42	Millet, Jean-François *Leconte de Lisle*

1707	1963.10.43	Millet, Jean-François *Portrait of a Man*
1708	1963.10.44	Modigliani, Amedeo *Café Singer*
1709	1963.10.45	Modigliani, Amedeo *Girl in a Green Blouse*
1710	1963.10.46	Modigliani, Amedeo *Nude on a Blue Cushion*
1711	1963.10.47	Modigliani, Amedeo *Chaim Soutine*
1712	1963.10.48	Monet, Claude *The Houses of Parliament, Sunset*
1713	1963.10.49	Monet, Claude *Rouen Cathedral, West Façade*
1714	1963.10.50	Morisot, Berthe *The Artist's Daughter with a Parakeet*
1715	1963.10.51	Oudot, Roland *Matador in White*
1716	1963.10.52	Picasso, Pablo *Le Gourmet*
1717	1963.10.53	Picasso, Pablo *Pedro Mañach*
1718	1963.10.54	Pissarro, Camille *The Bather*
1719	1963.10.55	Raffaelli, Jean François *The Flower Vendor*
1720	1963.10.56	Redon, Odilon *Pandora*
1721	1963.10.57	Redon, Odilon *Saint Sebastian*
1722	1963.10.58	Renoir, Auguste *Girl with a Hoop*
1723	1963.10.59	Renoir, Auguste *Marie Murer*

1724	1963.10.60	Renoir, Auguste *Suzanne Valadon*
1725	1963.10.61	Ribot, Augustin Théodule *Portrait of a Man*
1727	1963.10.63	Rousseau, Henri *Boy on the Rocks*
1729	1963.10.65	Stevens, Alfred *Young Woman in White Holding a Bouquet*
1730	1963.10.66	Toulouse-Lautrec, Henri de *Jane Avril*
1731	1963.10.67	Toulouse-Lautrec, Henri de *A Corner of the Moulin de la Galette*
1732	1963.10.68	Toulouse-Lautrec, Henri de *La Goulue and Her Sister*
1733	1963.10.69	Toulouse-Lautrec, Henri de *Rue des Moulins, 1894*
1734	1963.10.70	Vuillard, Edouard *Théodore Duret*
1736	1963.10.72	Derain, André *Woman in an Armchair*
1737	1963.10.73	Derain, André *Woman in a Chemise*
1738	1963.10.74	Gromaire, Marcel *Vendor of Ices*
1739	1963.10.75	La Fresnaye, Roger de *Nude*
1740	1963.10.76	Modigliani, Amedeo *Monsieur Deleu*
1741	1963.10.77	Modigliani, Amedeo *Nude on a Divan*
1742	1963.10.78	Vallotton, Félix Edouard *Marigolds and Tangerines*
1743	1963.10.79	Wright, Joseph, After *The Widow of an Indian Chief*

1745	1963.10.81	Bazille, Frédéric *Edouard Blau*
1750	1963.10.86	Bonnard, Pierre *The Letter*
1751	1963.10.87	Boudin, Eugène *Return of the Terre-Neuvier*
1752	1963.10.88	Braque, Georges *Nude Woman with Basket of Fruit*
1753	1963.10.89	Braque, Georges *Nude Woman with Fruit*
1754	1963.10.90	Braque, Georges *Peonies*
1755	1963.10.91	Braque, Georges *Still Life: Le Jour*
1756	1963.10.92	Braque, Georges *Still Life: The Table*
1764	1963.10.100	Cézanne, Paul *The Artist's Son, Paul*
1765	1963.10.101	Cézanne, Paul *Louis Guillaume*
1766	1963.10.102	Cézanne, Paul *House of Père Lacroix*
1767	1963.10.103	Cézanne, Paul *Landscape near Paris*
1768	1963.10.104	Cézanne, Paul *Still Life with Peppermint Bottle*
1769	1963.10.105	Cézanne, Paul *Flowers in a Rococo Vase*
1771	1963.10.107	De Chirico, Giorgio *Conversation Among the Ruins*
1772	1963.10.108	Corot, Jean-Baptiste-Camille *Agostina*
1773	1963.10.109	Corot, Jean-Baptiste-Camille *Forest of Fontainebleau*

1774	1963.10.110	Corot, Jean-Baptiste-Camille *Rocks in the Forest of Fontainebleau*
1775	1963.10.111	Corot, Jean-Baptiste-Camille *A View near Volterra*
1776	1963.10.112	Courbet, Gustave *Portrait of a Young Girl*
1777	1963.10.113	Courbet, Gustave *The Promenade*
1778	1963.10.114	Courbet, Gustave *A Young Woman Reading*
1779	1963.10.115	Dali, Salvador *The Sacrament of the Last Supper*
1780	1963.10.116	Daubigny, Charles-François *The Farm*
1781	1963.10.117	Daumier, Honoré, Follower of *Hippolyte Lavoignat*
1782	1963.10.118	David, Jacques-Louis, Follower of *Portrait of a Young Woman in White*
1785	1963.10.121	Degas, Edgar *Madame Camus*
1786	1963.10.122	Degas, Edgar *Four Dancers*
1787	1963.10.123	Degas, Edgar *Achille de Gas in the Uniform of a Cadet*
1788	1963.10.124	Degas, Edgar *Madame René de Gas*
1789	1963.10.125	Degas, Edgar *Edmondo and Thérèse Morbilli*
1790	1963.10.126	Delacroix, Eugène, Follower of *Algerian Child*
1791	1963.10.127	Delacroix, Eugène *Columbus and His Son at La Rabida*
1792	1963.10.128	Derain, André *Flowers in a Vase*

1793	1963.10.129	Derain, André *Harlequin*
1794	1963.10.130	Derain, André *The Old Bridge*
1795	1963.10.131	Derain, André *Still Life*
1796	1963.10.132	Domergue, Jean-Gabriel *Maud Dale*
1797	1963.10.133	Domergue, Jean-Gabriel *A Picador*
1798	1963.10.134	Doornik, Frans van *Anna de Peyster (?)*
1799	1963.10.135	Doornik, Frans van *Isaac de Peyster (?)*
1804	1963.10.140	Dufresne, Charles Georges *Judgment of Paris*
1805	1963.10.141	Dufresne, Charles Georges *Still Life*
1806	1963.10.142	Dufy, Raoul *Reclining Nude*
1807	1963.10.143	Dufy, Raoul *Saint-Jeannet*
1808	1963.10.144	Anonymous British 18th Century *Portrait of a Little Girl*
1809	1963.10.145	Fantin-Latour, Henri *Portrait of Sonia*
1810	1963.10.146	Fantin-Latour, Henri *Still Life*
1812	1963.10.148	Gauguin, Paul *Brittany Landscape*
1813	1963.10.149	Gauguin, Paul *Fatata te Miti (By the Sea)*
1814	1963.10.150	Gauguin, Paul *Self-Portrait*

1815	1963.10.151	Gogh, Vincent van *La Mousmé*
1816	1963.10.152	Gogh, Vincent van *The Olive Orchard*
1817	1963.10.153	Gogh, Vincent van, Imitator of *Portrait of van Gogh*
1818	1963.10.154	Gros, Antoine-Jean, Baron *Dr. Vignardonne*
1819	1963.10.155	Guillaumin, Jean-Baptiste-Armand *The Bridge of Louis Philippe*
1822	1963.10.158	Laurencin, Marie *In the Park*
1823	1963.10.159	Léger, Fernand *Woman with a Mirror*
1824	1963.10.160	Lurçat, Jean *The Big Cloud*
1825	1963.10.161	Manet, Edouard *Madame Michel-Lévy*
1826	1963.10.162	Manet, Edouard *The Old Musician*
1827	1963.10.163	Marcoussis, Louis Casmir Ladislas *The Musician*
1828	1963.10.164	Marquet, Albert *The Pont Neuf*
1829	1963.10.165	Matisse, Henri *La Coiffure*
1830	1963.10.166	Matisse, Henri *Les Gorges du Loup*
1831	1963.10.167	Matisse, Henri *Odalisque with Raised Arms*
1832	1963.10.168	Matisse, Henri *The Plumed Hat*
1833	1963.10.169	Matisse, Henri *Still Life: Apples on Pink Table*

1834	1963.10.170	Matisse, Henri *Woman with Exotic Plant*
1835	1963.10.171	Modigliani, Amedeo *Adrienne (Woman with Bangs)*
1836	1963.10.172	Modigliani, Amedeo *Madame Amédée (Woman with Cigarette)*
1837	1963.10.173	Modigliani, Amedeo *Leon Bakst*
1838	1963.10.174	Modigliani, Amedeo *Gypsy Woman with Baby*
1839	1963.10.175	Modigliani, Amedeo *Madame Kisling*
1840	1963.10.176	Modigliani, Amedeo *Woman with Red Hair*
1841	1963.10.177	Monet, Claude *Banks of the Seine, Vétheuil*
1842	1963.10.178	Monet, Claude *Woman Seated under the Willows*
1843	1963.10.179	Monet, Claude *Rouen Cathedral, West Façade, Sunlight*
1844	1963.10.180	Monet, Claude *The Seine at Giverny*
1845	1963.10.181	Monet, Claude *Vase of Chrysanthemums*
1846	1963.10.182	Monet, Claude *Palazzo da Mula, Venice*
1847	1963.10.183	Monet, Claude *Waterloo Bridge, Gray Day*
1848	1963.10.184	Monticelli, Adolphe *Madame Cahen*
1849	1963.10.185	Morisot, Berthe *In the Dining Room*
1850	1963.10.186	Morisot, Berthe *The Mother and Sister of the Artist*

1851	1963.10.187	Oudot, Roland *The Market*
1853	1963.10.189	Picasso, Pablo *Classical Head*
1854	1963.10.190	Picasso, Pablo *Family of Saltimbanques*
1855	1963.10.191	Picasso, Pablo *Juggler with Still Life*
1856	1963.10.192	Picasso, Pablo *The Lovers*
1857	1963.10.193	Picasso, Pablo *Dora Maar*
1858	1963.10.194	Picasso, Pablo *Madame Picasso*
1859	1963.10.195	Picasso, Pablo *Still Life*
1860	1963.10.196	Picasso, Pablo *The Tragedy*
1861	1963.10.197	Picasso, Pablo *Two Youths*
1862	1963.10.198	Pissarro, Camille *Boulevard des Italiens, Morning, Sunlight*
1863	1963.10.199	Pissarro, Camille *Peasant Woman*
1864	1963.10.200	Puvis de Chavannes, Pierre *The Prodigal Son*
1867	1963.10.203	Redon, Odilon *Evocation of Roussel*
1868	1963.10.204	Renoir, Auguste *Bather Arranging Her Hair*
1869	1963.10.205	Renoir, Auguste *Diana*
1870	1963.10.206	Renoir, Auguste *A Girl with a Watering Can*

1871	1963.10.207	Renoir, Auguste *Odalisque*
1872	1963.10.208	Renoir, Auguste *Caroline Rémy ("Séverine")*
1873	1963.10.209	Renoir, Auguste *Mademoiselle Sicot*
1874	1963.10.210	Rouault, Georges *Café Scene*
1875	1963.10.211	Rouault, Georges *Nude with Upraised Arms*
1876	1963.10.212	Rouget, Georges *Jacques-Louis David*
1877	1963.10.213	Rousseau, Henri *The Equatorial Jungle*
1878	1963.10.214	Sisley, Alfred *The Banks of the Oise*
1879	1963.10.215	Sisley, Alfred *The Road in the Woods*
1880	1963.10.216	Soutine, Chaim *Portrait of a Boy*
1883	1963.10.219	Toulouse-Lautrec, Henri de *Maxime Dethomas*
1884	1963.10.220	Toulouse-Lautrec, Henri de *Alfred la Guigne*
1885	1963.10.221	Toulouse-Lautrec, Henri de *Quadrille at the Moulin Rouge*
1886	1963.10.222	Utrillo, Maurice *The Church of Saint-Séverin*
1887	1963.10.223	Utrillo, Maurice *Marizy-Sainte-Geneviève*
1888	1963.10.224	Vlaminck, Maurice de *Carrières-Saint-Denis*
1889	1963.10.225	Vlaminck, Maurice de *The Old Port of Marseille*

1890	1963.10.226	Vlaminck, Maurice de
		The River
1891	1963.10.227	Vlaminck, Maurice de
		Still Life with Lemons
1892	1963.10.228	Vlaminck, Maurice de
		Vase of Flowers
1893	1963.10.229	Vuillard, Edouard
		Repast in a Garden
1894	1963.10.230	Vuillard, Edouard
		The Visit
1895	1963.10.231	Zuloaga, Ignacio
		Achieta
1896	1963.10.232	Zuloaga, Ignacio
		Mrs. Philip Lydig
1897	1963.10.233	Zuloaga, Ignacio
		Merceditas
1898	1963.10.234	Zuloaga, Ignacio
		Woman in Andalusian Dress
1899	1963.10.235	Zuloaga, Ignacio
		Sepúlveda
1900	1963.1.1	Legros, Alphonse
		Hampstead Heath
1901	1963.1.2	Legros, Alphonse
		Portrait of a Woman
1902	1963.4.1	Goya, Francisco de
		The Duke of Wellington
1903	1963.4.2	Goya, Francisco de
		The Bookseller's Wife
1905	1963.5.1	Poussin, Nicholas
		The Assumption of the Virgin
1908	1963.8.1	Rubens, Peter Paul, Sir
		Tiberius and Agrippina
1909	1964.2.1	Canaletto
		Landscape Capriccio with Column

1910	1964.2.2	Canaletto *Landscape Capriccio with Palace*
1911	1964.2.3	Devis, Arthur *Lord Brand of Hurndall Park*
1912	1964.2.4	Devis, Arthur *Conversation Piece, Ashdon House*
1914	1964.11.1	Vigée-Lebrun, Elisabeth *The Marquise de Peze and the Marquise de Rouget with Her Two Children*
1916	1964.19.2	Debains, Thérèse *Head of a Woman*
1917	1964.19.3	Dufeu, Edouard-Jacques *Moroccan Landscape*
1918	1964.19.4	Dutch 18th Century *The Harbor*
1919	1964.19.5	Luka, Madeleine *Jean Pierre, du Pré Clos*
1920	1964.19.6	Saint-Jean, Henri de *Still Life: Flowers*
1921	1964.19.7	Stevens, Alfred *Study of a Model*
1922	1964.19.8	Vuillemin, L. de *Portrait of an Old Woman*
1923	1964.19.9	Vuillemin, L. de *Portrait of a Young Woman*
1924	1964.19.10	Zak, Eugene *The Nun*
1928	1965.1.1	Sittow, Michel *The Assumption of the Virgin*
1929	1964.20.1	Largillière, Nicolas de *Elizabeth Throckmorton*
1930	1964.16.1	Anonymous French 15th Century *A Knight of the Golden Fleece*
1931	1964.21.1	Guardi, Gian Antonio *Carlo and Ubaldo Resisting the Enchantments of Armida's Nymphs*

1932	1964.21.2	Guardi, Gian Antonio *Erminia and the Shepherds*
1945	1965.7.1	Roberti, Ercole de' *The Wife of Hasdrubal and Her Children*
1947	1965.8.1	Corneille de Lyon *Portrait of a Man*
1948	1965.13.1	Rubens, Peter Paul, Sir *Daniel in the Lions' Den*
2310	1966.1.1	Weyden, Rogier van der *Saint George and the Dragon*
2315	1967.3.1	Avercamp, Hendrick *A Scene on the Ice*
2316	1967.4.1	Gossaert, Jan *Portrait of a Merchant*
2326	1967.6.1a-b	Leonardo da Vinci *Ginevra de' Benci*
2329	1966.12.1	Delacroix, Eugène *Arabs Skirmishing in the Mountains*
2331	1967.7.1	Juan de Flandes *The Temptation of Christ*
2332	1967.13.1	Renoir, Auguste *Nude*
2347	1968.6.1	Lawrence, Thomas, Sir, Follower of *Portrait of a Lady*
2348	1968.6.2	Lawrence, Thomas, Sir *Marquis of Hertford*
2349	1968.13.1	Heyden, Jan van der *An Architectural Fantasy*
2350	1968.13.2	Pannini, Giovanni Paolo *Interior of Saint Peter's, Rome*
2355	1969.1.1	Claude Lorrain *The Judgment of Paris*
2356	1969.2.1	Jordaens, Jacob *Portrait of a Man*

2358	1969.10.1	Renoir, Auguste *Madame Hagen*
2367	1969.13.1	Baj, Enrico *Furniture Style*
2368	1969.13.2	Baj, Enrico *When I Was Young*
2369	1970.5.1	Cézanne, Paul *The Artist's Father*
2371	1970.18.1	John, Augustus *Mrs. Alexander H. McLanahan*
2372	1970.11.1	Gleizes, Albert *Football Players*
2373	1970.17.1	Anonymous French 19th Century *Le Croisic*
2374	1970.17.2	Béraud, Jean *Paris, rue du Havre*
2375	1970.17.3	Bonnard, Pierre *Two Dogs in a Deserted Street*
2376	1970.17.4	Bonnard, Pierre *The Cab Horse*
2377	1970.17.5	Bonnard, Pierre *Children Leaving School*
2378	1970.17.6	Bonnard, Pierre *The Artist's Sister and Her Children*
2379	1970.17.7	Bonnard, Pierre *The Green Table*
2380	1970.17.8	Bonnard, Pierre *Table Set in a Garden*
2381	1970.17.9	Bonnard, Pierre *Bouquet of Flowers*
2382	1970.17.10	Bonnard, Pierre *A Spring Landscape*
2383	1970.17.11	Bonnard, Pierre *Stairs in the Artist's Garden*

2384	1970.17.12	Boudin, Eugène *Beach at Trouville*
2385	1970.17.13	Boudin, Eugène *On the Jetty*
2386	1970.17.14	Boudin, Eugène *The Beach*
2387	1970.17.15	Boudin, Eugène *Women on the Beach at Berck*
2388	1970.17.16	Boudin, Eugène *Yacht Basin at Trouville-Deauville*
2389	1970.17.17	Boudin, Eugène *Washerwomen on the Beach of Etretat*
2390	1970.17.18	Boudin, Eugène, Style of *Beach at Deauville*
2392	1970.17.20	Cazin, Jean-Charles *Paris Scene with Bridge*
2393	1970.17.21	Cézanne, Paul *Riverbank*
2394	1970.17.22	Corot, Jean-Baptiste-Camille *River Scene with Bridge*
2395	1970.17.23	Corot, Jean-Baptiste-Camille *Madame Stumpf and Her Daughter*
2396	1970.17.24	Daumier, Honoré, Style of *Study of Clowns*
2397	1970.17.25	Degas, Edgar *Dancers Backstage*
2398	1970.17.26	Degas, Edgar *Dancers at the Old Opera House*
2399	1970.17.27	Degas, Edgar *Ballet Dancers*
2400	1970.17.28	Derain, André *Road in Provence*
2401	1970.17.29	Derain, André *Abandoned House in Provence*

2402	1970.17.30	Dufy, Raoul *Regatta at Cowes*
2403	1970.17.31	Dufy, Raoul *Regatta at Henley*
2404	1970.17.32	Dufy, Raoul *The Basin at Deauville*
2405	1970.17.33	Anonymous French 19th Century *Melon and Lemon*
2406	1970.17.34	Gogh, Vincent van *Farmhouse in Provence, Arles*
2407	1970.17.35	Lepine, Stanislas Victor Edouard *Pont de la Tournelle, Paris*
2408	1970.17.36	Manet, Edouard *A King Charles Spaniel*
2409	1970.17.37	Manet, Edouard *Flowers in a Crystal Vase*
2410	1970.17.38	Manet, Edouard, Style of *Bon Bock Cafe*
2411	1970.17.39	Manet, Edouard, Follower of *Madame Lepine*
2412	1970.17.40	Matisse, Henri *Still Life*
2413	1970.17.41	Monet, Claude *Bazille and Camille*
2414	1970.17.42	Monet, Claude *Argenteuil*
2415	1970.17.43	Monet, Charles *Ships Riding on the Seine at Rouen*
2416	1970.17.44	Monet, Claude *Bridge at Argenteuil on a Gray Day*
2417	1970.17.45	Monet, Claude *The Artist's Garden at Vétheuil*
2418	1970.17.46	Moret, Henri *The Island of Raguenez, Brittany*

2419	1970.17.47	Morisot, Berthe *The Artist's Sister at a Window*
2420	1970.17.48	Morisot, Berthe *The Harbor at Lorient*
2421	1970.17.49	Morisot, Berthe *Young Woman with a Straw Hat*
2422	1970.17.50	Morisot, Berthe *Girl in a Boat with Geese*
2423	1970.17.51	Pissarro, Camille *Orchard in Bloom, Louveciennes*
2424	1970.17.52	Pissarro, Camille *Peasant Girl with a Straw Hat*
2425	1970.17.53	Pissarro, Camille *Hampton Court Green*
2426	1970.17.54	Pissarro, Camille *The Artist's Garden at Eragny*
2427	1970.17.55	Pissarro, Camille *Place du Carrousel, Paris*
2428	1970.17.56	Redon, Odilon *Flowers in a Vase*
2429	1970.17.57	Renoir, Auguste *Head of a Dog*
2430	1970.17.58	Renoir, Auguste *Pont Neuf, Paris*
2431	1970.17.59	Renoir, Auguste *Regatta at Argenteuil*
2432	1970.17.60	Renoir, Auguste *Madame Monet and Her Son*
2433	1970.17.61	Renoir, Auguste *Picking Flowers*
2434	1970.17.62	Anonymous French 19th Century *Woman and Two Children in a Field*
2435	1970.17.63	Renoir, Auguste *Young Woman Braiding Her Hair*

2436	1970.17.64	Renoir, Auguste *Georges Rivière*
2437	1970.17.65	Renoir, Auguste *Landscape between Storms*
2438	1970.17.66	Renoir, Auguste *Woman by a Fence*
2439	1970.17.67	Renoir, Auguste *Woman Standing by a Tree*
2440	1970.17.68	Renoir, Auguste *Woman in a Park*
2441	1970.17.69	Renoir, Auguste *Child with Blond Hair*
2442	1970.17.70	Renoir, Auguste *Child with Brown Hair*
2443	1970.17.71	Renoir, Auguste *Young Girl Reading*
2444	1970.17.72	Renoir, Auguste *Landscape at Vétheuil*
2445	1970.17.73	Renoir, Auguste *Small Study for a Nude*
2446	1970.17.74	Renoir, Auguste *Nude with Figure in Background*
2447	1970.17.75	Renoir, Auguste *The Blue River*
2448	1970.17.76	Renoir, Auguste *Young Spanish Woman with a Guitar*
2449	1970.17.77	Renoir, Auguste *Maison de la Poste, Cagnes*
2450	1970.17.78	Renoir, Auguste *Jeanne Samary*
2451	1970.17.79	Renoir, Auguste *Peaches on a Plate*
2452	1970.17.80	Rouault, Georges *Christ and the Doctor*

2453	1970.17.81	Seurat, Georges *Study for "La Grande Jatte"*
2454	1970.17.82	Sisley, Alfred *Boulevard Héloïse, Argenteuil*
2455	1970.17.83	Sisley, Alfred *Meadow*
2456	1970.17.84	Toulouse-Lautrec, Henri de *The Artist's Dog Flèche*
2457	1970.17.85	Toulouse-Lautrec, Henri de *Carmen Gaudin*
2458	1970.17.86	Utrillo, Maurice *Row of Houses at Pierrefitte*
2459	1970.17.87	Utrillo, Maurice *Landscape, Pierrefitte*
2460	1970.17.88	Utrillo, Maurice *Rue Cortot, Montmartre*
2461	1970.17.89	Utrillo, Maurice *Street at Corte, Corsica*
2462	1970.17.90	Vuillard, Edouard *Child Wearing a Red Scarf*
2463	1970.17.91	Vuillard, Edouard *Woman at Her Toilette*
2464	1970.17.92	Vuillard, Edouard *The Conversation*
2465	1970.17.93	Vuillard, Edouard *Woman in Black*
2466	1970.17.94	Vuillard, Edouard *Two Women Drinking Coffee*
2467	1970.17.95	Vuillard, Edouard *The Yellow Curtain*
2468	1970.17.96	Vuillard, Edouard *Woman Sitting by the Fireside*
2469	1970.17.97	Vuillard, Edouard *Breakfast*

2470	1970.17.98	Vuillard, Edouard *The Artist's Paint Box and Moss Roses*
2471	1970.17.99	Vuillard, Edouard *Vase of Flowers on a Mantelpiece*
2473	1970.17.101	Merle, Hugues *Children Playing in a Park*
2478	1970.17.106	Hoppner, John, Style of *Portrait of a Man*
2479	1970.17.107	Dyck, Anthony van, Sir *Saint Martin Dividing His Cloak*
2480	1970.17.108	Edzard, Dietz *Flowers in a Vase*
2481	1970.17.109	Edzard, Dietz *Three Flowers in a Vase*
2482	1970.17.110	Ferneley, John *In the Paddock*
2483	1970.17.111	Fragonard, Jean-Honoré *Love as Folly*
2484	1970.17.112	Fragonard, Jean-Honoré *Love as Conqueror*
2485	1970.17.113	Anonymous French 18th Century *Portrait of a Young Boy*
2486	1970.17.114	Anonymous French 19th Century *Race Course at Longchamps*
2487	1970.17.115	Anonymous French 19th Century *Pont Neuf, Paris*
2488	1970.17.116	Anonymous French 19th Century *Rose in a Vase*
2489	1970.17.117	Corot, Jean-Baptiste-Camille *Beach near Etretat*
2490	1970.17.118	Anonymous French 19th Century, Attributed to *Woman by the Seaside*
2491	1970.17.119	Dupont, Gainsborough *Georgiana, Duchess of Devonshire*

2492	1970.17.120	Dupont, Gainsborough *William Pitt*
2493	1970.17.121	Gainsborough, Thomas *Seashore with Fishermen*
2494	1970.17.122	Dupont, Gainsborough *Mrs. Richard Brinsley Sheridan*
2495	1970.17.123	Goya, Francisco de *Condesa de Chinchón*
2497	1970.17.125	Marshall, Benjamin, Attributed to *Race Horse and Trainer*
2498	1970.17.126	Molyneux, Edward *Artist on a Quay*
2499	1970.17.127	Molyneux, Edward *Chapel in Provence*
2500	1970.17.128	Molyneux, Edward *Chinese Statue of a Dog*
2501	1970.17.129	Molyneux, Edward *Chinese Statue of a Bird*
2502	1970.17.130	Raeburn, Henry, Sir *Mrs. George Hill*
2503	1970.17.131	Raeburn, Henry, Sir, Attributed to *Miss Davidson Reid*
2504	1970.17.132	Ricci, Marco, Attributed to *A View of the Mall from Saint James's Park*
2505	1970.17.133	Romney, George *Sir William Hamilton*
2506	1970.17.134	Thaulow, Frits *River Scene*
2507	1970.17.135	Turner, Joseph Mallord William *Van Tromp's Shallop*
2533	1970.26.1	Eversen, Adrianus *Amsterdam Street Scene*
2542	1970.35.1	Cézanne, Paul *Antony Valabrègue*

2545	1971.2.1	Delaunay, Robert *Political Drama*
2546	1970.36.1	Miró, Joan *Shooting Star*
2547	1971.2.2	Soutine, Chaim *Pastry Chef*
2549	1970.37.2	Riley, Bridget *Balm*
2557	1971.93.1	Greuze, Jean-Baptiste, After *Benjamin Franklin*
2558	1971.18.1	Rubens, Peter Paul, Sir *Deborah Kip, Wife of Sir Balthasar Gerbier, and Her Children*
2560	1971.56.1	Momper, Joos de, II *Vista from a Grotto*
2561	1971.55.1	Massys, Quentin *Ill-Matched Lovers*
2563	1971.51.1	Mondrian, Piet *Diamond Painting in Red, Yellow, and Blue*
2585	1971.85.1	Manet, Edouard *The Plum*
2586	1972.9.1	Cézanne, Paul *At the Water's Edge*
2587	1972.9.2	Cézanne, Paul *The Battle of Love*
2588	1972.9.3	Cézanne, Paul *Man with Pipe*
2589	1972.9.4	Cézanne, Paul *Mont Sainte-Victoire*
2590	1972.9.5	Cézanne, Paul *Still Life*
2591	1972.9.6	Chardin, Jean Siméon *Still Life with a White Mug*
2592	1972.9.7	Courbet, Gustave *Boats on a Beach, Etretat*

2593	1972.9.8	Courbet, Gustave *Landscape near the Banks of the Indre*
2594	1972.9.9	Degas, Edgar *Girl Drying Herself*
2595	1972.8.1	Derain, André *Marie Harriman*
2596	1972.9.10	Derain, André *Still Life*
2597	1972.9.11	Gauguin, Paul *Haystacks in Brittany*
2598	1972.9.12	Gauguin, Paul *Parau na te Varua ino (Words of the Devil)*
2604	1972.9.18	Matisse, Henri *Still Life with Pineapple*
2605	1972.9.19	Picasso, Pablo *Lady with a Fan*
2606	1972.9.20	Rousseau, Henri *Rendezvous in the Forest*
2607	1972.9.21	Seurat, Georges *Seascape at Port-en-Bessin, Normandy*
2608	1972.9.22	Toulouse-Lautrec, Henri de *Lady with a Dog*
2609	1972.10.1	Teniers, David, II *Peasants Celebrating Twelfth Night*
2610	1972.11.1	Wtewael, Joachim Antonisz *Moses Striking the Rock*
2616	1971.87.3	Hartung, Hans *Composition*
2621	1971.87.7	Millares, Manolo *Cuadro 78*
2623	1971.87.8	Soulages, Pierre *Composition*
2624	1971.87.9	Sutherland, Graham *Palm Palisades*

2628	1972.25.1	Géricault, Théodore *Trumpeters of Napoleon's Imperial Guard*
2629	1972.17.1	Magnasco, Alessandro *The Choristers*
2631	1972.46.1	Picasso, Pablo *Nude Woman*
2632	1972.44.1	Cantarini, Simone *Saint Matthew and the Angel*
2633	1972.74.1	Degas, Edgar *Woman Ironing*
2634	1972.73.1	Pacher, Michael, Follower of *Saint Alban of Mainz*
2635	1972.73.2	Pacher, Michael, Follower of *Saint Wolfgang*
2636	1972.73.3	Pacher, Michael, Follower of *Saint Valentine*
2637	1972.73.4	Pacher, Michael, Follower of *Saint Alcuin*
2642	1973.2.1	Jawlensky, Alexej von *Easter Sunday*
2643	1973.2.2	Münter, Gabriele *Christmas Still Life*
2644	1973.7.1	Chagall, Marc *Houses at Vitebsk*
2648	1973.13.1	Gaertner, Eduard *City Hall at Torun*
2649	1973.17.1	Matisse, Henri *Large Composition with Masks*
2650	1973.18.1	Matisse, Henri *Beasts of the Sea*
2651	1973.18.2	Matisse, Henri *Venus*
2652	1973.18.3	Matisse, Henri *Woman with Amphora and Pomegranates*

2653	1973.6.1	Matisse, Henri *La Négresse*
2655	1973.68.1	Cézanne, Paul *Houses in Provence*
2656	1973.68.2	Gauguin, Paul *Te Pape Nave Nave (Delectable Waters)*
2664	1973.69.1	Jawlensky, Alexej von *Murnau*
2665	1973.71.1	Lipchitz, Jacques *Still Life*
2672	1974.52.1	La Tour, Georges du Mesnil de *The Repentant Magdalene*
2673	1974.88.1	Bloch, Martin *The Cocoon Market at Mantua*
2674	1974.87.1	Giorgione, Attributed to *Giovanni Borgherini and His Tutor*
2676	1974.109.1	Kalf, Willem *Still Life with Nautilus Cup*
2680	1975.77.1	Teniers, David, II *Tavern Scene*
2688	1975.97.1	Soulages, Pierre *6 March 1955*
2689	1976.7.1	Bacon, Francis *Study for a Running Dog*
2692	1976.36.1	Böcklin, Arnold *The Sanctuary of Hercules*
2694	1976.26.1	Dutch 17th Century *Flowers in a Classical Vase*
2695	1976.26.2	Kouwenbergh, Philip van *Flowers in a Vase*
2700	1976.59.1	Gris, Juan *Fantômas*
2701	1976.67.1	Master of Frankfurt *Saint Anne with the Virgin and Christ Child*

2702	1976.63.1	Gauguin, Paul *The Invocation*
2704	1976.62.1	Smith, William *Mr. Tucker of Yeovil*
2705	1977.7.1	Huysum, Jan van *Flowers in an Urn*
2706	1977.21.1	Ostade, Adriaen van *Tavern Scene*
2709	1977.63.1	Soest, Gerard *Portrait of a Woman*
2720	1978.11.1	Goyen, Jan van *View of Dordrecht from the Dordtse Kil*
2722	1977.45.1	Miró, Joan *Woman*
2724	1978.46.1	Isenbrant, Adriaen *The Adoration of the Shepherds*
2725	1978.48.1	Kandinsky, Wassily *Improvisation 31 (Sea Battle)*
2726	1978.41.1	Klimt, Gustav *Baby (Cradle)*
2729	1978.47.1	Tissot, James Jacques Joseph *Hide and Seek*
2730	1978.62.1	Walker, John *Untitled (Oxford)*
2732	1978.73.1	Matisse, Henri *Palm Leaf, Tangier*
2765	1979.27.1	Pynacker, Adam *Wooded Landscape with Travelers*
2768	1979.50.1	Grimmer, Abel, Attributed to *The Marketplace in Bergen op Zoom*
2770	1979.65.1	Hoppner, John *Lady Harriet Cunliffe*
2771	1979.66.1a-b	Kirchner, Ernst Ludwig *Two Nudes*

2772	1979.67.1	Soulages, Pierre *Painting*
2773	1980.5.1	Degas, Edgar *The Loge*
2778	1943.3.26	Forain, Jean-Louis *Sketch of a Woman*
2779	1980.45.1	Forain, Jean-Louis *Backstage at the Opera*
2780	1980.45.2	Forain, Jean-Louis *The Petition*
2781	1980.45.3	Forain, Jean-Louis *The Requisition*
2846	1981.9.1	Miró, Joan *Head of a Catalan Peasant*
2847	1981.41.1	Picasso, Pablo *Peonies*
2852	1981.87.1	Gossaert, Jan *Madonna and Child*
2853	1981.85.1	Hartung, Hans *T.51.6*
2854	1981.84.1	Vlaminck, Maurice de *Woman with a Hat*
2857	1982.8.1	Picasso, Pablo *Guitar*
2858	1982.36.1	Aelst, Willem van *Still Life with Dead Game*
2859	1982.34.1	Ernst, Max *A Moment of Calm*
2863	1982.55.1	Bonington, Richard Parkes *Seapiece: Off the French Coast*
2865	1982.75.1	Manet, Edouard *Ball at the Opera*
2868	1982.76.2	Cross, Henri Edmond *Coast near Antibes*

2869	1982.76.3	Derain, André *Charing Cross Bridge, London*
2870	1982.76.4	Derain, André *Mountains at Collioure*
2873	1982.76.7	Rousseau, Henri *Tropical Forest with Monkeys*
2881	1983.1.6	Bazille, Frédéric *Negro Girl with Peonies*
2882	1983.1.7	Boudin, Eugène *Ships and Sailing Boats Leaving Le Havre*
2883	1983.1.8	Boudin, Eugène *Bathing Time at Deauville*
2884	1983.1.9	Boudin, Eugène *Jetty and Wharf at Trouville*
2885	1983.1.10	Boudin, Eugène *Festival in the Harbor of Honfleur*
2886	1983.1.11	Boudin, Eugène *Coast of Brittany*
2887	1983.1.12	Boudin, Eugène *Figures on the Beach*
2888	1983.1.13	Boudin, Eugène *Beach Scene*
2889	1983.1.14	Boudin, Eugène *Beach Scene at Trouville*
2890	1983.1.15	Boudin, Eugène *Washerwoman near Trouville*
2891	1983.1.16	Boudin, Eugène *Entrance to the Harbor, Le Havre*
2894	1983.1.19	Gauguin, Paul *Breton Girls Dancing, Pont-Aven*
2895	1983.1.20	Gauguin, Paul *Landscape at Le Pouldu*
2896	1983.1.21	Gogh, Vincent van *Flower Beds in Holland*

2897	1983.1.22	Klee, Paul *The White House*
2898	1983.1.23	Miró, Joan *The Flight of the Dragonfly before the Sun*
2899	1983.1.24	Monet, Claude *The Bridge at Argenteuil*
2900	1983.1.25	Monet, Claude *The Cradle—Camille with the Artist's Son Jean*
2901	1983.1.26	Monet, Claude *Interior, after Dinner*
2902	1983.1.27	Monet, Claude *Waterloo Bridge, London, at Dusk*
2903	1983.1.28	Monet, Claude *Waterloo Bridge, London, at Sunset*
2904	1983.1.29	Monet, Claude *Woman with a Parasol—Madame Monet and Her Son*
2907	1983.1.32	Renoir, Auguste *Flowers in a Vase*
2908	1983.1.33	Seurat, Georges *The Lighthouse at Honfleur*
2909	1983.1.34	Staël, Nicolas de *Ballet*
2910	1983.1.35	Villon, Jacques *From Wheat to Straw*
2911	1983.1.36	Villon, Jacques *Drink to the Chimera*
2912	1983.1.37	Villon, Jacques *Bridge of Beaugency*
2913	1983.1.38	Vuillard, Edouard *Woman in a Striped Dress*
2914	1983.1.39	Crome, John *Moonlight on the Yare*
2915	1983.1.40	Devis, Arthur *Arthur Holdsworth, Thomas Taylor and Captain Stancombe Conversing by the River Dart*

2916	1983.1.41	Fuseli, Henry *Oedipus Cursing His Son, Polynices*
2917	1983.1.42	Hogarth, William *A Scene from the Beggar's Opera*
2918	1983.1.43	Wheatley, Francis *Family Group*
2919	1983.1.44	Wilson, Richard *Lake Albano*
2920	1983.1.45	Wilson, Richard *Solitude*
2921	1983.1.46	Wright, Joseph *The Corinthian Maid*
2922	1983.1.47	Wright, Joseph *Italian Landscape*
2923	1983.1.48	Zoffany, Johann *The Lavie Children*

Subject Index

Religious subjects

Angels
Cherubim
 Matteo di Giovanni, no. 1937.1.9
Gabriel
 Gaddi, no. 1937.1.4.a
 Juan de Flandes, no. 1961.9.22
 Masolino da Panicale, no.
 1939.1.225
 Puccio di Simone and Nuzi, no.
 1937.1.6.a
 Simone Martini, no. 1939.1.216
Michael
 Signorelli, no. 1961.9.87
Raphael
 Lippi, Filippino, no. 1939.1.229

Ceremonies
Investiture
 Titian, no. 1960.6.38

Old Testament
Aaron
 Koerbecke, no. 1959.9.5
 Tintoretto, J., no. 1939.1.180
Abel
 Christus, no. 1937.1.40
Abraham
 Rubens, no. 1958.4.1
Absalom
 Eyck, Jan van, no. 1937.1.39
Adam
 Altdorfer, Workshop of, no.
 1952.5.31.b
Cain
 Christus, no. 1937.1.40
Daniel
 Rubens, no. 1965.13.1
David
 Castagno, no. 1942.9.8
 Eyck, Jan van, no. 1937.1.39
 Koerbecke, no. 1959.9.5
 Memling, no. 1937.1.41
Deluge
 Turner, no. 1960.6.40

Elijah
 *Koerbecke, no. 1959.9.5
 Piazzetta, no. 1952.5.70
 Savoldo, no. 1961.9.35
Enoch
 *Koerbecke, no. 1959.9.5
Eve
 Altdorfer, Workshop of, no.
 1952.5.31.b
Expulsion from the Garden of Eden
 Christus, no. 1937.1.40
 Giovanni di Paolo di Grazia, no.
 1939.1.223
Ezekiel
 Duccio di Buoninsegna, no.
 1937.1.8.c
Gathering of Manna
 Bacchiacca, no. 1952.5.4
Gideon
 Koerbecke, no. 1959.9.5
Goliath
 Castagno, no. 1942.9.8
Holofernes
 Mantegna, no. 1942.9.42
 Mantegna, Follower of, no.
 1939.1.178
Isaac
 Eyck, Jan van, no. 1937.1.39
Isaiah
 Duccio di Buoninsegna, no.
 1937.1.8.a
Jacob
 Eyck, Jan van, no. 1937.1.39
Job and his Daughters
 Blake, no. 1943.11.11
Joseph
 Rembrandt van Rijn, no.
 1937.1.79
Joshua
 *Koerbecke, no. 1959.9.5
Judith
 Mantegna, no. 1942.9.42
 Mantegna, Follower of, no.
 1939.1.178
Lot and his Daughters
 Dürer, no. 1952.2.16.b

Melchizedek
 Rubens, no. 1958.4.1
Moses
 Bacchiacca, no. 1952.5.4
 Bourdon, no. 1961.9.65
 Eyck, Jan van, no. 1937.1.39
 Koerbecke, no. 1959.9.5
 Tintoretto, J., no. 1939.1.180
 Veronese, no. 1937.1.38
 Wtewael, no. 1972.11.1
Noah
 Turner, no. 1960.6.40
Potiphar's wife
 Rembrandt van Rijn, no.
 1937.1.79
Rebecca
 Veronese, no. 1952.5.82
Samson
 Eyck, Jan van, no. 1937.1.39
Susanna
 Tintoretto, J., no. 1939.1.231
Tobias
 Lippi, Filippino, no. 1939.1.229
Worship of the Golden Calf
 Tintoretto, J., no. 1939.1.180

New Testament
Adoration of the Magi
 Angelico, Fra and Filippo Lippi,
 no. 1952.2.2
 Benvenuto di Giovanni, no.
 1937.1.10
 Botticelli, no. 1937.1.22
 Giovanni di Paolo di Grazia, no.
 1937.1.13
 Juan de Flandes, no. 1961.9.24
 North Netherlandish 15th Cen-
 tury, no. 1952.5.41
Adoration of the Shepherds
 Florentine 15th Century, no.
 1960.6.25
 Giorgione, no. 1939.1.289
 Isenbrant, no. 1978.46.1
 Piero di Cosimo, no. 1939.1.361
 Savoldo, no. 1961.9.86
Agony in the Garden
 Benvenuto di Giovanni, no.
 1939.1.318

*indicates a possible identification of
the subject*

Maurelius
Tura, no. 1952.2.6.d
Maurus
Lippi, Fra Filippo, no. 1952.5.10
Marmion, Studio of, no. 1952.5.45
Nicholas of Bari
David, Gerard, no. 1942.9.17.a
Gentile da Fabriano, no.
1939.1.268
Piero di Cosimo, no. 1939.1.361
Paul
Daddi, nos. 1937.1.3, 1952.5.61
Domenico di Bartolo, no. 1961.9.3
Rembrandt van Rijn, no.
1942.9.59
Tintoretto, J., no. 1961.9.43
Paul the Hermit
Sassetta and Workshop, no.
1939.1.293
Paula
Zurbarán, no. 1952.5.88
Peter
Bellini, G., no. 1943.4.37
Cimabue, Follower of, nos.
1937.1.2.a, 1952.5.60
Daddi, no. 1952.5.61
Domenico di Bartolo, no. 1961.9.3
Duccio di Buoninsegna, no.
1939.1.141
Giambono, no. 1939.1.80
Martino di Bartolomeo di Biago,
Attributed to, no. 1950.11.1.a
Nardo di Cione, no. 1939.1.261.a
Rubens, Studio of, no. 1960.6.32
Zoppo, no. 1939.1.271
Placidus
Lippi, Fra Filippo, no. 1952.5.10
Marmion, Studio of, no. 1952.5.45
Roch
Perino del Vaga, no. 1961.9.31
Sebastian
Anonymous Portuguese 17th
Century, no. 1960.6.30
Aspertini, no. 1961.9.1
Corot, no. 1960.6.4
Perino del Vaga, no. 1961.9.31
Redon, no. 1963.10.57
Tanzio da Varallo, no. 1939.1.191
Sigismund
Nerroccio de' Landi, no.
1952.5.17
Simon
Memling, no. 1937.1.41
Simone Martini, Workshop of, no.
1952.5.24
Strigel, no. 1961.9.88

Stephen
Martino di Bartolomeo di Biago,
Attributed to, no. 1950.11.1.c
Thaddeus (see Jude)
Thomas
Girolamo da Carpi, no.
1939.1.382
Twelve Apostles
Dyck, van, After, no. 1960.6.11
Unknown Saint
Tiepolo, no. 1956.9.16
Ursula
Gozzoli, no. 1939.1.265
Valentine
Pacher, Follower of, no. 1972.73.3
Venantius
Puccio di Simone and Nuzi, no.
1937.1.6.c
Veronica's Veil
Fetti, no. 1952.5.7
Memling, no. 1952.5.46.a
Wolfgang
Pacher, Follower of, no. 1972.73.2

Miscellaneous
Forms of Worship
Adoration of the Skulls
Dandré-Bardon, no. 1956.3.1
Baptism of Clovis
Master of Saint Giles, no.
1952.2.15
Church Congregation
Daumier, no. 1943.11.1
Invocation
Gauguin, no. 1976.63.1
Preaching
Erri, no. 1941.5.2

Portraits
Adorno, Paolo
Dyck, van, no. 1942.9.91
Adrienne
Modigliani, no. 1963.10.171
Agostina
Corot, no. 1963.10.108
Alberti, Alessandro
Titian, Follower of, no. 1952.5.80
Alençon, Duc d', Prince Hercule-
François
Anonymous French 16th Century,
no. 1961.9.55
Altoviti, Bindo
Ralphael, no. 1943.4.33
Amédée, Madame
Modigliani, no. 1963.10.172

Anderson, David
Raeburn, no. 1942.9.56
Aubigny, Lady Catherine d' (née
Howard)
Dyck, van, no. 1942.9.95
Averoldo, Bishop Altobello
Francia, no. 1952.5.64
Avril, Jane
Toulouse-Lautrec, no. 1963.10.66
Bakst, Léon
Modigliani, no. 1963.10.173
Balbi, Marchesa
Dyck, van, no. 1937.1.49
Barbarigo, Agostino
Veronese, Follower of, no.
1957.8.1
Barry, Madame du
Drouais, F.-H., no. 1960.6.9
Bazille, Frédéric
Monet, no. 1970.17.41
Bembo, Cardinal Pietro
Titian, no. 1952.5.28
Benci, Ginevra de'
Leonardo da Vinci, no. 1967.6.1.a
Benozzi, Jeanne-Rose-Guyonne
("Sylvia")
Watteau, no. 1946.7.17
Bentivoglio, Ginevra
Roberti, no. 1939.1.220
Bentivoglio, Giovanni II
Roberti, no. 1939.1.219
Bergeret, Madame Marguerite-
Josèphe
Boucher, no. 1946.7.3
Betty, Dame
Raeburn, no. 1945.10.3
Betty, Master William Henry West
Ramsay, After, no. 1947.17.36
Beverley, 1st Earl and Isabella
Countess of
Anonymous British 18th Century,
nos. 1956.9.4, 1956.9.5
Binning, Alexander
Raeburn, no. 1942.5.2
Binning, George
Raeburn, no. 1942.5.2
Blair, Mrs. Alexander (née Mary
Johnson)
Romney, no. 1942.9.77
Blau, Edouard
Bazille, no. 1963.10.81
Boghe, Margaretha, wife of Joris
Vezeleer
Cleve, J. van, no. 1962.9.2
Bonnier de la Mosson, Joseph
Nattier, no. 1961.9.30

Millet, no. 1949.1.9

Modigliani, nos. 1963.10.46,
1963.10.77

Morisot, no. 1970.17.49

Picasso, nos. 1963.10.189,
1963.10.197, 1963.10.207,
1972.9.19, 1972.46.1

Pissarro, nos. 1963.10.54,
1963.10.199

Renoir, nos. 1948.18.1, 1956.4.1,
1956.4.2, 1963.10.60,
1963.10.108, 1963.10.204,
1967.13.1, 1970.17.66,
1970.17.67, 1970.17.68,
1970.17.71, 1970.17.73,
1970.17.74, 1970.17.76

Ribot, no. 1963.10.61

Rouault, no. 1963.10.211

Stevens, no. 1964.19.7

Wilkie, no. 1960.6.42

Profane

Achates
Dossi, Dosso, no. 1939.1.250
Adonis
Titian, no. 1942.9.84
Aeneas
Dossi, Dosso, no. 1939.1.250
Aesop, *Fables*
Liss, no. 1942.9.39
Agrippina
Rubens, no. 1963.8.1
Allegory
Donducci, no. 1952.4.1
Lotto, no. 1939.1.156
Piero di Cosimo, no. 1939.1.160
Titian, Follower of, no.
1939.1.259
Venetian 16th Century, no.
1948.17.1
Allegory of Astronomy
Vouet, no. 1961.9.61
Allegory of Love
Cézanne, no. 1972.9.2
Fragonard, nos. 1947.2.1,
1947.2.2, 1970.17.111,
1970.17.112
Venetian 16th Century, no.
1948.17.1
Allegory of Music
Boucher, no. 1946.7.2
Allegory of Mourning
Wright, After, no. 1963.10.79
Allegory of Painting
Boucher, no. 1946.7.1

Allegory of Poetry
Vouet, no. 1961.9.61
Allegory of Rest
Puvis de Chavannes, no. 1942.9.54
Allegory of Solitude
Richard Wilson, no. 1983.1.45
Allegory of Spain
Tiepolo, no. 1943.4.39
Allegory of Temperance
Vermeer, no. 1942.9.97
Allegory of Work
Puvis de Chavannes, no. 1942.9.55
Apollo
Anselmi, no. 1939.1.350
Bellini, G., no. 1942.9.1
Tiepolo, no. 1952.5.78
Apotheosis
Tiepolo, no. 1939.1.100
Ariadne
Tiepolo, no. 1960.6.36
Ars Moriendi
Bosch, no. 1952.5.33
Athena
Anselmi, no. 1939.1.350
Bacchus
Altdorfer, no. 1952.5.31.a
Bellini, G., nos. 1942.9.1, 1961.9.5
Carracci, A., no. 1961.9.9
Tiepolo, no. 1960.6.36
Baucis
Rembrandt van Rijn, no.
1942.9.65
Calliope
Vouet, no. 1961.9.61
Camillus
Biagio d'Antonio da Firenze, no.
1939.1.153
Carlo
Guardi, G. A. and F., no.
1964.21.1
Cephalus
Luini, nos. 1943.4.53, 1943.4.54,
1943.4.55, 1943.4.57,
1943.4.58, 1943.4.59
Ceres (Summer)
Bellini, G., no. 1942.9.1
Tintoretto, J., no. 1961.9.90
Watteau, no. 1961.9.50
Charity
Andrea del Sarto, no. 1957.14.5
Circe
Bellini, G., no. 1942.9.2
Dossi, Dosso, no. 1943.4.49
Claudia Quinta
Neroccio de' Landi and the Master
of the Griselda Legend, no.
1937.1.12

Cleodolinda
Raphael, no. 1937.1.26
Sodoma, no. 1952.5.76
Weyden, Rogier van der, no.
1966.1.1
Clovis
Master of Saint Giles, no.
1952.2.15
Columbus
Delacroix, no. 1963.10.127
Corinthian Maid
Wright, no. 1983.1.46
Cupid
Boucher, no. 1943.7.2
Carracci, A., no. 1961.9.9
Crespi, no. 1939.1.62
Fragonard, nos. 1947.2.1,
1947.2.2, 1970.17.111,
1970.17.112
Titian, nos. 1937.1.34,
1939.1.213, 1952.2.12
Georgione, Circle of, no.
1939.1.142
Cybele
Bellini, G., no. 1942.9.1
Daphne
Tiepolo, no. 1952.5.78
Decius Mus
Rubens, no. 1957.14.2
Diana
Boucher, no. 1960.6.2
Luini, nos. 1943.4.52, 1943.4.54,
1943.4.55
Renoir, no. 1963.10.205
Doctor of Bologna
Watteau, no. 1946.7.9
Endymion
Boucher, no. 1960.6.2
Erminia
Guardi, G. A. and F., no.
1964.21.2
Eunostos of Tanagra
Master of the Griselda Legend, no.
1952.5.2
Feast of the Gods
Bellini, G., no. 1942.9.1
Daumier, Follower of, no.
1943.11.2
Flaminia
Watteau, no. 1946.7.9
Harlequin
Derain, no. 1963.10.129
Watteau, no. 1946.7.9
Hasdrubal's wife
Roberti, no. 1965.7.1
Hebe
Nattier, no. 1946.7.13

Hercules
 Böchlin, no. 1976.36.1
Isabella
 Watteau, no. 1946.7.9
Italian Comedians
 Watteau, no. 1946.7.9
Judgment of Paris
 Claude Lorrain, no. 1969.1.1
 Dufresne, no. 1963.10.140
 Sons, no. 1961.9.80
Juno
 Claude Lorrain, no. 1969.1.1
 Sons, no. 1961.9.80
Jupiter
 Bellini, G., no. 1942.9.1
 Poussin, no. 1952.2.21
 Rembrandt van Rijn, no.
 1942.9.65
Laocoön
 Greco, El, no. 1946.18.1
Lelio
 Watteau, no. 1946.7.9
Livy, *Book I*
 Crespi, no. 1952.5.30
Lucretia
 Crespi, no. 1952.5.30
 Rembrandt van Rijn, no.
 1937.1.76
Luna
 Bellini, G., no. 1942.9.2
Mario
 Watteau, no. 1946.7.9
Mars
 Altdorfer, no. 1952.5.31.c
 Carracci, A., no. 1961.9.9
Marsyas
 Anselmi, no. 1939.1.350
Mercury
 Bellini, G., no. 1942.9.1
 Rembrandt van Rijn, no.
 1942.9.65
 Sons, no. 1961.9.80
Mezzetin
 Watteau, no. 1946.7.9
Michelangelo
 Delacroix, Follower of, no.
 1963.10.19
Minerva
 Claude Lorrain, no. 1969.1.1
 Sons, no. 1961.9.80
Napoleon's Imperial Guard
 Géricault, no. 1972.25.1
Neptune
 Bellini, G., no. 1942.9.1

Nicoló da Correggio, *Cefalo*
 Aspertini, no. 1961.9.1
 Luini, nos. 1943.4.52, 1943.4.53,
 1943.4.54, 1943.4.55,
 1943.4.56, 1943.4.57,
 1943.4.58, 1943.4.59,
 1943.4.60
Nymph of the Spring
 Cranach, no. 1957.12.1
 Luini, no. 1939.1.120
Ochne
 Master of the Griselda Legend, no.
 1952.5.2
Oedipus
 Fuseli, no. 1983.1.41
Orpheus
 Bellini, G., no. 1942.9.2
Ovid, *Fasti*
 Bellini, G., no. 1942.9.1
 Neroccio de' Landi and the Master
 of the Griselda Legend, no.
 1937.1.12
Ovid, *Metamorphoses*
 Luini, nos. 1943.4.52, 1943.4.53,
 1943.4.54, 1943.4.55,
 1943.4.56, 1943.4.57,
 1943.4.58, 1943.4.59,
 1943.4.60
 Rembrandt van Rijn, no.
 1942.9.65
Palladia
 Angelico, Fra, no. 1952.5.3
Pan
 Bellini, G., nos. 1942.9.1, 1942.9.2
 Luini, no. 1943.4.54
Pandora
 Redon, no. 1963.10.56
Pantalon
 Watteau, no. 1946.7.9
Paris
 Sons, no. 1961.9.80
 Claude Lorrain, no. 1969.1.1
Parau na te varua ino
 Gauguin, no. 1972.9.12
Philemon
 Rembrandt van Rijn, no.
 1942.9.65
Pierrot
 Watteau, no. 1946.7.9
Plutarch, *Moralia*
 Master of the Griselda Legend, no.
 1952.5.2
Polynices
 Fuseli, no. 1983.1.41
Priapus
 Bellini, G., no. 1942.9.1

Procris
 Luini, nos. 1943.4.52, 1943.4.56,
 1943.4.60
Proserpine
 Turner, no. 1951.18.1
Putti
 Raphael, no. 1952.5.72
Quarrel
 Creti, no. 1961.9.6
Sabine Women
 French 18th Century, no.
 1942.9.79
Saltimbanques
 Daumier, no. 1963.10.14
 Picasso, no. 1963.10.190
Satyr
 Bellini, G., nos. 1942.9.1, 1942.9.2
 Liss, no. 1942.9.39
 Lotto, no. 1939.1.147
Scapin
 Watteau, no. 1946.7.9
Scaramouche
 Watteau, no. 1946.7.9
Scipio Africanus, Publius Cornelius
 Bellini, G., no. 1952.2.7
Shovell, Admiral Sir Clowdisley,
 Memorial to
 Ricci, S. and M., no. 1961.9.58
Silenus
 Bellini, G., no. 1942.9.1
Silvanus
 Bellini, G., no. 1942.9.1
Singerie
 French 18th Century, nos.
 1957.7.1, 1957.7.2, 1957.7.3,
 1957.7.4, 1957.7.5, 1957.7.6
Summer (see Ceres)
Sylvia
 Watteau, no. 1946.7.9
Tarquin
 Crespi, no. 1952.5.30
Tasso, *Gerusalemme Liberata*
 Guardi, G. A. and F., nos.
 1964.21.1, 1964.21.2
Three Graces
 Carracci, A., no. 1961.9.9
Tiberius
 Rubens, no. 1963.8.1
Timocleia and the Thracian
 Commander
 Tiepolo, no. 1939.1.365
Ubaldo
 Guardi, G. A. and F., no.
 1964.21.1
Ulysses
 Ingres, no. 1963.10.34

Unicorn
 Luini, no. 1943.4.60
Urania
 Vouet, no. 1961.9.61
Venus
 Sons, no. 1961.9.80
 Boucher, no. 1943.7.2
 Carracci, A., no. 1961.9.9
 Claude Lorrain, no. 1969.1.1
 Luini, no. 1939.1.120
 Matisse, no. 1973.18.2
 Titian, nos. 1937.1.34, 1942.9.84,
 1952.2.12
 Giorgione, Circle of, no.
 1939.1.142
Vesta
 Bellini, G., no. 1942.9.1
Virgil, *Aeneid*
 Dossi, Dosso, no. 1939.1.250
Vulcan
 Carracci, A., no. 1961.9.9
Zenobia, Queen of Palmyra
 Tiepolo, no. 1961.9.42

Topographical Subjects

Fantasy
 Ernst, no. 1982.34.1
 Lurçat, no. 1963.10.160
 Rousseau, H., nos. 1963.10.213,
 1982.76.7
 Tanguy, no. 1984.75.1

Great Britain
England
 Gainsborough, no. 1937.1.107
Ashdon House
 Devis, no. 1964.2.4
Cowes
 Dufy, no. 1970.17.30
Dedham
 Constable, no. 1942.9.9
Hampstead Heath
 Legros, no. 1963.1.1
Hampton Court
 Pissarro, no. 1970.17.53
Henley
 Dufy, no. 1970.17.31
London
 Charing Cross Bridge
 Derain, no. 1982.76.3
 Houses of Parliament
 Monet, no. 1963.10.48
 Mall
 Ricci, M., Attributed to, no.
 1970.17.132

Waterloo Bridge
 Monet, nos. 1963.10.183,
 1983.1.27, 1983.1.28
Mortlake Terrace
 Turner, no. 1937.1.109
Medway River
 Turner, no. 1942.9.87
Norwich
 Crome, Follower of, no. 1942.9.14
Oxford, Merton College
 Highmore, no. 1951.7.1
Richmond, Easby Abbey
 Cuitt, no. 1959.1.1
Salisbury
 Constable, no. 1937.1.108
Thames River
 Turner, nos. 1937.1.109,
 1942.9.87
Tyne River
 Turner, no. 1942.9.86
Wivenhoe Park
 Constable, no. 1942.9.10
Yare River
 Crome, no. 1983.1.39

France
 Anonymous French 19th Century,
 no. 1970.17.62
 Bonington, no. 1982.55.1
 Bonnard, nos. 1970.17.7,
 1970.17.8, 1970.17.10,
 1970.17.11
 Cazin, no. 1949.1.1
 Cézanne, nos. 1970.17.21,
 1972.9.1
 Corot, no. 1943.15.1, 1949.1.2
 Courbet, no. 1943.15.2
 Daubigny, nos. 1949.1.3,
 1963.10.116
 Dupré, no. 1949.1.5
 Le Nain, no. 1946.7.11
 Morisot, no. 1970.17.50
 Renoir, nos. 1970.17.61,
 1970.17.65, 1970.17.75
 Rousseau, T., no. 1949.1.10
 Vlaminck, no. 1963.10.226
Antibes
 Cross, no. 1982.76.2
Argenteuil
 Monet, nos. 1970.17.42,
 1970.17.44, 1983.1.24
 Renoir no. 1970.17.59
 Sisley, no. 1970.17.82
Arles
 Gogh, van, no. 1970.17.34
Auvers
 Cézanne, no. 1963.10.102

Avray
 Corot, no. 1955.9.1
Aix-en-Provence
 Cézanne, no. 1958.10.1
Barbizon Forest
 Diaz de la Peña, no. 1949.1.4
Beaugency
 Villon, no. 1983.1.37
Brittany
 Boudin, no. 1983.1.11
 Gauguin, nos. 1963.10.148,
 1972.9.11, 1983.1.20
 Moret, no. 1970.17.46
Cagnes
 Derain, no. 1963.10.130
 Renoir, no. 1970.17.77
Cannet, Le
 Bonnard, no. 1970.17.11
Carrières-Saint-Denis
 Vlaminck, no. 1963.10.224
Chatou
 Renoir, no. 1951.5.2
Collioure
 Derain, no. 1982.76.4
Corsica, Corté
 Utrillo, no. 1970.17.89
Coubron
 Corot, no. 1942.9.12
Croisic, Le
 Anonymous French 19th Century,
 no. 1970.17.1
Deauville
 Boudin, no. 1970.17.16
 Dufy, no. 1970.17.32
Epernon
 Corot, no. 1942.9.13
Eragny
 Pissarro, no. 1970.17.54
Etretat
 Corot, no. 1970.17.117
 Courbet, no. 1972.9.7
Fontainebleau
 Corot, nos. 1963.10.109,
 1963.10.110
Giverny
 Monet, no. 1963.10.180
Grande Jatte, La
 Seurat, no. 1970.17.81
Havre, Le
 Boudin, no. 1983.1.7
 Boudin, no. 1983.1.16
Honfleur
 Boudin, no. 1983.1.10
 Seurat, no. 1983.1.33
Indre River
 Courbet, no. 1972.9.8